ENDURING CREATION

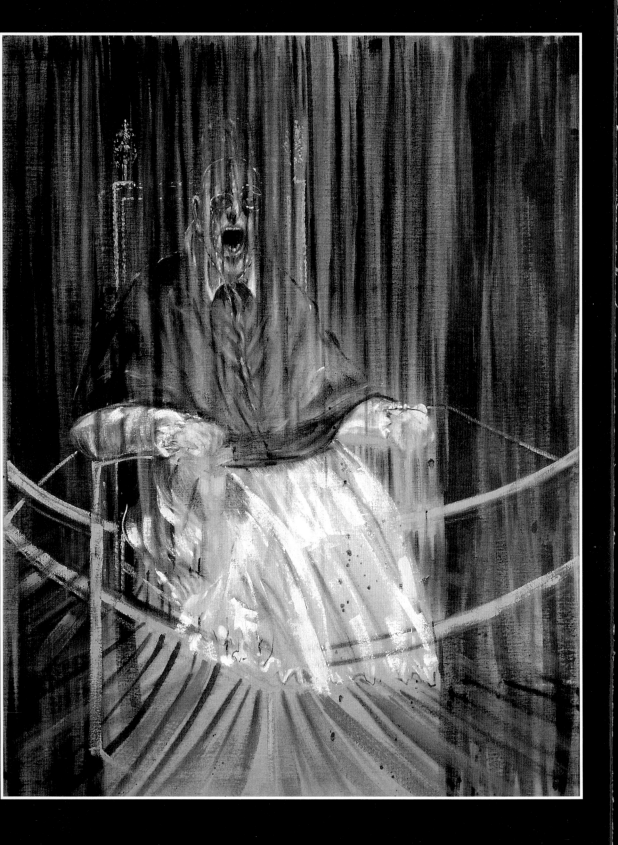

Nigel Spivey

ENDURING CREATION

Art, Pain, and Fortitude

UNIVERSITY OF CALIFORNIA PRESS

BERKELEY LOS ANGELES

To Rachel Polonsky
di fiamma viva

University of California Press
Berkeley and Los Angeles, California

Published by arrangement with
Thames & Hudson Ltd, London

© 2001 Nigel Spivey

ISBN 0-520-23022-1

Printed in Singapore

9 8 7 6 5 4 3 2 1

1 *Frontispiece*
STUDY AFTER VELÁZQUEZ'S
PORTRAIT OF POPE
INNOCENT X
Francis Bacon, 1953

CONTENTS

PRELUDE

Anthropologists have documented a certain tribal community in which the reflexes of pity and sympathy are extinguished. An old man trips into the fire, and everyone laughs as he flails. A weakling child is teased to death: more merriment all round. Illness, mishap, act of malice: it is all the same in this community. Tough luck, and serves you right.

The existence of such a tribe does not prove our primal nature to be inherently 'nasty'. But it confirms a truth about our emotional reflexes. Which is, that we are compassionate by habit, not from birth. Pity is something that we learn to feel.

This is a book about art that habituates us in that way; it is about the aesthetic of feeling for others.

So it is also a book about horror, fear, death, ghastliness and grievous bodily harm; it is, predominantly, a book about pain.

It is about pain lodged at the core of human experience. Pain feared; pain avoided; pain inflicted; pain endured; pain savoured; and pain regarded.

There is, one might say, no shortage of data.

Yet it is a book about art.

Art soothes our lives. Art may bring the craved relief of sheer delight in this world. But art also shows how we have disfigured ourselves.

Art feeds on what befalls us.

Art arrives at the sites of agony; art agonizes there.

And art keeps us going, in our wounded state.

Many stories flow from human painfulness. This is a collection from the Western hemisphere, and it seems quite enough for one book. I have not sought much further.

The opening chapter is an overture: partly confessional, broadly moralizing, and, I should say, obligatory, since there is a strong case for arguing that 'the Western cultural tradition' went to ground at Auschwitz, and was thoroughly mocked by what happened, at Europe's centre, under National Socialism. I deny the notion of anyone being 'a Holocaust bore'; yet admit that I write as simply one more belated witness.

The rest of the book is ordered more or less chronologically. A large central section is preoccupied with the images of Christian devotion: the art of a faith uniquely built over and founded upon a body in distress. How might Western art have looked without its prime heraldic inheritance: Christ strung out and bleeding on two jointed beams of wood; and all the apostolic martyrs – cut, peeled, pounded, skewered and seared? There is no preaching intent here, but I felt some scruple to sketch in and cross-hatch the varying historical shades of Christian credence. Zealous torture and murderous hatred are still with us, but we seem no longer inclined to maim our fellow-mortals, or embrace extremes of pain, in the name of God the Father, God the Son and God the Holy Spirit. Imaginative energy is required to recall the times when our ancestors might do just such.

Images are images and words are words: both make a *discourse* about pain, which is pursued in this book beyond the usual cordons of academic discipline. Overlappings of art, drama, philosophy, science, literature and all the stuff of history – at worst they will clash and annoy like a bag of tricks; at best they may combine for mutual clarity.

A character who briefly appears in the pages of Boswell's *Life of Johnson* says he has tried to be a philosopher, but failed because 'cheerfulness was always breaking in'. I hesitate to guess how often cheerfulness erupts in what follows, but I have sought not to indulge a gluttony of grief, too much vinegary harangue. It is a mystery of both art and existence that we take pleasure from a tragedy; find beauty in a body pierced or torn; may be erotically stirred by hurt received or given.

We know how reporters, with notebooks and lenses, thrive in zones of human disaster – scouting and jabbing like crows over carrion. The compulsion to hurry to the view of a kill seems an instinct in us all: bad news is good business, therefore.

At the same time, we may understand, or part-understand, what it is of us that gains from loss of blood; what it is of us that is forged or unforsaken when our bodies are smashed and maimed.

Some call it 'the human spirit'.

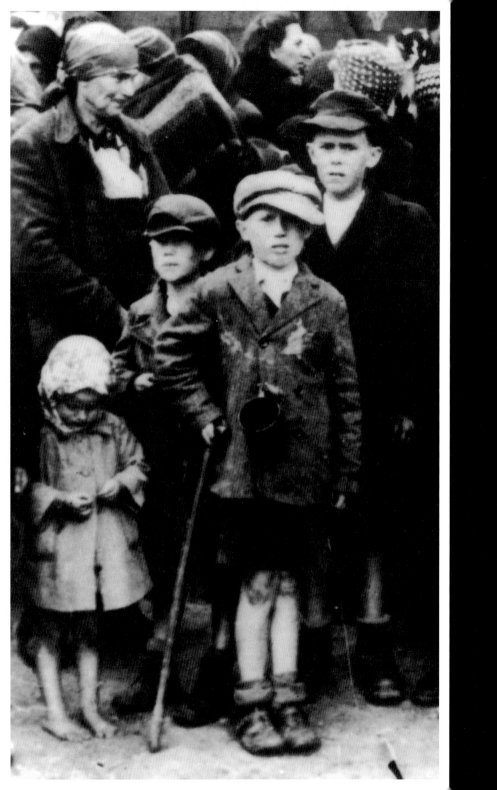

1 STEPPING WORSTWARDS

You are taking the night train.

Not because the night train was, or is, in any sense the rightful way of getting there. Just one of those things that happen. Air traffic gone awry – arrival in the country at odd hours. No room reserved in the capital, nor anywhere else. A seat in a railway carriage as warm a place as anywhere to wait for the day. Might as well start shifting to the destination of the pilgrimage.

No plan of yours, then, to enact the part of vicarious victim. But the national rail system seems to connive as far as it can. Those apparently random slowings-down in apparent nowhere; those ten-minute halts in a deep, tree-spoked silence. An engine's sudden asthma. You peer into a swampy-dark outside.

'Where the hell . . .?'

Would there were anyone to ask. There have been some fellow-passengers – grunting, vodka-sodden. They seem to have gone – evaporated, or collapsed.

A bone-clumping shunt, the squealed scrape of reluctant traction. Off again.

So it goes, till you arrive at the station and sidings before six with dawn still unbroken.

It is too soon for coffee in the lobby. But a quick pastryman, bashing through doors with a warm tray, is slightly lightened of his load. You sit and chew the bun upon a drab stone bench and study the plans of the place. A trudging mop-lady's transistor emits two unsolicited little international anthems for this adventure. 'Hold on tight to your dreams,' warns one. 'What's love got to do with it?' cries another.

Beyond the station, connivance continues. Prior to sunrise, the whole town looks like old barracks. Rags of smoke flap from low-lain industrial plants: the air is sulphurous. Passing a fence, you leap electrically as some unkennelled hound crashes alongside and sets up his bloodlust. Big lamps eye an ugly gloom.

The crusty cold verge creaks beneath your boots and you can hardly fail to be glad to be well-heeled.

Now. There. There is a glimpse of railtrack, unused yet not so olden. It issues from brambles and back-gardens, but its direction grows obvious in debutant day. It is a spur, and from a fair distance you see where it must go. Past tilled earth, ditchworks, and tumuli of turnips – there, a raised pagoda-tower. A tower designed by an architect not lacking in sense of proportion; a tower flanked by officious wings of brickwork. It is not a forbidding entrance: somewhat like the portals of an English coaching-inn.

Treading with the sleepers brings you surely to its bourn.

So here you are. At daybreak, with cockerels all over – and, in early January, the air chaffingly sub-zero. Apparently solo: if one can say so; if that can ever be – here.

You have anticipated the latterday guards who patrol this wired-off site of UNESCO heritage. Still, there is a torn convenient gap in the rusting barbs.

2 'BIRKENAU 1944. FAMILIES ON THE RAMP.'

The photographer remains anonymous; so too the subjects, believed to be Jews deported to Auschwitz from Hungary, and just disembarked from the train that carried them. It is likely that everyone we see here was gassed within hours, perhaps minutes, of this photograph being taken.

You crunch across the silvered turf, to rejoin the railway track. It runs within the compound for almost half a mile. It terminates here, upon a ramp. This has been a landmark in the mind's eye. This is the long esplanade of cursory assessment; that platform from which some ('able-bodied') were set aside to labour for their new masters; the rest (most) shepherded direct into cryptic basements – no further than a shuffle, hobble or skipalong from this disembarking place.

For the swift reliable sequence of confinement, gas, cremation.

Enlarged images are displayed at the site, on billboards. View, then, how the wagonloads huddled once, not so long ago: blinking, clustering close; dwarfed by those tall men in steel-grey livery. The wardens jack-booted. But not toting their guns, nor even the brisk bull-whip. Rather, lording it over this judgement-place with rustic staves and goads – with diligent, almost pastoral gestures – and beaming, some of them, a near benign solicitude. Yes, yes – a warm shower after that long journey – no lice allowed beyond this point – see, we are not in the ghettoes now – down, down, down is where to go. The smiles of well-oiled deception.

The flock? Half-panicked, half-scuttling along.

So the pictures say; so every vistor learns to imagine how it was done and executed – the logistics of the piece.

You catch yourself straining to listen too.

The soundless drumming down there. Where the moles now paddle along. Industrious moles. Who knows what objects – old canisters, dare say – may clog their humus-tunnels throughout this ample compound? Meanwhile the ramp is cropped by pert deer. The numbered lodging byres, the slatted storage huts – acre upon acre, so true to some orthogonal matrix: so strikingly extensive – today their doors are swung open, here and there. Wander at will, like the deer: you are free to inspect the planks on which the transient inhabitants were racked and stored. You witness, now, that some latter visitors have not felt afraid to mark the plasterwork and wood. School parties, perhaps. Teenagers with hormones more pressing than this – this pious trail from one blockhouse to another. Seemingly it is all the same, the same again, too big to comprehend. A bore, perhaps. 'This is gross, man.' Or else – with a shrug – 'Yeah. Like, incredible.'

Hold on tight to your dreams.

Brick fingers rise from the muffle-furnace ruins. See, they *knew* – they knew, the executives of this place. How else to explain, with an avenging vanguard pounding hard by, that frenetic botched effort to detonate, to eradicate these death-efficient installations?

Burned crematoria. A late flare of shame. The archaeology of a last and sorry but saving grace? Maybe. Maybe.

A crisp blur of uniforms. Ah. The latterday sentries have arrived at the pavilion; stamping, huffing into mittened hands. Coffee and laughter within; the first flick of greasy cards is easily supposed. But come on, and come away. Let your legs perform the once unthinkable. You can simply stroll out from here; depart this terminus.

That was Birkenau: which lies close to a small, dull place in Poland called Oswiecim.

Ho, poor Oswiecim. Arrive on a January morn, and you find a town terrorized by ice. Everywhere the glottal churr of chillsome motors being willed to start. Sunshine paints the urban roads and fails to embellish them. And it is as well that signs denote the museum enclosure which bears the old German name for Oswiecim, 'Auschwitz'. All you might otherwise observe, amid the greying postwar precincts, were an establishment of desirable – yes, desirable – elegance and sturdiness. Auschwitz 'proper'. How proper it does seem. As its satellite camp, Birkenau, presents itself like a refuge for the weary traveller, so Auschwitz has its aspect of civility. Stucco and brickbuilt – two-storeyed – spacious attics – wrought-iron lanterns – tree-lined cobbled avenues – what more bourgeois and trim? If you had been told this was once a model habitation created for his workforce by some God-fearing industrialist (cheering motto over the entrance: *Arbeit macht frei*, 'Work Makes Free'), you would not be surprised. Reception area, shower facilities, medical centre, laundry-rooms. *Wie heimlich*, 'how homely': homeliness exemplified. And *so* fussy about the bed-making here. Hospital corners down to the inch and woe betide the slovenly.

The rooms where former arrivals were clipped and sprayed and tattooed to cipher-status now make a vestibule to the museum experience. Pay the modest toll. Guidebooks, postcards. 'English? Video?' Video, *videbimus*: 'we shall see'. Off you go, under that quaint gate with its quaint motto. Some of the respectable-looking blocks in the tree-lined boulevards have become archives, administration. Others are open for view. With galleries; glass cabinets, if some of unusual magnitude; rooms more or less as they were. Museum things – curiosities – for you to see and associate with Auschwitz. 'Aids to contemplation', perhaps. A purist might quibble over provenance, since such a quantity of these exhibits came hauled from those wooden-slatted store-barns at Birkenau; full of confiscated belongings, a seemingly untold and far-away bounty that prisoners apostrophized as 'Canada'. But perhaps it does not matter. Let 'Auschwitz' cover what happened here, and at Birkenau, and the nearby factory-*Lager* of Monowitz where No. 174517 – the Italian chemist and witness Primo Levi – served. Presently enough we shall want the name 'Auschwitz' extended further, as a symbol of all the Holocaust. It has become a capacious name, Auschwitz: and it still seems like a capacious place.

Here, though . . . amongst so many *objets trouvés* . . . beyond catalogue . . . what to salute? Exactly what can one laggard pilgrim report – that Primo Levi, for example, did not tell us?

This particular pilgrim expected to be rendered speechless; yet carried a notebook around, and found that powers of speech did not entirely collapse. Take, for example, that great depository of saved and plaited hair. Banked behind glass, piles of fusty brittle clippings. They are oddities to look upon – detached, peculiar and nasty. But they resist wordless gaping. Visitors nudge one another, and make noises. These are testimonials that count.

For myself I can say I made the tour; quietly enough, yet making notes of this and that. Such as:

Item. Gallows, portable. Designed for rapid assembly, impromptu use. Nifty as any queen's commode.

Item. Strewn wire spectacles. Giant nests thereof. The playground barons take their sport – with a nimble-brained but cornered prey.

Item. One resting array of legs, wooden; plus sundry crutches, trusses and likewise supports. Not able-bodied, but by God they were trying . . .

So?

So I, for one, say: this was salvage of the flammable, and – considered thus – truly petty perverse; truly monumental grotesque. Absurd. (You could almost laugh.)

Item. Or should one make it plural? A page headed: *Verstorbene Häftlinge* – 'Inmates Destroyed'. Such well-entered tallies of them. Such a neat ledger. Such a schooled hand . . . writing we'd call – in its way – 'careful'; painstaking.

Hah.

Item. Toddler's pinafore. No, correction: several. 'Used', yet hardly so – too dainty, too dear, too much like miniature workwear. Their dinky slippers, sandals and padders too.

At which point . . .

. . . saline blots in notebook . . .

As one was due to expect. Sooner or later.

* * * * *

There is a warning at Auschwitz Museum to the effect that it is unsuitable for children. As if parents could sally round the place with more emotional competence. This *is* presumptuous, but let us presume that when museum-goers at Auschwitz become tearful, tears may not start from the documented numbers as such: so many thousands per month – that tidy ledger filled, then abandoned from excess – the traipse from the ramp of a million and more. Nor, to extend this presumption, may the photographic images of mangled humanity cause weeping outright. Striped pyjama-folk, gathered mutely at a wire. Bare forked animals – in a pit, in a pile – a wickerwork of corpses. Barely to be recognized. Recovered for a camera lens but still remote from us.

I confess – with the due nuance of shame implied by confession – that it took a more ordinary monochrome, a mere ordinary monochrome, to blast with weepiness this visitor to Auschwitz Museum. 'Birkenau 1944. Families on the ramp.' That was the caption. The image includes one young face caught front-on and screwed in apprehension – a boy, under a jaunty cap, socks hooped round his ankles. There is a drinking-mug tied to his jacket; all else that he carries is an old man's walking-stick. Near to him there is a girl, with a shawl over her head. Absorbed and looking down. Not aware of the lens. Not aware, one would suppose, of very much at all – except she seems to be fiddling with a button-hole. At a guess, she is coming up for five. When buttons can still be hard and fiddly to do.

And?

And what. Not much, you might say. The suckling curve of her cheek (Rubens sketched that convex well). The same profile glimpsed in my own daughter – coming up for five. So: a personal, familial, 'meta-Jewish' cue to wail. And, as I

realize in retrospect, an unforgivably unthoughtful response. The easy tabloid strike to the heart: the child framed and posed for innocence eternal. As if the notice of a child made the immolation of wizened people any the less grim. And as if comeliness in that child should count: as it did on Birkenau's ramp and elsewhere, according to Himmler's policy of selecting blond-haired or otherwise 'Germanic-looking' youngsters of the hunted Jewry for redevelopment as 'Aryan' citizens.

There. Take a look (2).

L'espérance est une toute petite fille,' as Charles Péguy declared: 'Hope is just a little girl.'

Or, as Dostoevsky voiced it through Ivan Karamazov: if it required the suffering unto death of just one small child to achieve perpetual harmony throughout the entire world, it were still too high a price to pay.

I lapsed into common parental dolour.

On a day like today . . . that girl . . . those lads, with their caps and sagging socks . . . as they should have been . . . yes, why not as a poet might see them: 'skating on a pond at the edge of the wood'.

It only occurs to me now, to wonder beyond such easy concern. The photograph was probably taken by one of the very same guards who ushered these people to their deaths. Why did he take it? Was he, conceivably, a father of children himself? What sort of album was this picture intended to fill – *res gestae,* 'things done' – in the course of a good day's work; or some private and illicit diary of shame (for Rudolf Höss, the commandant of Auschwitz, explicitly prohibited all photography within camp confines)?

Did they know what they did?

* * * * *

Museum. Meaning: 'Place of the Muses'. Reserve of learning; sanctuary of creative effort; niche of inspiration.

Of course, there are ghoulish ensembles elsewhere: all those cranky accoutrements of inquisitors and torturers, manacles dangling in a drip-punctured dungeon (thanks to special-effects department); Disneyworld fleshcreepers. But when we think of 'Museum' as the customary denomination – of the Prado or the British or the Getty or the Met – we at least subconsciously acknowledge King Ptolemy's original establishment at Alexandria: the 'Musaeum' as haven of human knowledge; a place for refreshment of the soul and advancement of the mind.

To which expectation Auschwitz Museum presents the antithesis. Pride, illumination, humanistic glee – whatsoever grace or gratification the museumgoer habitually seeks – each countered at Auschwitz with its own demeaning gravity. Opprobrium in a showcase. Darkness rendered visible. Sadism as artistry: the drag-push-tug of that distorted Darwinian slide from man to *Untermensch,* whereby all surreptitious insults to the manners and 'civility' of mankind became tickets to survival.

Survival at Auschwitz proved, in that sense, the survival of the worst. The bully-lords, the *kapos,* fixed its price: survival might be bought by undertaking to

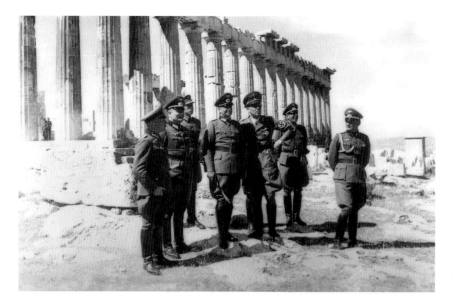

pluck the gold dentistry from the jaws of gassed parents, or to grease the bodies of kinsfolk for incineration, or toss infants alive into flames. So Auschwitz grows into the absolute locus of moral collapse and abasement; the place where, as Primo Levi perceived, the best all went under. (In Levi's view, certain fellow-inmates were murdered at Auschwitz not *despite* their valour, but precisely *because* of it.) What should an 'Auschwitz Museum' then constitute, if not so many prompts to extreme melancholia?

Yet there is a sense of homeliness there. That building labelled *Krankenbau*, 'Sick-bay'. While Auschwitz, conserved, tells us that we enter hell's tenantry of earth, yet it also says: how plausible, how cosy. How 'as we are'.

Aliens did not make the Holocaust. Its makers, they say, liked Alpine flowers and Schubert songs. When forests outside Weimar were cleared by the SS to create the death-camp at Buchenwald, one tree was specially spared: the oak under whose boughs, according to local romance, the great national poet Goethe fondly relaxed, and dreamed of lands where lemons bloomed. Deutschland, cradle of cultural history; Germany pining for Arcadia. See those slate-grey polished gentlemen basking upon the Athenian Akropolis (3). That Heinrich Himmler admired the Parthenon may not constitute a reason for incredulity at his approval of Auschwitz. Still, it gives the stab of pique to the likes of us book-hoarding, art-loving, museum-going folk. Two cheers for culture, we sigh.

What? Only one?

Less?

★ ★ ★ ★ ★

'*Alle Kultur nach Auschwitz . . . ist Müll.*' 'All culture after Auschwitz . . . is trash.'

Back to Oswiecim station: and nothing beats that refrain. Certainly not those slick tinny ditties from the radio. 'What else?' you shrug. A kiosk window packed

with the many grinning nabobs of global celebrity. Of course, you think. We get what we deserve.

'All culture after Auschwitz is trash.' Theodor Adorno's drastic indignation rings along the rails back to Krakow. Trash, trash, trash, there is nothing left but trash. A rattling, prattling, damn-it-all catch-phrase for the pilgrim in retreat. What matters now? Humanity rubbished at Auschwitz; humanity rubbished by Auschwitz. In similar spirit, Adorno famously declared that it was 'barbaric' to write poetry after Auschwitz. And whatever one might feel about Adorno as a philosopher, his tags of superb indignation – hasty, strident, comprehensive – are welcome on this ride. On the train away from Oswiecim, they ring with a very forgivable rage, or *Weltschmerz*: contempt extended to God and all notions of 'providence'.

Theodor Adorno (1903–69) belonged to the predominantly Jewish and Marxist 'Frankfurt School' of Social Research, which the Nazis abhorred and hounded. He was never at Auschwitz himself: his war years were passed in California, swapping dialectics with fellow émigré-intellectual Max Horkheimer. Yet Adorno's angry and banging recourse to the phrase 'after Auschwitz' seems passionate and immediate; it has just the vehemence that the belated witness craves. Auschwitz, says Adorno, has imposed upon us all a categorical imperative: to think and act in ways that will ensure it does not happen again. For once (and just the once, probably), Herr Professor Adorno echoes all those Holocaust-site visitor-book entries which plead, in shaky emphatic capitals, 'NEVER AGAIN'.

We visitors – so late, too late – we rock in the tawdry carriage that bears us away. Some good must come of this.

Adorno wrote: 'Neither Timur nor Genghis Khan nor the English colonial administration in India systematically burst the lungs of millions of people with gas.' It is Adorno's insistence that those railtracks to Auschwitz lead to a *non plus ultra*: 'the pits'; an absolute depth; fundamental horror. This recognition ruins the linear ideal of history as progress, and more. Adorno proceeds to build a systematic negativity, or 'melancholic science', from its basis. 'No universal history leads from savagery to humanitarianism,' he declares, 'but there is one leading straight from the slingshot to the megaton bomb.' Adorno's expositors – he needs them – define his use of the 'after Auschwitz' prescription as a sort of inverse Messianism. If Messianism is the faith in the arrival of a saviour who will release us from misery and captivity, then its inverse is Adorno's conviction about Auschwitz: Auschwitz as the mark and stratum of evil's permanence. The Holocaust accordingly becomes, as another philosopher (the American Robert Nozick) styles it, 'an event like the Fall in the way traditional Christianity conceived it, something that radically and drastically alters the situation and status of humanity'.

Never mind the 'culture-become-garbage' after Auschwitz. Adorno asks: Can one *go on living*, after Auschwitz? Was it made manifest to damn us all?

After Auschwitz After Auschwitz, Primo Levi repeatedly likened himself to the Ancient Mariner of the ballad by Samuel Taylor Coleridge: a sleeve-tugging old nuisance, insatiably eager to tell his ghastly tale over and again to anyone who would listen. Levi records how he, No. 174517, would go among schoolchildren

with his burning memoranda. Until it dawned on him that he was no longer credible. Boys would pipe up and ask why all the numerous inmates never rushed to overpower the guards, cut through the wire, heroically to escape. At which point Adorno's question became fatally pertinent. Can one go on living after Auschwitz? Levi, who had heard certain 'veterans' of Auschwitz howl with laughter at the prospect of *going up the chimneys*, had no choice but to cease to survive; to drop himself down a stairwell.

As he did, in April 1987, at his old home in Turin.

So.

So what? Adorno drags out the following onerous answer for whoever would yet believe in the viability of the 'examined life', as conceived by philosophers from Socrates onwards.

'There is nothing innocuous left . . . there is no longer beauty or consolation except in the gaze falling on horror, withstanding it, and in unalleviated consciousness of negativity holding fast to the possibility of what is better.'

<center>★ ★ ★ ★ ★</center>

'No one wrote tragedies in the extermination camps,' it has been noted – perhaps a cruel note, since merely to possess a writing implement, or any stuff to write upon, was the sort of offence at Auschwitz for which the mobile gallows were customarily deployed.

Others say there was no tragedy to be written; and that, in any case, the words and syntax lack which might describe it all.

As howls happen before words.

Pause. While we meditate if silence be more decent than *belles-lettres*.

<center>★ ★ ★ ★ ★</center>

Belles-lettres or argy-bargy: the word will not stay down for long.

Even those who have analyzed the failure of language to cope with the topic of the Holocaust, or prescribed the decorum of silence for matters deemed 'unspeakable' – they seem to have done so too eloquently, too noisily, to be persuasive of the case. Once upon a time there was a 'Liar Paradox': that ancient Greek conundrum whereby the philosopher who says 'everything is lies' must include his own declaration as a falsehood too. A form of this paradox extends to Adorno, too. If all culture – including books, art, philosophy and piano-playing – if all culture is garbage, then why should we not hurl the many hefty writings of Theodor Adorno into the bin?

'And yet', one wants to say – and yet . . . (say it delicately, as befits the Gentile latecomer to the scene.) Auschwitz was *not quite* absolute in its nature. There was Levi's *zona grigia*, 'grey zone' – that ashen moral half-light in which all blame simply wanders, and there is nothing either good or bad, only living. After a fashion. The micro-economy of scraps and scrounging and bartered radishes; the society of favours, bullying, bribery and guile. It was a beggarly subsistence, but it *was* subsistence: it was 'life' within a camp of death.

Rising above Adorno's apocalyptic mandate, we may hear a cracked voice of esperance, somehow sustained: it sounds like the wronged man who is everyman, Edgar in *King Lear*, when he cries 'The worst is not, as long as we can say "This is the worst"'. Zero help to the families on Birkenau's ramp: yet it echoes all the same. And below Adorno's specification of Auschwitz as the very last harbour of human injury, there is that steady chuntering roll-call of other names: snatches of which, in our time, claim not only mid-European mouthfuls – 'Treblinka', 'Majdanek', 'Dachau' – but also, more or less arrestingly, 'Bapaume'. . . 'Beaumont Hamel'. . . 'Paschendaele'. . . 'Kolyma'. . . 'Hiroshima'. . . 'My Lai'. . . 'Kigali'. . .

A gazetteer of stepping worstwards: 'to be continued . . .', as the world-weary will say.

But suppose we concur – is it permissible to say, 'in the light of Auschwitz'? – with Adorno's dismissal of all pre-Auschwitz 'enlightenment'. Suppose we accept the classification of our generic selves by one literary critic (George Steiner) as 'post-Auschwitz *homo sapiens*'. So we are 'knowing beings after Auschwitz'. In what forms should our knowingness consist? Adorno argued that the devolved awareness of horror is essentially an aesthetic condition – so no one can ever again say 'How lovely!' without the attached 'responsibility of thought' spoiling all loveliness. If that is so, then what remains to us, we who 'come after', of beauty – ecstasy – grace?

'All art is quite useless.' How unhappily Oscar Wilde's salon tinkle chimes with the null boom of dialectical rigour. Adorno himself sweeps aside the aesthete's lily-strewn trail. 'Useless art', art for some enchanting momentary swoon, is banished from his scheme. As Adorno decrees: 'The work of art demands more than that one should merely abandon oneself to it. Anyone wishing to find the *Fledermaus* beautiful must know that it is the *Fledermaus*.' Strauss's operetta *Die Fledermaus*, he says, if considered purely by itself, makes no sense, achieves no beauty. Art is art by the sanction of decorum, and decorum is born of the layerings of tradition and accretion. If we live in the moment, such decorum cracks apart.

In short we are burdened and possessed; harried by the muse who is Mnemosyne-Moneta – remembrance and admonition. If we have not seen the worst then we may feel we have been close enough. But even when Adorno ends by hoping for nothing to exist, he does not preach quietism. If culture 'failed' to prevent Auschwitz, that is not sufficient cause for resignation.

Auschwitz Museum may moulder (as it is mouldering).

The grass spreads green at Birkenau.

The onus of knowing remains.

★　★　★　★　★

'*Die Menschheit hat ihre Würde verloren, aber die Kunst hat sie gerettet.*'

There is a puerile satisfaction in calling upon the principled German Romantic literature of aesthetics to move us forward.

'Humanity lost its worth. Art restored it.' Friedrich Schiller supplies the text. Insomuch as this liberal, 'Enlightened', late eighteenth-century creed was made forlorn by Auschwitz, we may want to share with Adorno a disparagement not

only of all culture after Auschwitz, but indeed of all culture before Auschwitz, too.

But assume we accept the historical particularity here. We know, like Adorno, that concentration camps were invented by the British in South Africa; but Auschwitz was made by Nazism – a political ideology precisely conceived and precisely practised in the country of Schiller and Adorno. And one aspect of that ideology was *Kulturpolitik*. 'Rarely was a national government's cultural ambition higher': an observation made by the modern German historian Joachim Fest not of the British (as if), but of the Nazis. *Kulturpolitik* – the administration of national aesthetics – was trenchantly embedded in the programmes of Nazism. So, not only Hitler (a failed artist) but also most of his henchmen – even the beery Göring – prided themselves as connoisseurs. Paragons of taste: 'cultured' types.

After their fashion. As they categorized various human beings – Jews, gypsies, homosexuals, Marxist agitators – as disposable rubbish, so the makers of Auschwitz assembled their own definition of culture-as-garbage. It began with the book-burnings of 1933, fuelled by what the Nazis considered to be biblio-trash – including the works of Freud and Proust. Then there was the great gathering of 'Degenerate Art' (*Entartete Kunst*) first put on display by Hitler's chief propagandist, Goebbels, in Munich in 1937. Some of the names of the forcibly selected exhibitors are not surprising, as obvious targets to be deemed as garbage on the doorstep of the Third Reich: Otto Dix, Max Ernst, George Grosz, Kurt Schwitters (why, in the case of the last-named, he openly went about the streets collecting litter with which to make litter-pictures, his so-called *Merzbildern*). But other artists in the Nazi salon of degenerates were called in from further afield: Braque, Chagall, de Chirico, Derain, Ensor, Gauguin, Van Gogh, Kandinsky, Klee, Kokoschka, Léger, Matisse, Modigliani, Mondrian, Munch, Picasso, Rouault, Vlaminck.

For the time, a fair trawl through the European ranks of outlaws, wastrels and renegades.

And in retrospect: nothing less than a redemptive register of virtuosi by default; a catalogue of proscriptions from which the bewildered liberal soul may draw some comfort. For if 'art' had co-existed with Auschwitz – if, under Nazism, it had been business as usual for all contemporary artists, architects, writers, composers, academics and so on – then surely Adorno would be right: the worth of 'culture' would have dwindled to null.

The truth is, rather, that National Socialism *was* Philistinism.

There is a coda to the observation that 'rarely was a government's cultural ambition higher', and it is ponderously true by general consensus: 'never was the result more provincial and insignificant'. Such artists as collaborated with National Socialism are generally reckoned to have been mediocrities (though one or two Nazi-sympathizing academics, such as the philosopher Martin Heidegger, salvaged some distinction). Again, it is of no redeeming use to the victims of Birkenau to declare that aesthetes in jackboots are boors and fools. But we see that the gross cultural pessimism which Theodor Adorno extracted 'after Auschwitz' has its own context and frame. Adorno himself came to regret his oft-quoted diktat (of 1949), that to write poetry after Auschwitz was 'barbaric'; eventually he would concede that 'perennial suffering has as much right to expression as a

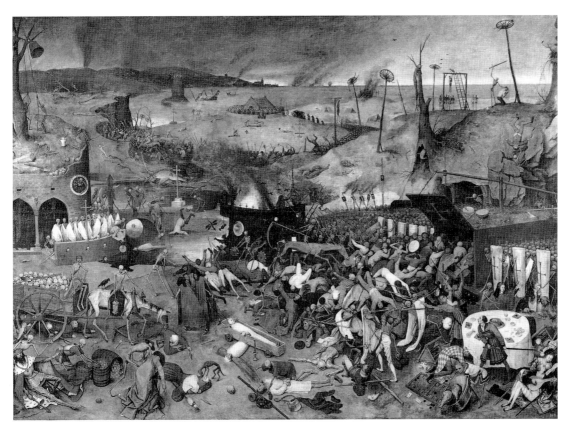

4 THE TRIUMPH OF DEATH
Pieter Brueghel, *c.*1562–64

On an almost miniaturist scale,
Brueghel composes a panorama
of death and destruction
which has been described
as 'a secular apocalypse'.

tortured man has to scream'. But Adorno never had the intellectual largesse to admit what we must reclaim as a durable truth: that 'culture' is a salve of our being.

Art keeps us going, in our wounded state.

⋆ ⋆ ⋆ ⋆ ⋆

Madrid. Some months later.

You are standing in a gallery and what you are looking at seems to be a sort of graphic premonition (4).

Victims driven into tunnel-mouths. Above, beyond – the ashy warmth of bodies burned.

Gibbets prick the skyline.

Skulls, skulls: being trundled away like a cartload of mangels.

The rag-child hooked over a coffin's edge.

Scatter of futile effects (scrip-satchels; shoes; plumed cap).

Some were caught while at play: their game-boards are overturned, their cards are decked, and their wine-flasks gurgling to waste. An agent of despatch – grinning with the grimace that must be worn by virtue of the office – winds up the dance of death with a hurdy-gurdy tune.

A crow struts on horseback.

Nothing holds the ranks of wraith-advance. They have scythes, daggers, hempen nooses and the long swords of ceremonial decapitation: but everywhere they chivvy and shovel for all the world as if they were about a hectic business called the Final Solution.

Relax. It is only the 'Triumph of Death', and it is easily glossed. A painter's wagging finger to his sixteenth-century patron – most likely some Flemish merchant or banker, flush with cash and success. Vanity of vanities; all is vanity. Bankers and beggars, kings and serfs, wise men and fools: all toppled into the grave.

And relax again. We are not about to examine each picture in this museum for signs of artistic insight about the ultimate blundering evil of humanity. (Though an assemblage of pictures by Francisco de Goya is displayed here which might serve just that line of enquiry.)

But there is a hubbub about Old Masters: and we need to establish why that is so. Before a portrait of a minor Habsburg princess with her maids and her dwarf-playmates – 'Las Meninas' by Diego Velázquez (5) – there is scarcely elbow-room. Cohorts of the camera-armed; stubborn rearguard of the tour-groups; crayon-jabbing youngsters.

What are we thronging for?

The cash-tills rattle without pause. There is no escaping that factor. Like other great temples of high culture, the Prado Museum in Madrid – commonly saluted as 'the greatest collection of Old Masters in the world' – has installed sales points of art-merchandise throughout its many galleries. Old Master bookmarks, Old Master carrier bags, Velázquez on a dishcloth – we worshippers will have the trophies of our presence here.

For the Marxist Adorno this is all so much of the despicable 'commodification' of art.

But for those of us standing here, in the thick of it – I think we should feel worse if we were alone. It should not, after all, be an act of eccentricity to stand admiringly before a fine painting. And, truly, we do not want the souvenirs and postcards merely in order to impress – to boast to those who never joined the throng; those who missed the thrill of enchantment at the shrine. We hoard, rather, the fingered memoranda of precious revelation. Brueghel, Goya, Velázquez. We may know next to nothing of their intentions at the easel. But we believe that when we gaze upon their work we see truths about who and how we are.

That is one way of putting it; and not very satisfactory. Some people may plausibly have strayed into the bustle of the Prado by the instinct of the herd. Or they have come because their itinerary afforded no choice. Or simply because, between breakfast and lunch, there was nothing else to do. In any case, the days of justifying art by claiming its powers of edification are gone, and laughably remote. In 1938, as the world became expectant of war, again, in Europe, the English poet W.H. Auden stood in front of another Brueghel painting – *The Fall of Icarus*, in Brussels – and surmised that all we were intended by the artist to learn from the scene was general heartlessness. 'About suffering they were never wrong, the Old Masters . . .' wrote Auden, in his well-known verses on 'The Musée des Beaux Arts'. It happens, on an everyday basis. Even when a boy falls out of the sky, as in Brueghel's picture, who takes notice? The world goes on.

Likewise it seems absurd to argue – though Leo Tolstoy did – that art should exist with the express purpose of reducing the quantity of violence in the world.

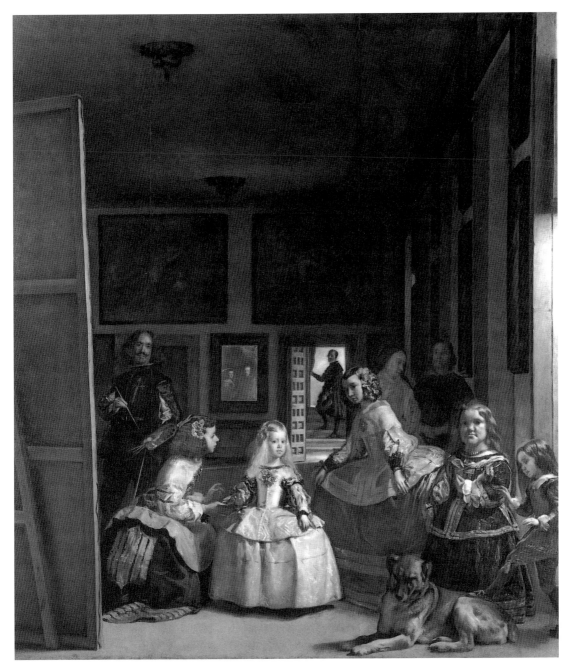

5 *LAS MENINAS*

'The Maids of Honour',
Diego Velázquez, *c.*1656

The 'Infanta Margarita'
poses centrally here; above her,
reflected in a mirror, the patrons
of the piece – Philip IV and
his wife Mariana.

Art is not an international peace-keeping force.

Still it is possible that most of us who gather in galleries are there beyond the call of a dutiful diversion.

Perhaps we have come to inspect the sheer technical dexterity of what is exhibited. That is an access to inspiration in our species: scrutinizing human handiwork at its best. Or we may revel direct in extraordinary shows of colour, line and form: which is to take fresh delight in creation. We may feel, then, that the objects of art before us make windows upon the world. These are 'ways of seeing', precious 'spots of time'. They may be rare panoramas; or simply present that satisfying paradox which we call 'still life'.

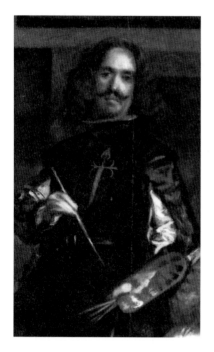

6 DETAIL OF 'LAS MENINAS'

Self-portrait of Velázquez. The painter wears on his chest the insignia of his own advancement into court circles.

No artist is obliged to be a preacher: but all 'great' or effective art provokes some sort of telepathic exercise on the part of its viewer. It urges our feelingness towards whatever has beauty and curiosity in nature, and in our selves; it both demands and fosters those reserves of delicacy that make us sensible.

We want to be touched. We want to be moved.

Stand with the crowd in front of 'Las Meninas' and through the mingle of many languages you begin to discern what is at work in this work of art. The dog, of course – the dog reminds some folk of their own hound at home. Much chatter is also prompted by the female dwarf: such a bright, belligerent face – all deformity vanished as she gazes proudly out. Then the posies in the hair of the pretty, solicitous handmaidens. As for the original epicentre of attraction, the tiny princess Margarita – why, for all we know she was a petulant minx who ran rings round the painter and tweaked his moustache; but here she is, perfectly poised to anticipate Péguy's sentiment: 'Hope is just a little girl.' And there is Velázquez himself (6). His hand is a blur; he is swiftly recording this ensemble. But he, too, looks steadily out towards us; and, though serious, he does not seem inscrutable. Absorb what you see, he says with his gaze: here we are, as we were, for your consideration. The child-princess, the hovering courtiers; the ladies-in-waiting, beauties as they must be; one stoutly stunted girl, one impish dart of a midget-boy; and the king and queen, whose sovereign power is palely retired to a mirror. An assortment of humankind, then, plus a gentle-natured dog: instilled upon a stretch of canvas by a painter who is, at once, part of the company and also its detached trustee. The brushwork is adroit, the composition is ingenious. But the ultimate invitation to view what Velázquez has wrought in 'Las Meninas' comes from a sense – a 'feeling', which is therefore 'aesthetic', strictly speaking – that the lives arrested on this canvas claim kinship with our own.

Photographers whose work abides – Diane Arbus, Henri Cartier-Bresson, and others – make no more nor less a claim.

Auschwitz Museum: there, too, that claim is staked. We did this; it was the handiwork of people like us; it was not *inhuman*.

The Prado gives us respite from the world; and renews the glee of affinity with its population.

So it is that art keeps us going.

So let us, then, proceed.

Note on the meaning of words (i)

'All languages that derive from Latin form the word
"compassion" by combining the prefix meaning "with"
(*com-*) and the root meaning "suffering" (Late Latin,
passio). In other languages – Czech, Polish, German,
and Swedish, for instance – this word is translated by a
noun formed of an equivalent prefix combined with the
word that means "feeling" (Czech, *sou-cít*; Polish, *wspól-
czucie*; German, *Mit-gefühl*; Swedish, *med-känsla*).

In languages that derive from Latin, "compassion"
means: we cannot look on coolly as others suffer; or, we
sympathize with those who suffer. . .

In languages that form the word "compassion" not
from the root "suffering" but from the root "feeling",
the word is used in approximately the same way, but to
contend that it designates a bad or inferior sentiment is
difficult. The secret strength of its etymology floods the
word with another light and gives it a broader meaning:
to have compassion (co-feeling) means not only to be
able to live with the other's misfortune but also to feel
with him any emotion – joy, anxiety, happiness, pain.
This kind of compassion. . . therefore signifies the
maximal capacity of affective imagination, the art of
emotional telepathy. In the hierarchy of sentiments,
then, it is supreme.'

MILAN KUNDERA

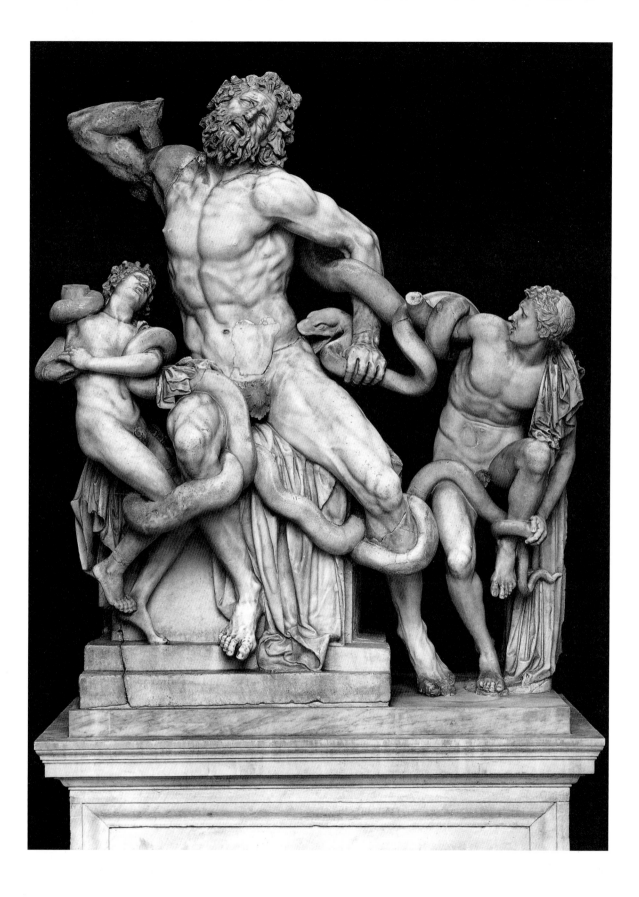

2 THE AUDITION OF LAOCOON'S SCREAM

It is the classic frozen howl.
It is the muse's chord with which they would expect us to begin.
('They' including Goethe, Schiller; Himmler)

* * * * *

In the history of Western art, one antique sculpture furnishes us with the proto-typical icon of human agony (7). 'The most insensible of mankind must be struck with horror,' records one eighteenth-century tourist – faced with nothing less than 'the deepest pathos of the sublimest character in the contemplation of the human mind'.

Since its unearthing in 1506, from a property near the church of Santa Maria Maggiore in Rome, the Laocoon, or 'Laocoon Group', has been an object of sustained if variable attention. To put it on a list of 'must-see' items at the Vatican may be an imperative swayed according to the visitor's taste for the style generically tagged as 'Baroque'. Yet even those who remain nowadays unmoved by the sight of the Trojan priest Laocoon writhing against the serpents sent to punish him and his sons must acknowledge this statue's prime historical importance as a focus of discussion about the aesthetics of pain. The first literary response to the discovered statue came from a learned churchman, Cardinal Jacopo Sadoleto, who assisted at the excavation: Sadoleto hymned the heroic groaning of a wounded man. Later it was J.J. Winckelmann, the pioneering German art historian based at Rome in the eighteenth century, who approved the pedantry with which Sadoleto specified the decibels implicit in Laocoon's features. 'He lets out no heaven-rending scream,' wrote Winckelmann of Laocoon, '. . . rather an anxious, heavy-burdened sigh . . . his misery cuts us to the quick, but we yearn for the hero's exemplary strength to endure it.' For Winckelmann, the aesthetic success of the Laocoon Group depended as much upon the suppression as the expression of anguish. The sensationalism of our title phrase 'Laocoon's scream' would have irked him.

There is no doubt that the carving of Laocoon is intended to delineate a body taken to the extremes of pain, though it took a biologist (Charles Darwin, no less) to point out that the corrugations of Laocoon's brow are exaggerated beyond anatomical accuracy. But such sculptural licence is beside the point; and, for our present purposes, the noise implicit from Laocoon's straining features does not really matter. Groan, scream or sigh. Whatever the sound, who in antiquity heard or heeded it?

Such is the lingering power of Winckelmann's influence that no one has ever asked if indeed this statue seeks a piteous response. The statue has been harboured in our collective consciousness for too long. No one ever seems to have considered the question: whether the sculptors of the Laocoon intended their

7 THE LAOCOON GROUP

Possible dates for the making of this sculpture range from the second century BC to the first century AD. This is the 'unrestored' view as exhibited in the Vatican since 1960 (compare 68).

work to be a masterpiece illustrating 'the deepest pathos of the sublimest charac-
ter in the contemplation of the human mind'. We – who customarily bind the term
'Classical' with 'civilization' as if by definition – should try an answer.

<p align="center">★ ★ ★ ★ ★</p>

The obvious point of departure – as befits an essay in the Classical mode – is a text.
The golden worth of direct ancient testimony. There is only one. It is a grand but
yet minimal salute to the Laocoon in the Elder Pliny's encyclopaedic *Natural
History*, 36.37: 'It is a work to be set above all that the arts of painting and sculpture
have produced. Out of a single block of marble, the consummate craftsmen of
Rhodes – Hagesander, Polydoros and Athenodoros – at the behest of council
designed a group of Laocoon and his sons, with the snakes remarkably entwined
around them all.'

Pliny's writing was known to the early sixteenth-century onlookers peering at
the statue's recovery in Rome; so there was an immediate identification of the
find. And Pliny's superlative formula, *opus omnibus . . . artis praeferendum*, 'a work to
be preferred to all other works of art', must have conditioned the extravagant
praise and particular status accorded to the Laocoon when it was placed in its
niche in the Vatican. The myopia of Pliny's astonishment at the marble-carving
(bearing in mind that such complex groups were more often done in bronze) is
pardonable, since it required specialist scrutiny to establish that the statue was not
made of one block of marble, but rather from seven or eight furtively intersecting
joints. And perhaps only the most cynical of pedants would have guessed that the
ancient location of the statue – adorning, around AD 80, the Esquiline Palace of the
emperor Titus – may have influenced Pliny's sedulous approval.

For the Laocoon, which the *Natural History* hailed as the universally supreme
work of art, belonged to Titus; and to Titus the *Natural History* was dedicated, with
fawning affection. It is not clear whether Pliny himself was a member of the impe-
rial council which advised Titus on the commission of the Laocoon. The phrase
used in Pliny's text about the statue's creation, here translated as 'at the behest of
council' (*de consilii sententia*), is ambivalent: some have taken it to mean that the
three Rhodian sculptors conferred among themselves before executing the work,
which seems an odd and unnecessary detail for Pliny to indulge. At any rate we get
the message. Apart from his patron's interest, Pliny's admiration for the Laocoon
is founded upon the technical virtuosity of the statue's production. Tragic insight,
glorified pathos, magisterial suffering: none of these traditional characteriza-
tions of the Laocoon encroaches upon the criteria of Pliny's esteem.

The ambivalence of Pliny's text is compounded by another factor. The names
of the three artists, attached also to a florid complex of sculptures recovered from
an early imperial grotto at Sperlonga, testify only to a father-to-son tradition in the
métier of sculpture on the island of Rhodes. The activity of this trio is difficult
to date with any certainty. So we cannot be sure that Titus, or his own council,
commissioned the Laocoon: Titus may have inherited it from a predecessor
(Nero is an attractive possibility; Tiberius – to whom the Sperlonga sculptures
plausibly belonged – has also been proposed). And it is, of course, credible that as

a 'moment' in figurative expression, the marble Laocoon commissioned in the first century AD may have been directly copied or adapted from a bronze group set up some two centuries previously. The Hellenistic kingdom of Pergamum in the second century BC is often identified as the likely provenance of such a supposed model. With that potentially broad span of existence allotted to it as an *objet d'art*, then, the Laocoon must be permitted an accordingly elastic range of conceivable ancient responses. The question remains: would any of these have anticipated the humane sympathies devolved from Laocoon's pain-burdened image by Michelangelo, Sadoleto, Winckelmann and others since?

<p style="text-align:center">⋆ ⋆ ⋆ ⋆ ⋆</p>

The ancient Greeks hold no exclusive rights to tragic sensibility.

That would seem a truism too obvious to state. Yet how can we demonstrate the force of it in cultures that have left no literature to match the preserved record of 'Greek tragedy'? In characteristically rumbustious style, the English man of letters G.K. Chesterton asserted that the essential gentility of 'primitive man' could be read from prehistoric cave-paintings: 'what was found in the cave was not the club, the horrible gory club notched with the number of women it had knocked on the head', Chesterton observed, but rather 'conscientious studies of how cattle swing their heads when they graze'. If we can similarly trust the language of images alone, we should credit the Egyptians with having at least afforded the occasions and the space for the external manners of lament. The tomb at Amarna thought to be that of Princess Meketaten, daughter of Akenhaten and Nefertiti, once presented a painted index of these expressions of grief: Meketaten seems to have died while giving birth, herself perhaps only ten or eleven years old; and when the pharaoh deeply wept, his grief was contagious. Those tomb-paintings are cracked and broken now. But there is plentiful evidence in Egyptian art generally to show outbursts of sadness put into clichés of desolation (8). Figures kneeling, beseeching, falling faint, head-slapping, hair awry – these may fairly be taken to be the pictographs of tragic gesticulation.

8 EGYPTIAN FUNERARY LAMENT

Scene excerpted from the papyrus of a scribe called Ani, in the 'Theban Book of the Dead', 19th Dynasty (c.1250 BC).

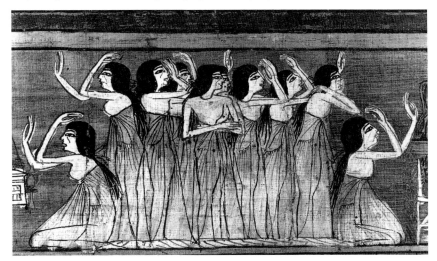

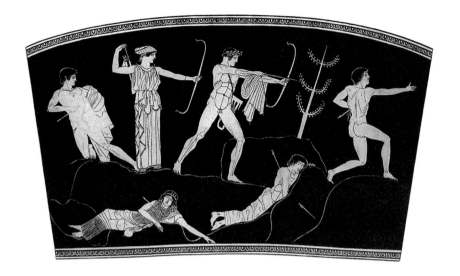

In all the Egyptian imagery of grief, however, there is no effort on any artist's part to render the face as distorted by pain. The quest for 'naturalism' in depicting human emotions was famously an enterprise of Classical artists. And the Laocoon statue traditionally stands at the end of this enterprise like some *non plus ultra*, or stylistic finishing-line.

Our next task, then, is to trace the Laocoon's antecedents. Can we establish any sort of aesthetic decorum in antiquity for the graphic representation of pain?

And a task within this task: to avoid retrospective attribution to 'the ancients' of intuitive tenets of Christian faith. In the early Middle Ages, the poet Dante, unable to contemplate Socrates amongst the damned, recruited honorary Christians from the schools of Athens; and during the Second World War, Simone Weil – while witness to the German occupation of Paris – constructed a reading of Homer which virtually incorporated him as a Messianic prophet. But our starting premise must be that for all the inklings of pity we find manifest in Classical thinking and literature, the kernel of Christian belief is not there. In believers' eyes, Christ died for the world: so Christians translate by faith the extremity of passive suffering into sublime victory. Nothing in Classical antiquity remotely foreshadows that grace ('amazing'). To appreciate the gap one has only to think of two myths where mortals are severely dealt with: the twelve children of Niobe, shot down with arrows because their mother had boasted her fecundity to the gods (9); or the satyr Marsyas, stripped of his flesh as the penalty for challenging Apollo on the pipes (10). The Niobids are not the multiple precursors of the Christian martyr St Sebastian (see 46–55): their mother had slighted deities whose response was rapid and predictable. The satyr-piper Marsyas did not blaze a path for St Bartholomew: he was flayed alive to punish vanity, and his slow agony redeemed no one.

Agreeing on this basic premise – that the Suffering Servant has absolutely no claim to honour in any of the moral systems devised by the Greeks and Romans – we may proceed to acknowledge Classical Greece as the birthplace of the Western literary genre we call 'tragedy'. The story of Laocoon belongs to the epic of the

9 **SLAUGHTER OF THE NIOBIDS**
'The Niobid Painter', mid-fifth century BC.

Detail of a red-figured vase. In retort to Niobe's claim that she had borne perfect children, Apollo and his sister Artemis rained arrows down upon those children – leaving the mother alive as witness to the upshot of her tragic pride.

fall of Troy: and few would dissent from George Steiner's salute to Homer's telling of that story as 'the primer of tragic art'. It is also accepted that the development of tragic drama in Classical Greece was an important prompt to expressionism in the figurative art of the time. Wounds and death and anguish are tragedy's flags. Characters on stage gesticulate and howl: if the actors do it well, and the tragedy works its proper effect (which the Greeks termed *catharsis*, or 'purging'), then the audience should howl along too. But two particular restrictions upon the theatrical presentation of suffering in ancient Greece should be noted.

The first is probably well known: that the conventions of Classical Athenian tragedy favoured, wherever possible, the carriage of violence by words. This does not mean that no one was ever seen to die on the proscenium, nor that screams from the wings were never heard. It has quite rightly been observed about the *Philoctetes* of Sophocles that 'there are few plays in which suffering holds centre stage for so long'. But the onus remained on graphic language to relate horror. Stereotypically, the verbal conveyance of such 'bad news' falls to the 'Messenger' – the classic example of this occurring in the *Bacchae* of Euripides (lines 1043–1151).

The second restriction may go some way to unpicking the conundrum of why tragedy should 'give pleasure' or serve as 'entertainment'. In fact, for the Greeks, tragedy did not necessarily yield

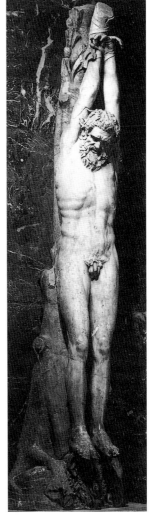

10 MARSYAS SUSPENDED FOR FLAYING

Copy from a group originally made in the mid-third century BC.

The story of Marsyas was located in Asia Minor: in Pliny's time, tourists could be shown to a particular plane tree in Phrygia where the satyr was said to have been punished by Apollo.

the satisfaction of *catharsis* – that douche of the emotions for the maintenance of sanity. The fifth-century BC historian Herodotus records (in his *Histories*, 6. 21) how the Athenians grieved over the Persian sack of their eastern colony at Miletus in 494 BC. 'In particular,' Herodotus says, 'when Phrynichus dramatized the event as *The Capture of Miletus*, it caused floods of tears in the audience. The author was fined a thousand drachmae for reminding the Athenians of a disaster which touched them so closely, and they forbade anybody ever to put the play on the stage again.'

Perhaps the playwright's mistake here was not to mythologize contemporary events. About a decade later, a humble Athenian vase-painter produced his own little vignette of Troy's seizure, conceivably making an epitome or parable of what Simone Weil described as 'the greatest of griefs that can come among men: the destruction of a city' (11). On the shoulder of a vase made to carry water, the painter packs as much dramatic detail as the field of illustration permits. Trojan defenders are dying on the floor. Half-naked before her rape, the princess Cassandra

clutches at an idol for sanctuary. Hector's widow Andromache picks up a kitchen implement and joins the fray; while old Priam on his throne is being hacked about. His bald head seeps blood, and on his lap is the mutilated poppet-body of his grandson Astyanax. Pathos is conjured here – see how the palm tree wilts over the woman weeping below – and even godforsakeness too: witness how the statue of Athena points its spear to no deterrent effect whatever at an encroaching warrior. The only hope lies in the launch of another epic: we see Aeneas shouldering up his father and sloping off, with only the old man glancing back.

All this disaster is what Laocoon the Trojan priest foresaw. The epic of 'The Fall of Troy' (*Ilioupersis*) was woven by archaic Greek rhapsodes in the style of Homer, and rewoven again by the Roman poet Vergil in the second book of his *Aeneid*. Troy's doom as a citadel begins when a huge wooden horse is presented as an offering to the Trojans by the Greeks who have the city under siege; it is Laocoon who calls for suspicion about the hollow horse ('I fear the Greeks, even when they come with gifts'). Laocoon dies; the horse is admitted, with its hidden contents – a crack force of Greek heroes who will spill out and put Troy to torch and sword. It is invariably a grievous narrative, wherever it is told or represented in art. But this painted vase comes at a juncture of the naturalistic development of Greek art when there is yet none of the incarnate physical and physiognomical expressiveness that would appear in Laocoon the statue. A gestural language of pain and doom is there in the vase scene – three figures clutch their heads, to protect or implore – but facial muscles are not apparently exerted. Ignoring the question of what an artist was technically able to produce at this time, we may wonder: was this, even remotely, the consequence of artistic self-restraint?

Around 400 BC a Greek painter called Timanthes attempted to depict the story of the sacrifice of Iphigeneia. Human sacrifice was not a custom of Greek religion, so it required some imaginative effort to reconstruct the scenario whereby Agamemnon, having boasted his prowess at hunting and thereby offended Artemis, was required to make amends with the goddess by sacrificing his daughter Iphigeneia. In an unusual fit of clemency – and nicely so for those who would compare this myth with the Old Testament story of Abraham and Isaac (Genesis 22.1–19) – Artemis relents at the last moment. But how would everyone convened for the sacrifice appear, prior to that moment?

11 THE SACK OF TROY
Details of a red-figured vase attributed to the Kleophrades Painter, *c*.480 BC.

Greek warriors have swarmed out of the wooden horse; the civilian population of Troy is unspared in their assault.

We do not have the picture to confirm – perhaps a faded replica only, from the House of the Tragic Poet at Pompeii – but Pliny tells us that Timanthes ducked the challenge. Having shown the familial bystanders at the sacrifice in grief and lament, Timanthes had 'used up' (*consumpsisset*) all his repertoire for depicting sadness (*tristitia*). When it came to painting the face of Agamemnon himself, the artist could only resort to a veiled head. 'Worthily [*digne*] the father could not be shown,' says Pliny (*Natural History*, 35.34): meaning, presumably, that on a relative scale, Agamemnon's hurt demanded to be shown as greater than that of everyone else – and it was more proper in the end for the painter to shirk from stressing that distinction.

This passage of Pliny was pounced upon by G.E. Lessing. Gotthold Lessing was J.J. Winckelmann's compatriot and intellectual antagonist: in a debate which much exercised late eighteenth-century minds, Lessing essentially stood for the superior effectiveness of poetry and plays over sculpture and paintings in conveying human experience. For Lessing, the tale of Timanthes showed ancient recognition that the graphic depiction of grievous matters was 'disfiguring' (*entstellend*) and 'belittling' (*verkleinernd*). Timanthes, argues Lessing, 'knew the limits which the Graces set to his art': that same awareness of what could fittingly be shown, continues Lessing, was why the sculptors of the Laocoon tempered the priest's shriek to a sigh.

There is a rival story – on which more comment later, in Chapter 5 of this book (see p. 95) – concerning the lengths to which Parrhasius, another Greek painter from the fourth century BC, was driven by the search for expressive realism, in a picture of Prometheus. Drastic lengths: involving no less than the fatal torture of a studio model. But since the work of Timanthes and Parrhasius does not survive, it seems unfair to question how far artists might solicit engaged response – compassionate or otherwise – by means of naturalistic depictions of pain.

Nonetheless, scholars of Classical art have long been content to attribute a sense or motive of 'pathos' to this or that artist, purely on the basis of appearances. Of the fourth-century BC sculptor Skopas, for instance, we are told that he created 'a new heroic mode' of reversed fortune, for which the arched brows of his characteristic figures, however battered (12), convey 'intense but indeterminate pathos'. Of the Laocoon and other groups, such as the 'Farnese Bull' (see 15), we are likewise reassured that they are 'concerned not merely with heroism, but with heroic pathos – suffering that ennobled'.

But what precisely were the wellsprings of 'pathos' as the Greeks conceived it?

12 HEAD OF A FIGURE FROM THE TEMPLE OF ATHENA ALEA AT TEGEA

Attributed to Skopas, *c.*340 BC.

Though battered, the arched brow and beseeching expression of this fragment show typical signs of the sculptor's style.

* * * * *

In the city of Athens an Altar to Pity was raised. We know it existed, but little more than that: it was a post of civic or personal prayer, decked with wistful female personifications of a minor

virtue. Athenian philosophers, however, have left more precise signals of pity's niche in the community.

Plato, pursuing in the fourth century BC the philosophical ideals bequeathed to the intellectual community of Classical Athens by Socrates, recognized that artists, poets and dramatists alike preyed upon the human capacity for sympathy, and encouraged its expression. For Plato, pity sullied reason. Pity for others fostered a penchant for self-pity, a weakness. Moreover, it was a gender-inclined sentiment: naturally embedded in the disposition of a woman, emasculating to the reason-guided male. This scorn for pity, or moral lordliness over pity's emotional origins, would stem naturally enough from Plato's admiration for the physical resistance displayed by his mentor Socrates: in the *Symposium*, the image given of Socrates on military service – standing in the snow unshod and for hours, immune from normal bodily pangs of hunger and pain – foreshadows an ethic of self-mastery which makes pity an affront to the philosophic life.

So much for Plato: his strictures were unlikely to have touched any artist of the time. Plato's most important philosophical successor at Athens, Aristotle, was not only much more sympathetic to the aims of contemporary poets and artists ; he was also intrigued to understand the nature of sympathy itself. In his *Art of Rhetoric* (2. 8: 1385–86) Aristotle defined pity (*eleos*) as 'a kind of pain excited by the sight of bad things, fatal or painful, befalling someone who does not deserve them'. In his methodical way, he itemized a catalogue of occasions which may frequently turn pitiable, ranging from death and separation from loved ones to suffering physical deformity or disappointed expectations. It is a discerning list: as if to qualify Plato's austere rationalism, Aristotle implies that it is not *unreasonable* for us to weep at the apprehension of loneliness, or having been unexpectedly hit on the head by a stranger. Yet one word keeps surfacing wherever Aristotle discusses pity: 'undeservedly' (*anaxios*). This is the clinging rider of crucial qualification.

How is it crucial? The tale of Laocoon will show. We began this chapter with an eighteenth-century viewer's appreciation of the great pathos exuding from the Laocoon group. That was a typical line of response in its time. However, it was not entirely unanimous. One or two observers took a more censorious line with the statue. Why, they asked, was Laocoon not making more of an effort to save his two sons?

Such an observation was condemned as eccentric by eighteenth-century authorities on art (notably Sir Joshua Reynolds, President of London's Royal Academy). But perhaps those who advanced this moralizing slant were acquainted with the tragic myth of Laocoon as woven by the Athenian playwright Sophocles in the fifth century BC. We lack his play in its entirety, but it can be assumed to have been the prevalent version of the Laocoon story in antiquity – at least prior to Vergil's partial and partisan (pro-Trojan) retelling of it in the second book of the *Aeneid*. In the Sophoclean plot, Laocoon actually survives while his two sons perish: his punishment is indeed to lose them. Summaries of the story compound this by describing one of the serpents sent by Apollo as 'child-hungry'; and Laocoon's crime against Apollo may then have been more substantially hubristic than the flinging of a spear at the flanks of a wooden horse. Laocoon the priest vaunted two sons: a clear affront to his vow of celibacy. As the editors of the

Sophoclean fragments conclude, the dramatic character of Laocoon must have been that of 'a scoffer who ridiculed the notion of divine interference'.

Mythologically, then, there is no doubt. Laocoon gets what he deserves.

<p style="text-align:center">⋆ ⋆ ⋆ ⋆ ⋆</p>

No pity for those who deserve their woes. Aristotle's reasoning was soundly echoed in the teachings of one of antiquity's most widely-diffused philosophical disciplines, Stoicism. Stoicism originated about 300 BC, and rapidly spread through the Greek world; it was further expounded in the Roman empire, and one Roman emperor (Marcus Aurelius) himself became an influential adherent.

There is no single canonical text of Stoicism, whose primary Greek protagonists were Zeno, Cleanthes, and Chrysippus. But in broad terms, the Stoics united in regarding 'emotional movement' (*pathetike kinesis*) as a source of irrational behaviour. They characterized passion as 'a weak opinion'. The wise man may have some good feelings (*eupatheiai*), but his ideal remains to avoid the fourfold 'tyrannies' of pleasure, desire, fear and distress.

Pity, said the Stoics, is 'grief for someone who suffers undeservedly' (*Stoicorum Veterum Fragmenta* 3. 412). Even then it was unwelcome. The Stoics sought the inner contentment which they called *apatheia*, 'freedom from emotion' (or 'fortitude', as it is sometimes translated). Apathy was the Stoic's cherished state of wisdom.

The caricature of Stoical apathy as endurance of pain or sheer insensibility is given in the biography of Stoicism's leading guru in the Roman world, Epictetus, who came to Rome in humble guise, as a slave to one of Nero's courtiers. On being put to torture by his master, Epictetus calmly observed: 'If you go on like that you will break my leg' – which accordingly happened; whereupon Epictetus, in the same level tone, merely commented: 'There. What did I tell you?' In his *Discourses* (3.24) Epictetus describes grief as a revolt against divine order – the griever is held to be *theomachountos*, a 'god-battler'. If terrible things happen they cannot be discounted from the design of the cosmos: they are no less acceptable than the most exquisite of worldly pleasures.

A Stoic adherent standing before the Laocoon statue may or may not have made the stylistic connection between Laocoon's tormented form and the twisting, writhing figures of the vanquished giants on the frieze of the Great Altar of Zeus at Pergamum (13). Philosophically, however, the similarly agonized bodily movements and facial contortions would be attributed to a shared rationale of deserved suffering. Laocoon's protestations amount to the histrionics of impiety. So too at Pergamum: the giants who would challenge divine order wear grimace-rippled masks of angry pain (14). Their corrugated brows alone bespeak villainy. For contrast, consider the faces of the Olympians as they sally against those reptilian giants. Serenity of expression is a feature that unites all the deities, however strenuously they are fighting.

Epicureanism – that Classical doctrine sometimes epitomized as putting the pursuit of pleasure above all else in life – might be imagined as the more indulgent school of thought. It too was very much alive across the period of the Laocoon's creation. The Epicurean goal of a life truly painless, however, entails a sort of

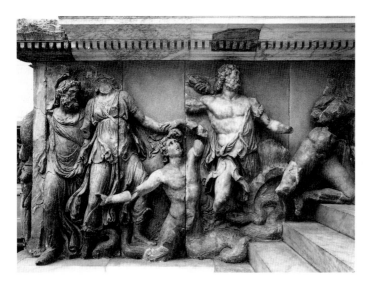

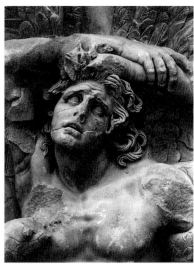

psychosomatic surgery. As Martha Nussbaum has argued, Epicureans did not seek cathartic expression of the passions, but rather their 'extirpation'. 'Even on the rack,' goes one Epicurean slogan, 'the wise man is happy.' An Epicurean standing before the Laocoon might have granted some credit to Laocoon for not howling overtly. But even a muted groan was more offensive than pitiable.

Card-carrying Sceptics would likewise have offered Laocoon little comfort. The Sceptics, who took pride in doubting all systems of knowledge, put faith in *metriopatheia*, a natural and tolerable level of pain in the world. Quantification of that mean is never made explicit. But Scepticism, like Stoicism, idealized a certain calmness of mind (in Greek *ataraxia*, or 'freedom from commotion'). So it is doubtful whether Laocoon's sculpted form stayed on the side of Sceptical restraint.

One could extend this discussion of the potential ancient reactions to the Laocoon, but perhaps the conclusion is already reached. What Winckelmann saw in the Laocoon – a paragon of pathetic but ennobling heroism under extreme duress – simply cannot be matched with any doctrinal view from Greece or Rome. Hence the residual question: if the Laocoon was *not* created to demonstrate an exemplary moment of heroic suffering, then what was its original *raison d'être*?

★ ★ ★ ★ ★

Some time during the second century a proposal came before Athenian city councillors to stage gladiatorial contests in the Theatre of Dionysos. Corinth, a long-time rival city, possessed not only a theatre adapted to host this mode of entertainment, but also its own purpose-built, Roman-style amphitheatre. A Cynic philosopher at Athens called Demonax gave his opinion. Let such games go ahead in the theatre, he said, but first demolish the city's Altar of Pity. Its votaries were hypocrites.

The question of adapting theatrical space for 'barbaric' uses was not a novel dilemma for the Athenians. The orator Dio Chrysostom, in a speech of the late

13 GREEK DEITIES TRIUMPHANT OVER STRUGGLING GIANTS
Detail of the frieze of the Great Altar of Zeus at Pergamum, *c*.170 BC.

Carved in deep relief, the figures here appear to spill onto the steps of the altar – such is the force of their combat.

14 DETAIL OF DEFEATED GIANT
From the Pergamum altar. His hair yanked by one of the Olympian deities, the Giant's features are cast in a pseudo-theatrical mask of despair.

first century addressed to Rhodians (*Oratio* 31, 121), implies that the Theatre of Dionysos, once host to the great Attic tragedians, had already been 'blooded' by spectacles of human and animal combat; and to this day one can see where the architectural structure of the theatre was modified to accommodate such sports. For the safety of front-row seatholders, a marble parapet had to be erected, as a base for wooden rigs and high netting to enclose the big cats. As Dio notes, that did not prevent close spectators, notably the priests of Dionysos, from being spattered with gore. For Dio this was uncleanliness in the sanctuary of Dionysos. Demonax, however, anticipates a more modern concern: that pity is profoundly alienated from the community that draws enjoyment from the witness of violent death.

For Athens to match the peer-pressure of Corinth was technically problematic. For Athens to rival contemporary Rome was, perhaps, ideologically impossible. In the year AD 80 Titus had inaugurated the amphitheatre *par excellence*, the Colosseum in Rome. The 'games' (ludi) lasted one hundred days. Historians record that nine thousand animals were slain over the period. Court poet Martial gives us some details of the more sophisticated amusements on offer there. Could the poet Orpheus really charm animals with his lyre? Romans were given the chance to see for themselves, and alas it seems not; the mock Orpheus, propelled into the arena, was torn apart by bears. Was Pasiphae really deluded into being enamoured of a bull? Yes, there she was: and a steer was goaded into mounting her. How did Hercules endure the 'intolerable shirt of flame'? One way to find out. The winged acrobat playing Daedalus had every incentive to believe a man could fly: no safety net but only hungry jaws lay below him.

It is possible to bring an anthropological perspective to these spectacles, and explain them as a form of social 'scapegoating' (again the notion of just deserts); and naturally scholars suspect a measure of sensational exaggeration of their extent (especially from Christian sources). What has not been remarked upon is the measure of coincidence between such tableaux in the amphitheatres and the subjects of certain Roman statue-groups.

This takes us to a further surmise: that the staging of 'fatal charades' in the ampitheatre fostered a taste for sculptures that captured the same voyeuristic thrill. One witness, Clement of Rome – resident in the city towards the end of the first century – tells us that a number of Christian women were martyred in the arena in the guise of *Dirkai*, or mythical 'Dirke-figures'. We know an outline of the story here: it was enshrined in a play by Euripides, the *Antiope* (now lost, but seemingly once perhaps the best-known work of the playwright). Dirke is a marginal figure in the saga of Thebes, and a decidedly unpleasant one. When the heroine Antiope escapes from a harsh captivity – imposed by Dirke's husband Lykos – to rescue her twin sons Zethos and Amphion, Dirke orders the two boys to punish the escaped prisoner. Though they had been estranged from her for years, the two boys recognize their mother and they apply the decreed punishment to Dirke herself. The punishment is to be bound to the horns of a raging bull, and thereby tossed, stomped and dragged to death.

Gazing over the marble pyramid that is 'The Punishment of Dirke by Zethos and Amphion' (15) brings with it a double strain on credulity. We may marvel at

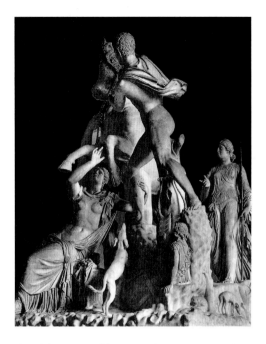

15 THE PUNISHMENT OF DIRKE BY ZETHOS AND AMPHION
Also known as 'The Farnese Bull'; from the Baths of Caracalla in Rome, perhaps *c*.150 AD.

In the original story, Dirke had intended this punishment for Antiope, mother of Zethos and Amphion. Learning of her intent, the two boys turned the treatment upon Dirke herself.

the risks courted by its sculptors, attempting such a technically intricate project on such a grand scale. Pliny, who knew a version of this group in the gallery of Asinius Pollio (*Natural History* 32.33) was most impressed by the 'one block of marble' factor. But those who have seen how bulls actually behave in tense situations will wonder even more how 'The Punishment of Dirke' was staged as a public divertimento. Presumably the perilous effort entailed in attaching a girl to an angry and panicking bull was all part of the compulsion to view.

We know that two Sophoclean themes were part-'enacted' as Roman executions: the *Trachiniae*, which had Hercules sizzled by the shirt of Nessos, and the *Ixion*, which involved some wretch being whirled around in the manner of the future St Catherine. And who can tell what else might have arisen from the programme of an ingenious Roman impresario? The group of Ulysses and Polyphemus from the emperor Domitian's fountain at Ephesus, for example – where the prostrate bodies of Ulysses' unfortunate crew members loll in the viewer's foreground – is that in fact a frozen circus game? And when we learn that snaky 'demons' (*larvae*) were sometimes released into an arena to claim a victim for the Underworld, we might think: could Laocoon's fate have been rehearsed in this mob-pleasing manner?

Stylistically the Laocoon Group may occupy an indeterminate age: datings have ranged over several centuries. Contextually, we are entitled to be more precise about its effect upon viewers. Laocoon's sculptors were Greek: but we have found no reason to surmise that any Greek was ennobled or sympathetically moved by the plight of Laocoon. Nor, in its Roman setting, can we accept the statue as anything close to the incitement of grand *misericordia* that J.J. Winckelmann supposed. Nominating the emperor Titus as the most likely patron of the Laocoon group is to accept that no ancient vicariously winced at Laocoon's plight.

It was the sculpture of tough justice; conceivably a record of imperial largesse.

Note on the body and soul (i)

Diogenes Laertius, the biographer of eminent
philosophers in the Classical world, takes note
of a fourth-century BC Sceptic called Anaxarchus.
On account of his conspicuous powers of disregard
(*apatheia*) and contentment with life, Anaxarchus
earned the sobriquet of 'Happy Man' (*Eudaimonikos*).
But he made an enemy of Nicocreon, tyrant of Cyprus,
who had Anaxarchus seized and put in a large mortar
bowl, to be done to death with iron pestles. As the
philosopher was being battered, he cried out:
'Pound, pound the pouch containing Anaxarchus:
ye pound not Anaxarchus!'

This is a minor ostentatious instance of 'dualism':
the logic whereby personal identity belongs with
a 'soul', inhabiting the 'body' by way of makeshift
shelter. Dualism, literally, splits us in two, puts us
asunder. And as the case of Anaxarchus shows,
dualism also serves as a sort of psychosomatic
defence. If the human self lies beyond flesh and
bones, then harm upon humans is hard to inflict.

This was a doctrine that, in various modes,
a number of Classical philosophers projected as
ideal. Anaxarchus demonstrates its ultimate
expression, which is the defiance of death. Yet, as we
shall now see, it was no Greek philosopher, but rather
one victim of provincial justice within the Roman
empire who proved the most exemplary stalwart
of dualism's transcendental anaesthetic strength.

**16 THE MARTYRDOM
OF ST LAWRENCE**
Lunette mosaic in the
'Mausoleum' of Galla Placidia,
Ravenna, c.430–50.

The central focus is the gridiron
heated by flames, in preparation
for its seemingly insouciant
victim, St Lawrence. A cabinet
containing the Four Gospels
stands on the other side.

17 *'DAMNATIO AD BESTIAS'*
'Condemned to the animals':
detail of a mosaic from the
Sollertiana Domus, El Djem
(ancient Thysdrus), Tunisia.
Late third century.

3 TEL EST MON PARADIS

Two ancient mosaics: compare and contrast.

The first – from a Roman villa in North Africa. Repeated scenes of half-naked humans being mauled by animals. Explicit enough. In one vignette the victim is tied to a pole mounted on a trolley, so that he can be gingerly propelled towards the beasts. In another (17) the bound victim is held upright by some arena stooge, as a leopard sets about his throat. Gashes and gargles of blood are duly picked out by the mosaicist in trails of scarlet stone.

To compare – from the chapel-mausoleum of the Roman empress Galla Placidia at Ravenna – a lunette composition presumed to show the martyrdom of St Lawrence (16). The instrument of the martyr's death is central – a flaming gridiron; to one side of the fire, a display cabinet containing the four Gospels; on the other, the figure taken to be St Lawrence. He is about to be roasted alive, but his imminent fate induces no evident fear in the saint. Lawrence goes trippingly towards his ordeal, as if it were a Sunday School hike, the Cross on his shoulders a happily carried talisman.

Centuries separate the making of these two mosaics: they are not pendant companions. But their subjects are perhaps historically related. According to hagiographic tradition, St Lawrence was martyred in Rome in the year 258. The various mosaic floors from Roman villas in North Africa featuring 'death as decoration' belong to the second and third centuries. We cannot say that the particular victims featured in these mosaics were Christians. But it was a period when the condemned criminals offered to the arenas in Roman North Africa – at Carthage, Lepcis Magna and elsewhere – were indeed tortured and killed there as confessed Christians. Some of the most tenderly documented narratives of Christian martyrdom – the *passio* of Sts Perpetua and Felicitas, for instance – come from this part of the world; Carthage was also the home city of Christianity's supremely indignant and pugnacious apologist, Tertullian (c.160–240).

The mosaics compared here both belong to the period which our ancestors referred to as 'the decline and fall of the Roman empire', and which we now more delicately denominate 'the transformation of the Roman world' – Early Christianity, Late Antiquity. If each mosaic makes its own attestation of Roman decadence and Christian zeal, then perhaps we are comforted to accept a straight conflict of opposing 'value systems'. But this conclusion is not so easily reached. Historians of Roman art have been openly puzzled by the bourgeois domestic contexts that scenes of arena violence appear to embellish. ('The realism,' writes Jocelyn Toynbee, 'is excruciating'; these mosaics raise 'in a most acute form the problem of how householders could wish to perpetrate such scenes of carnage on the floors of their homes'.) But should the Romans then be caricatured as heathen connoisseurs of gore, irredeemably bloodlusty and insensate: and should Christianity be hailed as a victory for civilization, gentle values, moral temperance and universal compassion?

Anyone who becomes immersed in the literature of the Christian martyrs soon encounters problems in making such a raw contrast. In the first place, there would appear to be nothing gentle or temperate about the manner in which this 'martyrology' was constructed – neither in literary records, nor in terms of visual publicity. The latter is all the more striking when it is remembered that Christianity was originally a faith that neither required nor favoured images for its articulation.

Within the simple cause-and-effect logic of art-historical narrative, we may accept that the cult of martyrs gave rise to the cult of relics, and in turn the cult of relics gave rise to the cult of icons. Hence 'Christian iconography'; and, as might be expected, a programme of images which were often indebted to pagan precedents. But what the early Christians accomplished ideologically was not some new strain of heroic Stoicism. They did not seek to diminish or deny the existence of human suffering. Quite the opposite. Christianity thrived because it mined for virtue in striations of distress.

In the baying amphitheatres of the Roman empire, Christian 'witness' – which is all that the Greek word *martys* or *martyr* denotes – found a stage, and displayed histrionic style with proselytizing glee. Pagan gladiators battled for applause and possible reprise. The Christian martyrs championed passive recklessness. If it issued from the veins of an unswerving and emboldened 'athlete of Christ', spilt blood made the insignia of victory – a costume of ultimate grace. This sacrifice extinguished the flames of Hell, it fertilized the greater cause of human salvation. So the lightfooted dance of St Lawrence at Ravenna moves to the drummed motto of martyrs down the ages, *sanguis martyrum est semen ecclesiae*: 'the blood of the martyrs is the seed of the Church'.

Nobody – so far as I know – has ever suggested that the bloodstreaked mosaics from Roman North Africa were commissioned by Christian patrons. Yet the suggestion, while unfounded, is not wholly absurd. Who would be more deeply gratified by the prospect or commemoration of arena violence? For a pagan audience, those *damnati ad bestias*, 'condemned to the beasts', were criminals (*noxii*), justly paying the wages of crime. For Christians living and dying under a pagan regime, that identical fate was exultantly to be coveted, a cause for zealous pride. It was the fee first claimed by St Stephen 'protomartyr', stoned to death in Jerusalem perhaps within a year or two of Christ's own Crucifixion. It was the *merces sanguinis*: the splendid reward of blood.

<center>* * * * *</center>

No great intellectual strain is required to imagine the quandaries facing those who sought to maintain good government in the Roman provinces during the first centuries *Anno Domini*. Imagine the situation of an administrator faced with a diffuse new faith in his area. Suppose he is the prefect or proconsul of a Roman province. The settlement of economic infrastructure; the maintenance of civil and military order; the harvest of taxes – these are the worries of his hours. He is bureaucrat and diplomat in one, obliged to bypass Roman law when it thwarts the local claws of justice. He cleaves to an inherited vocation, which is to rule the

world. But peace is not supposed to be a desert. Rome's dominion should constitute a local boon, with order imposed and the benefits of orderliness perceived by all – rulers and subjects alike.

From Bithynia-Pontus – now the northern part of Turkey, by the Black Sea – a moderate and conscientious Roman governor famously addressed his emperor in a letter about the problems posed by Christians in the years around 110. This governor was Pliny the Younger, whose uncle had so admired the Laocoon statue; and he was not by disposition severe. In a less formal letter from his retreat in Tuscany, for instance, he deplores his neighbours' use of slave labour. But the irksome clangour of chain-gangs in Chianti country was morally less bewildering than the 'crimes' (*flagitia*) to which these Bithynian Christians confessed. As a sect, the Christians had forsworn theft, adultery and defaulting on debts. They met together to sing antiphonal hymns and eat perfectly ordinary food at a common table. Pliny applied routine torture to a couple of slave-girls in the group, and discovered nothing more remarkable than that the two girls served as *ministrae*, deaconesses. Such social mobility among slaves may have been as depraved a practice as Pliny could uncover: he does not mention the slur, reported by some earlier persecutors of the Christians in Rome, that their 'holy supper' was a cannibalistic rite. What bothers him is that while he has been able to persuade some of the alleged Christians to recant, and prove themselves as backsliders by burning incense to an image of the emperor and cursing the name of Christ, others have clung to their faith – even when given several ready opportunities to bluff their way out of the threatened punishment. 'Out of their minds' (*amentiae*) concludes Pliny – and has them despatched. But the more he pursues this business, the more cases come to light. What should he do?

The emperor Trajan's reply survives. It is brief and decent advice. Do not go hunting down these Christians. And take no notice of what lurking informers report about them. Anonymous lists of denunciation, declares Trajan, 'do not belong to the spirit of our age'.

How to elicit lugubrious sighs from Edward Gibbon. For Gibbon there were joint culprits responsible for Rome's eclipse, as narrated in his *The Decline and Fall of the Roman Empire* (1776–88). Primary were the Christians, whose flagrant aim was to destabilize Roman rule. Secondary were the Romans themselves: those nobler and softer Romans, like Trajan and Pliny, who followed what Gibbon's contemporary David Hume described as 'the paradoxical principle and salutary practice of toleration'. Trajan may have striven to exercise fairness in his dealings with adherents of a new religious enthusiam. But the pledge of flexibility was not mutual.

As Gibbon perceived, the extent and horror of the periodic persecutions of Christians in the Roman empire was grossly magnified by apostolic propagandists, including Tertullian. Written up as *passiones*, the tales of martyrology circulated swiftly amongst the Christian communities as scripts of hope and prescriptions for glory. The generic category of 'tenacious pamphlets' (*libelli tenaces*) describes them well. 'Desire not to die in bed, in miscarriages or easy fevers, but in martyrdoms, to glorify Him who suffered for you,' urged Montanus, an early captain of Christian sects in Asia Minor. Martyrdom was a pharmacy to be shared

with the world; death for Christ's cause quintessentially flamboyant. The clinical scientist Galen, who served as physician to emperor Marcus Aurelius in the second century, was impressed by the conspicuous fortitude displayed by Christians meeting their end. The emperor Marcus himself was not. 'What a brave soul is that which is well prepared to leave the body,' he noted in his *Meditations* (XI. 3), 'but prepared by rational means, not mere defiance, such as the Christians show.' The waft of affectation must raise old Stoic contempt. But ideologically it was a headlong collision. The Stoic enshrinement of true apathy is beset by the new ideal personified by Jesus Christ – to be a 'sufferer' (*pathetos*) triumphant.

St Lawrence in the chapel of Galla Placidia is such a victor, happy to quit flesh and bones and fellow mankind to join the company of angels. His direct route to Paradise was eulogized in the fourth century by Prudentius, another master of pagan eloquence finding fresh inspiration from the heroics of Christian witness. In the poetic bouquet cast by Prudentius (*Peristephanon* II), here is an instance of sainthood attained by an act of pointed trickery. The presiding Roman imperial governor has asked the cleric Lawrence to hand over the contents of his church treasury. Lawrence entreats a full three days to have it all delivered. The prefect rubs his hands with greed for the anticipated quantity of riches. 'Give unto Caesar what you know to be Caesar's,' he wheedles. 'I ask nothing unreasonable. Unless I am mistaken, your God stamps no money . . . so you should hand over the cash, cheerfully.' Meanwhile Lawrence collects all the ragged people of his parish – the blind, the crippled, the withered and the indigent – and musters them in his church. He then declares to the governor that his treasure has been assembled: Christ's beautiful people are there.

The duped and enraged governor will not countenance a straight beheading of this upstart. Revenge shall be a slowly measured end. But as Prudentius racily relates it, this prolongation of death suits its victim perfectly well. Typically, in the style of such fanciful *passiones*, no screams pierce the air as Lawrence sizzles on the gridiron. Instead he delivers wisecracks to his tormentors. 'Turn me over,' he gags in the midst of agony, 'I'm done on this side'; then 'It is cooked' (*coctum est*) with his final breath.

From such densely embroidered records no statistics can be unpicked. No one can estimate how many Christians courted self-destruction so tenaciously from the Roman empire, though one partisan source (Origen, a Christian intellectual who himself experienced torture and persecution in the mid-third century) did candidly wonder if the tally reached double figures. But numbers never mattered. The dramaturgy of martyrdom fostered its own kinetic scale of commitment, whereby the exquisite details of individual enthusiasm counted for more than any calculation of sheer numbers. 'Heap refined cruelties upon us,' Tertullian urged his pagan Roman readers. 'The more you cut us down, the quicker we proliferate.' This is what happened in the end: the roar of the arena crowd eager to witness blood was out-bellowed by the roar of those Christian volunteers clamouring to provide it.

★ ★ ★ ★ ★

We will later retrieve an iconographic curiosity from the centuries of early Christianity. Why, when the literature of Christian martyrdom was so adoringly descriptive of fleshly pain and the Hell-quenching conduits of blood, were images of martyrs so anodyne, so clean? Why, in particular, was the exemplary pain of Christ Crucified never made explicit in this period?

But before we address those questions, it seems only fair to neaten the Roman side to our story. What follows may be taken as a little sop to those who would stoutly uphold 'the glory that was Rome'.

It has not been unknown for Classical pedants to acknowledge the amazing moral energy that polemicists such as Tertullian and Prudentius released into Classical literature. (Of Tertullian's *Apology* one Victorian editor noted: 'What literary gee-gaws do the finest orations of Cicero and Demosthenes appear after this!') But any blanket characterization of pagan Romans as essentially, or dogmatically, pitiless would be resented by antiquarians, and with some reason. There is a plangently burdensome phrase in Vergil's *Aeneid*, which translation hardly conveys: *sunt lacrimae rerum, et mentem mortalia tangunt* – 'the sense of tears in mortal things', in one paraphrase. In its context, this is a comment upon the fall of Troy, but it is often taken to reflect the sorrow-prone sensibility of Rome's official poetic conscience. Compounded by the Christian predilection for regarding Vergil as an honorary Messianic prophet, the acknowledgment of tragedy at the heart of human existence encourages us to suppose that neither Vergil nor his admirers were amongst those Romans who found a pastime in viewing violent death. Which has us wondering. Did Pontius Pilate seek any more than the token scourging of his death-bound 'Messiah'? On how many other occasions were the senior managers of Imperial Rome battered by *vox populi* – the voice of the people – into shows of judicial 'brutality'?

By tradition we think of the Roman populace as a mob periodically contented by the provision of 'bread and circuses'. This twinning of amphitheatre sport with daily sustenance is either telling or unfortunate. Several Roman writers recognized that to participate in the spectacle of bloodshed was more of an addiction than a form of necessary fare; among them the Stoic Seneca, who attempted to give moral instruction to the emperor Nero. So too did the North African bishop St Augustine, who devotes a passage of his *Confessions* (composed around the year 397), to the surely autobiographical record of an individual joining the arena crowd at Rome against his better judgement. The unwilling spectator resolutely shuts his eyes as combat commences; until a near-deafening shout goes up from the audience, which tempts him to peep. Once he has seen the blood, he is transfixed for the rest of the action, indeed eager to witness the infliction of ever more terrible wounds. Only the castigation of self's weakness and renunciation of vulgar pleasure prevent him from returning to the ring.

The Roman Imperial court biographer Suetonius relates that Nero liked to dress up in furs and set about the genitals of staked victims. The poet Ovid, in one of his characteristically direct similes, likens the mythical attack by Bacchic women upon the lovelorn Orpheus to the fury of dogs ransacking a deer dragged down in the amphitheatre sands. To gather such literary allusions is to appreciate that the circus was known by at least some Romans as an enclosure of base

instinct. And it was generally realized to be a place of hardening-up. Historians of the second-century emperor Caracalla tell us that as a boy he hated to see living things hurt – and that to cure him of this disposition to blub, his elders forced him to attend the games and watch the bloodsports diligently. In time the young Caracalla learned: as emperor, his name became a byword for capricious acts of cruelty.

The Christian martyrologists claim cases of mass conversion in the arena, due to swells of respect garnered by Christians who demonstrated fortitude. More likely, Christian victims rather frustrated mob entertainment by accepting their fate so passively: a one-sided tussle was a contradiction in terms and an impresario's nightmare (for this same reason criminal executions in the arena were customarily put on as *meridiani*, midday-interludes for the chronically bored). Pagan writers record no astonishing swings of public mood regarding the fate of any mortals condemned to bleed and die. The sole documented incident of widespread *misericordia* in the amphitheatre relates to some twenty elephants introduced into a triumphal entertainment by Pompey 'the Great' in the mid-first century BC. The crowd, we are told, delighted to see the wounded elephants tusk and toss their gladiatorial tormentors high into the air, like jugglers. But when the elephants began to sag and crumple, and trumpeted grand lamentations as they died, all sense of pleasure (*delectatio*) evaporated. Pompey's munificence back-fired. The Romans, 'feeling that these beasts had something in common with the human race' (as Cicero puts it), cursed him for this gift.

Again – and it will not be the last time – we apprehend that the successful institutionalization of cruelty rests upon a rationale of just deserts; also upon the specious classification of certain humans as sub-human. That elephants could suffer outrageously was not beyond understanding in pagan Rome. That a crucified criminal could save souls was more difficult to see.

<p style="text-align:center">★ ★ ★ ★ ★</p>

Literally so. Difficult to see; difficult to imagine. Our own familiarity with the Cross as a logo, with Christ Crucified as amulet or homely presence, clouds our capacity to comprehend the original abysmal horror of what Latin legal language deemed to be the 'utmost punishment' (*summum supplicium*).

Crucifixion was a punishment with a truly putrid reputation in the Roman world. It was death deserved by the most unworthy of all unworthies; it was death with grim humiliation, ignominy and abasement. It was *mors turpissima crucis*. Who on earth would want its souvenir or remembrance?

Tales of mass crucifixion – such as the revenge meted out to the rebel-gladiator Spartacus and his followers in 71 BC – should not deceive us into thinking that this punishment was a routine recourse of Roman justice. The Romans themselves blamed its invention on barbaric others – Easterners, Greeks, Carthaginians or Jews – and they reserved its use for exceptional crimes. Treason and desertion came into the category. But above all crucifixion was punishment applicable to those of servile status, and as such, infamously, it might be invoked for trivial miscreance (tasting the master's soup; failing to untangle the matron's hair).

By euphemism it was 'the unhappy tree' (*arbor infelix*), whose extremes of pain offered variants few Romans cared to describe. We only know that victims of crucifixion might be either impaled or bound (the latter protracting death over days), in either case available for promiscuous torment and abuse; and that the finality of a body expiring upon a cross was marked by its being torched alight at nightfall, or discarded as carrion for dogs and crows and vultures. Customarily there was no burial of the corpse, which in the eyes of many must have compounded crucifying's cruellest strains of punishment. Non-burial was limbo: loss of status for eternity. So crucifixion as a punitive device was intended to carry the maximum of negative exemplarity. And so we find the fastidious first-century rhetorician Quintilian urging display of the crucified at busy road junctions – lest deterrent effect be squandered.

As Martin Hengel has argued, the 'theology of the Cross' – the preaching of the redemptive power of Christ Crucified – was in itself the most formidable challenge undertaken by St Paul and the first Christian evangelists. They nursed a conundrum at the heart of their message: a yoking together, as it seemed, of contemptible lordliness and majestic folly – which was in turn demonstrated by the paradox of a 'living corpse'. And to many of their Romanized Judaic or Gentile audiences, it was the precise mode of Christ's death that appeared either scandalous or incredible.

It is true enough that other faiths had been built around the figure of a dying god. Classical mythology reported Dionysos once torn limb from limb; a similarly vigorous distribution of bodily parts befell the Egyptian god Osiris. Dionysos was of course reborn, and he promised rebirth to his followers; and it was the patient reassembly of Osiris that would justify the Egyptian ritual of mummification. But though violent, the deaths of Dionysos and Osiris had been quick, ephemeral, involuntary and essentially free of shame. Just as the disciples of Socrates could be proud of his honourable suicide, and decently enheartened by the moribund optimism shown by their master, so the devotees of Dionysos and Osiris had no cause to regret any extravagant lapse of immortal invulnerability. Christ's death by crucifixion was, by contrast, deeply bewildering. Let the Son of God deign to assume a mantle of humanity. But why the dregs? Why walk to a death as squalid as it was unnecessary? Why stoop to the deserts of a rogue slave – beneath humanity?

Because the theology of voluntary humiliation or self-'emptying'(*kenosis*: on which more in the following chapter) was so alien to any existing school of thought in the Roman empire, some early Christians simply declined to accept it. Hence the attitude of the Gnostics or 'Knowing Ones' in the second century, who maintained that the Son of God only *seemed* to have been crucified. But for those who understood Christ's crucifixion as St Paul explained it – 'I have been crucified with Christ; and it is no longer I who live, but it is Christ who lives in me' – the social penalty was firmly fixed, and stinging. In Greek terms the mode of Christ's death was *moría*, folly. The Gospel of St Matthew (27.42) records the 'proper' response to the sight of Christ Crucified: hoots of derision ('He saved others, but he cannot save himself!').

To join the band of disciples was like boarding the ship of fools. This wilful foolhardiness must explain our first supposed image of 'Christ Crucified', a

cheeky coarse graffito from the Palatine in Rome probably done some time during the third century (18). There is a figure raising his arm in salutation, scratchily labelled in Greek: *Alexamenos sebate theon*, 'Alexamenos worships his god'. Before him is another figure, with arms outstretched as if crucified – and with the head of an ass.

<div align="center">

★ ★ ★ ★ ★

</div>

Reluctance to contemplate their Redeemer so desolately impaled must partly explain the fondness among early Christians for the figure of the 'Roman Christ' (19). The Roman Christ is consistently youthful and amiable. When he was not being portrayed as a scroll-flourishing pedagogue, then this Jesus was cast as 'the Good Shepherd', with a sheep snugged upon his shoulders. There was already a millennium-long history of this motif of animal-carrying in Classical art, especially in the type of Hermes Kriophoros, 'Hermes the Ram-bearer', but in a Christian context its significance is radically altered. For pagans the motif was indeed pious, but invariably the record of a beast brought to the altar for sacrifice. For Christians, by contrast, it was the pastoral metaphor of salvation and divine welfare. It was the lost lamb, gathered to the bourn; the ultimate solicitude of love as husbandry. The lamb might even stand bleatingly by itself as a token of Christ's vulnerable presence.

'The earliest Christians took little interest in art.' Steven Runciman's assessment of a 'Stoic' disregard for art amid Christian sectaries of the first and second centuries is misleading. At their 'love-feasts', or *agapai*, and in their subterranean burial-places, Christians celebrated Jesus Christ not as the Man of Sorrows, but as Bringer of Joy ('Rejoice in the Lord always, and again I say rejoice,' as St Paul commanded the Philippians). That images were mostly covert and often informal does not make them insignificant in the affirmation of this joyance. The catacombs of

**20 CHRIST AND
THE TWO THIEVES**
Panel from the doors of the
Basilica of Santa Sabina
on the Aventine, Rome.
Fifth century.

This early image of triple
crucifixion is made
extraordinary by the disguising
of the three crosses amid
an architectural backdrop.

Rome were designated peripheral sites of funerary deposition, but where amid their underground decorations is the imagery of death – or any symbolic assertion of the Cross? The chill of dying is shrugged away here. Optimism rules. We see Jonah disgorged by the Leviathan, we see Lazarus raised, we see Samson and Daniel dealing with their respective lions. In a painted cubiculum along the Via Latina, Egyptian soldiers stumble and drown in the waters of the Red Sea, but the believer's gaze is upon young fair-haired Moses and the happy prancing ranks of his children of Israel. Salvation is the unwavering hymn of all these paintings.

As Christian imagery 'surfaced' from underground in the fourth century it maintained this aversion to witnessing Christ Crucified. On the well-known marble sarcophagus of Junius Bassus, once laid close to St Peter's supposed tomb in Rome, there may be a vignette of Christ on trial before Pilate, and other episodes of the Passion, but still there is no scene of crucifixion. The programme of mosaics on the walls of the basilica of St Apollinare Nuovo at Ravenna (*c*.500) likewise makes clear reference to events leading to Christ's condemnation, such as the kiss of Judas – but it also refrains from presenting the narrative conclusion.

Only hesitantly in the fifth or sixth century, it seems, were Christian artists and their patrons able to make some show of Christ Crucified. To judge by the surviving examples – such as the figured panel on the carved cypress-wood portals of the Basilica of Santa Sabina in Rome – it is an apologetic debut. In fact, at Santa Sabina the modern viewer could be forgiven for not at first apprehending what subject appears here, discreetly included not as a central event but scarcely visible in the top left-hand corner of the doors (20). Only nails through the palms of the hands confirm it as a scene of crucifixion. There are no crosses, rather a solid but indeterminate brick pavilion, where Christ and two gurning cherubim-thieves constitute some peculiar version of the standard Roman divine threesome which we know as the Capitoline Triad (Jupiter, Juno and Minerva). They raise their hands like flippers – more the posture of benediction than attenuated pain.

On subsequent proto-representations of the Crucifixion, the hill of Golgotha may be topographically defined as a setting for the death of Christ, but little else about these early depictions could be considered 'realistic'. They do not attempt to engage with the physiological paradox germane to the notion of a 'living corpse'. Not only the first Western images of Christ Crucified, but also those originating in the East (as evident from the illuminated Syriac text we know as the Rabbula Gospels, produced in Mesopotamia in the year 586), tentatively essay the type which would come to be known as *Christus Triumphans* – Christ fully robed, patently alive and ruling from the Cross.

Pardonably so. For if viewers were used to any particular image of Christ by the fifth century – lacking textual guidance, artists had not settled upon any codified or schematic representation – it was likely to be the reverend enthroned figure of Christ Pantocrator, 'Ruler of All': more akin to the Classical type of all-powerful Jove, and a polar iconographic opposite to some slave-wretch dangling from a hilltop gibbet. But it is also true that by the fifth century, the collective memory of crucifixion's punitive abhorrence was fading. Its application as a tool of Roman law was officially discontinued after 312 by the first 'Christianized' emperor Constantine, who also sanctioned the legal rights of Christian worship within the Roman empire. While Constantine was busy creating a 'new Rome' at the Eastern site of Byzantium – renamed 'Constantinople' in 330 – his mother Helena was claiming to have sought out the archaeological relics of the True Cross from Jerusalem. By the mid-fourth century, then, the cognitive attachment of Christ with 'the Cross' was losing its tag of embarrassment – or constituting, for the pious, a rather less eccentric source of pride.

And it was in Constantinople, in 692, that the iconographic chorus of this pride was given a first blessing. A convocation of the Eastern bishops of the Christian Church met to establish certain principles of doctrine and ecclesiastical protocol left unresolved by earlier Ecumenical Councils (latterly the Sixth, in 680). From the eighty-second canon of their assembly (known as the Trullan Synod or the Quinisext Council) comes the following statement:

> In order that perfection be represented before all peoples even in paintings, we ordain from now on that the *human figure* [my italics] of Christ our Lord, the Lamb, who took upon the sins of the world, be set up even in the images instead of the ancient Lamb. Through this figure we realize the height of the humiliation of God the Word and are led to remember His life in the flesh, His suffering and His saving death and the redemption ensuing from it for the world.

From this same Synod came instructions for the ubiquitous deployment of the Cross as a Christian symbol. Not strictly ubiquitous, in fact: the Synod prohibited the representation of the Cross upon floors, where it might be despoiled by careless feet. But the licence to capitalize upon the imagery of Christ Crucified almost immediately caused a crisis within doctrinal Christianity. The Old Testament clearly expressed God's displeasure with the practice of worship before images. Now churches had permission to let images abound. Whatever had happened to

21 THE CRUCIFIXION AND ICONOCLASTS

Illuminated manuscript-page (folio 67r) from the Khludov Psalter, mid-ninth century.

The scrubbing-out of an icon, and the mocking of Christ on the Cross, appear to be reckoned equal by their juxtaposition on this page.

the Second Commandment of Mosaic Law – the transgression attached to idolatry? In 726 the emperor Leo III drastically outlawed all images of Christ and the Virgin Mary, allowing only the simple symbol of the Cross. The result was the panic-phenomenon we know as Iconoclasm, from the juncture of the Greek words 'image' (*eikon*) and 'breakage' (*klasma*). It was not settled in Christendom until 843, when in the 'Triumph of Orthodoxy', worship at the images of Mary and the saints was restored as permissible.

The distress of artists and the aficionados of icons during the period of Iconoclasm has been documented well enough. We need merely observe here that for some while, the painters of Christian images risked forms of torture and persecution peculiarly consonant with the treatment of the martyrs in the Roman Empire. And when the 'image-lovers' (Iconophiles, or Iconodules) eventually prevailed, we may almost sense a new charge of graphic energy being levied as vengeance. While clerics and theologians wrangled over the control and codification of sacral images, the artists, as it were, stole a march upon them. Our attention may be drawn to a page in a ninth-century manuscript known as the Khludov Psalter, at the point where Psalm 68 is illuminated: 'I was thirsty, and they gave me vinegar...' We see Christ robed but spouting blood from the Cross (21), and the ugly features of a soldier proffering the vinegar-loaded sponge. Adjacent are two known Iconoclasts, busy whitewashing a tondo icon of Christ. Their sponge-on-a-pole is dipped into a chalice of whitewash which plainly imitates the chalice of vinegar at the foot of the Cross. Antipathy towards images is thereby judged equivalent to the mockery of Christ in agony.

Christ in agony. The 'Roman Christ' whose image appeared within a century of *Anno Domini* went bare-legged and genial. By the close of the first Christian millennium, Christ was otherwise envisaged. He was no longer triumphantly

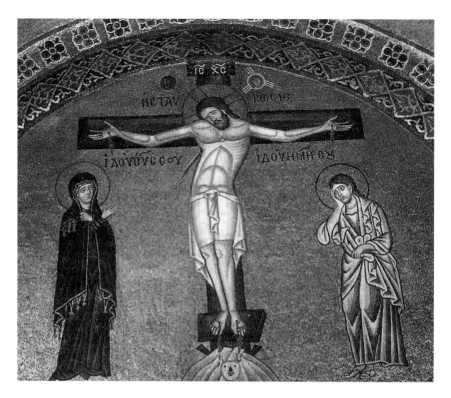

Apolline. Around the year 1000, not far from Apollo's great oracular site of Delphi, the monastery of St Luke, or Hosios Loukas, was built, and in its chapel narthex we find a new reckoning with the prospect of Christ Crucified (22). Here we are served with a body slung into the meander of collapse, and invaded five-fold by open wounds. Here is a face creased with weariness, and the pain-stalked surrender of life. Flanked symmetrically by Mary and John – two bystanders at once admiring but downcast – this monumental Cross proposes a revisionary signal of Christian affirmation. Its very timbers loom like baulks, shoring up that emphatically limp and stricken form. 'But God forbid that I should glory, save in the Crosse of our Lord Jesus Christ, by whom the world is crucified unto me, and I unto the world.'

This valediction from St Paul to the Galatians (6. 14: in the King James English rendering) launched the authority for what we see on the walls of the monastery of Hosios Loukas: a fresh aesthetic of devotion. It may be that the developed liturgy of the eucharist was driving the message of Christ's sacrifice, and therefore fostering more intensive remembrance (*anamnesis*) of Christ's suffering for mankind. But Iconoclasm's disputes had cleared the way for a revived confidence in the power of images. It was the power not only to expose or mediate doctrine, but to produce a Second Nature: the artist's privilege of 'imitation' or *mimesis*. Orthodoxy decreed that Christ was to be worshipped *with* the image, not *in* the image. But the professed vocation of imitating Christ Incarnate would soon require artists throughout Christendom to strive for mimetic fidelity in the image of Christ Crucified – and seek, accordingly, to prompt the response of sheer grief.

22 CHRIST CRUCIFIED
Mosaic in narthex of the Katholikon (main church) of the monastery of Hosios Loukas, by Mount Helicon, Greece. Before 1038.

Some clerical authorities at this time would have considered such a scene 'heretical': one papal delegate to Constantinople in 1054 is recorded as objecting to the 'image of a dying man' (*hominis morituri imago*) he saw in the city.

That is to anticipate the subject of the next chapter: a lachrymose territory at which we are not quite ready to arrive.

The more immediate task is to return to the death-questing destinies of Christ's apostolic martyrs.

It is romanced that St Peter, when condemned to crucifixion at Rome during Nero's reign, insisted upon the punishment applied upside-down, lest it be thought that he was competing with Christ by mimicry. We have seen why Christ's mode of death was, to the first Christian communities, 'unmentionable'; or, at least, no subject for ostentatious imagining. Yet the passionate word-pictures diffused for the deaths of the martyrs were vivid enough. If Christ's death were truly inimitable, then what were they trying to achieve?

The simple answer is: 'saintliness'.

Saintliness has been identified as a variety of religious experience; and if religious enthusiasm be considered not so much an opiate as an amphetamine, then not only the phenomenon of the Christian martyrs but also the 'spectacular austerities' of the Desert Fathers and other Christian fanatics may be classified as a form of spiritual ecstasy. In the tales of arena martyrdom such transports of delight are often recorded: the indefatigable smug brimmings of happiness in those bound for death which cause gnashings of teeth and snarls of thwarted anger from their enemies. By the time of the last serious Roman campaign to inhibit Christian practice – Diocletian's 'Great Persecution', which took place during the years 303–12 – such public displays of sanguine superiority were rare, if only for lack of opportunity. (At Rome, stubborn Christians who refused to worship Diocletian's image were simply condemned to quarry stone for the emperor's colossal bath-complex.) But, from the late second century on, posthumous sainthood was a direct incentive for martyrdom.

Spumes of blood, talons at the throat. 'Tel est mon paradis, dit Dieu. . .' sings the latter martyrologist (and martyr, for some) Charles Péguy, saluting the infants slain by Herod as 'the first victim[s] of Christ'. Nowhere does the transcribed Word of God stipulate explosive bloodshed as the categorical price of entry to Paradise, but for the early Christians martyrdom was no gratuitous gesture. Tertullian and Cyprian refer to the practice of honouring annually the 'birthdays' (natalitia) of named martyrs with vigils and festivals; on such days (actually the nominal day of worldly death) a martyr might also join Christ as the object of remembrance and refreshment at the eucharist.

Martyrs, saints: heroical thus, and, like the heroes of Homer, definitively to be recognized by extraordinary physical prowess. Only whereas a Classical Greek hero demonstrated his status by a tally of swerving feats and prodigal slaughter – graced, it may be, with scars, and showing some insouciance towards staying unharmed – the Christian martyr gained veneration from spiritual indestructibility. Such heroism was as feasibly demonstrated by a woman as by a man; and nobility of birth was no qualifying condition.

An icon preserved at the monastery of St Catherine's in Sinai shows St George (23 April) being flogged, raked by metal claws, burned with torches, buried in a pit of caustic lime, and more. It does not matter what his persecutors do to the saint: he is, so to speak, beyond their range. St Catherine (25 November) herself

could not be broken when affixed to a spiked wheel. St Lawrence (10 August) treads towards the flaming gridiron with the assurance of one who knows that he can only be refined, not consumed, by the fire. We could go on: this is a catalogue and a calendar whose items are all plucked from the same moral altitude.

Was St Paul (29 June) present, as 'Saul', for the stoning of St Stephen (26 December) – prior to his conversion on the road to Damascus? It would be tidily symmetrical to end this chapter with the tale of a zealous persecutor of Christians turned keen pleader of Christ Crucified, but New Testament scholars are too hostile to the suggestion of its likelihood. However, the consecration of St Stephen's witness in words and images makes a sufficiently appropriate close. We possess the text of a Byzantine chorus to the saint, possibly the hymnal accompaniment to an icon:

> Stephen was steadfast with a manly purpose.
> In the face of stoning it was as if he had a nature above nature,
> and a flesh that would manifestly deny the laws of nature . . .
> In the face of the blows from the stones, he was himself a stone.

'A nature above nature'. . . just as Christ was rendered in triumph or tranquillity upon the Cross, so the early artistry of a martyr's death need not entail the specifics of bodily disintegration. A Catalonian painter envisaging St Stephen's death for a church mural in the eleventh century is heir to this reasoned disregard (23). St Stephen bleeds from the rocks besetting him, but for his cretin-featured assailants it is like coaxing blood from a stone. The saint sees them only with the whites of his eyes. Blood indeed crowned defiance in the arena, as flesh fell apart under torture and upon the scaffold. But in the end, to suffer was not its own reward. It was the toll of perpetual bliss.

23 THE STONING OF ST STEPHEN
Fresco from the church of St Joan de Boí, in Catalonia. Late eleventh century.

Stephen implores the heavens, not his assailants; a jet of divine intercession streams down from above.

Note on the meaning of words (ii)

Pain. Old French *peine*; Italian *pena*. The root taps
down to Latin: *poena*.
 This is a pretext for what we shall now confront:
those folk we locate in 'the Middle Ages', and the relics
and images which hold and convey their understanding
of pain – and all the privations of the human body
prone to come apart. 'The Middle Ages', as an epoch,
is an historiographical device of the late eighteenth
century, now less happily understood as being the
'middle' between antiquity and the Renaissance.
But let us allow it to cover the years 1000 to 1500;
and let us keep in mind the word-play of pain as *poena*.
 For then scholars and ignoramuses alike knew the
source of *pain*. The Latin *poena* is perfectly parametered.
It means 'penalty'; it means 'punishment'.

24 DEPOSITION FROM THE CROSS

Pietro Lorenzetti, 1316–19

Part of an iconographic account of Christ's Passion which entirely covered the walls of the south transept of the Lower Church of San Francesco at Assisi.

4 TEARS OF DEVOTION: A MEDIEVAL GLOSSARY

The plump friar: 'Friar Tuck'. If collective consciousness preserves any significant image of the celibate vocation in Christendom, it will most likely approximate to some jowly robed figure under a tonsure. He swings from the plaques of English hostelries as often as he waddles on to a Hollywood set. Yet the Rule of St Benedict – effectively the ideological cornerstone of European monasticism, scripted c.535 for a community of Christian devotees at Monte Cassino in Italy – clearly embeds the principle of moderate frugality into conventual living. Our modern image of the portly quaffer-priest may be maintained with affection. In fourteenth-century England the paradox of jovial monk was regarded more spikily. Geoffrey Chaucer's Monk in *The Canterbury Tales* (1387–1400), 'a lord full fat and in good point', cloisters himself for the sake of good living; Chaucer's Friar ('He knew the taverns well in every town') sallies out into the world with the double mission of gathering cash and girlfriends.

This satire was not anti-clericalism as such. The most brusque allegations of corrupt practice within English churches and the religious orders came from John Wyclif and William Langland, parsons both. An 'afterthought' passage in Langland's fourteenth-century poem *Piers Plowman* pleads for sympathy on behalf of 'the poor in their hovels': 'while the friars feast on roast venison, they have bread and thin ale, with perhaps a scrap of cold meat or stale fish.' It was an easy, obvious route for criticism. Across Europe – from the early twelfth century onwards – liturgy, images and devotional literature combined to propagate a faith profoundly preoccupied with pain, doom and self-denial. A friar went roaming 'mendicant', in beggarly condition, for one original virtuous reason: that his lack of possessions freed him to speak truthfully of good and evil wherever he found it and without self-interest. Therefore the fat or affluent friar should never have existed.

Further contradictions follow. For example:

Salvation lay in poverty. Spare some silver for the cause?

Holiness belonged in little things. Raise high those rib-strung vaults and spires.

Earthly beauty shall pass away, indeed it shall – fugitive as blooms of Spring. Meanwhile gild the parish Crucifix. Let it shimmer with costliest pearls.

And then this odd extreme of empathy. Christ suffered, suffered to the uttermost limits of hurt upon flesh and frame. Take a barb-knotted lash, strike and lacerate yourself for as many days as he had years. Join His Passion, share in His suffering.

Make a revel of it.

In the history of art there is one obvious candidate to play the part of the medieval rotund ascetic. Abbot Suger of St-Denis (1081–1151) provides us with a famously incriminating text. Building his abbey church on the Ile de France, Suger waxed shamelessly on the necessity of worldly treasures for spiritual satisfaction.

Sapphires, rubies, emeralds and topaz – these were the nugget-bequests of the Holy Martyrs, precious by association with all that was shining and gleeful and steeped in glory. Great golden goblets and chalices were lovingly inventoried by Suger as rightful belongings of the Church, hoarded trophies of praise and benediction. Artists may have fashioned them, but such glittering prizes were happily glossed as God-given. Art and rarities and miracles were as one. (In the early fifteenth century Suger's fellow-countryman Jean, Duc de Berry would duly itemize, among his collection of paintings and curiosities, a certain quantity of 'manna from Heaven'.)

There were dissidents. Within France, St Bernard of Clairvaux (1090–1153) stands at almost polar opposition to Abbot Suger, strenuously voicing concern for austerity and minimalism in the Christian vocation. The monasteries of his reformed order, the Cistercians, architecturally exemplify St Bernard's suspicion of art and embellishment as a distraction from prayer. While Suger hymned the sheen of ocean-harvested pearls set around a Cross as some holy endowment, St Bernard condemned all the fantastic carvings of the prevalent style (which we know as 'Romanesque') as accretions of 'elegant deformity' (*formosa deformitas*). 'The curious discover things to amuse them,' he laments, 'but the poor find no relief.'

Art for worship's sake; art as enemy of the worshipful soul. The tension between two French interpretations of Benedictine monastic discipline (Suger is on the side known as 'Cluniac', after the grandiose centre developed at Cluny by successive abbots from 910 onwards) warns us against making any synthesis of medieval aesthetics. Both Cluniac and Cistercian valued psalmody in worship, which explains why the rival orders shared a predilection for masonry vaulting: functionally, it enhanced acoustics. And a Cistercian monument such as the abbey church of Pontigny, in Chablis country, may be striking for its lack of ornament, with or without contrast to its encrusted Cluniac counterparts (including Vézelay, Moissac, Autun). But any blanket analysis of the 'Gothic' architectural style which subsumes the divergent monastic creeds under something so vague as 'the medieval world-view' is unlikely to hold good under scrutiny. It is true that much of the content of medieval art was literally prescribed, albeit with variant texts (church pedants hotly disputed, for example, whether Christ had been crucified with three nails or four). But even when medieval artists remain anonymous, we might bear in mind the art historian Otto Pächt's observation that the subjects most commonly commissioned from those artists were miracles – amazing events. How could there not be space for individual creativity; a striving for impact, innovation and amazement in showing the miraculous – whatever the rules?

Occasionally one registers a pejorative inflection in the use of the word 'medieval': as if it were equal to 'benighted'; as if 'the Middle Ages' were epochally bound in superstition, cruelty and intellectual stupor. It was the nineteenth-century Neo-Classical architect Gottfried Semper who characterized Gothic style as 'Scholasticism in stone', implying a heartless, fussy and fundamentally redundant system of decorative design; and in turn the tradition of medieval logic and fine quibbling we refer to as 'Scholasticism' has been historically used to characterize an age fundamentally opposed to the spirit of rational inquiry. Again, such a

broad sweep of disparagement does not serve us well. The oldest universities in Europe – including Bologna, Cambridge, Paris, Pavia and Oxford – date their foundations to around the end of the twelfth century, and were fundamentally committed to what might be paraphrased as 'world-wide learning' (*studium generale*). It is now clear that much Classical and Arabic scholarship underpinned this tradition: we can no longer conceive of the medieval academy as a closed shop for narrow theological disputes.

Scepticism towards the possibilities of synthesis is a way of explaining why the following 'account' of medieval imagery in Europe is arranged with no clear narrative pace or impulse. What follows is a glossary, presented (for the sake of *some* coherence) as a piecemeal alphabet. Many of the title terms are in Latin, though that is not as arcane as it might seem: it is worth remembering that when the writer Hilaire Belloc made a journey on foot across Europe in 1901, he used Latin as a means of communication (usually with the local priest) all the way from Calais to Rome. But this is not intended to be an erudite jigsaw-puzzle. What we are seeking to comprehend by way of this glossary is a devotional culture of inspired suffering in Europe; a culture epitomized in this vignette of medieval piety given by the Dutch historian Johan Huizinga in 1919:

> The mind was filled with Christ to such a degree that the Christological note immediately began to sound whenever any act or thought showed even the slightest congruence with the life or suffering of the Lord. A poor nun who carries firewood to the kitchen imagines that she is carrying the Cross. The notion of carrying wood by itself is enough to bathe the activity in the bright glow of the highest act of love.

Medieval devotion to the suffering Christ was of a truly passionate nature: a devotion that wove wonder and weeping into a daily round, so that even a routine chore became an investment in Christ's agony, and the slightest bodily pain could suffice for meditative praise. Say it is a species of virtual reality and we may begin to savour the transfiguring grace of this religious engagement. Huizinga wrote primarily of its historical manifestation in The Netherlands. But we can commence our glossary with its genesis in a warm climate. This is where 'the fount of tears' rises: in a honey-dun town spread upon Umbrian foothills.

Assisi

Birthplace of St Francis c.1181

Nowhere in the sacred description or 'hagiography' of St Francis is it recorded that the saint himself claimed the status of Second Messiah. But the reputation of Francis as *alter Christus*, 'the other Christ', was current in his lifetime; and both sainthood and the monumental development of a posthumous cult came very soon after his death (in 1226). The double church of San Francesco at Assisi was begun in 1228, its arched extension reaching across an olive-silvered hillside like some pristine Roman aqueduct (25). Pope Gregory IX guaranteed the building's financial buttress. He was thereby blessing the 'Order of Friars Minor', already established as 'Franciscan' and uniformly attired in the coarse brown robe

25 THE CONVENT AND CHURCH OF SAN FRANCESCO AT ASSISI View from the valley.

Though retaining many features of local Romanesque architecture, the building (begun in 1228, with the Upper Church developed in 1253) is usually classified as 'Early Gothic'.

which Francis had adopted as 'the mantle of poverty'.

It may be demurred that the identity of Francis as unworldly *poverello* (beggarman) is compromised by the scale of San Francesco, and the expanse of its interior decoration. But the evangelical momentum here was ebullient and unstoppable. St Francis comes down to us as a man of exquisite tenderness, graced with affection for animals, birds and fishes: we may forget that he took part in the Fifth Crusade (in 1219) – admittedly as mediator not swordsman, yet striving for Muslim souls all the same.

And although the first Franciscans at Assisi occupied a shanty-zone of mats and huts, their upgrading to great basilica and belfry had some hagiographical justification. St Francis is shown as a propper-up of churches: for the legendary moment of his original commitment came in terms of a construction edict. This was the occasion when Francis, then a well-heeled and gaudy young hedonist in Assisi, was arrested by a voice from the Crucifix in the church of San Damiano, saying 'Francis, repair my falling house.'

Young Francis obeyed the imperative – and literally: he went out forthwith in search of bricks and mortar.

The artists who came to paint the walls and vaults of San Francesco were not inclined (or instructed) to show the crusading side of the saint whose bones were hallowed in the crypt. Rather they created a pictorial microcosm – panoplied over with starry firmament – in which the life of St Francis 'the Poor Man of Assisi' was elided with the Passion of Christ. Germane to this enterprise was the iconographic stabilization of the *Christus Patiens* type (see p. 63), in which the impoverishment of Christ Himself was stressed by bodily emaciation and a miserable loincloth-scrap. But equally important was the show made of the 'stigmatization' of Francis – the supernatural occasion on the Alverna mountain during which Francis became marked with the five wounds (*stigmata* are literally 'points' or 'impressions') of Christ.

It was the Florentine master Cimabue who, in *c.*1280, planted a high standard here. Its colours are gone, but the outlines of essential energy remain visible, proving the galvanic impetus of Franciscan faith. Cimabue's *Crucifixion* in the south transept of the Upper Church (26) does not so much eschew the type of 'Christ Triumphant' as display the triumph of 'Christ Suffering', with ranks of involved onlookers joining angels in a grand accolade. Whilst the disciple John and Mother Mary make a formal clasp of right hands, Mary Magdalene throws her arms up with an abandon that suggests as much hail as lamentation; others in the flanking crowd half-imitate her adulatory salute. As for the haloed figure in monk's habit crouched at the stone base of the Cross, it is already unmistakable as St Francis – the prime tenet of whose piety was indeed the empathizing veneration of Christ Crucified.

According to his followers, the 'stigmatization' on Alverna (or La Verna) in the Apennines happened while Francis was praying there in 1224. Certain friars could

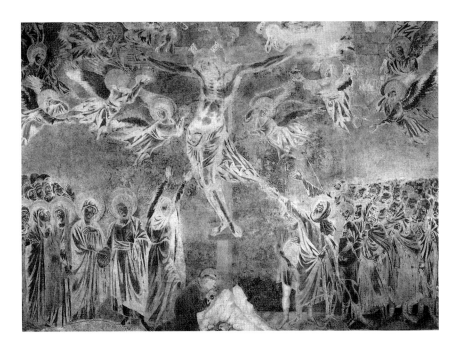

26 THE CRUCIFIXION
Cimabue, *c.*1280

Fresco in the south transept
of the Upper Church of
San Francesco, Assisi. An early
show of the Franciscan pride in
conspicuous self-abasement
and reverence at the foot
of the Cross.

'verify' the marks, and St Bonaventure, Minister General of the Franciscans after 1257, specified that a Christlike seraph transmitted the signs. By Giotto or some 'Giottesque' associate, the image of the stigmatization at Assisi comes as part of a sequence of large illustrations of the canonical 'Legend of St Francis' (Bonaventure's *Legenda maior*), painted during the last decade of the thirteenth century (27). The symmetry of marks is made by cords, like filaments or laser beams, connecting Francis on his rocky fastness with a Christ in pink-red plumage. 'Lofty indeed, yet tethered to the earth, like a captive balloon' is how one latter-day devotional writer, Evelyn Underhill, has phrased the Franciscan state of exaltation. Medical experts earnestly assure us that by applying persistent pressure on parts of the body a person may produce 'stigmata' at will. But, symbolically, the lines that Giotto paints between Francis and the feathered Christ are firm bonds of alliance and fraternity. Francis was disowned by his father, a prosperous cloth-merchant of Assisi: so when the Franciscan author of the influential fourteenth-century *Meditations on the Life of Christ* urges devotees to 'turn your eyes away from Christ's divinity awhile, and consider Him purely as a man', we sense the radical nature of affiliation here.

Christ the man; bereft of paternal support; threadbare; and prone to all human hurt. On the walls of the south transept of the Lower Church at Assisi, Pietro Lorenzetti rendered pictorial confirmation of the person-to-person claim of Franciscan piety.

Along with Simone Martini, another illustrious painter from Siena, Lorenzetti was called to San Francesco after Giotto's studio had departed – proof of continued determination among the friars at Assisi to glorify their headquarters and sanctuary. And the fresco-cycle of the Passion which Lorenzetti produced was packed with details and nuances likely to gratify Franciscan 'taste'. For example, Franciscan texts stressed the compliance of Christ at the time of His betrayal by

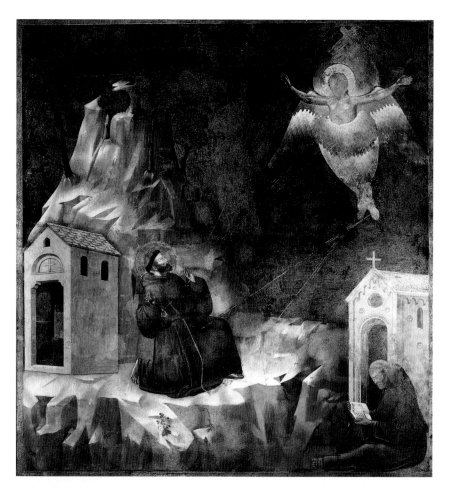

27 STIGMATIZATION OF ST FRANCIS
Giotto or associate, *c.*1297

Fresco in the nave of the Upper Church of San Francesco, Assisi. St Bonaventure's account of this event specifies that the crucified Christ manifested Himself to Francis in the form of a seraph.

28 SUICIDE OF JUDAS
Pietro Lorenzetti, *c.*1320

Fresco in the south transept of the Lower Church of San Francesco, Assisi. As related in St Matthew's Gospel (27.3–5), immediately after Christ was led to Pontius Pilate, Judas flung back his 'fee' for betrayal (the thirty pieces of silver), and went out and hanged himself.

29 DETAIL OF LORENZETTI'S DEPOSITION

In Lorenzetti's tableau (see front of chapter), faces are creased with grief as the wood of the Cross is engrained with knots.

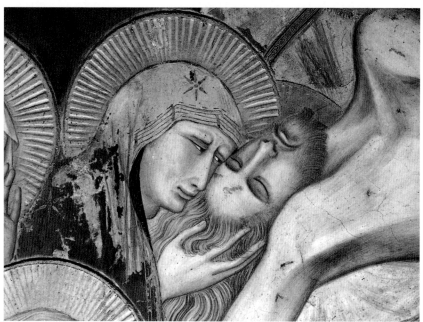

Judas. Bonaventure had extolled the boundless loving mercy of Christ, who paused in arrest only to heal the severed ear of one of His captors (rebuking the disciple Peter who had sprung to His defence): Lorenzetti gives us just such a passive victim. And though Lorenzetti as a painter evidently relished all manner of fine drapery, we notice here that he has attired Christ's enemies and tormentors in particularly gilded and luxurious costumes, as if to confirm the Franciscan equation of riches with evil. Judas – denounced by Bonaventure as 'the apostle who held a purse' – explicitly meets a traitor's end, strung up and disembowelled (28). And Christ's correspondingly virtuous espousal of 'sheer-naked poverty' (*nudissima paupertas*) is demonstrated not only by his abject figure in the midst of a grand operatic *Crucifixion*, but also, and even more palpably, in the grief-darkened sequel of Lorenzetti's *Deposition* (24). The twitch or rictus that distorts the face in moments of greatest emotion is written here on Mary's features, and held close as possible to the serene spent visage of Christ (29): pain and beatitude contrasted and joined.

St Francis was not, they say, so very harsh upon the human frame. In Underhill's words again: 'He called it Brother Ass, and restrained the zeal of those fervent brethren who wished to chastise it without mercy.' Why yearn keenly toward self-laceration, when the world itself nursed so many opportunities for harm and loss of life? The Franciscans were not strict dualists of soul and body: Bonaventure, mellifluously, would argue for the composite dependence of body and soul in making a 'person'. But, in any case, the general acceptance of sickness as sin's punishment was about to be tested Europe-wide. In 1348 Pietro Lorenzetti and his brother Ambrogio were two among hundreds and thousands of thousands of victims of a plague that seemed to some then to be the very Apocalypse.

Black Death

Defined as 'bubonic plague with complications', which may not be enlightening. Cause: a bacterium, spread by the bite of a flea from an infected host (usually a rat). Symptoms: swellings or abscesses around the glandular parts of the body, especially the lymphatic nodes in groin or armpits. Fatal in sixty per cent of cases.

Why it is known as 'the Black Death' is not clear (the English usage is simply a translation of a later German denomination, *der schwarze Tod*). Perhaps the artistic recourse of depicting the advance of pestilence by dark, scythe-swiping demons itself coloured verbal reference.

Epidemic statistics: sufficient to replace 'epidemic' with 'pandemic' – spreading everywhere. The first wave of plague (1347–50) is estimated to have taken twenty million: a quarter of Europe's population.

Locally, during recurrent visitations of this plague, the ratio could be worse. In Florence, three quarters of the population succumbed between 1338 and 1447. England, during the particular outbreak of 1348–49, may have lost a similar fraction of its inhabitants. Of contemporary responses, the eye-witness account from Giovanni Boccaccio, in the opening to the rag-bag of tales that is his *Decameron* (c.1350), is most often cited: extra-mural trenches dug for mass-graves, pigs rummaging amidst piles of putrefied corpses – these were some of the many *miserie* which justified a double escape, first into the calm of the country and then into the weave of stories. Whether Boccaccio's characters are repenting their

sinfulness or seizing the day remains ambiguous, but in either case the plague was acting vividly as a *memento mori* – a reminder of mortality.

Historians of medicine point to the eventual salutary effects of the Black Death across Europe: municipal Health Boards set up; relaxation of ecclesiastical rules regarding post-mortem examinations; and the rapid expansion of hospitals (often staffed and administered by the various religious orders acting as charities).

Historians of art are less sure about the impact of the Black Death: they rightly wonder how far the phenomenon of 'post-plague malaise' in medieval church imagery had already been fostered by a disposition in medieval church teaching to instruct 'the art of dying' (*ars moriendi*). But it is hard to suppose artistic aloofness. In 1951 – and overtly evoking Holocaust images in his citation of Boccaccio – the American scholar Millard Meiss argued that workshops of Tuscan painting were forced by the calamity of plague to revise their repertoires. For example, the story of Job, used prior to the thirteenth century as an emblem of Christian 'long-suffering', or *patientia*, had faded from the regional canon of subjects; in 1367, the Sienese painter Bartolo di Fredi made a point of reviving it in the Old Testament cycle he produced for the left aisle of the San Gimignano Collegiata (30). Though the lead may have been set by Taddeo Gaddi in the frescoes attributed to him in the Camposanto of Pisa, we know that San Gimignano had been locally struck by plague in 1363. Mercantile patrons, hurt by plague's outbreak, may credibly have insisted upon the redress of homiletic consolation in Bartolo's pictures.

As Primo Levi perceived, the story of Job squats at the very base of the human condition. If we 'research our roots' (in Levi's terms) it is Job whom we find in the end. A sheikh reduced to the ash-heap; a paterfamilias bereft of his children; a decent man blasted with sores; a just individual heaped over with injustice. Victim of a wager between God and Satan, Job offers a model of comportment to whoever would plead, in the midst of personal disaster and dereliction, 'Why me?' – and struggles to retain faith.

30 COLLAPSE OF JOB'S HOUSE
Bartolo di Fredi, 1367

Fresco in the Collegiata, San Gimignano. The Book of Job (1.18–19) relates how a message came to Job that his sons and daughters were feasting together in their oldest brother's home 'when suddenly a mighty wind swept in from the desert and engulfed the house, so that the roof collapsed, and all were killed'.

A struggle which Levi himself conceded. But, theologically, the clerics of medieval Europe were able to hoist both the tale of Job and the experience of the Black Death into Christian parables. To suffer outrageously was to understand the meaning of the Cross, whose victim was supreme claimant of the cry, 'Why me?' – yet who was ever more emphatically defined as the unprotesting recipient of all the indignity and pain that the world could provide.

Christus Patiens

It is reported that when the Franciscan leader Bonaventure was offered the status of cardinal – which came symbolically in the form of a hat – he was in the middle of washing-up. His hands were greasy and wet. The cardinal's hat must wait.

'Idleness – the soul's enemy' is a Benedictine sentiment embedded in the Rule of the Franciscan Order. But it is a case of taking up one's own cross. Doing the dishes will do; especially when no one else wants to.

Which is a humble or mundane mode of introducing the cult of *Christus Patiens*, the Christ-who-endures. In a chapter of his *Breviloquium*, or meditative handbook, Bonaventure stresses the deliberative suffering of Christ. Christ *volunteered* for lowliness and despicable pain: it was a matter of choice. This would be developed as the doctrine of *kenosis*, Christ's 'emptying-out' of His self on behalf of the world; but for those never likely to be privy to the finer arguments of 'kenotic' theology, medieval artists consolidated the image. The Passion became a serial horror – certain stages of which we shall encounter elsewhere – culminating upon Calvary: and Calvary must be the signal, unmistakable culmination. Christ's body rendered merely slack upon the Cross became insufficient to this end. Annals for the City of London in the year 1305 make mention of a *Crux horribilis*, a Cross of terrible aspect, attracting crowds when displayed in a church on Good Friday. Bishops at the time were disturbed by the impropriety of the actual shape of the Cross, which was a rough-hewn Y-shaped scaffold without a formal cross beam. But with the so-called 'Gothic Christ', it was not only the Cross that became disfigured. In Germany and Italy, around the year 1300, artists also began to show Christ's body upon the Cross as a mangled, beaten and broken mess.

To label this elaboration of *Christus Patiens* as 'the Gothic Christ' perhaps properly evokes the sense of gratuitous horror which belongs to the concept. It worked by taking whatever unpleasant details could be gleaned from gospel and apocryphal accounts of the Crucifixion and compounding them. Some of those details had been included in Byzantine icons, and as such had not seemed incompatible with the type of 'Christ Triumphant', in His unflinching, wide-awake glory. In Byzantine iconography we find the centurion Longinus who pokes a javelin into the side of Christ; and the figure of Stephaton who proffers vinegar on a sponge. No pictorial emphasis is placed upon their acts as cruel, nor causing particular distress. Longinus was later a convert to the cause; Stephaton was conceivably acting out of solicitude; and according to John's Gospel (19.28–37), both episodes were necessary for 'fulfillment of scripture'.

John also mentions that the criminals crucified with Jesus had their legs broken, prior to being pulled down. A final grind or vent of punishment: John says the leg-smashing was not inflicted on Jesus because the soldiers found him

'already expired' (*hede tethnekota*) – and in John's narrative this is when the spear-thrust is made. Graphically the extra pains of the Two Thieves became the echo-chorus of Christ's voiceless agony. As the term 'Gothic' also suggests, painters in Central and Northern Europe were given to depicting this scene: representative of a widespread type is the panel known as the 'Kaufmann Crucifixion' (31).

Dripping plenteously at hands and feet, the newly pierced Christ showers blood: Longinus puts a hand to his eye as the 'emptying-out' happens, which is an allusion to a minor legend whereby Longinus is cured of some personal sight problem as the liquid spills. One thief appears almost to catch blood in his gaping mouth: he will be the one who accepts the saving grace of Christ. But both thieves are twisted beyond excruciation; their arms and legs have been hacked and shattered; they are the mangled wreckage of the human form. This is, so to speak, their supporting role.

31 THE 'KAUFMANN CRUCIFIXION'

Central panel of an altarpiece assigned to a certain 'Bohemian Master', *c*.1360.

The fractures that distort the two crucified thieves conceivably relate to injuries inflicted in the medieval judicial recourse to 'the wheel' – whereby condemned criminals had their bones shattered either by, or upon, a cartwheel.

'For the sake of Christ Crucified,' urged St Catherine of Siena, 'be a glutton for abuse.' That was the intended Franciscan response to the image of *Christus Patiens*: infectious passivity. But gluttony of abuse was not to everyone's taste. There was the Christ who suffered. There was also the Christ who avenged.

Hence: a troubling memorandum to record here.

Crusades

Troubling – to whom?

To all 'right-minded Christian folk'. To anyone whose image of the Crusading phenomenon evokes honour-blazoned knights; sweet balladry; a king with the heart of a lion; coach tours to remarkable castles in Syria.

Call it the 'recovery' of Jerusalem in July 1099 to preserve that halo of chivalric mission. 'Ransack' is the truer term; 'pogrom' may be understood – if so rarely admitted as to seem virtually taboo in the popular historiography of the Crusades. Certainly the protagonists themselves made no attempt to conceal the fate of Jerusalem's Muslim and Jewish inhabitants when the city was breached.

For some of them, the easiest way, had their heads cut off; others were shot at with arrows and fell from the towers; some indeed were harshly tortured and were flaming with fire. In the streets and square, there were piles of heads and hands and feet . . . [the Crusaders] rode in blood up to their knees and the bits of their horses by the just and wonderful judgements of God.

This account, from a chaplain in the company of Raymond of St Gilles, Count of Toulouse, may be classified as 'eye-witness'; its reportage of vendetta-driven violence is hardly denied by subsequent and more romantic narratives of Crusading zeal, such as the memoirs of Jean de Joinville (who served King Louis of France as a knight in the Seventh Crusade of 1248). A 'feat of arms', performed in the noble course of 'deeds done beyond the sea', could as readily cover a murderous spree among Muslim civilians as the combat heroics of Jean de Joinville's own priest, who single-handedly 'routed' eight Saracen warriors. For above all it was slaughter sanctioned as piety. Crusaders used the terminology of pilgrimage (*peregrinatio*) for their ventures; ever since Pope Urban II first incited the movement (from Clermont-Ferrand, in 1095), Crusading service was blessed with the promise of remission of sins.

Chevaliers such as Joinville knew about blood-feuds: score-settling was part of their 'culture' of spurs and repute. And the Crusading movement evolved out of an injury to honour that was no less rankling for being ancient. The first epic of the Crusades, *La Chanson d'Antioche*, composed in the early twelfth century, supplies the original cause for revenge. Its opening stanzas hail Christ upon the Cross, between the Two Thieves. Some extra-Gospel conversation ensues. The Good Thief asks Christ how He intends to deal with these 'churlish [*cuvers*] Jews' who have treated Him so sorely. 'My friend,' replies Christ, 'they are not yet born who will come to avenge me [*me venra vengier*]. . . but in a thousand years my land will be conquered, my rule restored. . .'

So this is how the Crusaders saw themselves: the bringers of millennial justice; charged with a vengeance-*manqué*, a filial duty (*Il ierent tot mi fil*, says Christ of his far-off warriors in the *Chanson d'Antioche*: 'they shall be all my sons').

'They killed the very children in their mothers' arms to exterminate, if possible, that accursed race – as God once wished should be done to the Amalekites.' Louis Maimbourg, Jesuit priest at the court of Louis XIV in the seventeenth century, could complacently relate the Crusaders' actions at Jerusalem to the Old Testament device of 'Holy War'. The Amalekites are recurrent enemies of the Israelites: Yahweh, Israel's God, desires them not only defeated but put out of existence. So King Saul received divine instructions to 'fall upon' the Amalekites: 'Spare no one: put them all to death, men and women, children and babes in arms, herds and flocks, camels and asses' (I Samuel 15.3).

Jerusalem the Golden. The Crusaders who cantered in crimson through its streets in the summer of 1099 did not discriminate in their killing between Muslims and Jews. Either infidels, or the murderers of Christ. The estimated number of victims of that double jeopardy tallies fifty thousand.

The Muslims present in the Iberian peninsula (the 'Moors', who first crossed from Morocco in 711) were an acknowledged enemy of the Papacy: the pilgrimage-cult at Compostela grew around a figure worshipped as *Santiago Matamoros*, 'St James the Moor-slayer'. But it was not necessary to go all the way to the 'Holy Land' in order to wreak vengeance upon the Jews. Jewish communities had been established in the heartland of Europe in the times of the Roman Empire. Along the Rhine the old Roman settlements – Cologne, Mainz, Worms, Speyer – were among the principal centres of medieval European Jewry. As the Crusaders gathered in

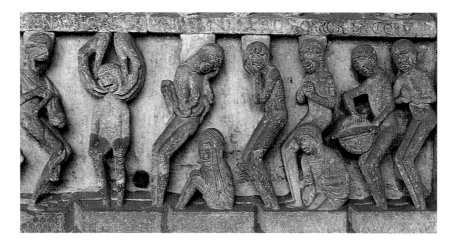

1096, more rabble than column, vulgar xenophobia, knightly belligerence and Christian dogmatic scapegoating combined to set off sprees of anti-Semitic persecution. Jews from Rouen to Regensburg were attacked under the banners of the Crusade. Enforced baptism might spare some lives; at Mainz, though, eleven hundred Jews committed mass suicide rather than be dragged to the font.

The First Crusade was not the only overture to Holocaust in Europe. As Black Death descended upon the Rhineland during 1348–49, groups of 'Flagellants' gathered to parade their self-mortification through plague-endangered towns. But while the penitents marched through streets whipping themselves and each other, their leaders chanted blame for disease elsewhere: this was not God's judgement upon ordinary folk; it was the Jews who, in their lingering hatred of Christ and his people, had poisoned the water supply. Reaction to this slander was swift, and not always ungovernably wild: in February 1349 the city councillors of Strasbourg themselves ordered the burning alive of the city's two-thousand-strong Jewish population.

Christ the avenger; without quarter. Those who have eyes to see will recognize the prime element of caricature in the medieval images of the avenging Christ's quarry: it is the very same as plied by the Nazis, the convex nose of Semitic physiognomy. And in the Crusading climate, artists were not afraid to go further. Around 1130, at the cathedral of Autun, the French sculptor Gislebertus carved his portal of the *Dies Irae*, the day of Christ's almighty wrath (32): and, in amongst the squealing, harrowed and often hook-nosed offenders, there is one who appears to hold tokens of generic crime. Ultra-villainy: he carries off the elements of Holy Communion, brandishing a knife – the knife of the kosher slaughterhouse, with all its rumoured associations of covert sacrifice.

The very church that Gislebertus decorated was founded upon a story streaked with anti-Semitism: it is the cult-place of St Lazarus 'friend of Christ' (*amicus Christi*), who, after being raised from the tomb by Christ, was subsequently driven out of Bethany by the Jews, and set adrift in a leaky boat to perish at sea. But Lazarus made it away – across the Mediterranean, some say with his sisters, Mary Magdalene and Martha – to become the first bishop of Marseilles in the south of France.

32 THE DAMNED
Gislebertus, *c*.1130

Detail of the carved limestone portal at Autun (Burgundy). Chartres, Rheims and Bamberg are among the other medieval cathedrals whose frontal tympana, or 'drums', were decorated with scenes of the Last Judgement.

More of Lazarus presently. We are bound now to stay awhile with the sight and fury of heavenly vengeance – in the spectacle of Judgement Day.

Dante and the Damned

Witness the dilemma of the mild at heart, when they are dismissed in the teeth of divine severity. This is how that dilemma is couched in the Apocalypse of St Paul (a text stitched together several centuries after St Paul's death, therefore deemed as 'apocryphal'):

> I sighed and wept and said: Woe to men! woe unto the sinners! to what end were they born? And the angel answered and said unto me: Wherefore weepest thou? Art thou more merciful than the Lord God which is blessed forever, who hath established the judgement and left every man of his own will to choose good or evil and to do as it pleaseth him?

The apostle has been given a vision of Paradise. Now he is touring the denizens of Hell, being escorted round the pits of eternal torment. He has set eyes upon the punishments meted out to transgressors (those from within the church are singled out for mention: dishonest deacons, proud bishops, lascivious priests and so on), and the punishments are severe enough (razors, firebrands and such like). At length Paul cries out with dismay, and so earns the reproof of his angel-guide: 'Wherefore weepest thou?'

What is there to lament, once final judgement has been passed?

The Damned are the absolutely damned. They may stuff their fists in their mouths, twist, crouch, put hands over ears and eyes, squirm and protest for all they are worth. But they have been weighed in the balance (a task of assessment usually allocated to the archangel Michael). They are, as it happens, worth nothing; nor – however dire the torments that beset them – do they deserve any pity.

Within the formal iconographic programmes of Byzantine representations of the 'Last Judgement' or 'Day of Reckoning' – most conspicuously laid out in the twelfth- and thirteenth-century mosaics in the cathedral on Torcello, in the Venetian lagoon – it was established that the Damned do not go gently to their fate. Their apprehension of imminent horror is made palpable and panicky. Eager blue-black beaky demons will hustle the process, clawing or shovelling their victims towards flames, or some mouthy tunnel: images of swallowing and regurgitation often prevail. Reprieve, clemency, court of appeal: unthinkable; inapplicable.

It has been suggested that the Christian 'formation of Hell' came about during the years of persecution as a prophetic yearn for revenge; that the early Christian martyrs threatened ultimate justice for their Roman enemies in the form of a cosmic crowd spectacle, and mass-consignments to flames. But some medieval Christians, pondering a Saviour distinguished by His infinite compassion, must have struggled to make sense of this Day of Wrath. At least that is the impression left by Dante's poetic vision of the event.

Dante – composing his *Divine Comedy* around the year 1300 – described a triple destination for humankind at death. Paradise was bliss, of course: the abode of saints and sinlessness; resplendent, cradling its blessed souls as if within a great

celestial smile. Below Paradise lay Purgatory. Purgatory literally means 'a place of cleansing': in fact, prior to Dante, no theologian, let alone any artist, had seriously attempted to visualize how this purification process worked. Such a stage was recognized as logically essential to Christian eschatology; otherwise any lifelong miscreant could delay repentance till his death-bed and gain direct access to virtue's eternal reward. Dante made Purgatory a great fortified city upon a mountain, terraced seven-fold by the Deadly Sins of pride, envy, wrath, sloth, avarice, gluttony and lust. Here wend upwards – if they can – all those dirtied and disfigured by mortal errors (*peccata*). They labour to escape this ridged bedrock: but with effort, time goes into reverse, and the souls in Purgatory recover their original purity – the purity of humankind fashioned in and by divinity for the Garden of Eden.

Purgatory may be glossed – accusingly or not – as a form of buffer zone or intersection; a state of 'blessedness within pain'. No such blessedness subsists in the third destination of Dante's scheme, which is Hell or *Inferno*.

Dante's guide to Hell is Vergil, who had mapped its Classical topography for his Roman hero Aeneas (in Book 6 of the *Aeneid*), and delineated the standing rules of this Underworld or 'Hades'. Exceptionally – as in the myth of Orpheus, woven into Vergil's *Georgics* – a case may be made for some reconciliation between the living and the dead. But the Classical Hades is not a site of arbitrage or bargaining. Those who are there are where they belong – with no prospect of release.

Dante loved Vergil, but he loved St Francis too, as a source of apostolic radiance and refreshment. So how should he apply Franciscan tenderness, wandering among the Damned? From the first canto describing his visit to Hell we register the poet's implicit crisis, as he draws (perhaps subconsciously) upon liturgical language to express his dismay at the place: hence his first self-pitying cry to Vergil, '*Miserere di me*'. The twinned bards share a single cause of grief: it is excess of insight. Canto IV has Vergil drained to pallor by not fear but *pietà*; at the close of Canto V, Dante has fainted with the onset of that pity's irresistible strength.

There it is occasioned by the discovery of a sin too harshly served. Paolo and Francesca – a pair of illicit sweethearts, but free of all harmful intent. Their crime – a tremulous kiss over a book of courtly love. This was venial, surely, as the errors of lust are enrolled; and anyway paid for with their lives. Why must they stay here?

As the radial circles of damnation deepen inward, Dante finds new tears: in himself and others. Canto XX brings this weeping to a climax. We are with those guilty of sorcery now – those made awry as they would make awry. As Dante focuses upon their individual forms, he sees that they are palsied or distorted somehow backwards. They have no forward aspect: if they cry (as they do), their tears drop to the clefts of their backsides. '*Certo io piangea*': 'of course I wept,' says Dante – what else could anyone do, when faced with such stress and ruin of the human species (*la nostra imagine*)?

But Vergil chides his companion at this point. And it is the same impatient reproof that the angel gives St Paul. Whoever grieves here is a fool (*sciocco*). These are wretched sights, but they are the finished articles of God's judgement: so what is sorrow but impiety? The phrase given by Dante to Vergil's suspension of grief is Scholastically acute: '*Qui vive la pietà quand'è ben morta.*' 'Here pity lives when pity is

well dead.' It is a play on word-sense. Allowing *pietà* to equivocate between 'pity' and 'piety', the truly 'pious' person must quench all lamps of loving-kindness here.

These sufferers reap what they have sown. *Basta!*

That ultimatum happens in a tranche of Hell's eighth circle. Among those consigned to the previous ring is a banker from Padua. His damning sin was usury: as described in Canto XVII, he squats amid a huddle of other purse-burdened moneylenders of Padua and Florence. He is identifiable by what he says as Rinaldo (or Reginaldo) Scrovegni – known to have amassed a great fortune, notoriously incarcerated on the charge of usury, and father of the Enrico Scrovegni who around 1303 commissioned Giotto to paint (and perhaps also design) the family shrine we know as the Arena Chapel at Padua.

We have noted in passing that Giotto, like Dante, implicitly gave his support to the idealized gentility of St Francis (see 27). But here, like Dante, the painter projects a Christian cosmology that concludes in resolved unforgivingness. Albeit that Dante had shut Rinaldo in a pit of Hell, Enrico Scrovegni may have intended the commission as an act of retrospective penitence; for these frescoes make no cover-up of the tainted source of their patron's family wealth. Patristic writers had condemned usurers as parasites, and medieval churchmen periodically denounced 'money made by money' as a sluggard's device, incriminated by greed.

33 THE DAMNED
Giotto, 1303–06

Detail of fresco inside the entrance to the Arena Chapel, Padua. Giotto's Hell, like Dante's, is a place of no return. 'Abandon all hope all you who enter here' (*Inferno*, Canto III.9).

There are distinct signs of such disapproval in the Arena Chapel scheme. Giotto memorably showed the treacherous Kiss of Judas, and Judas collecting his pieces of silver, as if to condemn generically the Scrovegni's avaricious former occupation. The north and south walls may reassure worshippers with a programme of scenes fairly described as 'Giotto's great poem of the Redemption'. But the parting message, on the west wall, presents a grand *caveat*.

Here gather 'the Elect', including Enrico Scrovegni himself, bearing a model of the Arena Chapel as if it were 'Exhibit A' in his case for entry to Paradise. But the viewer's attention naturally settles lower down – and upon the beastwise consumption of the Damned (33). Not only are they devoured by the horned monster who is Satan; we see them excreted too. Those not processed in this way are stung and molested otherwise. The moneylenders are there: simply throttled by means of their own purse-strings.

St Francis had preached: if a thief takes your hat, run after him – and hand over your coat, too. 'Christlike' this may have been: Christ was the teacher who had time for whores and thieves. And the French poet François Villon, composing his poignantly jaunty *Ballade des Pendus* ('Song of the Hanged-Ones') in the mid-fifteenth century, appealed for public commiseration with criminals who had been condemned to the gibbet. '*Frères humains qui après nous vivez . . .*' 'Fellow humans who live after us . . . we cannot all be perfect . . . show mercy and gain God's mercy for yourselves . . .'

But these were sentiments with which the penal codes of medieval Europe did not concur. Dante's thieves are found in nether Hell, with their hands tied behind them and darting serpents all around. And when, at the beginning of the sixteenth century, Lucas Cranach 'illustrated' one of the thieves strung up on Calvary with Christ Crucified (34), he could refer directly to a protocol of judicial vengeance known as 'the Wheel' – whereby it was not enough, it seems, to apply straight capital punishment to certain malefactors; they must have a cartwheel dashed down upon their bodies, shattering their bones.

Cranach's thief has been fractured at the base of the spine. Nailed by the feet, garrotted at the neck, he is, in Dante's language, '*travolto*', 'upside-down' – an effrontery, in his punishment, to the image of mankind.

Decensus ad Infernos

Down, down they go. In an altarpiece once intended for representatives of the Medici banking house in Bruges, Hans Memling made a scrambling chute of the Damned, pitched into freefall by slimy batwinged

34 'THE BAD THIEF'
Lucas Cranach the Elder,
*c.*1510–12

Detail of *Calvary* woodcut.
By the frenzied face of the victim
we are intended to know that
he remains (somehow) alive.

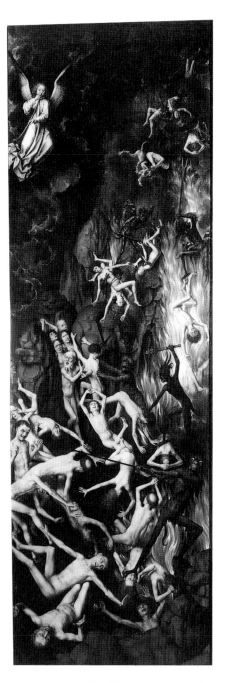

35 THE DAMNED

Detail and left-hand panel of a triptych attributed to Hans Memling, 1467–71.

We see here those who have fared badly when weighed in the scales of the angelic St Michael. (On the other side, the blessed ones ascend to the lofty portals of New Jerusalem.)

demons (35). 'Abandon all hope' was Dante's motto for this 'Descent to the Depths'. But our picture of the Christ-who-avenges is incomplete if we do not acknowledge His own foray into Satan's domain: the apocryphal, yet canonical, Passion episode known as the 'Harrowing of Hell'. Christ descends: He gate-crashes the keep of eternal imprisonment, and releases all those who should not be there.

It is a statement in the Apostles' Creed; it is a story written down between the first and fifth centuries as the 'Gospel of Nicodemus' or 'Acts of Pilate' – so, by any

account, the story of Christ's rout of Hell belongs to the early Christian concept of *Christus Triumphans*, the Lord of Glory who (in the words of Psalm 68) 'makes captivity captive', and deploys the Cross as an offensive weapon. In some medieval imaginings of the episode – which was chronologically situated as the preamble to Christ's Resurrection – the Cross is indeed wielded to clobber sprites or prise open the maws of the Leviathan who swallows the dead.

The Apostle's Creed only states the belief that Jesus Christ 'descended to the dead': since there is no specification of what happened during this descent, medieval painters might be content to show Christ breaching Hell's threshold with no more than a flying pennant. Such is the rescue-mission depicted in one cell of the convent of San Marco at Florence by Fra Angelico and his studio, *c*.1438–50. San Marco was a Dominican foundation, and Fra Angelico ('Brother Angelic') a Dominican painter. Here we might note the punned reputation of that order as *Domini canes*, 'the hounds of the Lord'. Known as the Black Friars (though their robes are actually white, only hood and mantle black), and founded by St Dominic (1170–1221) around the same time as the Franciscans, the Dominicans may broadly be regarded as the representatives of Christ-who-avenges. At worst they served as the predators of heresy for the Papal Inquisition; at best their intellectual captain St Thomas Aquinas (1225–74) gave his mind to thinking through precisely what it meant – for state, church or individual – to exercise 'the power of the sword'.

(So – for example – Claus von Stauffenberg invoked the authority of Aquinas to justify his attempted assassination of Hitler in July 1944.)

Devotio moderna

For Dante, the piety of St Francis rendered Assisi an Orient; the dawn-rise of worldly warmth. Or, perhaps, better call it a well-spring: since so much of Franciscan expression was invested in 'the gift of tears'. The attributed sayings or *Fioretti* ('Little Flowers') of St Francis conceive of tears as freshet-streams 'whereby the inner eye is cleansed, that it may avail to see God'.

From the Low Countries came a lugubrious echo: 'Devotion is a certain tenderness of heart, whereby an individual may readily dissolve into tears.'

Along the River Yssel, among peat-fields and meadowland north of Deventer, a peculiar cult of self-purification and ascetic evangelism flourished in the fourteenth and fifteenth centuries: the 'Brothers and Sisters of the Common Life'. A variety of Augustinian monasticism that turned to the world with evangelical energy, it was not destined to last beyond the Middle Ages: its urge for reform was eclipsed by Luther's Reformation, and its principal mode of industry – the copying of manuscripts – was ruined by the arrival of printing. But the movement's mission, to encourage the laity to practise daily meditations on Christ's Passion, was successful beyond its span and sectarian confines.

The lead came from two Dutchmen, Geert Grote (or Groot) and Florentius Radewijns. Geert Grote (1340–84) is usually referred to as a 'mystic', but that should not evoke some head-in-the-clouds detachment on his part. He produced a vernacular 'Book of Hours' – prayers and meditations by the clock – which brought the routine of monastic dedication into the lives of burghers throughout

the Low Countries. He pressed for clarity and purity in ecclesiastical and monastic practice, and attracted a following. At Windesheim near Zwolle a convent was founded by Grote's followers, committed to his standards of 'modern' or 'renewed' devotion; and from one of the many locally spawned establishments of 'the Windesheim Congregation', Thomas à Kempis, the best-known spokesman of *devotio moderna*, issued (c.1441) the series of tracts collected as *The Imitation of Christ*.

'I teach without noise of words, without confusion of opinions; without pride of emulation, without fence of logic.' Mindful, perhaps, that the output of St Thomas Aquinas totalled some eight and half million words, Thomas à Kempis consciously writes as someone who would rather *feel* contrition than know how to define it; his work is salted with anti-Scholasticism, which helps to explain the subsequent favour found by *The Imitation of Christ* in the Puritanical tradition. Puritans, too, approved the tone of this book: the exhortations of à Kempis are based on a fundamentally miserable outlook ('How can it even be called a life, that begets so many deaths and plagues?'); and he is unsparing in his message ('Unless thou use violence with thyself, thou shalt never get the victory over vice.'). Most importantly for us, however, *The Imitation of Christ* exhorts its readers to behold and see the object of their remembrance. This imitation was not proposed as a part-time activity, to be resumed and put aside at certain hours of the day. It should be consistent and continuous: an image to which the devotee's gaze was unswervingly fixed.

Naturally enough artists assisted with the fixing. Typical of their appeals for concentrated attention is a small panel by a Dutch painter based at Haarlem, Geertgen tot Sint Jans or 'Little Gerard of St John' (36). It is a highly conceptual image: the illusion of 'being present' is less important than the revelation of extremely affected response. There is not a dry eye around, as the bloodied Christ manifests his state to the viewer, with the Virgin and Mary Magdalene red-eyed in regret, and St John copiously moping nearby. Three angels in the background are also demonstratively unhappy, but they are busy all the same. They are collecting those items which were known as the *arma Christi*, 'Christ's weaponry' – an almost heraldic ensemble of whips and scourges, along with the lance and the sponge-on-a-stick. Almost heraldic, but not entirely symbolic. The *arma Christi* included the do-it-yourself tools of self-flagellation.

In 1520–21 the German master Albrecht Dürer made a tour of the Low Countries. It is a journey made remarkable by the survival of the artist's diary-record, though that turns out to be a predominantly mundane document. There are some notes on the beauty of Bergen op Zoom, but mostly Dürer was preoccupied with a balance-sheet of daily

36 MAN OF SORROWS
Geertgen tot Sint Jans, second half of fifteenth century

Detail of a painted panel. 'O Father in Eternity,' says a Dutch devotional handbook of the period, '... is this really Your Child, so sorely wounded, so mutilated...?'

transactions. The painter does not come across as a particularly ascetic character: he is appreciative of the numerous 'costly feasts' offered in his honour, he evidently likes drinking and gambling, and he keeps a precise log of gifts – 'a small green parrot', for example – made to himself and his wife. Nonetheless, the spirit of 'modern devotion' seems to have been infectious, or at least was congenial to Dürer's own cultivation of *Homo melancholicus* – 'melancholic man', man born under planet Saturn's gloomy humour. In 1522 he made a portrait of himself as the 'Man of Sorrows' (37). He has not gone so far as to indicate the scar on his left side where the lance pierced – as some connoisseurs have observed on an earlier self-portrait, in Weimar, of the artist in naked and stricken state – but there are the twigs and the flail, the signal means of self-inflicted pain. Stripped, distraught and verging upon tears, Dürer shows himself close to the ideals of *devotio moderna*.

37 SELF-PORTRAIT AS 'MAN OF SORROWS'
Albrecht Dürer, 1522

Dürer's support for the cause of 'Reformation' within the Christian church evidently did not preclude his attachment to such conspicuous ritual pieties as self-flagellation.

'Gastly Gladnesse'

So to the English and their Britannic neighbour-tribes: befogged, lumpen, porridge-chewing. What had they to do with these tears of devotion, those for whom the term 'phlegmatic' has sometimes served as an ethnic characteristic of 'the island race'?

The answer is that these Northerners too were stirred, in their fashion.

Spectacularly so: as in the case of Margery Kempe from Lynn (now King's Lynn) in East Anglia. Daughter of a merchant and local politician, she could count herself as 'well-born'. By the age of forty, however, she was bent upon a course of penitence whose outward expressions would earn her barracking, assault and arraignment – not to mention widespread clerical hatred and disdain. Her speciality was sobbing: bouts of which could last for hours, even days. Accounts of Margery state that she gained 'the gift of tears' during her pilgrimage to the Holy Land in 1413, but in her own transcribed recollections – *The Book of Margery Kempe*, whose full manuscript surfaced in 1934 – it is clear that her tendency to wail was already irritating fellow-passengers on the outward stage of pilgrimage, indeed on the boat departing Yarmouth.

Margery's favourite adjective to describe her sobbing is 'boisterous'; it is perhaps no wonder that preachers often objected to her presence in their congregations. But for us to interpret Margery's demonstrations as 'hysteria' would be untrue to her own 'shafts of recollection'. She wept primarily from 'compunction' – the 'pricking' of conscience as a physiological state brought on by the very thought (or image) of Christ injured. When Margery uses the word 'boisterous' of a nail at the Crucifixion we may comprehend the quick ecstasy of purgative association intended here. Prodigal weeping, punctuated by shrieks ('It slayeth me';

'I die, I die'), soon earned Margery the forgiveness she sought. Thereafter her capacity for sobbing was like a pouch or treasury, which she would willingly open for the benefit of redeeming those around her.

'Gastly gladnesse' expresses it well. The phrase was coined by Margery's near-contemporary, the hermit Richard Rolle, who died in some rustic hutch *c*.1349, but left behind the literary remains of extravagant cordial response to the Passion: 'If I had not steadily taken the Blood of my Saviour as my end, and meditated His bitter death deep in my mind . . . I would suddenly have fallen into sin.' Rolle's grat-

38 CRUCIFIXION
Single-leaf illumination, ink on paper, fourteenth century.

Bright scarlet is used all over the body of Christ – with two tiny dabs of the same colour saved for the lips of the devotees at the foot of the Cross.

itude for the plenteous pains of Christ excites him to one conceit after another. As heaven was full of stars, so was the Saviour's body full of wounds; or say that body is like unto a net, as full of wounds as a net is full of holes; or like a dovecot, or a honeycomb. Or think of it as any scribe should: 'Thy body is like a book written all with red ink; so is thy body all written with red wounds.'

Across in the Rhineland, it is as if a fourteenth-century German artist were following the lyrical meditations of Richard Rolle when she lavished paint upon a simple image of a nun (perhaps herself) with St Bernard at the foot of the Cross (38). This is untutored, 'boisterous' work. Its brushstrokes are loaded with the 'gastly gladnesse' of the Anglo-Saxon sort.

Lazaretti

Corpus Christi, 'the body of Christ': scrawled all over with wounds. Across medieval Europe there was a culture of vivid focus and vicarious feeling towards that exemplary mortal battleground. But how far 'exemplary'? That is: to what extent was sympathy with the suffering of Christ transferable to anyone else blighted with pain?

We have observed that the Black Death caused certain measures of public health to be instituted (our word 'quarantine' derives from the *quarantina* or 40-day isolation procedure effected by some northern Italian cities at the time of plague visitations). The Black Death, too, was prompt to the clarion call that was the first sentence of Boccaccio's *Decameron*: 'it is a human thing to have compassion for those afflicted' ('*Umana cosa è aver compassione agli afflitti . . .*'). But, in reality, there is sparse evidence of useful or immediate concern. Medieval medical practice, still centuries before 'the birth of the clinic', was dominated by the resort to segregation, rather than cure, of the sick. Hence *Lazaretti* – 'Lazarus-houses' – where the seriously ill or diseased could be set aside as pariahs.

There are two distinct figures of Lazarus in the New Testament: the Lazarus raised from the dead at Bethany (John 11.1–45), and Lazarus the scab-embroidered beggar who scratches for crumbs at the gate of wealthy Dives – in a parable

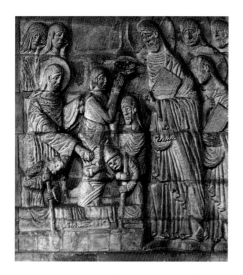

which consigns the rich man to Hell and has the beggar brought Heavenwards 'to the bosom of Abraham' (Luke 16. 19–31). In medieval imagery the two figures seem often to be conflated; at any rate, this compound-Lazarus marks a rare allowance of sympathy for the 'afflicted' in these times. An anonymous twelfth-century relief in Chichester cathedral shows the moment when Lazarus is bidden to rise from the grave (in which he has lain, as deceased, for several days), and it is an entirely plangent scene (39).

39 THE RAISING OF LAZARUS

Relief sculpture panel from Chichester Cathedral, second quarter of twelfth century.

A companion piece shows Christ's arrival at Bethany.

Christ, on a colossal scale, makes the gesture of benediction with his brow aslant in care; the sisters Mary and Martha look upon the miracle with hands held up to desperately creased faces. It may be significant that in the Franciscan telling of this story (in the *Meditations on the Life of Christ*, on which more presently), the principal concern is not the amazing resurrection of Lazarus, but the bravery of Jesus in approaching a corpse supposed to be in some state of decomposition; indeed the sisters of Lazarus actively try to keep the lid on his tomb. 'O God,' runs the text, 'see the wonderful love of these sisters for the Lord Jesus, for they did not wish the stench to reach his nostrils.'

So we have it. Further reason to venerate Christ, for doing what 'normal' mortals shunned: stepping amid putrefaction and disease. At Autun, in Burgundy, the precincts of the cathedral of St Lazarus were opened once a year (on the first day of September) to pilgrims who were lepers. Imprecation to St Lazarus was their only hope of relief. No measures were otherwise taken against leprosy: except to shut it away.

Mater Dolorosa

'The Sorrowing Mother'. She originates, it seems, from a disgusting character.

He was not diseased (though many thought him mad). Self-defilement was his speciality. Jacopone da Todi (1230–1306) was conspicuous among the immediate followers of St Francis for the neglect he showed to his body. Not washing, neither changing his clothes; subsisting on food deliberately left to go rotten; making the 'intimate companionship of vermin'. We may be glad, as one donnish aside goes, to be standing seven hundred years downwind of him. And yet this same repellent Jacopone bequeathed a corpus of sacred lyrics distinguished by their sweet delicacy of phrase and sentiment; lyrics which may swim through our consciousness even if we think we do not know them.

> *Stabat Mater dolorosa*
> *Iuxta crucem lacrimosa*
> *Dum pendebat filius*

> Sorrowing mother stood there
> Tearful by the Cross
> While son dangled . . .

Jacopone's *Stabat Mater* may be regarded as a sustained variant of 'Hail Mary', and more effectively trilled than studied: but its words repay some analysis. Stark translation cannot convey the primary force of the Latin, which lies in its choice of verb-tense – the imperfect or 'unfinished'. *Stabat*: Mother Mary stood by the Cross, and she still stands there; where Jesus was suspended – and remains suspended (*pendebat*).

It is an image designed to persist, then. As such, it becomes an invitation to share in Mary's grief:

> *Fac me vere tecum flere,*
> *Crucifixo condolere,*
> *Donec ego vixero*

> Let me truly weep with you
> To lament the Crucifixion
> As long as I shall live

Jacopone's hymn was soon lodged in the canons of Franciscan worship. His vision was by no means eccentric: in the twelfth century, drawing upon the sensuous imagery of Solomon's *Song of Songs*, St Bernard of Clairvaux had already created an intimate, pseudo-erotic literature of Mary as Mother of God and 'Bride' of Christ (the tradition whereby Mary appeared young and lovely and scarcely any older than her son has its origins in the early Church). And while bishops might periodically curb excessive impulses of 'Mariolatry', the cult of Mary-in-lamentation burgeoned beyond strictly ecclesiastical control. The *Planctus Mariae*, 'Mary's Mourning', became an expected set-piece of popular theatre in medieval Europe. Intellectual hermits such as the Swiss Dominican Heinrich Suso (c.1295–1366) crooned to Mary as *Schmerzenmutter*, 'Sorrows-mother', but there was nothing rare or recondite about the presentation of dolorous Mary in the English genre of so-called 'Mystery Plays'. These knockabout, straight-talking dramas rather demystify. A typical outburst from the 'Corpus Christi' cycle of such Mystery Plays makes Mary protest on behalf of every indignant (to the point of incoherence) mother robbed of her offspring:

> There never was mother that saw this,
> So her son despoiled with so great woe.
> And my dear child never did amiss!

Only a twentieth-century Surrealist (Max Ernst) would be so delinquent as to show Mary spanking her infant son. Medieval image-makers accepted the histrionics of Mary's role as *Mater dolorosa* without demur. Several Flemish painters, notably Jan van Eyck (*c*.1395–1441), were so given (or so often commissioned) to depicting the Madonna that they may be called 'Marian' specialists; of those who showed Mary's grievous collapse at the foot of the Cross, Rogier van der Weyden (*c*.1399–1464) seems most extravagant in costume and gesture. Immaculately robed, his Mary will fall backwards in a faint, or fling herself to clutch at the Cross; either way, she leaks resinous, globular tears (40).

By the sixteenth century – when Michelangelo attempted several sculptural groups of mourning over the lifeless Christ – the formal image of a *Pietà* would be charged with eroticism; or, at least, suggest the logic (as phrased by Julia Kristeva) that the sorrowful Virgin 'knows no masculine body save that of her dead son'. Medieval texts and tableaux specified a context for the scene: Joseph of Arimathaea brings Jesus down by a ladder, and lays the body on Mary's lap; further participants in the 'Deposition' stand aside. A German limewood group made at the turn of the thirteenth to fourteenth centuries may reflect the expressive requirements of this moment as staged in popular Passion plays whose audience was 'Everyman' (41).

Christ lies awkward there, like a knotty mannikin. His mother's face is pulled, appalled; her mouth squared in the wake of the intolerable.

Mary has been characterized as 'alone of all her sex': but in the medieval fostering of Mary's image as *Mater dolorosa* there is a strong sense that if Christian faith is anchored by the capacity to empathize with the suffering of Christ, then women are – as a gender – better disposed, or more naturally disposed, to show that faith. For Plato it had been axiomatic that women were more tender-hearted than men; in ancient Greek burial practice the funerary lament, or threnody, was accepted as a quintessentially female rite. Medieval physiology, based upon Aristotle, tended not to revise this gender-stereotype.

'Whenever I saw the Passion of Christ depicted I could scarcely contain myself, and fever seized on me, and I

40 DETAIL OF THE VIRGIN SUPPORTED BY ST JOHN
Rogier van der Weyden, *c*.1450–55

St John was the only apostle to witness the Crucifixion, and the only eye-witness among the Gospel writers: it is a command from Jesus on the Cross (John 19.27) that specifically entreats the disciple to take care of Mary.

41 'THE ROETTGEN PIETÀ'
Middle Rhenish wooden sculpture, *c*.1300.

According to Gospel, Mary the Mother of Jesus must feel the rejection of her son particularly – like 'a sword piercing her soul' (Luke 2.35); but the cult of the Virgin Mary largely relies upon devotional literature much later than the New Testament.

became weak.' Angela of Foligno, who died in 1309 (subsequently beatified), may record her 'weakness', yet with proper pride. A sister-Italian visionary, the Blessed Umiliana Cerchi, was not satisfied with her ordinary 'feminine' tide of tears before the image of Christ: she rubbed her eyes with quicklime that she might increase the flow. In doing so, she near utterly ruined her powers of sight.

Which would have been deeply disastrous. In this pious ambience, abstract 'contemplation' of the Passion was not adequate. Vision – visualization – to the state of burly empathy that caused a falling to the ground, was craved above all. So artists were encouraged to 'think through' or picture the Passion with especial care: down to the smallest detail.

Minutiae: the *Meditationes Vitae Christi*

We have encountered this text already, and will do so again: it is a key that unlocks much of medieval iconography.

According to the *Meditationes*, the moment of Mary's collapse is precisely when Longinus thrusts his lance into the side of her son.

Which would be between the sixth and ninth hours of the Crucifixion.

That is, upon a Cross measuring fifteen feet in height.

A Cross rising on the hill of Calvary – which stood as far distant from Jerusalem's walls as such-and-such a convent stands from the gate of such-and-such a city (specific measurements were inserted as appropriate to local readership). For the precise purposes of the *Meditationes*, the vagueness of the phrase, '*a green hill far away*', will not do.

We may register here the following aspect of medieval Christian devotion. 'Gospel truth' was not enough. It required this topping-up of verisimilitude and itemization. The *Meditations on the Life of Christ* were once ascribed to St Bonaventure, then to a more shadowy 'Pseudo-Bonaventure', and now to some anonymous 'Franciscan monk living in Tuscany during the second half of the thirteenth century'. At any rate a Franciscan project. What is significant is the 'grounding' of the flights of inspiration in details and minutiae. Not a piety of pettiness: just a location of the extraordinary amid familiar surroundings; or (as Evelyn Underhill says of Jacopone's poetry), a turning to the world without capitulating to it. This is true, too, of medieval 'mysticism'.

Mystics

A proposition: that Christianity is founded upon the loss of a body.

As voiced by Mary Magdalene in John's Gospel (20.13): 'They have taken away the body of my Lord and I do not know where they have put Him.'

An absence; a loss; something hidden.

If this is what 'mystical' means – the search for what is concealed – then it may seem to us a game: the higher Hide-and-Seek. But that is to misconstrue the search operation as conducted and communicated in the Middle Ages. Its yield may come as searing clarity.

Medieval mysticism was not a female prerogative, but in the steps of Mary Magdalene we meet, among others, the Abbess Hildegarde of Bingen (1098–1179),

St Catherine of Siena (died 1380), and St Birgitta of Sweden (1303–73); and – perhaps most approachable of all – Dame Julian of Norwich (c.1343–c.1416).

Historically there has been – largely on the part of post-medieval male clerics – an inclination to dismiss the writings of these women ('senseless tittle-tattle'; 'hysterical gossip'). There remains a suspicion, generally, that mysticism – within any religious tradition – creates a mind-body divide, as the soul makes astral moves. But to study the revelations ('Showings') of Dame Julian is not to be confronted with quaint dualism. She has visions, and relates them with the immediacy of a photographic close-up; she knows they are visions (otherwise, she admits, she should find her bed awash with the blood from the wounds of Christ); yet these visions impart a faith directly applicable in the world ('I saw that each kind compassion that man hath on his even-Christians with charity, it is Christ in him').

So this is not a closeted, escapist practice; nor is Dame Julian's record of active piety reflected if we take her title as 'anchoress' to mean estrangement from both world and flesh. But how were the enthusiasms of Dame Julian and others to be pictured?

On the predella, or base, of an altarpiece painted c.1393, a minor Italian painter took up the challenge, and tried to show St Catherine of Siena in a sequence attesting the passive dynamism of mystical prayer (42). If it works at all, the piece works centrifugally: the outer episodes depict the saint absorbed in an initial state of contemplation, unassisted by images; then we see Catherine's excitement when beholding a statuette of Christ Crucified upon an altar. The statuette is also excited, and leaps into the air, impressing Catherine with the stigmata.

These were the crude external signs of the mystic 'moment'.

Ecstasy; joyance; transports of delight. St Francis is not classified among the medieval mystics, but his language of adoration resonates through the confessionals of Dame Julian and the others. Francis himself swayed to the beat of Provençal troubadours, and he shamelessly adopted their language of courtly love to express his mingled sensation of suffering and bliss.

> *Tanto è quel bene ch'io aspetto*
> *Che ogni pena m'è diletto.*
>
> Such is the happiness to come
> Every pain is glad to me now.

Understandably, this posed a conundrum of representation beyond graphic resources at the time; arguably it was only solved later by the 'Baroque' sculptures

42 ST CATHERINE OF SIENA PRAYING
Andrea di Bartolo, *c.*1393

Predella to an altarpiece. The focus here is what happens in the central vignette, where the crucifix contemplated by St Catherine leaps aloft and beams down a set of stigmata.

of Bernini (and even then, it was open to misinterpretation: see p. 130). Still, we should keep to this acceptance of the medieval mystic ideal, as one modern scholar has summarized it. 'In such piety, body is not so much a hindrance to the soul's ascent as the opportunity for it. Body is the instrument upon which the mystic rings the changes of pain and delight.'

'Perpetual Passion'

Margery Kempe once burst into her 'boisterous' tears before an image of the dead Christ in the arms of the Madonna. A priest rebuked her for this blubbing. 'Damsel,' he said, 'Jesus has been dead long since.' Margery cried on. 'Sir,' she gasped, when the weeping died away, 'His death is as fresh to me as if He had died this same day, and so, methinketh, it ought to be to you and to all Christian people.'

The Passion of Christ has a chronology. It may even claim an archaeology of material remains. But there is no understanding of its representation in medieval and later art unless we make ourselves privy to the doctrine of 'Perpetual Passion': the idea that the sins and shortcomings of humankind were continuously demanding atonement by the 'satisfaction' (as the eleventh-century St Anselm of Canterbury called it) of Christ's suffering and death. This idea was first articulated by Origen, one of the 'Church fathers', in the third century. It became diffused in popular understanding throughout the Middle Ages in Europe.

Obviously, the doctrine tinctures our understanding of Passion-depictions. When any artist makes a claim – on behalf of self or patron or local community – to 'relocate' the Passion, or make it 'contemporary', by creating a backdrop of particular new surroundings, and adding not only prevalent whims of costume and armament, but also distinctive features of portraiture and caricature, we must refrain from viewing such treatment as 'anachronistic'. If it were categorized as an 'event without time', then the Christian Passion would be the stuff of myth. But 'Perpetual Passion' is not timeless; rather, never-ending.

In other words, Christ suffers till the end of time. This, as historians would perceive, was a timely notion for the late Middle Ages. To consider the state of Christendom by 1500 is to see how any faith in Christ's self-sacrifice as a once-and-for-all act of grace was hardly tenable. Plague we have surveyed. Schism we have not, but the division of rival Popes – one in Rome, the other fortressed at Avignon in the Rhône valley – lasting several decades during the fourteenth and early fifteenth centuries, can fairly be regarded as collectively 'traumatic'. Muslim Turks put an end to a thousand years of Eastern Christianity when they seized control of Constantinople in 1453; during the second half of the fifteenth century they advanced to take Greece and the Balkans. As if this were not enough, a new disease appeared, even more plausibly punitive than the Black Death: this was syphilis, the 'great pox' which made 'smallpox' look small. Whether or not it returned from the Americas with Columbus after his expedition of 1492, Europe's first experience of widespread sexually-transmitted disease could readily be counted as the wages of sin.

In short, it seemed that by the mid-point of His second millennium Christ Crucified had much remaining to redeem. 'Revivalists' throughout the Middle Ages had urged the cultivation of vivid empathy before images of the Passion

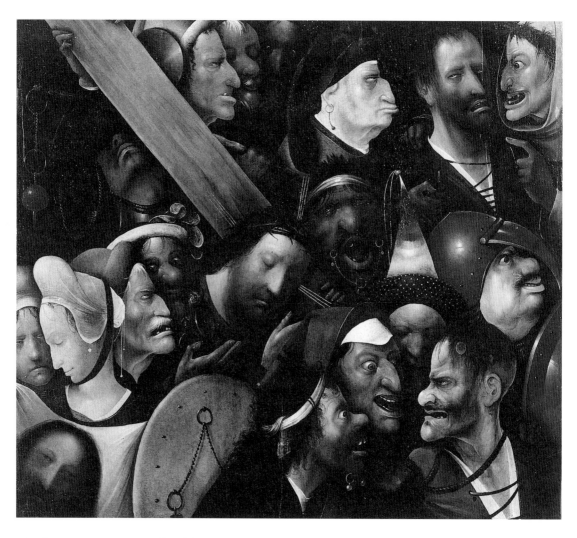

(St Vincent Ferrer, a crowd-pulling Dominican preacher active in Spain and France in the early fifteenth century, regarded loud weeping as an integral part of the celebration of Mass). Revivalist memoranda for the daily achievement of tears ('the wine of angels') not only made good copy for the early printing industry, but also gained fresh pertinence as handbooks of the 'Perpetual Passion'.

One such was the 'Life of Christ' (*Vita Christi*) written by a fourteenth-century Carthusian monk, Ludolph of Saxony. First disseminated in 1474, Ludolph's narrative happily elaborates on the nastiness of those who tormented Christ *en route* to Golgotha. They hawk gobbets of their phlegm and mucus down His throat. They spit on His wounds, turning them septic. They nick His face with hot eggshell. They rub the welts of His flogging with dirt. And so on. These tormentors of Christ are all playground bullies down the ages.

The Dutch painter Hieronymus Bosch squandered none of his talent for the grotesque in their delineation. Grotesque: but who knows how much fantasy Bosch called up when – probably not long before his own death in 1516 – he conjured the 'Cross-Dragging Christ' that now hangs in Ghent (43). Some

43 CHRIST CARRYING THE CROSS (DE KRUISDRAGING)
Hieronymus Bosch, *c.*1515

There is an iconographic tradition to the composition here: depictions of the *Arma Christi* – the 'kit' of Christ's Passion – often included caricatures of the faces of those who abused and reviled Christ en route to Calvary.

scholars suppose that Bosch was here influenced by the blubber-lipped carica-tures done by Leonardo da Vinci. But we may sense the whiff of direct vengeance here, as Bosch apparently packs into his assembly of Christ's aggressors every thug he has ever himself encountered.

The painting shows a crowd in all its greasy, beery force, brim-full of cackle, slander and belch. Central is the snaggle-toothed ogre who howls malice and ignorance. Beyond him, advancing the procession, a preposterously plum-nosed man of arms. In the upper-right corner we see the 'Good Thief' raising the whites of his eyes, wedged as he is between a grinning Franciscan friar and some reptil-ian person of self-importance. In the lower-right corner the 'Bad Thief' snarls back at a trio of grinning detractors. Assistance for the portage of the Cross is minimal: Bosch gives only an oblique view of Simon of Cyrene, gripping the beam as if with tiny claws. But the visage of Christ shows no strain at all. Christ occupies an island of calm, even disregard. He is beyond this mob.

There is one other detached figure. A lady, wearing a head-dress, smiling almost smugly to herself. This is St Veronica, who in the apocryphal elaboration of the Passion narrative came forward with a handkerchief and wiped the sweat from the brow of Christ. Her reward was the 'Veronica' or 'vernicle': an imprint of the Saviour's face upon her veil. See how proudly she holds it up here, like some cult T-shirt. Even she does not escape the artist's censure here. It is as though she has her souvenir; so Veronica turns away. The one face that beseeches us is the mask upon the veil.

Pilgrimage

'If mysticism is an interior pilgrimage, pilgrimage is exteriorized mysticism.'

Many other things too: a farrago of motives, some of which were decidedly subversive, put people on the true arterial routes of medieval Europe; the pilgrim trails which led to shrines, lesser and greater, all over the continent, and beyond. Jerusalem may have been paramount; but the English wayfarer with scarcely six-pence for a Channel crossing could be content to trek to Amiens, and pay a vow to the head – or better say *a* head – of John the Baptist. There was always, in touristic terminology, something 'worth the voyage'. At Vézelay, in Burgundy, the robes of Mary Magdalene; at Walsingham, in Norfolk, a crystal phial containing the Virgin Mary's breast-milk; at Santiago de Compostela, in Spanish Galicia, the bones of the disciple James. Not only hostels but brothels lined the roads toward these shrines: it was in the spirit of proto-Puritanical censure that William Langland, in his *Piers Plowman* (c.1378), urged righteous folk to wend 'no further to Rome nor Rochemadour' (Book 12, 37).

But neither the chicanery of holy relics, nor the sociable fun of adventuring forth, should distract us from the religious justification of pilgrimage. In various world faiths pilgrimage has been practised as a penitential exercise. For Chris-tians it offered (as it does yet) the chance to tread in the vestiges of the *Via Crucis*, 'the Way of the Cross'; ever since Helena, mother of Constantine the Great, estab-lished a reliquary of the 'True Cross' at Jerusalem during her visit there in 326–8.

To go on foot, or even barefoot, itself expressed the desire for making pilgrim-age a slog or ordeal. But as the European pilgrim routes became increasingly

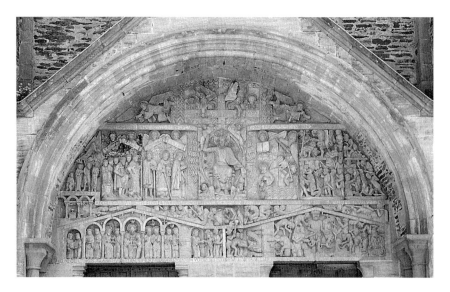

44 THE LAST JUDGEMENT
Tympanum of west front of
Church of Ste Foy, Conques,
c.1124.

Traces of paintwork beneath
the arched hood indicate that
the carvings were once picked
out in a rich and 'picturesque'
polychromy.

thronged (from the eleventh century onwards), it became a part of episcopal duty
to remind those *en route* of the ongoing requirement to seek penance. Individually,
pilgrims might harbour very particular motives for gaining atonement by their
journey: for example, the four English knights who murdered Archbishop
Thomas Becket in Canterbury Cathedral, on 29 December 1170, were bound to go
to Jerusalem in expiation's quest. But the greater multitude of ramblers required
stern and graphic memoranda.

Hence the 'Doom' images carved on portals at the great gathering-stations of
medieval pilgrims – Chartres, Rheims, Bamberg and more. Some we have already
encountered – those of Gislebertus at Autun – and since such scenes are 'normal'
vehicles of the Romanesque style, we may be inclined to shrug at their didactic
effect. The modern visitors who puff to the top of the town of Conques (in the
Aveyron region of southern France) may feel, perhaps, that the carved tympanum
over the west door of the abbey church (44) was cynically commissioned; or at
least done as a matter of routine. But its substance belongs to a genuine impulse
of creed.

Conques lies on one of the approach-ways to Compostela; the church, of
Cluniac foundation, owes its solidity and treasures to some adroit manipulation
of the relics of one Ste Foy ('Faith'), martyred as a girl at nearby Agen in Roman
times. A dossier of miraculous cures associated with the bones of Ste Foy was
compiled in the eleventh century: so it happened that an isolated site in the stony
Rouergue ('rye-land') hills became frequented by those flourishing staff and
scallop-shell (badge of St James at Compostela). Why were they doing it? Not to
get over a personal crisis, find themselves, or feast on the scenery. As they
emerged from the gorges of Aubrac, the Compostela pilgrims were confronted at
Conques by a clamorous sorting of humanity, spelt out in stone. Christ sits in
judicial assurance. To His right, the blessed; to His left, the damned. There are
Seven Deadly Sins: those who commit them, stay to the left.

True, it is done with a flicker of cloister-wit. Beyond a trio composed of the
Virgin, St Peter, and some uncertain saint, the elect blessed ones are led with a

spirit of ebullient confidence by a distinctly chunky abbot; drawing along a nervous king (perhaps great Charlemagne, the first 'Holy Roman Emperor' – between 800 and 814) as if to declare, 'This gentleman is with me'. The damned, opposite, topple into their usual mêlée of cramped, mangled, trussed-up bodies. And on the lintel is lodged a message without ambivalence: addressed to everyone who would be a pilgrim:

O peccatores, transmutetis nisi mores iudicium durum vobis scitote futurum.

'O sinners: unless you change your ways – know that an unyielding judgement stays in store for you.'

Relaxati

A tiny, not insignificant note.
'Relaxati' means 'the relaxed ones'. Softies, shall we say.
The name given to those friars who slept on mattresses.

Transubstantiation

And finally. Or centrally, as it may be. A note on which to finish and summarize; and leave wide open.

Transubstantiation is the mystery and the heart of the Catholic Mass: a teaching of the Church first promulgated at the Fourth Lateran Council in 1215.

Transubstantiation means that during the celebration of the Lord's Supper (45), bread changes its substance and becomes the body of Christ, while wine turns into the blood of Christ. This doctrine implies that appearance, taste and texture are all external 'accidents'. 'The sacrifice of Christ and the sacrifice of the Eucharist are *one single sacrifice*,' states the Catholic Catechism. Every celebration of the Eucharist is therefore a *re-presentation* of Christ's offering of Himself to the Cross.

In due time we shall encounter the objections to such orthodoxy raised by 'Protestantism'. For our present purposes, however, transubstantiation is of truly crucial importance – because it encouraged those 'taking Communion' to meditate upon the physical reality of the body and blood of Christ. Doctrine declared a memorial 'perpetuated until the end of the world', re-presenting and re-presenting over and again a salutary source for the forgiveness of sins daily committed.

Liturgically, a 'Real Presence' is re-presented at the altar. What wonder is it then that images around the altar contrive to re-present by stark 'representation' of the body 'in bloody manner'?

This is the faith that stands behind and beyond the art of medieval Europe. It is what calls forth tears of devotion. It is what cheers those gathered at the feast.

45 THE LAST SUPPER
'The Naumburg-Meister', mid-thirteenth century

Detail of the West choir screen, Naumburg Cathedral (in the region of Germany once known as Thuringia). Verisimilitude of feasting here combines with scriptural allusion: see how Jesus holds his sleeve while handing a sop of dipped bread to Judas Iscariot – to indicate the betrayer (John 13.21–6)

5 VASARI AND THE PANGS OF ST SEBASTIAN

Francesco Bonsignori is not one of the better-known Italian artists to appear in Giorgio Vasari's *Lives of the Painters, Sculptors and Architects* (1550–68). Vasari (calling him Monsignori) includes the painter in a group of minor *virtuosi* from Verona. Bonsignori, Monsignori: he remains little more than a name amid many Renaissance names, working most of his life (1455–1519) in Mantua. But the following story, told of him by Vasari, deserves our attention.

> Monsignori [Bonsignori] painted a picture of St Sebastian which was eventually placed in the Mantuan church of the Madonna delle Grazie. He went to extreme lengths in this project to achieve naturalistic effects, copying many items from life. It is said that his patron the Duke [Gianfrancesco II of the ruling Gonzaga family of Mantua], while visiting the painter in his studio (as was his custom), told Francesco that he should model the saint on some fine figure of a man [*pigliare l'esempio da un bel corpo*]. Replied Francesco: 'I am indeed using such a model – a sturdy porter, whom I specially bind up to get a natural effect.' 'But look at the saint's figure here!' cried the Duke. 'Do his limbs writhe as they should if he were being pinned down? Does he show the sort of panic you would expect in a man bound up and being shot at with arrows? Permit me to demonstrate how you might make the figure more convincing.' Francesco agreed; he would let the Duke know when he next had his model trussed up as St Sebastian.
>
> The next day, when Francesco had his porter tied up, he sent a secret message to the Duke – but with no idea of what the Duke intended to do. The Duke burst in from an adjacent room, furiously waving a loaded crossbow: he rushed towards the porter, yelling 'Traitor! You're dead! I've got you cornered!' and similar threats. The wretched porter, terrified of the imminent attack, manically tried to erupt from the ropes that held him, straining to break them – and in doing so, truly replicated [*rappresentò veramente*] the fear and horror in facial expression, and the sheer physical frenzy, of one about to be mortally pierced with arrows. Then the Duke turned to Francesco. 'There! Now you have him as he should be: I leave the rest to you.' Absorbing the lesson, the painter made his figure as perfect as anyone could imagine.

46 ST SEBASTIAN
Francesco Bonsignori, *c.*1490

A painting hung in the Cappella Zibramonti, Santa Maria delle Grazie, Curtatone (Province of Mantua). Another painting of St Sebastian by Bonsignori, possibly using the same model, was formerly in Berlin (destroyed in May 1945).

'*Fece la sua figura di quella miglior perfezione che si può immaginare*'. Peering into the lodging-place of this perfected image of St Sebastian (a side chapel in the church of Santa Maria delle Grazie at Curtatone, a little way outside Mantua: the sanctuary itself a votive set up by Francesco I Gonzaga in 1399, as thankoffering for the relief of plague at Mantua), we shall struggle to join Vasari in his use of the superlative (46). In the foreground of some rocky Italian niche, a winsome youth strikes the pose of trim saintliness. One arrow is lodged in his thigh, another has

 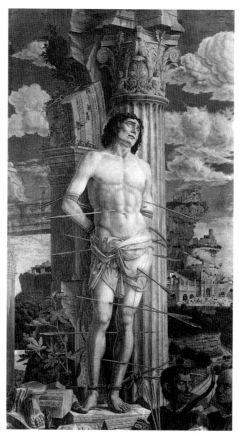

punctured his raised left arm. The bindings are minimal, and there is no sign of frenzy to loose them. The figure seems transfixed. That is not to say it is effete, or lacks the power to transfix a viewer. But in neither this nor in any of Bonsignori's other renditions of St Sebastian do we find the 'verisimilitude' of struggle which Vasari's story might lead us to expect.

So what was 'perfection' in the image of St Sebastian? Was it the conveyance of a supernatural and faith-charging event, whereby a Christian witness was shot through with arrows and yet lived? Or did artistic excellence consist in the persuading the beholder of the raw actuality of suffering for sainthood – as Vasari's story implies?

<div style="text-align:center">★ ★ ★ ★ ★</div>

Bonsignori (relates Vasari) went to Mantua in order to 'seek out' Andrea Mantegna, artist to the court of the Gonzaga family from 1459 until his death in 1506. We know that St Sebastian was locally favoured at Mantua: in 1460, Lodovico III Gonzaga commissioned the 'temple' of San Sebastiano from Leon Battista Alberti; subsequently, Gianfrancesco II Gonzaga's palace-retreat by the Pusterla gate (opposite Alberti's church) was also given the saint's name. But what might Bonsignori have learned from Mantegna with regard to depicting St Sebastian as martyr?

47 ST SEBASTIAN
Andrea Mantegna, perhaps c.1459

Panel, possibly occasioned as a thank-offering in the city of Padua after an outbreak of plague there during 1456 to 1457.

48 ST SEBASTIAN
Andrea Mantegna, perhaps c.1470

A composition chiefly animated by the troubled archer vividly caught in conversation at the lower right-hand corner.

Mantegna himself produced three paintings of the subject (47–49). As we shall see, the established narrative of St Sebastian's martyrdom essentially concerned the Christian witness of a man who served with an elite cohort of Roman Imperial soldiery, the Praetorian Guard. Twice, Mantegna has Sebastian tied to the ruins of a Roman triumphal arch, as a pierced but stalwart trophy. In the Vienna version (47) a Classical Victory figure flutters aimlessly in the spandrel of the arch, celebrant of some distant, passing glory. A similar arch is more signally a ruin in the Paris canvas (48): fig-tree and ivy claim the stone, and the foot of a dismembered statue, once triumphant, is placed vengefully close to the martyr's marble plinth. Mantegna's final engagement with the subject shows less of the painter's alleged 'stony manner' (49). Here the saint is reduced in age, and reduced in steely acceptance of his plight. His arms are tightly pinioned. His eyes roll skywards, more desperate than aloof. His mouth and eyebrows form that emphatic

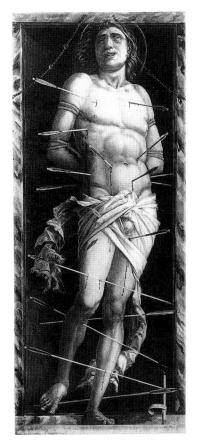

49–50 ST SEBASTIAN (AND DETAIL)

Andrea Mantegna, perhaps *c.*1490

A painting counted among Mantegna's estate, and therefore usually considered to be his 'last word' on the theme of St Sebastian.

triangle which recalls the formulaic masks of Greek tragic stagecraft. The arrows even draw blood; and different blood trails suggest a sequence of arrows fired.

Is it the transcendent marvel of martyrdom that faith serves as an inner armoury, or anaesthetic; that God (as St Thomas Aquinas argued) instils His witnesses with special strength and resistance? If that were the case, then what purpose would it serve to show 'the sheer physical frenzy' of any man shot at with arrows? A studio-model is not energized with divine, delirious conviction. Mantegna's threefold variants on the St Sebastian theme seem like meditations on this question, each time pointing to the adamant obduracy within a martyr's resolve. A miniature pennant curls round the guttering candle in the foreground of the Venice painting (50). It carries the legend: NIHIL NISI DIVINUM STABILE EST, CETERA FUMUS. 'Nothing save the divine is stable, the rest is smoke.' Mantegna's tumbled antiquities buttress that same contrast, of steadfast Christian witness with vainglorious pagan rule – characteristically pedantic of the artist, and quite in keeping with piety's profile here. For St Sebastian's narrative heroizes a man who has a distinguished military career, yet shows more obedience to Christ than to his Roman Imperial superiors (the emperors Diocletian and Maximian). Ordered to be used as target practice for his fellow guardsmen, Sebastian survives, being nursed back to health by a co-believer called Irene, only to reaffirm his faith with extra vigour. Diocletian then has him flogged, or pulverized, to death on the Palatine and his body flung into the great sewer of Rome, the Cloaca

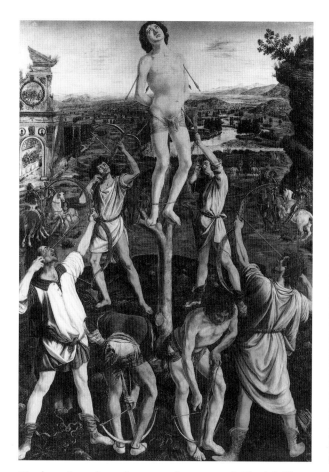

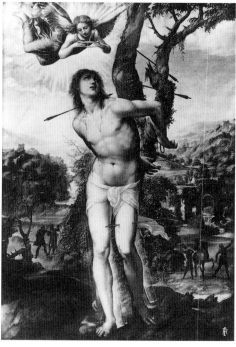

Maxima. Somehow the corpse is recovered. Final defilement proves a further step to canonization.

Few artists show the actual end of St Sebastian. Vasari, as draughtsman, may have tried his hand at a composition of the fatal flogging before Diocletian; a painting by Ludovico Carracci (1555–1619) in the Getty Museum depicts the dumping of Sebastian's beaten body into the Cloaca. The earliest representations of the saint eschew drama altogether: on sixth- or seventh-century mosaics at Rome (in the church of San Pietro in Vincoli) and Ravenna (in the Basilica of St Apollinare Nuovo), he appears robed and bearded and simply carrying the crown of martyrdom. The depiction of the covert removal of arrows by Irene eventually gains popularity in the seventeenth century: a subject well-suited for such candle-lighting specialists as Georges de la Tour. But it is fair to say that St Sebastian's formulaic popularity amongst Italian Renaissance painters (and some sculptors) is almost exclusively located in the target-practice episode. Stripped to loin-cloth or diaphanous briefs, a standard Sebastian flaunts the typical *déhanchement* of a Classical Greek athlete: that is, one leg relaxed, and the hip consequently pronounced. Whether dandy, ephebe or trooper, St Sebastian, in these images, is rarely bereft of erotic allure. Setting aside any speculation of sadomasochistic pleasure in the story of his punishment, it has been generally supposed that one appeal of the saint's image to Italian Renaissance painters

51 ST SEBASTIAN
Antonio Pollaiuolo, 1475

Tuscan boys flexing their muscles and prowess in a Tuscan landscape.

52 ST SEBASTIAN
'Il Sodoma' (Giovanni Antonio Bazzi), completed 1531

Whatever the interests of Sodoma in undertaking this scene, the paean it later gained from J.A. Symonds can safely be counted as a homoerotic response.

lay in the respectably pious possibilities it offered for study of the near-nude male frame.

So, for Cima da Conegliano (an altarpiece in the National Gallery, London), St Sebastian was a barely pubescent boy. To Piero della Francesca, as a figure in his *Misericordia Polyptych* at Sansepolcro, Sebastian was a distinctly stumpy youth, utterly oblivious to the thick darts lodged around his body. Giovanni Bellini, for an attributed altarpiece in the church of Sts Giovanni e Paolo (Venice), flagrantly used Sebastian's heroic near-nudity for the purpose of making contrast with the robed clerical sanctity of his central subject, St Vincent Ferrer. Antonio Pollaiuolo's version of 1475 (51) earned praise from Vasari, not only for the figure of St Sebastian (again boyish: Vasari cites the name of the model as one Gino di Lodovico Capponi, evidently a gentleman), but also for the circle of archers – each one of them imaginable as some strutting Florentine blade, and whether shooting or stringing their crossbows, all brawnily absorbed in this sport. Pollaiuolo set his scene quite distinctively – out of town, with the Arno valley unwinding beyond. Antonello da Messina (in his version now at Dresden, painted *c*.1474–75, and latterly much admired by Samuel Beckett) chose a location in a piazza, allowing for more nuances of urbane heartlessness: dames chatting from their balconies; a soldier sprawled on the pavement; carpets hanging out to air. Finally (this list could be much protracted), we might mention the artist known (to Vasari, and hence posterity) as 'Il Sodoma', or 'the Sodomite'. Between 1525 and 1531 he painted a banner for the Company of St Sebastian at Siena (52). Whatever its effect upon us now, it suffices to note Vasari's approval of the work as 'truly beautiful, and much to be praised' (*veramente bella, e molto da lodare*) – and the elicitation of this Victorian accolade from J.A. Symonds: 'Suffering, refined and spiritual, without contortion or spasm, could not be presented with more pathos in a form of more surpassing loveliness.'

Naturally enough, these artists used a model for their images of the vulnerable saint. That is the craftsmanlike setting for Vasari's anecdote about Francesco Bonsignori. Of the result of Piero's effort at Sansepolcro, one art historian (Kenneth Clark) indeed grumbles that the figure of Sebastian is 'taken too directly from a model'. The almost bas-relief subcutaneous forms of Botticelli's Sebastian are surmised to be the effect of the artist working from a figure posing in candlelight. There are no fewer than eleven known paintings by Pietro Perugino of St Sebastian and, typically (of such a prolific artist), he more or less recycled his own vision of the saint, invariably languid and hygienic. We may possess the life-study, or copy of such, which served as prototype of Perugino's stock (53). It shows

53 ST SEBASTIAN

Pietro Perugino, *c.*1493

The gentle contours of this study are replicated in two paintings of St Sebastian by Perugino (one in the Uffizi, the other in the Louvre).

a boy with his hands behind his back, neck tilted, hip swung out, and aspect wistful (how long, maestro, must I hold this stance?). Gazing over Perugino's draughtsmanship, we might share the aesthetic dismay of Bonsignori's patron in Vasari's tale. This is magnificent, but it is not the stuff of martyrdom.

★ ★ ★ ★ ★

A penchant for fine-limbed boys? A competitive vogue? To these suggested reasons for the incidence of images of St Sebastian we must also add the factor of saintly function. Renaissance painters may have relished the chance that St Sebastian offered them to demonstrate virtuosity

54 ST SEBASTIAN

Assigned to a painter known simply as 'Tommaso', and datable to c.1500, this image of St Sebastian is probably typical of the function of such panels – marking an altar where prayers could be left, with lighted candles, for the sake of good health.

and, perhaps, anatomical insight in the delineation of a *bel corpo ignudo*. Still, the commission of subject came from elsewhere: priests and secular authorities commissioned the image of St Sebastian because they shared a joint interest in fostering the cult of St Sebastian. Along with St Antony, St Christopher and St Roch, St Sebastian was a 'thaumaturgic' or wonder-working figure, specifically efficacious against the plague. In art-historical jargon we might speak of 'the viewer's share' of St Sebastian; it is equally important to evoke the viewer's *prayer* to St Sebastian. On the right edge of a panel of St Sebastian, attributed to the Umbrian painter Tommaso (54), there is a discernible candle burn, a mark of the painting's liturgical or votive use. It is rarely sensible to investigate the logic behind such popular–sacral traditions, but in this case some reasoning can be sketched. In both Biblical and Homeric poetry (see respectively Psalm 7.13 and *Iliad* I, 10–68), arrows may be metaphoric for the shower or prickings of divine wrath. Any picture caption of St Sebastian punctured by arrows which entitles it 'The Death of St Sebastian' is terribly careless. The power of the saint's legend lies in its association of recovery against all odds from physical ailment or assault. Hence his availability to be invoked at outbreaks of disease.

Sebastian was invoked in this way regularly from the seventh century onwards, and not only in Italy (prophylactic relics of the saint became the basis of a cult centre at Soissons in northern France, for example; while at Linz in Austria, Albrecht Altdorfer made a visual narrative of Sebastian's *passio* in 1518 for the 'therapeutic' Convent of St Florian). The report of St Sebastian delivering the citizens of Rome from some affliction in 680 earned him the status of Rome's third patron-protector, after saints Peter and Paul. Thereafter, dedicated with thanks or with prayers for intercession, the medieval image of St Sebastian in any civic or sacred context can usually be taken as a marker of plague. Benozzo Gozzoli's twin images of the

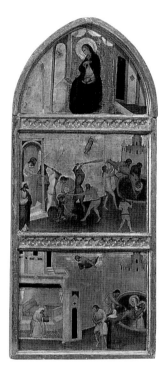

55 ST SEBASTIAN TRIPTYCH
Giovanni del Biondo, *c*.1370

An altarpiece executed for the Florence Duomo. In the central panel, a 'pincushioned' St Sebastian; to the side, scenes attesting the saint's efficacy in times of plague.

saint at San Gimignano are just that: commissioned in the years 1465–66, when Black Death menaced one Tuscan town after another, Gozzoli first showed Sebastian near-naked and pincushioned (at the Collegiata), then clothed and in prayer (at Sant'Agostino).

As the plague left the bodies of its victims spotted with multiple sores, so the exemplary pangs of St Sebastian ought to be manifold. The text of Sebastian's martyrdom made explicit a great quantity of arrows piercing the saint's flesh – such that he looked 'like a hedgehog' (*quasi ericius*). A triptych painted for the Duomo of Florence by Giovanni del Biondo in the second half of the fourteenth century has, as its centrepiece, a conspicuous imagining of this effect (55); and in a flanking panel of the triptych, del Biondo shows the protocol of imprecation to the saint. Sebastian stands robed and haloed here, with his hands clasped; figures kneel and pray before him; above, the black demon of pestilence seems to be buzzing away. But the situation of the afflicted town is dismal. Inhabitants lie prone from doorways and crenellations. In the foreground, two grave-diggers lift the corpse of a priest down from a wooden bier. This epidemic has all estates as prey.

Giovanni del Biondo's hedgehog-Sebastian may have been precisely occasioned by a documented outbreak of Black Death or some related disease in Florence in 1376. It follows, then, that we can suppose a simple eventual reason for the demise of St Sebastian images during the sixteenth century, which is the rise in esteem and authority of municipal Health Boards. But we seem no nearer to resolving the problem raked up by Vasari's account of Francesco Bonsignori's panic-harried model – that he did not look sufficiently terrified by his painted fate.

This was not a question of homoerotics or public health but of aesthetic decorum.

<p style="text-align:center">⋆　⋆　⋆　⋆　⋆</p>

To return to that story.

Vasari introduces Bonsignori's essay at St Sebastian as a particularly strenuous effort of naturalistic painting. 'He took many things from the natural' is Vasari's phrase (*vi ritrasse molte cose dal naturale*). Presumably the painter studied arrow-shafts of the day, then; perhaps arranged (*à la* Mantegna) a credibly Roman site for the firing-squad. What else could Bonsignori do? It has been remarked (by Lionello Puppi) that some Renaissance painters show first-hand acquaintance with techniques of execution and torture: that is, they had sufficient opportunities provided by the penal codes of their own cities to observe the motions of flogging, hanging and decapitation (thus Domenico Beccafumi's early sixteenth-century picture of the execution of St Paul has been described as 'disturbingly *professional*'; and Fra Angelico's *Beheading of Sts Cosmas and Damian* (c.1438–40) evokes an unnerving sense of suburban normality). With St Sebastian, however, as with the Crucifixion, there was no such opportunity for a Renaissance artist to 'document' the reality of violence. Bonsignori sets up a model who 'looks good' (*di bella persona* is Vasari's phrase, which I may mistranslate as 'sturdy' – 'good-looking' is possible), and ties him up in the studio. What next?

What next is what Bonsignori's patron the Marquess of Mantua suggests. Terrify the model with a loaded crossbow.

And then . . .?

Morbid readers will already have spotted the logical flaw apparent in Vasari's tale of naturalistic diligence. If Bonsignori is attempting the conventional sacred image of St Sebastian, he does not intend to paint the moment immediately *before* the shooting starts, but rather when it is in full progress, or just completed. In which case the Duke must do more than angrily wave his crossbow about. He must let fly.

'Of course not!' protests common decency, and Vasari does not pursue that logical next step. But it was not unthinkable. In Vasari's own time, the rumour circulated that Michelangelo had put one of his models through death by crucifixion; later, a similar crime was alleged in connection with a particular carving of Christ on the Cross by the Austrian Baroque sculptor, Francis Xavier Messerschmidt. But Vasari's story also has a precedent in antiquity; and this antique precedent does not shirk from the conclusion.

We know Vasari was a jackdaw among the remains of the Classical literature of artistic renown: but since Vasari did not annotate himself, we must be content to suppose his plagiarisms as they arise. (No one has yet done the full sleuthing job of estimating how much Vasari, in creating his cosmos of Italian artistic genius, borrowed tropes and criteria from Pliny and other Classical canons.) In the case of this anecdote about Bonsignori, the possibility must be strong that Vasari adapted a story to be found in Seneca (whose texts were more or less established by Vasari's time). It is not a story given serious credence by anyone today ('sheer fiction' is how one editor dismisses it). In terms of credibility, perhaps, it is on a par with the 'Orientalizing' story concerning the Venetian painter Gentile Bellini's sojourn in Constantinople at the court of Mehmet II, in 1479–80 (wherein the Sultan, unimpressed by Bellini's rendition of the severed head of St John the Baptist, has a passing slave immediately decapitated in order to show how the neck muscles react). But the critique of incredulity was rarely applied to Classical authors in Vasari's time.

Seneca presents it as a pseudo-juridical problem; as one of his rhetorical exercises or *Controversies*, 'topics for debate'. The situation for discussion is as follows (*Controversiae*, 10.5). The Athenian painter, Parrhasius, purchased an old man in a sale of captives taken after the siege of Olynthus (in 348 BC) by Philip II of Macedon. He tortured the old man, in the course of painting a picture of the mythically tormented Prometheus. The old man died, yet Parrhasius proudly exhibited his picture in a temple of Athena. So. Discuss – proceeds Seneca, as teacher – whether Parrhasius is guilty of 'injuring the state'.

Most Roman tales of the mistreatment of slaves (typically, perhaps, the Augustan aristocrat Vedius Pollio tossing them alive into his pond of flesh-feeding lampreys) are regarded with suspicion by social historians of Classical antiquity – slaves were simply too valuable as assets. Which explains why we may hesitate to believe that this drastic *exemplum* of 'life-class' unto death ever happened. And the oratorical students, whose discussion is summarized by Seneca, struggle to defend Parrhasius – even though they, after all, belong to a society where 'fatal charades' such as Prometheus Bound could somehow be staged in the gladiatorial arena.

This case has a specious plausibility insofar as Parrhasius (whose work has not survived) was celebrated for his commitment to illusionistic naturalism, and special interest in 'facial expression' (*argutiae vultus*: Pliny, *Natural History* 35.67). But more important than plausibility here is the sense that Seneca and his pupils seem alive to the aesthetic (and ethical) dilemma involved: so concerned with it that they neglect the actionable question originally attached to the 'Controversy' ('injury to the state', which one presumes to mean acting against the public interest or suchlike). In the medley of rhetorical 'colours' and 'soundbites' recorded by Seneca there are, it is true, some quibbles which equate to legalistic small print: Parrhasius, opines one youth, should not have killed his model because Prometheus was condemned not to death, but to eternal torture (every day Zeus sends an eagle to peck at the gizzards of Prometheus; every night the damage heals, to happen all over again). But otherwise the protagonists in the debate keep returning to a division that they want to maintain between art and life.

'*Hoc Promethea facere est, non pingere*' – 'this is to make a Prometheus, not paint one', goes one complaint. What would Parrhasius do if commissioned to paint a battle-scene (watch out everybody)? Surely the celebrated sculptor Pheidias did not install Zeus in his studio in order to make a splendid image of the great god?

And so on. Perhaps they do not get very far, save generally agreeing upon the 'unreasonableness' of Parrhasius in fatally torturing his Prometheus-model (as a staunch Stoic, Seneca can only praise the quality of mercy when generated by reason, not pity). Still: these budding Roman barristers grasp the issue more tenaciously than Vasari, or Bonsignori, or the Marquess of Mantua. In Classical Greek terms, there was 'imitation' (*mimesis*), and 'imagination' (*phantasia*). The balance of these factors in any artist's search for naturalistic conviction was a matter for philosophical dispute. The artist, however, possessed no creative autonomy in reproducing nature for public delight. Parrhasius may be specifically praised as a 'life-painter' (*zoographon*), but here he has disgracefully recorded torture and death; thus become 'an anti-artist, directing violence against the idea of art itself'. This is why the Elder Pliny cites with such palpable disgust an archaic Greek sculptor called Perillus, who served the Sicilian tyrant Phalaris. Perillus ('whom no one should praise', warns Pliny), devised a hollow bronze bull for his patron, in which miscreants could be enclosed. With a fire crackling beneath the bull's flanks, the statue would soon begin to emit believably bovine roars (*Natural History* 34.89). As Pliny demands – is this what the pioneers of bronze-casting worked so hard to achieve?

Dante knew what befell Perillus, according to legend. The artist had engineered a fiendishly convincing figure of a bull. Very well: he was first to be roasted inside it (*Inferno* XXVII, 7–12). This satisfaction – the satisfaction of seeing a torturer tortured – fits well enough with Dante's wider vision of Hell's absolute and vindictive justice. But the moral connection between the human experience of pain and art that 'reproduces' or articulates such pain was not of apparent concern to Italian Renaissance artists and their hagiographer, Giorgio Vasari. A latter-day commentator, Elaine Scarry, has noted the curious inadequacies of the English vocabulary when it comes to describing pain; she concludes that pain's 'resistance to language' is not accidental, but 'essential to what it is'. Those who suffer from migraines, therefore, tend to think that no one who has never had a migraine can imagine its quality of painfulness; the pain is verbally inexpressible.

But in Vasari's world, we sense a dauntless arrogance in the asserted power of art over words. 'Your pen will be worn out before you can fully describe what the painter can demonstrate forthwith by the aid of his science,' wrote Leonardo da Vinci, 'and your tongue will be parched with thirst [. . .] before you can describe with words what a painter is able to show you in an instant.' Where words failed, call for the draughtsman, the painter, the sculptor. Nothing should lie beyond the measure of genius in the figurative arts, not even the truly supernatural – such as the image of a man shot through with arrows and yet still alive.

* * * * *

Not a genius, but a diligent practitioner of art, Vasari himself undertook some ostensibly violent subjects. His narrative-cycle for the Sala Regia in the Vatican Palace includes *The Battle of Lepanto*, *The Wounding of Admiral Caspar de Coligny*, and *The Massacre of the Huguenots*. Done to the successive orders of popes Pius V and Gregory XIII, these frescoes were considered by Vasari to be guarantees of his fame to posterity. In fact, they soon went into relative obscurity; and modern guidebooks to the Vatican do not encourage any belated admiration. Their 'Mannerist' style, admittedly, was of passing fashion; and it might be argued that the historical particularity of their subjects almost immediately relegated these scenes to mere academic interest. But it is the residue of moral-aesthetic offence regarding the content of Vasari's Sala Regia frescoes which has done most to ensure the continued disdain in which they are held.

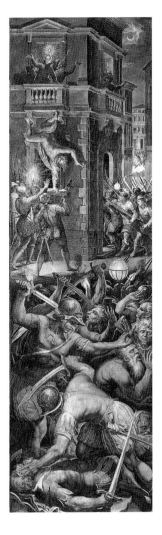

56 THE MASSACRE OF THE HUGUENOTS

Giorgio Vasari, 1572–73

Fresco in the Sala Regia of the Vatican. Vasari's theme in this commission was unequivocal: that terrible punishment awaits all who fail to accept the Catholic faith.

Vasari had hardly finished his tumultuous panoramic evocation of the Battle of Lepanto – a joint Spanish-Italian naval victory over Turkish forces in October 1571 – when his commission was extended to illustrate another great victory for the Christian Church. This was the mass-murder, on the night of 24 August 1572, of those French religious dissidents known as Huguenots: some 3,000 in Paris, and an estimated further 25,000 elsewhere throughout France. And this by the royal consent of France's ruler, Charles IX. To the Papal authorities of the time, and allied European monarchs, the slaughter was no evil necessity, but (as Philip II of Spain hailed it) 'a glorious event': serving as sequel, or pendant, of Lepanto, to confirm that both infidels and rebels against the true faith alike call for punishment. Decorating the Sala Regia, where the Pope sat enthroned to receive petitions and issue judgement, any 'audience' conducted in that room was surrounded by the proof of swift powers – vicarious and murderous – to implement divine will.

The irony redolent from the occasion of the massacre of the Huguenots seems not to have tinctured Vasari's epitome of the event. It happened on the feast-day of St Bartholomew, apostle, martyred in Armenia by having his skin peeled away from his frame. Whence derived St Bartholomew's saintly emblem – a butcher's knife, the instrument of his flaying alive. Now Bartholomew became eponymous with a night of terror by long knives – in the name of the Holy Apostolic Church.

But conceivably, for Vasari and his patrons, the suggestion of such irony never arose. From their view (and Vasari locates his sequence of the persecution not

in Paris, but Rome) the Huguenots were no martyrs, rather pamphleteering separatists whose impudence warranted quick extermination. And so we see Vasari's iconographic recourse (56). By moonlight and lanterns the 'pesticide' is accomplished. The half-naked corpse of the Huguenot spokesman, Coligny, is tossed from a balustrade, cartwheeling as it falls. Swordblades curve and flash. One of their quarry (in the foreground) is armed, but otherwise the Huguenots are patently defenceless, attempting to shield themselves from these assailants with bare hands alone. Still Vasari seeks our jubilation, not distress. So he moulds the faces of the stricken victims into the demonic masks of the damned. These are twisted types, monsters who cannot take pain without squealing.

Unlike the blessed St Sebastian.

<p align="center">* * * * *</p>

'Sebastos' is Greek for 'Augustus': meaning 'august', or 'venerable'. A simple – and philologically incontestable – etymology for the name 'Sebastian'.

There is, however, an altogether more shady, or fantastic, family tree: 'Sebastian comes from sequens, following; beatitudo, beatitude; astin, city; and ana, above; and it means one who pursues the beatitude of the city on high.'

Fantastic, fanciful, pseudo-sophisticate and pious, this explanation of 'Sebastian' is characteristic of the text to which it belongs – the Golden Legend (Legenda aurea) of Jacobus da Voragine.

Not very much is known about Jacobus da Voragine (1230–98), other than his vocation as a Dominican friar, and sometime service as Archbishop of Genoa. But his Golden Legend is not to be dismissed on the grounds of its author's effacement nor his penchant for etymological whimsy. As the French medievalist Emile Mâle insisted, the Golden Legend is a key text for understanding Christian imagery throughout the fourteenth, fifteenth and early sixteenth centuries. For it was one of the world's first best-sellers, rolling off prototype presses throughout Europe, not only in its original Latin but also multiple vernaculars (personally translated by pioneer printer William Caxton, the Golden Legend went through nine editions in English alone between 1483 and 1527).

This was the textual source for the passio of St Sebastian. There are allusions to the Sebastian-story from the fourth-century St Ambrose of Milan (in his commentary on Psalm 118), and other martyrologies may well have contributed to the shaping of the story: for example, the account given by Prudentius of St Cassian, the Christian schoolmaster pricked to death by the spiteful pen-nibs of his pagan pupils. But undoubtedly it was the Golden Legend which supplied the canonical 'document' for the images of St Sebastian which we have so far surveyed. It is true that when the Golden Legend became exposed to the learned scrutiny of Italian humanists in the late fifteenth century, it was held up for some ridicule, as a farrago of tall tales of Christian witness. Nevertheless, we should assume that for Francesco Bonsignori and his viewers, and for Giorgio Vasari and his readers, St Sebastian was known as the Golden Legend presented him. In graphic terms, the picture was grotesque: it is the Golden Legend that says Sebastian quasi ericius ita esset irsutus ictibus sagittarum, 'was needled like a hedgehog with the strikes of the

arrows'. As we have seen, that particular image was mostly eschewed by the artists, presumably because it risked making a laughably odd metamorphosis of the saint who was the 'Soldier of Christ' (*Miles Christi*). At the same time, this chapter of the *Golden Legend* helps to explain the aspect of noble passivity so invariably bestowed upon the saint. For Jacobus allows no purple swell of empathy for the pangs of pierced Sebastian. His Sebastian does not writhe or struggle, nor scream skyward as the arrows spit his flesh. Jacobus locates the ordeal in Rome's Campus Martius, upon 'the Field of Mars', keeping us aware that Sebastian, while not inured to pain, was renegade from an elite Roman cohort by dint of faith, not cowardice.

As we have seen, this is the image of sainthood which, despite interference, Francesco Bonsignori finally delivered to his patron at Mantua.

Giorgio Vasari we may forgive: he simply could not resist a good story – even when it fundamentally failed to square with the artistic achievement it was supposed to explain. Indeed, Vasari never defined what made a 'perfect' image of St Sebastian. However, he does tell us that when the Florentine painter Fra Bartolommeo (1472–1517) created an image of St Sebastian to prove that he, a practising Dominican friar, could master the nude figure as well as any artist, the result had to be removed from the church where it was first exposed. Female viewers were coming to the confessional, as Vasari puts it, 'having sinned [*peccato*] at the very sight of the allure and suggestive realism given to the figure by Fra Bartolommeo'.

This record of a Renaissance transfiguration of St Sebastian into an icon of sex appeal anticipates a rather modern response towards the saint. It was the Japanese writer Yukio Mishima (1925–70) who – drawing deep upon his own erotic and suicidal impulses – perhaps best voiced this semi-secular understanding of Sebastian's distress. Mishima admits to experiencing his first ejaculation, while masturbating in front of a reproduction of a 'Baroque' image of St Sebastian (Guido Reni's, to be precise: in the Palazzo Rosso, Genoa). Mishima was a bodybuilder, imbued with the logic of 'no pain, no gain'; he may also have been conditioned by a non-Christian cultural tradition with its own decorum of pain and beautified cruelty. But Mishima seems instinctively to perceive the rapturous charge of faith built into every sacral commission to represent St Sebastian down the ages.

'*His was not a fate to be pitied. In no way was it a pitiable fate. Rather was it proud and tragic, a fate that might even be called shining.*'

6 THIS IS MY BODY

Its first inventory-listing describes the picture simply as: 'A dead man by Hans Holbein, oil on wood, with the title *Jesus Nazarenus Rex*' (57: the full Latin wording is in fact *Jesus Nazarenus Rex Judaeorum*).

'A dead man by Hans Holbein'. No doubt about that. This constitutes proud graphic power. As if the artist were telling us: see, here is a corpse, which you can neither touch nor smell – but I can show it. Look. Can you look without flinching?

The viewer's share of the panel has found distinguished voice in the past. Still, it seems worth adding the notes of several quiet minutes gained before it in the Basel Kunstmuseum.

At the centre of the length-wise composition is the gouged hand, whose flesh-spare digits darken blue against white linen. Instinctively, the gaze travels to seek further touches of the same chill blue. At one extremity that blue has settled on the lips and nostrils; at the other, on the toes – toes that are extenuated and claw-like as the fingers. Being displayed more or less at eye level, the picture invites absorption in its stretched-out sections. Christ's torso makes its own pallid landscape, in which the spear wound features like some freak valley, red and autumn-succulent. The tendons of the legs are tautened with striations of suspense. The mouth may make rictus or gasp. Despite encroaching gangrene, this is not a body at rest. The linen is fresh, but the coffin not new: or is the crack in its greenish stone a harbinger of breaking-forth?

This is Jesus of Nazareth, King of Jews, as he had never been previously envisaged by any artist: within the absolute loneliness of the tomb, deprived of all placatory apparatus. To account for its stark effect, there seem to be three routes of response or explanation. The first is a reaction of devotional horror. How could an artist stoop to such mortuary sensationalism, to show the body of Christ advancing towards a state of rank decomposition? And so some observers have accused Holbein of mischief, tantamount to blasphemy: this painting would deny the Resurrection.

A second course of commentary allows Holbein simply to maintain fidelity to his own reputation for verisimilitude. This is the same artist who, perhaps on the eve of leaving his family to seek favours abroad, showed his own wife and children looking weary, worried and spent (58). Naturally, such a portraitist would want to show the entombed Christ not only prey to the transience of bodily form (as Mantegna had already done; likewise, as we shall see, Holbein's compatriot and near-contemporary, Matthias Grünewald) but also,

57 'THE DEAD CHRIST IN THE TOMB'
Hans Holbein, 1521–22

One of the legends around the painting is that Holbein used, as a model, the corpse of a Jewish man found drowned in the Rhine.

58 THE ARTIST'S WIFE, ELSBETH BINZENSTOCK, AND HER TWO CHILDREN, PHILIP AND CATHERINE
Hans Holbein, c.1528–32

Although hued with golden tones, this seems essentially a study of family desolation.

as it were, archaeologically 'intact'. Apart from the artist's initials and a date, the only artificial device here is the cross-sectioning of the tomb, and its illumination.

A third alternative remains: to treat this picture as a gravely engaged statement of faith.

If it is such, then Holbein's panel is a far bolder image than it seems. It states a true limit of representation: the absolute sacrifice of divinity to flesh. 'This is my body. . .'

This is the way we shall try to take here.

★ ★ ★ ★ ★

Fyodor Dostoevsky's second wife, Anna Grigorievna, was with him in Basel in August 1867 when the novelist contemplated Holbein's 'Dead Christ'. 'He stood for twenty minutes before the picture without moving,' she records. 'On his agitated face there was the terrified expression I would recognize as the onset of one of his epileptic fits.' Biographers wonder whether the picture did indeed throw Dostoevsky into a show of 'indecorous' behaviour on the spot (risking a fine, or expulsion from the gallery). But, if the character of Myshkin in Dostoevsky's novel *The Idiot* (1868–69) is the author's ideal self-impersonation, there can be no doubt that some sort of seizure or transfixed crisis did occur in Basel. In *The Idiot*, Holbein's painting is seen via a reproduction hanging in the house of Rogozhin. 'That picture!' exclaims Myshkin. 'Why, some people might lose their faith by looking at that picture!' A lesser character in the story who looks on the picture, Ippolit, provides a chorus of similarly desperate dismay. How could anyone conceive that the Resurrection was viable, from this image; the laws of mortal nature ever challenged?

We may understand, from Dostoevsky's own definition of Christ as the 'absolutely beautiful man', that the writer's shock at the image was a function of his own sense of the Christian picturesque. It was the case that icon-painters within Dostoevsky's Russian Orthodox church traditionally eschewed not only images of Christ's death, but all images of palpable suffering in the Passion. (Accompanying liturgical texts of the Russian church likewise avoided describing the florid particulars of martyrdom.)

With Orthodoxy deep in his own fibre, Dostoevsky was familiar with icons as prescriptive signs. While postures of suffering were not themselves represented, indications of the appropriate response to suffering were customary. And Holbein plainly frustrates that expectation of some wailing bystanders. 'None of them are shown in the picture,' wails Dostoevsky's Ippolit, 'but those actually present by this corpse could have felt nothing but an awful anguish and desolation on that night; causing all their hopes, all their beliefs perhaps, utterly to collapse.' The previous, Italian painters of Christ's deposition and entombment may have shown a wrecked and wretched corpse, but they had never exposed it in such hermetic isolation, so immured in its solo deathliness. This is why certain Christian viewers of Holbein's painting have taken his image of Christ derelict as not only 'irreverent', but 'offensive'. Such censors would be gratified to find, in a nearby corridor of the same gallery, a 'corrected' version of Holbein's Christ done by the

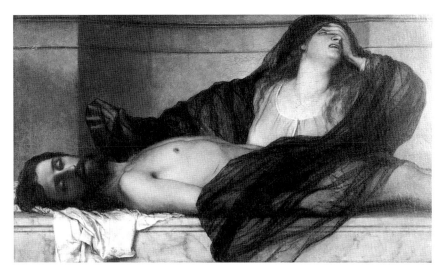

59 'MARY MAGDALENE'S GREVING OVER THE DEAD CHRIST'
Arnold Böcklin, 1867–68

59 'MARY MAGDALENE'S GRIEVING OVER THE DEAD CHRIST'
Arnold Böcklin, 1867–68

This clearly looks to be a 'revision' of Holbein's painting in Basel; Böcklin produced it, however, shortly after seeing Grünewald's Isenheim Altar at Colmar.

nineteenth-century Swiss artist Arnold Böcklin (59). Considerate of prevailing taste, Böcklin has tidied Christ's body to a near-immaculate state of repose, and allowed a fuller swathe of drapery across the holy loins; more significantly, he has supplied the comfort of a howling attendant – Mary Magdalene, mourning as extravagantly as any music-hall heroine.

Back to Holbein's panel. Local folklore – no more than that – alleges that Holbein made, if one can say so, a still-life study here: from the cadaver of a drowned Jew, retrieved from the River Rhine. Half accepting that tradition, Holbein's nineteenth-century expositor, Alfred Woltmann, goes so far as to argue that we would not recognize the subject of this painting as the body of Christ, were it not for the later additions to the frame: the title's explicit sanction and the puffy cherubim clasping tokens of the Passion.

Uncertainty about the picture's original purpose has added to speculation about its potentially 'secular' origins, if not its faith-shaking effect. It seems unlikely ever to have been part of an altarpiece, though it may have served as the lid of some 'sacred coffin', to be unveiled only on certain special occasions. The first record of its provenance (in 1586) is simply that it was in the collection, or *Kabinett*, of the Basel law professor Bonifacius Amerbach, known to have been not only a patron but also a friend of Holbein's. The likelihood that the picture may have been displayed in a town hall rather than a church, or hardly displayed in public at all, then favours an interpretation of the image as an essentially psychological document rather than a devotional image. The bodily isolation which so appalled Dostoevsky, therefore, becomes germane to the picture's power over its modern or secular viewers. We may take the French scholar Julia Kristeva as speaking on behalf of such beholders when she hails what Holbein has achieved as 'a composition in loneliness'; a mirror of the artist's own 'serene, disinterested sadness' and melancholia. If we share such empathy with the artist, Holbein's compositional 'minimalism' – his eschewal of onlookers – itself constitutes 'the metaphor of severance'.

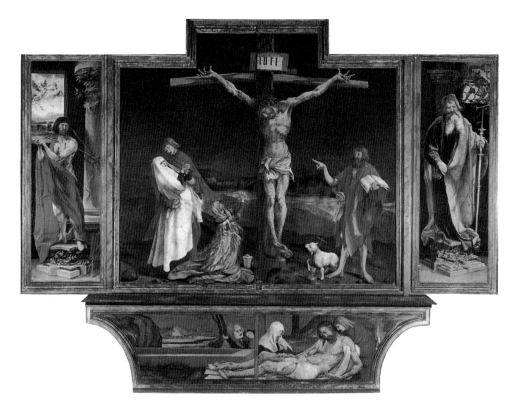

Unlike his near-contemporary, Albrecht Dürer, Holbein has left us no self-annotated or confessional life. Swiss legal records mark him as a blade and brawler in his apprentice days; later archives at Basel signal Holbein, just prior to his emigration to England in 1532, as a hesitant recruit to the Protestant cause. Holbein's friendship with the Dutch humanist scholar Erasmus is presumed largely from the fact that Erasmus not only sat for several portraits by the artist, but also supplied letters of recommendation on his behalf to the English court. Beyond sketches and brief witness of the esteem Holbein secured (including a vignette from the English miniaturist Nicholas Hilliard), there is little else to guide us. We can only guess at some of Holbein's movements and motives. That he may have travelled to Italy; that he accompanied his father, also an artist, to Isenheim in the Alsace; that he left Basel because of threats by local iconoclasts to his works and his livelihood: this is all conjecture.

At Isenheim – we presume – Holbein might have gazed upon an altarpiece attributed to a painter who is even more clouded in biographical obscurity, Matthias Grünewald. Between 1512 and 1516, probably, Grünewald executed a folding polyptych for the church of the monastic hospital of the Canons Regular of St Antony, which had stood since Crusading times by a main military and pilgrim route through Europe. The front of the altar – its normal 'closed' state, when not opened out on certain festal occasions – would cause any worshipper darts of disgust (60). This was not only a place of supplication but also a place of remedy and healing (*therapeuticum*); pain belonged to the state of sinfulness; and here was the image of a body which had absorbed all the sins of the world.

60 THE ISENHEIM ALTAR
'Closed state' of the altarpiece at Isenheim attributed to Matthias Grünewald, *c*.1512–16.

The predella shows the body of Christ with a disciple and the two Maries. Flanking the Crucifixion are images of St Sebastian and St Antony, both considered prophylactic against disease.

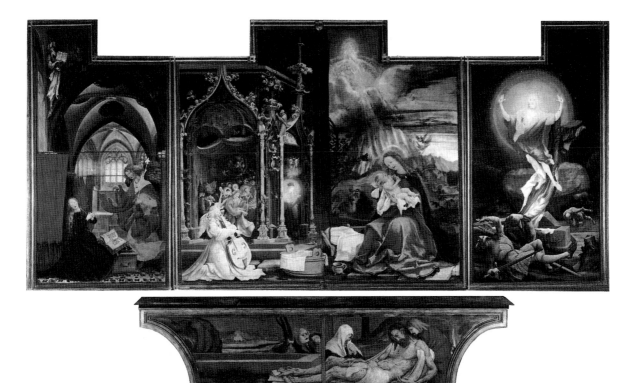

61 THE ISENHEIM ALTAR

The opened retable, showing the Annunciation, the Birth of Christ, and the Resurrection.

Brought down for the tomb, it is a scrawny yet still solid focus of contemplation: and as the joinery operates, this slumped figure at the base, or predella, of the altar remains on view when the panels above open out to reveal the bright lights of Christ's Incarnation and Resurrection (61).

A half-putrefied body, laid out to mark the grounding of Christian belief: who knows how deeply Grünewald's message at Isenheim may have impressed the young Holbein?

That is a hypothetical source of influence. If we look to the wider historical context, however, there is little doubt in identifying two 'revolutions' immediately local to Holbein's existence. The first was the 'print revolution': that effusive scattering of posters, pamphlets, broadsheets and books made possible by new mechanical techniques. Gutenberg's contrivance of movable type c.1454 had not immediately released such an effusion. But by 1500 Augsburg – the city of Holbein's birth and apprenticeship – had become home to pioneers in the exploitation of the power of the printing press through not only the typography of vernacular literature, but also the fine reproduction of images by copperplate engraving. Add to this the vigorous popularization of woodcuts, and printed material became a medium highly associated with the message it carried in places such as Augsburg, Nuremberg and Basel. That message concerned the German-Swiss defiance of Papal authority which developed into the European theological and sectarian dynamic we call 'the Reformation': the other major turmoil of Holbein's life and times.

Holbein, as noted, was officially counted in Basel as an adherent of the 'reformed' church, though he is listed as having harboured reservations about the

'reformed' Holy Sacrament. From the number of commissions to illustrate rebellious tracts and texts garnered by Holbein it is generally concluded that, along with Cranach and Dürer, he should be counted as a 'Reformation artist'; or, at the very least, a sympathizer with the Erasmian humanistic critique of doctrinal fudging and clerical hypocrisy in the established Church. But can we speculate more precisely on Holbein's engagement with the flux of theological dispute surrounding him? And might we then understand more clearly Holbein's 'Dead Christ' as not so much an act of artistic sensationalism, but as a brave new devotional image called forth by rebellious creed?

★ ★ ★ ★ ★

The 'protest' of Protestantism originated with Martin Luther: an earnest, stolid and self-castigating Augustinian monk on the teaching staff of the University of Wittenberg, in the central German region of Saxony. The protest in question came naturally enough to a man obsessed with his own sinfulness; it was not a particularly novel protest, still less an overtly radical one. In another concatenation of circumstances the ninety-five 'theses', or debating-points, posted by Martin Luther on the castle door at Wittenberg in 1517 might simply have added their noise to the rustle of ephemera issuing from the many new German printing presses. But soon enough the whole continent of Europe was subject to these documents' effect.

Luther's protest was against the sale of Indulgences. Since Indulgences are no longer a marketable commodity, they may need some explanation. According to medieval Catholic theology, Christ's death was so huge a sacrifice that it provided a substantial surplus of grace for humanity. This surplus, first entrusted to St Peter, was to be administered by St Peter's own church in Rome. Prayers, fasting, pilgrimage and almsgiving might all assist an individual in bargaining for a share of the surplus; by Luther's time, however, the monetary factor prevailed. The doctrine of Indulgences had come to facilitate the forgiveness of sins by purchase. A financial contribution to the church's mission (originally, the Crusades) was taken as token of penance, whether on behalf of oneself or loved ones; tallying with the measure or frequency of donated penance, release from the pains of Purgatory could be secured by the year, or the decade, or even more. So it was that in the late fifteenth century Cardinal Albrecht of Brandenburg (the presiding episcopal power at Augsburg, therefore, when Holbein was a boy) could calculate that by cash donations and expenditure on holy relics, he had acquired precisely 39,245,120 years of remission from punishment of his sins.

A Flemish coloured woodcut of c.1450 (62) illustrates how this formal accountancy system of individual redemption managed to soak up the splashy protocols of *devotio moderna*. 'Behold the man': whoever would recite the prayer printed below this fountain-image of Christ Crucified was assured 80,000 years of Indulgence. Buyers of such leaflets were encouraged to assess how many times the invocation 'Our Father' (*Paternoster*) should be muttered by trying to compute how many drops of Christ's blood had been shed for them: the usual reckoning lay somewhere between 36,500 and 54,000.

62 'ECCE HOMO'
'Behold the Man'.
An anonymous woodcut
on paper, from Flanders,
*c.*1450.

The text of the prayer is in
vernacular Flemish, though
ending with the liturgical Latin
of *Paternoster* and *Ave* ('Hail').

In Luther's time the Medici pope, Leo X, embarked upon fund-raising for a new Crusade against the Turks, as well as an appeal to rebuild St Peter's basilica in Rome (following a programme begun by his predecessor, Julius II). In aid of these twin causes a Dominican friar called John Tetzel had been exceptionally assiduous in hawking Indulgences in certain parts of Germany: the abuse of the practice had become flagrant. But Luther was not protesting against the shameless exploitation of God-fearing peasants. Nor was he particularly vexed about the end to which Indulgence-proceeds were destined: in this case, as it happened, a monumental embellishment of St Peter's, first by Bramante and Raphael, then eventually at the hands of Michelangelo, Borromini, Bernini and others. Luther's primary conviction was that no amount of money or intercession or even acts of charity ('good works') could atone for mankind's sin-ridden nature: rather, salvation came from the pure and simple trust in Jesus Christ as the Son of God. Hence the slogan which would underpin the Lutheran Reformation: 'justification by faith alone'. And hence, in due time, Luther's assertion that believers needed nothing beyond the word of God for their spiritual guidance.

In other words, the Pope and all his pontifical apparatus were declared redundant. The political results of that declaration are well known, or easily imagined, but of little actual consequence to the work of Holbein. The theological ramifications, however, require our lingering patience.

It was in 1522 – contemporary, then, with Holbein's composition of the 'Dead Christ' – that Luther issued his own version of the New Testament. In Wittenberg,

it was reprinted fourteen times in the course of the following two years. To the south, four cities – Augsburg, Basel, Leipzig and Strasbourg – marked their 'Reformist' leanings by reprinting Luther's text no fewer than sixty-six times. And this despite Leo X having decreed, in 1515, that no book should be published, anywhere in Christendom, without prior papal approval. In Basel, the publisher Adam Petri entrusted the title-page illustration of Luther's New Testament to Holbein. Holbein's images – featuring the apostles Peter and Paul, both patron saints of Rome – were hardly subversive. But the very assignment of the job to Holbein warrants our speculation about the artist's own receptiveness to Luther's theological radicalism.

Of late, art historians have shied away from attributing to Holbein much Lutheran sympathy. The term 'Christian paganism' has been used to describe Holbein's likely attitude; Holbein has also been credited with 'the making of Erasmian art'. But neither 'Christian paganism' nor 'Erasmian art' is a happy phrase. Erasmus may have recommended Holbein as a 'celebrated artist' (*insignis artifex*), and it is true that Holbein illustrated Erasmian works, notably (though originally by way of private marginalia) Erasmus' satire, first published in 1511, *The Praise of Folly*. But Erasmus was generally critical of the cult of devotional images; and such images formed a considerable part of Holbein's livelihood. Unlike certain Swiss reformers (notably Huldrych Zwingli, and a little later, John Calvin), Erasmus did not sanction outright iconoclasm. However, he voiced strictures on the graphic tendencies of devotional art severe enough for us to be sure that, if Erasmus had set eyes upon Holbein's 'Dead Christ' (as well he might, since he was resident in Basel when it was painted), he would have deplored its apparent ghastliness. 'Let us give up the business of wailing,' Erasmus urged, 'unless we do it on account of our sins, not His wounds. We should rather be joyfully proclaiming His triumph.'

The labours of Erasmus to steer a middle way between Luther and Rome were fruitless: ultimately both sides condemned him. The labours of Luther, to channel sane discontent with abused practices or sophisticated doctrines into a newly definable faith, gave rise to direct militancy. In 1527, convinced Lutherans were among the troops of the emperor Charles V who sacked Rome: some of them impudently scrawled Luther's name across Raphael's frescoes in the Vatican Stanze. How far Holbein shared these vandals' anti-papal enthusiasm is impossible to gauge, though he did make a telling woodcut of Luther as 'Hercules Germanicus' – where the hero appears as a great robed avenger swinging a pope by the nose, and trampling over the prostrate bodies of worsted Scholastics, including Aristotle, Aquinas, William of Occam and Duns Scotus. In the fluent and vivid propaganda of the time, consistency of artistic vision can scarcely have been possible. By the same token, this was a genuinely divulged and populist issue. Only in retrospect can the doctrinal debates subsumed in the historiography of the Reformation seem like so many abstruse wrangles. In those days, theological disputes caused pavement riots and alehouse rucks. In this context, the slightest allusions to controversy must be deemed significant: such as, for example, Holbein's display of a distinctively Lutheran hymn-book amongst the status-symbols in his 1533 double portrait, *The Ambassadors*.

Luther himself was not opposed to devotional images. Luther's theology, however, was not without consequences for the nature and appearance of devotional images. Technically, Luther's stance is characterized as 'kenotic': dwelling upon the thoroughly absorbent 'mortality' of the person who was Christ. Less technically, much less precisely – and with profound implications for our entire project in this book – this theology, as it develops, is given another word: *humanitarian*. So the Oxford Dictionary's listing of the earliest usage of this word (c.1819) defines it: 'One who affirms the humanity (but denies the divinity) of Christ.' It was one of Luther's hymns, indeed, which sang of 'the death of God'. Wrenched out of context, those words could so easily be held up as heretical: but philosophical elegiacs of God's death would not be seriously composed until the nineteenth century (first by G.W. Hegel, then by the atheist Friedrich Nietzsche). Luther argued Christ's voluntary humiliation and subjection to human form as St Paul expressed it in his letter to the Philippians (2.8) 'obedient unto death, even death on a cross'.

And as Luther extended this logic to the rite of Holy Communion: 'The Lord's bread in the Supper is his true natural body. . . he who will not believe this should let me alone and hope for no fellowship with me.'

This was the dogmatic tone of Luther recorded in the minutes of the Marburg Colloquy of October 1529. A 'colloquy' implies a talking-shop, a conference, with overtones of give-and-take, dialogue, reasoning. But Luther came to the parleying table at Marburg with no intention of compromise. He was by now known as the champion of the Real Presence: the belief that Christ's institutional words for the Eucharist were meant to be taken literally. 'This is my body': '*Hoc est corpus meum*'. English church-goers, unversed in Latin, are thought to have derived the term 'Hocus-pocus' from that sacramental phrase, and extended its meaning to cover any kind of trickery and bamboozling. But Luther took it as a command of the most unmistakable power and clarity. Philip of Hesse, the politician who brought Luther to discuss the issue at Marburg, must have been dismayed to see Luther's first action on arrival at the negotiating table. HOC EST CORPUS MEUM: Luther chalked it on the surface before him, more flourish than memorandum.

The Real Presence: to certain distinguished theologians sharing Luther's 'Protestant' label, this was rationally indigestible. Luther was not entirely alone at Marburg – at the time he was supported by Philip Melancthon, whom we shall re-encounter presently – but he was becoming increasingly isolated over this particular insistence upon Biblical literalism. One of the participants at Marburg (Oecolampadius) pleaded that Christ must have been speaking figuratively when he said 'This is my body'. But Luther's more aggressive opponent was Zwingli, from Zürich. In Zwingli's eyes, the Lutheran insistence upon a non-symbolic understanding of the Eucharist was a grotesque lapse into pagan 'anthropophagy', or cannibalism. How could the Protestant cause advance if branded with such absurdity? What was the difference then between Luther's stand and the Catholic doctrine of 'Transubstantiation'?

The mire of fine and not-so-fine dispute at Marburg does not require our entry here. It was all recorded at the time, and makes wearisome reading today. Luther had his stockades of self-defence already erected: he never intended to shift. With

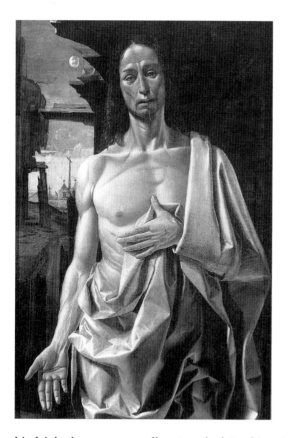

63 THE RISEN CHRIST
Panel attributed to Bramantino,
c.1490–1500.

Volume is given to the pallid
figure of Christ by the near-
sculpted drapery – producing
an effect at once spectral
and solid.

hindsight, he seems cussedly entrenched. But historians of the Reformation have since interceded on Luther's behalf. As Gordon Rupp argues, Luther's attitude at Marburg was not due to asinine obstinacy, nor even a simplistic unquestioning fundamentalism when it came to interpreting scripture. Rather, the stress on 'Hoc est' – 'this is' – inspired the rallying-cry of Lutheran credence, 'justification by faith alone'. To turn 'is' into 'signifies' or 'symbolizes' or 'stands for' was an act of subversion, which would destroy the saving grace of God incarnate.

The task of matching Luther's message with an image conceivably fell to Hans Holbein.

<p align="center">★ ★ ★ ★ ★</p>

In the early 1530s Holbein painted a miniature portrait of Luther's erstwhile buttress at the Marburg Colloquy, Philip Melancthon. It may have been done indirectly, and is not an outstanding example of Holbein's skill as a portraitist. Nevertheless, on the reverse of the tondo vignette Holbein added a boast. '*Qui cernis tantum non, viva Melanthonis ora, Holbinus rara dexteritate dedit*': which paraphrased would mean – 'You seem to see the living face of Melancthon. Actually this is the result of Holbein's rare skill.'

Like Luther, Melancthon approved of images and did not question their religious functions. He doubted, however, what power the image might claim. From his Classical reading, or from contacts with humanist scholars, Melancthon had

learned of the ancient Greek painter Apelles, and the astonishing claims of naturalistic depiction associated with the reputation of this Classical 'genius'. Although, as for us, there was no surviving work by Apelles on which Melancthon could base his assessment, the theologian upheld a principle of *literary* superiority all the same. In 1521 Melancthon produced an edition of St Paul's Letters to the Romans. In his preface he praised Paul's epistolary delineation of the figure of Christ. No Apelles, declared Melancthon, could match Paul's convincing evocation of Christ the man.

The ancient Apelles was gone. But he was not short of aspiring progeny in Renaissance Europe. To be hailed as 'the next Apelles' (*alter Apelles*) had become an artistic ambition. Fra Angelico and Dürer had already won the designation. Holbein was also covetous – as his boast on the back of Melancthon's portrait makes clear. The antique critical trope of being deluded by a show of illusionistic skill was central to gaining the accolade 'second Apelles'.

Some small settling of an old score may have been Holbein's purpose in producing his inscribed portrait of Melancthon: 'So you think we artists cannot match the powers of address?' But suppose Holbein, in 1521, had taken to heart the original challenge implicit in Melancthon's remark about St Paul's superior capacity for achieving verisimilitude, and delivering an essentially 'credible' figure of Christ. And suppose that Holbein pondered how that credibility could be taken *in extremis* – and applied to the figure of Christ at the end of mortal existence?

Luther – relying upon St Paul as the textual authority for his 'kenotic' theology – was vigorously preaching the voluntary mortal degradation of Christ Crucified. In his Palm Sunday sermon of 1522, Luther pounded out the logic of this gracious condescension by Christ. 'Even in His humanity He could have exalted Himself over all men and saved no one,' Luther declared.

The painters of *devotio moderna* had already shown how art could connive with the practice of affective piety and serve pell-mell for the incitement of tears. Grünewald and others had made the lacerated state of Christ during the Passion evident to the point of nausea. In a stylistic context, though, we feel 'High Renaissance' looming. Holbein was not eccentric from the technical expectation of painters in the early sixteenth century, to produce 'a developed use of the human body, and an enrichment of the total image presented by even a motionless figure'. On the threshold of that epoch (if we want to indulge such terminology), the technical synthesis of perspectival depth, resonant colours and the investment of volume in painting – the pride of the 'Venetian School' – is already evident in Bramantino's raw apprehension of the Resurrected Christ (63), enabling wraith and giant to appear as one.

Holbein was alive to these tests of virtuosity. And coveniently, perhaps, the challenge of creating the effect of three-dimensions upon a flat surface was now blessed with doctrinal impetus. For Martin Luther's call was not for the histrionics of lamentation. Luther's object of faith was plain and steady; almost lumpen. *Hoc est corpus meum*. This is my body. To death and beyond death: to the true mortification of the flesh.

The test for a second Apelles was to mirror that devotional tenacity. The result was Holbein's 'Dead Christ'.

64 THE ENTOMBMENT
Raphael, 1507

Calvary is a green hill far away;
those bearing the body of Christ
are treading backwards,
to a rock-cut place of rest.

**65 STUDY FOR
THE ENTOMBMENT**

One of several pen and chalk
sketches by Raphael that survive
as *concetti* for the painting.

7 PATHOS BY FORMULA, HORROR BY DECREE

'Two households, both alike in dignity. . .'

. . . in the old Umbrian town of Perugia. On one side, the kinsfolk of the Oddi; on the other, those of the Baglioni. Both families customarily accepted address as 'the High and Mighty'. But neither was above thumb-biting and brawling in the streets.

In the course of such family antagonisms – such as drive the plot of Shakespeare's *Romeo and Juliet* – one young scion of the Baglioni, Grifone or (more affectionately) Grifonetto, was cut down on Perugia's flagstones in July 1500. His assailants were from his own side: he was reviled as a traitor. For he, Grifonetto of the Baglioni, had led an attempt to slaughter senior members of the Baglioni clan even while they slept. And so his mother, Atalanta, herself widowed by the feuding, had cursed him for his treachery and refused him entrance to her house when he was pursued. But as news of his wounds reached her, Atalanta hastened to Grifonetto's side. Accompanied by Grifonetto's wife, Atalanta was with her son as he lay dying, coaxing forgiveness from him, and being reconciled to the boy with his last gasps. Then she was inconsolable: 'Had anyone been found so cruel as to slay her,' says the chronicler of Atalanta's *pietà*, 'she would indeed have died rather than lived.'

Atalanta lived on. And eventually – perhaps some five years later – she brought herself to commission a memorial to Grifonetto, embellishing the Baglioni chapel of the church of San Francesco al Prato in Perugia. Available for the task was a young, studious and promising painter, formerly apprenticed to local maestro Pietro Perugino. His name was Raphael: and the picture he painted for Atalanta Baglioni to honour her slain son Grifonetto was the *Entombment* (or *Deposition*) which now hangs in the Borghese Gallery in Rome (64).

It was Jacob Burckhardt, the eminent nineteenth-century historian of the Italian Renaissance, who first identified the links of local history and patronage with Raphael's picture. In Burckhardt's words, Atalanta, by commissioning an image of grief over Christ's dead body, 'laid her maternal sorrows at the feet of a yet higher and holier suffering'. But preparatory sketches for this image seem to indicate no such clarity of purpose originally conveyed to the painter. Raphael laboured to reach it.

The painting's present title itself provokes incertitude (as often with Renaissance pictures, we do not have any original label for the picture). What we view is neither 'Deposition from the Cross' – for the three crosses, upon a hill, make a faraway landmark – nor 'Entombment', since (strictly viewed) there is no sepulchre in sight. Neither are we confronted with the generic 'Showing' (*Ostensio*) prior to 'Entombment', an overtly devotional image in which the body of Christ is propped upright for final contemplation. Rather, we witness an arrested state of carriage between these events: a state we might describe as 'transitional', with one of the protagonists treading feelingly backwards up the slope where the

rock-cut grave will be found. Yet if 'transitional' implies 'passing', or even 'transient', then it is the wrong word for the effect Raphael has created. This is – famously – a monumental moment of motion and lament.

Raphael's early designs (*concetti*) explore a composition which assimilates the formal requirements of a proper 'Lamentation' or *Pietà*. That is, a more or less static assembly of figures inclined around the half-slumped, half-propped body of Christ: along the lines, perhaps, of Perugino's *Lamentation over the Dead Christ* in the Uffizi Gallery in Florence. Raphael's final painting would accommodate one element of melodrama often definitive of such scenes, the swooning (*svenimento*) or agony (*spasimo*) of the Virgin Mary. We do not have the full cartoon prepared by Raphael as the matrix for his final painting. Still, the record provided by his scattered studies of an overall 'vision' is eloquent enough (65). At a certain juncture, Raphael decided to propel the action beyond usual iconographic expectations (a tableau located at the foot of the Cross; or in some leafy Umbrian valley). He chose to make his team of mourners move.

So there is action in this squared-off frame. Captaining this action is the bearded figure of Joseph of Arimathaea who, according to the narratives of not only the Gospels but also the popular *Meditations on the Life of Christ*, tenderly took down the body of Christ, wrapped this precious freight in linen, and carried it up to a cliffside tomb. His assistant Nicodemus may or may not be among Raphael's company (since the other bearded elder is haloed, perhaps it is St Peter brought into the train). We have the beginning of ascent here: and by implying a craggy destination, Raphael has not followed the Italian quattrocento painters' custom of making Christ's tomb a grandiose box of best marble.

But Raphael is taking typical artistic and devotional licence when he adds extra participants – including, if such a central and powerful figure can be called 'extra', the flying-haired youth who supports the lower part of the sling for Christ's body. Clusters of such extra participants in conventional Italian 'Deposition' or 'Entombment' scenes – when not identifiable as stray angels – are usually glossed as servants of Joseph of Arimathaea, whom Matthew (27.57) describes as 'a rich man' (*anthropos plousios*). And if the painting served the likely function of altarpiece, this recruitment of impassioned onlookers or bystanders may be regarded as some sort of eucharistic invitation. In such pieces it would not be unusual for a portrait of the patron to appear amid these onlookers. Raphael, however, puts the presence of 'extras' to particular effect.

The effect is one that Classicists would describe as a quasi-*thiasos*: a company, or a gang, in processional mode. Not necessarily ecstatic (but often so), this cortège – in a Classical context – would signify the presence of a charismatic deity or demi-god. That antique sacral association may have been enough to justify Raphael's re-evocation of the *thiasos* here. But the painter's antiquarianism went further still. This 'Lamentation', painted for the lady whom Raphael saluted as 'Madonna Atalanta', became a procession because Raphael saw how it could be done – upon an old Classical sarcophagus. Studied individually, certain components of the painting may be claimed as borrowed from, or influenced by, a number of Raphael's predecessors and contemporaries: Donatello, Mantegna, Signorelli and Michelangelo are among the distinguished list of supposed

sources. But as a composition, there can be little doubt. This 'innovatory' depiction of Christ's improvised funeral is essentially indebted to a pagan model.

The influence of Classical forms upon Raphael's *Entombment* (for convention's sake we will stay with that inexact title) has been noticed before; but its extent has never been properly defined. Nor (more importantly) has anyone explained why Raphael, when commissioned to honour and sublimate a mother's loss of her son, had recourse to archaeology. The commission came as a result of a more or less contemporary, and apparently commonplace, event. Raphael was (we suppose) well aware of the piazza-death of Atalanta's Grifonetto. So why take as model the carvings of some ancient stone?

* * * * *

To describe Raphael as a serious antiquarian is no exaggeration. His contemporaries noted an interest that was truly scientific; especially after 1509, when the painter took up residence in Rome. (It was a scientific interest, but selective: Raphael appears to have believed in clearing Rome of all its uncouth 'Gothic' accretions, for the sake of restoring a skyline of Classical candour and consistency.)

Prior to his premature death in 1520, Raphael had elaborated a scheme to create an axonometric elevation of the structures of ancient Rome, based upon matching a careful measurement of existing ruins with whatever could be gleaned from Vitruvius and other Latin sources about the principles of Roman architecture and design. To his friends and admirers, there was no question that Raphael would have completed this scheme splendidly. But the principles behind the project were already laid down by the Florentine polymath and Vitruvius-scholar, Leon Battista Alberti.

That Raphael absorbed Alberti's writings is not generally doubted. If he was obedient to Alberti's prescriptive advice for the decorous representation of passionate behaviour, then we can understand why, even before he arrived at Rome, Raphael was an enthusiast for Classical antiquities: these relics, Alberti maintained, were object-lessons for all ambitious painters.

Alberti's handbook *On Painting* (*De Pictura*, or *Trattato della Pittura*) was published in the mid-fifteenth century; before, in fact, very many examples of Classical art had been documented and displayed as such. Nonetheless, Alberti was confidently dogmatic in his counsel: when a painter takes a theme, let 'history' rule.

Let history rule. Neither Alberti's Latin (*historia*) nor his Italian (*istoria*) is quite served by our term 'history'. By extolling the value of *istoria* as a basis for composition, Alberti does not mean a painter must eschew the depiction of all contemporary events. Nor does he deem that painters must earnestly study the works of Herodotus or Livy or Machiavelli. In Alberti's Italian parlance, *istoria* does not imply written history. It indicates 'decoration with scenes of happenings and stories'. (Thus, for example, the imperial Roman relief-spiralled columns of Trajan and Marcus Aurelius are referred to in Italian as *colonne istoriate*, 'historiated columns'.) Some ancient paintings with such narrative registers may conceivably

have been on view in subterranean Rome and elsewhere during Renaissance times. Bas-relief sculptures, however, were more likely to have been available for study – and, as we shall see, Alberti has these in mind as his most esteemed types of *istoria*.

But what might a painter learn from antique masters of narrative carved in bas-relief? How to render emotional states, according to Alberti. Since emotions (or 'movements of the soul') were given expression by postures (or 'movements of the body'), so there existed schematic means of expressing emotional comportment – which Classical sculptors had already established. Moreover, argues Alberti, the same sculptors had reached figurative perfection in depicting the extremes of human experience: especially when charged with decorating death's solid casket, the sarcophagus (and 'flesh-digester' is how the Greek *sarkophagos* could be literally construed).

Corpses, no less. Very difficult, notes Alberti, to show a truly morbid form in art. But see (he continues) – see how it has been accomplished upon one ancient sarcophagus. This, he tells us, features a relief depicting the death of the mythical Greek hero Meleager. Not only are those bearing the weight of Meleager's body convincingly distressed and straining, the form of the dead hero strikes its viewers as 'lifeless in every limb of his body' (*in ogni suo membro ben morto*).

Right down to the fingernails.

Alberti approves. This is how it should be done. A paradigm of *istoria* at work.

* * * * *

To note: Meleager, death of.

In life, he was of royal stock; an outstanding young warrior and athlete; slayer of the Calydonian Boar; and lover of a great huntress.

When Meleager was born, though, the Fates teased his mother Althaea. They hissed a cruel prediction. Her son's lifespan, they said, would last no longer than – ah, than that firebrand on the birth-room hearth! Immediately, Althaea snatched the firebrand away from the flames, and she concealed it for safekeeping.

So long as his mother kept the wood intact, Meleager flourished. Years later, when a colossal wild boar bristled into the land of Calydon, Meleager was the natural choice to lead its hunt.

He prevailed. Some say Meleager threw the spear which killed the boar and that he dedicated the boar's hide to his cherished huntress. But there was bickering after the hunt. Two of Meleager's uncles – the brothers of his mother Althaea – tried to take the boar's hide as their trophy. Meleager slew them.

When Althaea learned of her brothers' ends, she cursed and disowned her son. She took from its storage-place the firebrand which the Fates had marked as the gauge of Meleager's lifespan. She caused a fire to be stoked up, and she threw the brand upon it. Far-off, as the brand burned away, so Meleager wilted. Surrounded by his sisters and heroic retinue, he perished in mysterious agony.

Althaea 'endured not long after for very sorrow' (as phrased by A.C. Swinburne in his 1865 verse-drama, *Atalanta in Calydon*): she threw herself upon a sword.

Meleager's sisters wailed and reduced themselves to guttural cries: they

were metamorphosed into guinea-fowl – which Greeks would thereafter call *Meleagrides*.

Perhaps Meleager's huntress-lover also mourned.

Her name was Atalanta.

★ ★ ★ ★ ★

Ovid is the Latin poet who tells the Meleager story most fully, in Book Eight of his *Metamorphoses* (260–546: though see also Homer, *Iliad* 9, 527–600). While not given to poetic self-deprecation, Ovid ends by declaring that he simply cannot convey the 'piteous outcry' (*tristia dicta*) of the women mourning Meleager. It was too piercing.

'If you wish to make me weep, then the tears must come first from you.' Ovid's contemporary, Horace, issued this magisterial precept to novice bards in his verse-letter on *The Art of Poetry*, and it comes across as a stern order. Horace is not commenting upon the desirability of feigned emotion in reciting a poem aloud (as some commentators have thought). He is instructing whoever would write 'moving' poetry to participate in 'being moved' from the outset. In other words, a poet cannot hope to arouse tears in the audience if his own eyes did not swim when composing the piece. Insincerity will out.

Horatian instructions to Roman poets may seem to have little pertinence to our discussion of a High Renaissance chapel-painting. But if we resume our reading of Alberti (who knew – need one add – that very same text of Horace), it may assist some understanding of Raphael's intent. For Alberti, having praised the sheer expressive poise of the Meleager sarcophagus, proceeds to outline a painter's obligation 'to move the soul of the spectator'. In compliance with Italian humanist theory – as laid down, for example, by the Ligurian teacher and scholar Bartolomeo Fazio – Alberti judges the success of a painting by its capacity to engage, emotionally, whoever stood before it. The test of depicting emotions is, therefore, the viewer's response. If successful, a painting will induce in the beholder the emotions it represented. Viewers should then, in Alberti's words, 'weep with the weeping, laugh with the laughing, grieve with the grieving'.

So, as far as we have sampled Alberti's treatise on painting, we have encountered two clear principles regarding the production of expressive images. Reversing their order in Alberti's argument, they could be summarized as follows:

Firstly: a painter will gain honour by making pictures of figures which by their attitudes credibly represent extremes of human emotion.

Secondly: the iconographic codes or schemata for such credible representation were discovered and exemplarily deployed by the artists of Classical antiquity.

Horace had described a poem as painting's verbal equivalent (*ut pictura poesis*. . .), but Alberti's twin principles entrust a distinct advantage to painting. Ovid, the poet confronted with having to describe Meleager's lamentation (at which, after all, he was never present), shrugs his shoulders and declares the scene indescribable. But the painter – or relief-sculptor – once embarked upon the same story, cannot leave such a blank. The artist may not have been a direct witness. Fortunately,

there is a stock of attitudes and postures appropriate or decorous to the occasion. *Istoria* repeats itself. Alberti sanctions that resort to the past.

'If you wish to make me weep, then the tears must come first from you.' For the artist, however, no such sudden immersion in 'method-acting', as Horace directed, is necessary. There is, in short, a figurative formula for pathos.

<p style="text-align:center">★ ★ ★ ★ ★</p>

'Pathos formula'. Alberti did not put it in so many (or so few) words. This is a fritter of scholarly argot which we must briefly expound.

Pathosformel was the original German coinage of art historian Aby Warburg (1866–1929). Warburg, eponymous founder of an entire institute and approach to art history, has been influential enough; and it has been said that his concept of the pathos formula 'may well prove to be one of the enduring notions which the study of the visual arts has contributed to modern thought'. Yet we remain reluctant, generally, to invoke and apply the term. It does not sit happily with the modern criteria for genius, perhaps, to explain some marvellous or profoundly touching effect by reference to an artist's reach for antique form. Pillage, we might think; or worse, a sort of plagiarism. The critic who comments upon Raphael's *Entombment* that 'it savours of the Academy' shares that prickly suspicion. But if we truly desire our genius-artists to be free of such indebtedness, we shall have to make some major revisions to the canonical lists. The dispute over assigning some crown of supreme mastery among the artists of the High Renaissance traditionally narrows it to a contest between Michelangelo, Raphael and Titian. All three of them, however, knew most adroitly how to exploit a pathos formula.

'Adroitly' is the key word. A pathos formula, in the hands of some lesser artist, merely yields grotesque sensationalism, or visual cliché.

Aby Warburg never published a fully coherent explanation of how his *Pathos-formel* worked. What we comprehend of the concept is largely due to Ernst Gombrich's search through Warburg's untidy residue of notes and writings. Gombrich's phrasing of Warburg's definition of pathos formulae, the 'primeval vocabulary of passionate gesticulation', slightly misleads: 'primeval vocabulary' (as a translation for *Urworte*) hardly suggests the naturalistic sophistication of Classical figurative style as featured in the archetypes of pathos. But on the basis of Gombrich's excavations, we can outline Warburg's concept of the pathos formula as follows.

Pathos, in its Classical Greek sense, signifies some strong feeling, or passion. In Stoic philosophy, *pathe* were defined as 'excessive impulses'. Such *pathe* amounted to 'the extremes of physiognomic expression in the moment of the highest excitement' (in Warburg's words). Accordingly, a repertoire of bodily attitudes and compositional patterns was developed by Classical artists, to denote the extraordinary seizures and transports of human mood and sensation: primarily the ecstasies of pain, fear, longing and delight.

So, for example, on early fifth-century BC Athenian figured vases, painters fashioned a certain mode of the female form to indicate a woman gone wild with

the cult of Dionysos: head thrown back, hair loose, lips parted, arms akimbo, and garments swirling and slipping from the shoulders (66). This will become the 'Dancing Maenad' type of the Classical tradition: and whether she appears upon a Greek vase or a Roman sarcophagus, the stamp or 'engram' (as Warburg called it) of this sappy Dionysiac woman remains essentially fixed – that is, formulaic of an emotional climax or 'superlative'. She is a soul possessed.

Warburg used the language of numismatics to stress how a pathos formula was first cast or 'minted' in Classical art, and thence acquired currency across a range of media. As it circulated from vase to sarcophagus, from sarcophagus to column relief, from column relief to fresco, and so on, the pathos formula became an association of form with emotion which was a psychological reaction, and conceivably a subconscious reaction at that. Warburg, however, did not intend any given pathos formula to be absolutely fixed in its appearance. Both Classical and post-Classical artists could deploy pathos formulae with nuances and supplements: so long as the essentials of gesture and composition were there. And more importantly, artists of a much later age could use a Classical pathos formula without necessary regard to its original intention or effect. The fact that the tossed-back locks of a Dancing Maenad once betokened the 'orgiastic' abandon of Dionysiac rites, therefore, did not inhibit a Renaissance painter from letting the Maenad become his model for (say) a Mary Magdalene distraught beneath the Cross. A pagan frenzy of delight could serve as a pattern for a Christian frenzy of grief: for the expressive impact, the frenzy is what counts.

<div align="center">⋆ ⋆ ⋆ ⋆ ⋆</div>

Says Vasari of Raphael's painting for Atalanta Baglioni: 'In composing this picture Raphael imagined to himself the sorrow harboured by the nearest and dearest relatives when carrying the body of a loved one – one in whom truly the well-being and reputation and functioning of an entire family had consisted.'

Vasari's application of the Horatian principle is sweet, but unverifiable. We do not know how much Raphael empathized with the grievous family events he was commemorating in the Baglioni chapel at San Francesco. When he came to decorate the frame of his picture, he (or his assistants) included figures of little gryphons, surely to evoke the name of Atalanta's slaughtered son Grifonetto (which means, literally, 'little gryphon'). The hypothesis that portrait-features of Grifonetto appear in the painting's central figure (the handsome flying-haired youth) is perhaps less easily indulged; as is Burckhardt's vignette of a young Raphael, apprentice to Perugino, staring wide-eyed at the street violence waged in Perugia by the factions of the Baglioni and Oddi. Raphael may have been sensible to the reality of Atalanta's spectacular bereavement, but the only correspondence

66 ECSTATIC MAENAD
Detail of a red-figured amphora attributed to the Kleophrades Painter, *c*.480 BC.

A figurative stereotype of Dionysiac *ekstasis*, or 'self-abandonment'.

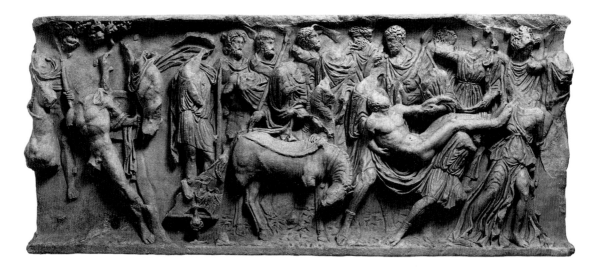

we possess between patron and artist is a note about remuneration – a complaint from Raphael that payment for his work was overdue.

But Vasari also gives us a more useful lead. Later in his life, he notes, Raphael was so grand that he had delegated draughtsmen (*disegnatori*) working for him all over Italy, and even in Greece. 'He was forever on the lookout,' comments Vasari, 'for whatever might assist his art.' One of Raphael's assistants, Giovanni da Udine, is recorded by Vasari as scavenging around the ruins of the palace of Titus in Rome, 'hunting for sculptures' (*per trovar figure*): it was from that site, in 1506, that the Laocoon Group was recovered. We may conclude that it was not so much Raphael's respect for honour among feuding Perugine families as his enthusiasm for Classical relics that shaped his work for Atalanta Baglioni.

We cannot identify which particular piece of ancient sculpture served to provide Raphael with the pathos formula suitable for sublimating the obsequies of Grifonetto. It may have been the same sarcophagus showing Meleager's death that Alberti described, or some other similar relief. Several sarcophagi survive in Roman collections that might qualify; possibly, Raphael studied one that has since disappeared. As it happens, though, the Archaeological Museum in Perugia displays a Meleager sarcophagus, dating from the late second century (67). Though battered, it will serve our present purpose; and with a history of various ownership in the region reaching back several centuries, this sarcophagus might indeed have been precisely what Raphael saw.

Mors immatura: 'precocious death'. On the sarcophagus, Meleager is borne away from his hunting cronies, his head tilted back, his right arm dangling in the foreground; his right shoulder is slightly raised as one of the bearers grips him underarm. This is the prone pose of Raphael's Christ. Meleager's left arm, however, is lifted. We can just make out the remnants of a female figure (head now missing) leaning over the corpse and clasping the dead boy's hand. This is the attitude of Raphael's Mary Magdalene. It was a stock attitude in Classical sarcophagi: Rubens later sketched a similar compositional motif from a sarcophagus showing the death of Adonis, and added his own 'text' for the grieving woman's instinct: '*Spiritum morientis excipit ore*' – 'she would take with a kiss the spirit of the dying one'.

67 DEATH OF MELEAGER
Panel of a Roman marble sarcophagus, late second century.

Meleager was one of the favoured mythical subjects for the decoration of such sarcophagi; it was a story which encapsulated the shock of sudden or unexpected bereavement.

Aby Warburg overestimated the neutrality of a pathos formula in action. Those who view Raphael's *Entombment* without any knowledge of Classical sarcophagi would not, it is true, lose any of the devotional force of the image; the same may be said of any viewer who comes to the painting ignorant of misfortune in the Baglioni family at the turn of the fifteenth century. But whoever recognizes the source of Raphael's double pathos formulae here is rewarded with an enrichment of meaning. Meleager was scarcely in manhood when cut down, as was Grifonetto of the Baglioni. Meleager died having been cursed by his mother; as did Grifonetto. Meleager's mother had cursed him because he had killed her own kin; precisely the reason Grifonetto's own mother had turned against him.

As for the correlation of names – pedantically, Atalanta as mother does not quite mirror Atalanta as mistress. But that is asking too much. Raphael has proved the power of pathos by formula. It rests in the fact of history repeated; and humanity revealed in response to its own suffering and death. In mythical Calydon, in an Umbrian city-state; or in some place with a view to the distant hill of Calvary.

★ ★ ★ ★ ★

It was the distinguished papal architect, Donato Bramante, who, as related by Vasari, set up the contest at Rome. In 1510, according to some; but perhaps in the same year (1507) that Raphael consigned his *Entombment*. The challenge: who could fashion the best wax replica of that marvellous ancient statue lately dug up near Santa Maria Maggiore – the Laocoon? Four sculptors competed. To judge this trial of artifice, Bramante called upon Raphael. The winner was Jacopo Sansovino. His prize was to have his model cast in bronze.

So begins the history of artistic homage towards the Laocoon Group when it came to be displayed in the Vatican: an object-lesson of art's power; a summit of technical ability; and a canon, or even *the* canon, of suffering given fixed form. By 1563, when the first formal fine art academy was established in Florence, it was axiomatic that all aspiring artists copied from the relics of Classical statuary. The Florentine institution was given the name *Accademia del Disegno*, and though *disegno* implies more than simply 'drawing', there is no doubt that draughtsmanship of the Classical figure had paramount importance in priming an artist's career.

The Laocoon Group attracted not only novices, though. Established masters also rigged their sketching-stools before it. The statue's imprint soon travelled, and not only upon paper: a plaster cast of the Laocoon is thought to have been available to Titian by around 1520. No wonder that a Laocoon pathos formula came about. It was hailed as the *exemplum doloris* – agony's paradigm. A frugal sample of the statue's formulaic influence during the sixteenth and seventeenth centuries will suffice to indicate its strength.

What are we looking for? Essentially, the Laocoon as a pathos formula is delineated by four features of physiognomic strain. First, the head: tilting sideways or thrown back, or both of those. Then the arms: as the statue was first reconstructed after its discovery, the right arm reached higher than it is now considered to have been (68; compare 7); but in any case, one arm is raised, creating a dynamic axis of

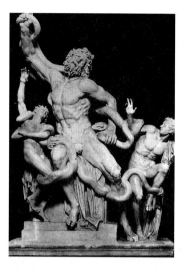

the thorax which is maintained by the other arm reaching downwards. Then comes the torso itself, twisting and convulsed and mapped with many lateral and abdominal muscles. Finally the legs: one outstretched, the other with raised knee.

Because Michelangelo is romanced as having been present at the discovery of the Laocoon in 1506, its effect upon his work is often cited, sometimes rashly (the *Entombment* attributed to Michelangelo in London's National Gallery – now dated to 1500 – can hardly be 'unthinkable without knowledge of the Laocoon'). Still, it is difficult to deny that a certain heroic cast of body held sway for decades of the High Renaissance and beyond. This 'somatype' was essentially indebted to twin Hellenistic exemplars: the Laocoon, and that tormented fragment-bulk we call 'the Belvedere Torso' (69). It is epitomized by the Risen Christ who sits as magistrate in Michelangelo's *Last Judgement* for the Sistine Chapel.

Victorian evangelists may have invented 'muscular Christianity', but Michelangelo created the original muscular Christ. In this instance we are not concerned with the Laocoon as a pathos formula, simply as a colossus. The harness of such bovine strength adds to Michelangelo's famed effect of 'terribleness' (*terribilità*). Broad-backed, great-chested, and with a girth at once both ample and taut, Michelangelo's Sistine Christ belongs to the epic plains of Troy, not the Roman province of Judaea. As such, this heroic form can seem misplaced, especially when aped by later painters. Of Domenichino's *Christ at the Column*, for instance (70), empathetic response is surely tempered by the viewer's suspicion that the plight of Jesus here could so easily be resolved: let the pinioned Christ flex those sinews, like Samson, and bring the pillar tumbling down. Eventually Michelangelo, in a series of what appear to be 'chalk meditations' upon the Passion done during his senior years, would soften and contract the hearty physique of his Sistine Christ. It is upon the vault of the Sistine Chapel, however, that we find a clear example of Michelangelo using the pathos formula of the Laocoon.

The formula occurs in a crucified figure. But it is not that of Christ. In a corner, or spandrel, of the frescoed ceiling – approximately above the location of the papal throne – Michelangelo inserted a visual memorandum of the fate of the Old Testament villain, Haman. Nailed to a makeshift structure, this Haman is virtually the image of Laocoon inverted (71). Head, arms, thorax and legs: they all corre-

70 CHRIST AT THE COLUMN
Domenichino, 1603

In the *Revelations* of the
fourteenth-century Swedish
mystic St Bridget, a vivid
account is given of how
Christ was scourged at a
column, on the orders of Pilate.
Domenichino's picture gives
us the small granite column
displayed in Rome as a relic
of this episode.

71 DEATH OF HAMAN
Detail of the Sistine Chapel
ceiling frescoes: completed
by Michelangelo in 1512.

This spandrel appears to belong
to a set of 'four corners' on the
ceiling that illustrate episodes
of Israel's deliverance from
disaster and persecution.

spond; with the central torsion made necessary because the main pole of crucifixion is a gnarly tree-trunk.

The programmatic structure of imagery across the Sistine Chapel has been the subject of much scholarly speculation. For the story of Haman, we should refer first to the Old Testament Book of Esther, where Haman appears as a scheming vizier at the Persian court of King Ahasuerus (or Xerxes, as the Greeks knew him). To paraphrase a complex plot, Haman is 'hoist by his own petard'. His plan to eliminate all Jews under Persian rule is thwarted; he is executed as he would have executed. A Franciscan mystic of the twelfth century, Joachim of Fiore, specified that the mode of punishment was crucifixion; then, in Dante's *Divine Comedy*, there is a vignette of Haman in Purgatory's 'Bridle of Wrath'. *'Crucifisso, dispettoso e fiero/nella sua vista, e cotal si morìa'*: 'one crucified, despiteful and arrogant in his visage, thus dying there' (*Purgatorio* 17. 25–7).

Michelangelo had a reputation as a *Dantista*, or aficionado of the poet; Dante's lines may well have supplied the artist with a cue to make of Haman some inverse prefigurement of Christ's redemptive death. But if we consider Michelangelo's Haman as the visual 'echo' or mirror-image of Laocoon – and we might remind ourselves that the statue itself was on display in Vatican precincts, not far from the Chapel – we could again be tempted to question the inherent 'neutrality' of a pathos formula as it is used here. Did Michelangelo know enough of the Laocoon story to grasp its ancient moral import: that is, overweening human ambition cut down by divine vengeance? If so, then the precision of his 'borrowing' is nice: it invests a Hebrew tale with as much pagan wisdom as Christian prophecy.

A similar investment of humanist understanding may be surmised from Domenico Beccafumi's annexation of the Laocoon pathos formula for his picture

of the suicide of Cato Uticensis in a Sienese palace (72). Perhaps painted after Beccafumi's visit to Rome in 1519–20, it is another example of apt utilization. Cato (or 'Cato Minor', as he is also known) was celebrated in Roman history and rhetoric not only as an uncompromising republican, but also for his noble Stoicism. As we have seen (p. 25), Jacopo Sadoleto, moved to verse when the Laocoon was retrieved in 1506, described the beleaguered Trojan priest as 'groaning' and thereby introduced a distinctly Stoical angle of appreciation for the theme. As J.J. Winckelmann was later to note, to groan (*seufzen*) is not to yell. A Stoic who deliberately took his own life might be imagined as the groaning sort: hence, perhaps, Beccafumi's nuanced reference to Laocoon.

A pathos formula is an accumulative phenomenon. It gathers new memories and fresh associations as its flexibility and usefulness are proved by artists over and again. Because Titian produced a caricature of the Laocoon Group as a trio of squealing monkeys, he is thought to have been protesting against the canonical or academic influence of the revered statue-group. But his wider work suggests that Titian, too, was an artist who could shrewdly manipulate the subliminal power of the Laocoon 'struggle posture'; that is, without compromising his own creative personality. In Titian's earlier work, such as the polyptych for the church of Sts Nazarius and Celsus at Brescia, the figure of Laocoon may subsist in the forms of both the banner-waving Risen Christ, and a writhing St Sebastian (74). Later in the *oeuvre*, however, it is only when consciously tracking the quartet of formulaic Laocoon features that one realizes that Titian's *Tityus* in Madrid, for example, is more or less Laocoon tipped upside-down (73). In Classical Greek cosmology, Tityus was a primordial giant who had assaulted Apollo's mother Leto: for which he was perpetually punished in the Underworld by vultures tearing at his liver. So the mode of retribution was similar to that meted out to Prometheus (and indeed Titian's canvas has often been mistaken as a *Prometheus*). Better for Titian to call upon the absolute 'superlative' of a pathos formula, we might agree, than follow Parrhasius – the Classical painter who had his Prometheus model tortured to death (see p. 95).

Far from provoking resentment, the formulaic imprint or 'engram' of Laocoon's body was institutionally made available to painters and sculptors throughout the sixteenth century and beyond. That is, the proliferating schools of fine art made study of the Laocoon Group routinely part of the curriculum. Perhaps few students went to the lengths of diligence demonstrated by the English neo-Classical sculptor Joseph Nollekens (1737–1823), who calibrated exactly the dimensions of the statue for his own records. But though hardly 'typical', the clearest example of an artist studying the Laocoon and turning that study to profit is perhaps provided by Peter Paul Rubens, who first came to Rome in 1601.

Some fifteen drawings survive of the hours Rubens spent with the Laocoon. The painter took diverse 'angles' of study from around the group, probably made during a series of visits to the Vatican's Belvedere Gallery between 1606 and 1608. He returned to his native Antwerp, in Flanders, late in 1608, where he was soon commissioned to undertake two enormous local projects. First was a triple altar-piece, or *retable*, for the church of St Walburga, for which Rubens produced a *Raising of the Cross*. He lost no time in announcing his Roman credentials. Emphatically, the Christ of Rubens departed from Flemish tradition: outstretched here was no spindly, slack-bellied ascetic, but a powerful alumnus of the Classical gymnasium. Then, in a similarly huge triptych painted for Antwerp cathedral, Rubens had this cumbersome champion hoisted down (75).

At its heart this *Deposition from the Cross* by Rubens is no less Classically-inspired than Raphael's panel of a century past. Light beams on to and away from a central figure which has ceased to struggle, but which is caught – literally – in Laocoon's schematic pose. And, as if to heighten that figurative recall of the pathos formula, Rubens brings on a further member of the Laocoon Group. He shapes Nicodemus,

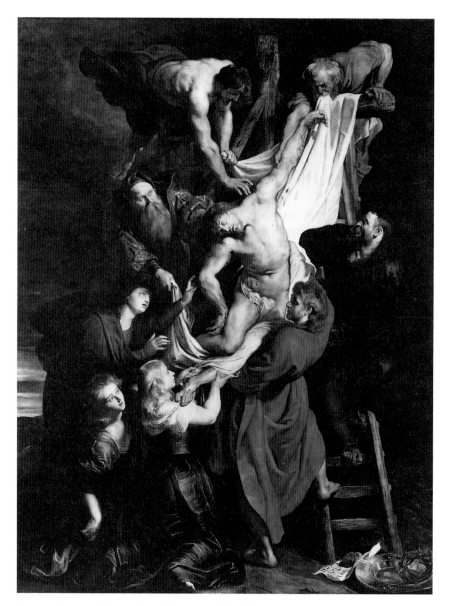

75 THE DESCENT FROM THE CROSS
P.P. Rubens, 1613

Central panel of the altarpiece of Antwerp Cathedral. The body of Christ makes the pose of Laocoon in reverse. Rubens has also allowed a supporting figure – that of Nicodemus, mid-way up the ladder – to repeat the attitude of one of Laocoon's sons.

descending a ladder on the right-hand side of the composition, into the attitude of Laocoon's elder son.

Section eighty-one of the medieval *Meditations on the Life of Christ* choreographs a piteous tableau for an event which none of the Gospel writers cared to describe in detail. 'Attend diligently and carefully to the manner of the Deposition. Two ladders are placed on opposite sides. . . the nail in the feet pulled out, Joseph descends part way, and all receive the body of the Lord and place it on the ground. The Lady supports the head and shoulders in her lap, the Magdalene the feet. . .' Rubens could draw deeply upon the iconographic tradition associated with this text, beginning with Duccio's grand *Maestà* altarpiece for Siena cathedral (1308–11). His capacity to honour that tradition while at the same time entirely remoulding its flesh-bound focus, proves Rubens not only an apothecary of

126

pathos by formula, but also – as he duly served in Spanish-ruled Flanders – the master diplomat.

<div align="center">★ ★ ★ ★ ★</div>

Rubens, it has been said, gives us 'exuberance *in sacris*': expansive, blaring statements of Catholic dogma invested with near-'orgiastic' gusto. Witness his painting *The Triumph of the Church* (76): brute heretics rolled over by the progress of the Roman Church, a trundling 'Dionysiac' revel commanded by a florid dame whose valet-angel holds aloft the papal tiara and whose equerry carries the standard of St Peter's double keys. History has a label for the spirit envisaged by Rubens here. It is 'the Counter-Reformation': that strict revitalization of Catholic theology intended as a response not only to the Protestants, but also to the liberal scientific 'Humanism' of Renaissance intellectuals.

The launch of the renewal is generally located in the proceedings of the Council of Trent. Trent (Trento) lies in the northern extremities of Italy, not far south of the German-dominated Tyrolean Alps. The very location of this gathering was supposed to be a conciliatory gesture towards the German Protestants. But though debate within the twenty-five sessions of the synod (held between 1545 and 1563) was often cantankerous, it was never ecumenical. The diverse factions of Continental Protestantism were already so dogmatically entrenched that they despatched no delegates. The Council of Trent became, in effect, the strategic headquarters for planning a Roman Church Militant; devising the logistics of an evangelical campaign, with ambitions of conquest ('increase of the faithful') that lay far beyond Europe.

'After the Council of Trent' is a phrase favoured frequently enough by art historians, especially those seeking the roots of that style we call 'Baroque'. But it is important to note that the business of the Council of Trent (eventually producing

76 THE TRIUMPH OF THE CHURCH OVER IGNORANCE AND BLINDNESS
P.P. Rubens, 1626

One of the figures stumbling aside from the triumphal cart appears to be Socrates, grafted with a pair of donkey's ears.

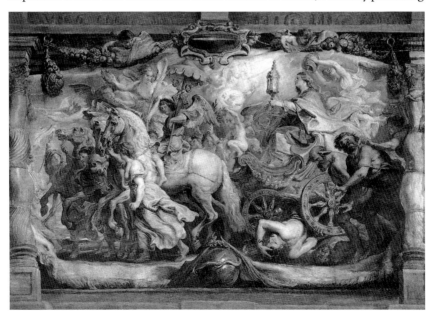

what are called 'Tridentine' decrees) hardly concerned itself with the visual arts. Only during their very last session did the councillors specify a code of practice for the display of images in sacred contexts. And then their conditions – such as the approval of subjects by appropriate bishops, even when a church lay outside diocesan control – were mostly predictable enough. Otherwise the Council of Trent merely reiterated the old 'Iconophile' justification of *arte sacra* serving as scripture for the unlearned. Following an adage usually associated with St Gregory (Pope Gregory the Great, 590–604), art was sanctioned as the most effective means of instructing the illiterate to understand the articles of faith, imitate the saints and, above all, in the Council's official prescription, 'be stimulated to adore and love God and to cultivate piety'.

The Council of Trent, it is true, contributed strongly to the discourse about censorship within 'the Counter-Reformation period'; it may even have given doctrinaire support for some of the extreme zeal shown by those clerics entrusted with hunting down 'errors' and 'heresies' (though the papal 'thought-police' or Inquisition had been established since 1231). 'Errors' might include the corruption of Christian imagery with pagan symbols and characters: so, for example, there was tampering with Michelangelo's Sistine frescoes, with one artist (El Greco) volunteering to repaint the entire chapel 'honestly and decently'. The Venetian painter, Paolo Veronese, was interrogated by the Inquisition in July 1573 and asked if he was aware of artistic 'mischief' (*scurrilità*) abroad 'in Germany and other places infested with heresy'. But – as we have already seen, with Rubens – artists were evidently not monitored for 'Classicizing' in their styles, nor indeed prohibited from pagan themes. (None of the painters at Venice in this period seems to have suffered such restriction, at any rate.) The influence of the Council of Trent upon art came rather by default.

What the Council unequivocally affirmed was the sacramental canon – Transubstantiation – whereby the 'sacrifice of the Mass' was a 're-presentation' of Christ's original 'bloody sacrifice' on the Cross. Humanists such as Erasmus had argued for a 'Christianity without tears'. They were absolutely repudiated at Trent. Whoever believed in Christ took shares in His suffering.

How so? By meditative empathy and passionate contemplation. And the medium for such excitement? Figurative art. Or better: art without qualms or qualifications; art which left no room for doubt; art as if thunderous declamation from the pulpit; direct, beseeching, inflammatory art.

In medieval times the effect of the liturgy upon the content and style of sacred images had been left to operate more or less of its own accord. During the sixteenth and early seventeenth centuries, however, a number of Italian and Spanish clerics took it upon themselves to compose directives to artists and their patrons with a view to promoting the fresh apostolic spirit. A new enthusiasm for codifying symbols is reflected in Cesare Ripa's dictionary-guide of 1593, called *Iconologia* ('image-reading'), and offering 'descriptions of universal imagery . . . necessary for poets, painters and sculptors, to represent the virtues, vices, affections and human passions'. But perhaps we are best primed by a sample of religious verse from the period. Richard Crashaw (1612–49) is described as 'pre-eminently the English poet of the Counter-Reformation': both his style and his subjects would

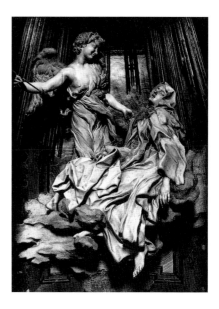

77 THE ECSTASY
OF ST TERESA
Bernini, 1647–52

Marble statue in the Cornaro
Chapel of Santa Maria della
Vittoria, Rome. St Teresa's own
testimony records penetration
by an angel's dart deep into
her entrails: 'The sweetness
caused by this intense pain is
so extreme that one cannot
possibly wish it to cease...'

epitomize what was to be expected from 'art after the Council of Trent'. Ornate,
darting and decorative imagery, 'lovingly fondled'; extreme sensuousness, to the
brink of erotic conceit; and unabashed immersion in the blood of Christ and the
martyrs as 'a deluge of deliverance'. In Crashaw's address to St Mary Magdalene,
or 'The Weeper', we find Mary's eyes become 'Two walking baths; two weeping
motions;/Portable and compendious oceans.' Dwelling 'Upon the Infant Martyrs',
the poet sluices us with 'one flood,/The Mothers' milk, the Children's blood'; and
in his best-known work, the 'Hymn to Saint Teresa', Crashaw lauds the eternal
ecstasy of martyrdom:

> *O how oft shalt thou complain*
> *Of a sweet and subtle pain;*
> *Of intolerable joys;*
> *Of a death, in which who dies*
> *Loves his death, and dies again;*
> *And would for ever be so slain.*

Even more well known is the statue which those words might almost have served
to describe: Gianlorenzo Bernini's *Ecstasy of St Teresa* (77).

★ ★ ★ ★ ★

Bernini, the sculptor now acknowledged as captain of the Italian Baroque, was
scarcely out of paternal apprenticeship when he fashioned the image of his holy
namesake St Lawrence (78). It may have been a technical challenge: how could a
sculptor show the flames of this martyrdom, which hitherto had been shown only
in painting and mosaic (see 16)? By any standards – let alone those one might
apply to a sculptor only sixteen years old – the result is impressive, and certainly
true to the original narrative of the martyr's fate. Upon a solid but busily flickering

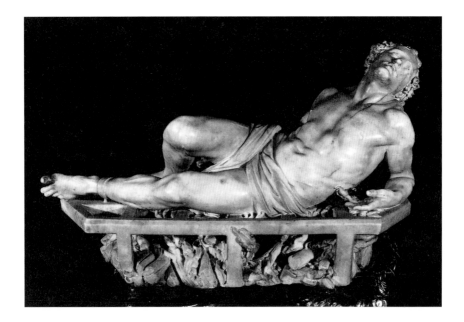

gridiron, St Lawrence reclines on his left elbow as languidly as any Roman ban-queter, with his head tipped back in voluptuous satisfaction. Torturers require noise for their gratification, but this is the victim who thwarts them of an ambience shrill with shrieks of pain: even laughs, and tells them (as we have heard) when to roast his other side. True ardour – and a carved attitude of rapture that Bernini would refine but not alter throughout his subsequent career.

Bernini's own son Domenico gives us a tale behind the making of the piece. We may feel a sense of the predictable here: it more or less recycles Vasari's story about Bonsignori's St Sebastian (p. 87). Domenico tells us that Bernini, in order to apprehend 'the effect that the fire should have on the flesh and the agony of martyrdom on the face of the saint, placed himself with his bare leg and thigh against a lighted brazier' – and recorded the result using a mirror. This seems like a measure of the sculptor's devotion to his *métier*, not an explanation of appear-ances. But what constitutes 'realism' here?

Those moderns who cannot look upon Bernini's work without glimpsing the physical insignia of sexual bliss – beginning with the eighteenth-century French cavalier who takes one look at Bernini's St Teresa and quips, 'If this is divine love then I know all about it' – underestimate the tenor of Counter-Reformation creeds. Impropriety lies in the mind of the beholder. Bernini and his contempo-raries knew very well what lay behind St Teresa's 'transverberation'. It was the result not of male sexual prowess, but Teresa's own struggle to climb the 'ladder of ascent': the four stages of prayer that end in utter surrender to God.

'Union', 'flames', 'saturation' – in her spiritual autobiography, published in 1562 and widely disseminated, St Teresa engagingly confesses how difficult it is to find words or metaphors to describe this ecstatic state. According to one interpre-tation, Bernini and other virtuosi of the Baroque 'were committed to a systematic exploitation of the inordinate', and so deservedly failed 'to find an adequate artis-tic expression for the mystical experience'. But mystical experience, within the

78 THE MARTYRDOM OF ST LAWRENCE
Bernini, *c.*1614–15

The tipped-back head, the pinioned legs and arms of the marble statue – again it is hard to exclude Laocoon's influence here.

context of the Counter-Reformation, was not transformation as such. The Council of Trent had affirmed the theology of God Incarnate. It may have outlawed 'lasciviousness' in religious imagery; still it was committed to carnal expressiveness, in the sense of 'carnal' as 'according to the flesh'. Only in that way could sacred art achieve its desired effect: to be vivid, intelligible and, above all, *inspirational*.

Inspired – for what? Not to rest with the quiet gain of self-gratification, but to go forth and communicate; just as St Teresa went out from her native town of Avila in Castile, broadcasting her mystical energies through the practical establishment of Carmelite communities throughout Spain. The Council of Trent laid out a system of seminaries (literally, 'seed-beds') at Rome in order to raise a more formidable clergy, fostering a culture of trained and outgoing priesthood that was radically different from the ideal of monkish retreat. The lead had already been given by another charismatic Spaniard, Iñigo, from the Basque town of Loyola. In 1540, St Ignatius (as he became) gained papal consent to organize a 'Band of Jesus', whose purpose was overtly evangelical and whose constitution pseudo-military. Ignatius served as 'General' over a brigade of highly disciplined recruits, charged with a mission as 'Jesuits' not only to preach but also to educate. Field orders, as it were, came from the handbook of *Spiritual Exercises* published, with papal approval, in 1548.

To his *caballeros imitadores* or 'apostolic cavaliers', Ignatius issued instructions for a passionate engagement with Christ's suffering and redemption through meditative strategies involving all five senses. The *Spiritual Exercises* are couched in the language of soldierly allegiance to Christ 'the King': service, fidelity, prevailing in the field. And by accepting that their uniform was the livery of Christ Crucified, the Jesuits were prepared for tests of conspicuous devotional gallantry. Of their cohorts in the time of the English Jesuit and poet Robert Southwell (executed in 1595) it has been said that they 'counted death for themselves, not others'; and Southwell's fellow martyr, Edmund Campion, is characterized as being recklessly 'chivalric' in the mission that led to his despatch at Tyburn gallows in 1581.

Lieutenants of Ignatius such as St Francis Xavier went out to establish beachheads in the Far East, the Indian sub-continent and South America. The spirit of Catholicism Militant diffused into poetry: the Italian poet Torquato Tasso was not a Jesuit, but his *Jerusalem Liberated* (published c.1581) makes an epic of the First Crusade in such a way that it reflects the missionary heroics of the Counter-Reformation. (In 1570, for example, forty Jesuits had been killed *en route* to Brazil.) And artists – inevitably – were given fresh incentives to rekindle the heat of early Christian witness and martyrdom.

'Inevitably'. There is a period in the history of Catholic Europe when it seems that no painter's career could move forward until some graphic scene of martyrdom had been proved as part of his repertoire. One could almost pluck names at random and the story would be the same. Jusepe di Ribera, for example – a Spaniard transposed to Naples in 1616 – only found favour, allegedly, after a *Flaying of St Bartholomew* was publicly exhibited in the city. Or consider Nicolas Poussin, a painter whose output (unlike Ribera's) we would not normally associate

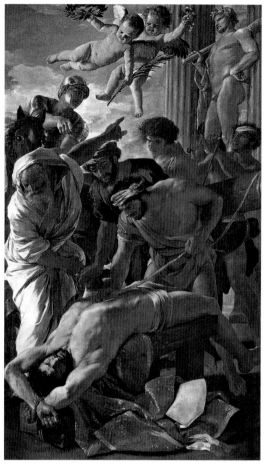

with visceral violence. Poussin's sole public commission in Rome was an altarpiece for the newly completed basilica of St Peter's: below a grimacing Hercules, and two fluttering *putti* who bring the martyr's palm, Poussin lays out the figure of St Erasmus (also known as St Elmo), who was legendarily punished during the time of Diocletian by having his intestines extracted – while still alive – and wound up on a device like a ship's windlass (79). The connoisseur of style may observe here that 'Poussin has demonstrated how a Classically minded artist can compose in a Baroque idiom'; we may be content to note that an artist competing for ecclesiastical patronage at the papal court may have had little choice but to address a subject such as this: horror of the most directly gut-wrenching sort; the extremity of committed Christian witness.

Of course, artists prior to the Council of Trent had not shirked vigorous scenes of martyrdom. Pontormo's *Martyrdom of the 10,000*, in the Pitti Gallery in Florence, for instance, was done in 1529; Luca Signorelli's circular *en grisaille* vignettes of massacre, torture and outrage for the San Brizio chapel of Orvieto cathedral belong to *c*.1500. Arguably, the ethereal elements of 'Baroque' devotional imagery were already present in the work at Rome of Sebastiano del Piombo (his lunettes for the Villa Farnesina, say, of *c*.1511). So the significance of deploying that phrase, 'after the Council of Trent', can be overestimated. Still, it seems true that the edict

79 THE MARTYRDOM OF ST ERASMUS
Nicolas Poussin, 1628–29

The work has been critically taken to show Poussin's unsuitability as a painter of altarpieces. (An oil sketch of the composition may be seen in Ottawa.)

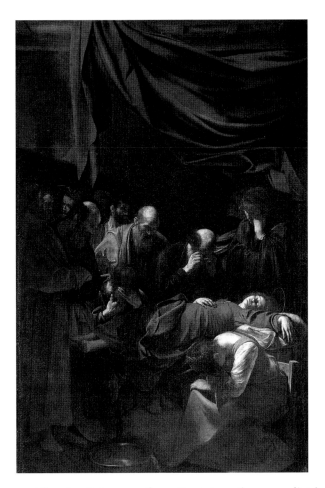

80 THE DEATH OF THE VIRGIN

Michelangelo da Caravaggio, *c.*1605–06

Removed, on the grounds of 'unseemliness', from its commissioned place by the Fathers of Santa Maria della Scala, and promptly purchased by the Duke of Mantua, it is now in the Louvre.

on 'direct' religious art from Trent in 1563 – an edict largely framed by two Spanish bishops who were close to Ignatius Loyola – was received as a decree encouraging the deliberate depiction of horror. Antonio Possevino, a Jesuit who produced a prescriptive tract on poetry and painting in 1593, specified the need for artists not only to depict explicitly the pains of Christian witness, but also to undergo such trials in person. We know that Bernini practised the *Spiritual Exercises* of Ignatius; it is speculated that other artists of the time also tried the Jesuits' discipline. Among these, the Baroque painter we know as Caravaggio, who apparently tested the proprieties of naturalism with his large altarpiece, *The Death of the Virgin*, for a church of Roman Carmelites (80). Some complained that Caravaggio's model was a squalid prostitute, or the corpse of some such unfortunate woman fished out of the river Tiber; others demurred that, in any case, the Madonna's swollen legs made her look too grossly moribund. The artist himself may have wondered if the ecclesiastical authorities indeed knew what they wanted of this subject. Nevertheless, the picture's essential effectiveness was recognized at the time by Rubens; and Caravaggio's assembly of grieving figures – mostly barefoot apostles – remains tender and credible: quite free of histrionics.

Not surprisingly, perhaps, the 'horror by decree' aspect of Counter-Reformation ideology was most vigorously implemented by mediocre artists. Either because

they were short of cash, or because they preferred to patronize a pliable craftsman rather than some wilful luminary, the Jesuits themselves commissioned distinctly second-rate painters to decorate their centres of worship in Rome. The churches of the Gesù, San Vitale and San Tommaso di Canterbury are all, in varying degrees, artistically undistinguished: the likes of Caravaggio, or the Carracci brothers, or even the notoriously docile Pietro da Cortona, were not called upon to embellish these shrines. And for the most architecturally distinctive church allocated to the Jesuits in Rome, the antique Santo Stefano Rotondo, two painters were employed who were readily acknowledged by their patrons as hacks. Niccolò Circignani da Pomarancio and Matteo da Siena will not be found in the roll of Italian artistic genius. But upon the ambulatory walls of 'St Stephen-in-the-round' they left a mark which even modern neglect has failed to erase.

<p style="text-align:center">★ ★ ★ ★ ★</p>

The novelist Charles Dickens wrote of his visit to Santo Stefano in 1845:

> Such a panorama of horror and butchery no man could imagine in his sleep . . . Grey-bearded men being boiled, fried, grilled, crimped, singed, eaten by wild beasts, worried by dogs, buried alive, torn asunder by horses, chopped up small with hatchets: women having their breasts torn with iron pincers, their tongues cut out, their ears screwed off, their jaws broken, their bodies stretched upon the rack, or skinned upon the stake, or crackled up and melted in the fire: these are among the milder subjects.

One biographer of Dickens observes that his subject was 'so out of sympathy with the Catholic Church that he saw only its surface'. But Dickens was not only unsympathetic to the subjects of the frescoes he saw there. The phrase 'these are among the milder subjects' is a naughty exaggeration.

Victorian tourists in Rome liked bustling up the Caelian hill to find this chamber of horrors. Thomas Arnold, abolitionist of fagging and flogging and other rigours of the English public school, is among those who have left accounts of their visit. Nowadays, Santo Stefano is less disturbed; and the frescoes by 'Il Pomarancio' and his associate have been allowed to flake and fade.

There are thirty in all: framed by Ionic pilasters, they make a programmatic circular tour of spectacular martyrdom, prefaced by a salute to Christ Crucified as *Rex gloriose Martyrum*, 'Glorious King of Martyrs'. We see that Gregory XIII – the same pope who ordered a 'Te Deum' to celebrate the massacre of the Huguenots in 1572 – subsidized the work, which was evidently initiated by senior staff at the Hungarian-German College of Jesuits (to whom Santo Stefano had been assigned). St Stephen, as 'protomartyr', may be said to spur the theme of the decoration, and indeed he appears second to Christ in the order of depictions; thereafter the martyrdoms, whether individual or multiple, are mostly so exposed that they hardly require the twin Latin and Italian texts provided alongside for identification or *aide-mémoire*.

81 **THE MARTYRDOM OF ST AGATHA**
'Il Pomarancio'
(Niccolò Circignani), 1582

Fresco in Santo Stefano Rotondo. Agatha's Christian witness is located in Roman Sicily; part of her torment lay in having her breasts crushed and then cut off. As well as being iconographically mistaken for bells, St Agatha's dismembered breasts were also understood as loaves – hence her service, in some places, as patroness of bakers.

On the walls of Santo Stefano, graphic explanation is all. We may have known that Pope Callistus I was killed in Rome's Trastevere by a lynch-mob: here it is made obvious that the mob dropped Callistus into a well. Possibly we were aware that toothache sufferers prayed to Apollonia, heroine saint of the dental profession: here we see St Apollonia's tongue and teeth plainly yanked out of her mouth. As for St Agatha, there is no evasion of the mammary dismemberment which inspired bell-makers to take her for their patron. Hence the bloodied instruments, bleeding body, and two detached breasts in the foreground (81).

To say that such scenes 'verge on anti-art' is impertinent. The frescoes belong to a place which hosted the daily ritual of Mass, and regular incantations of the Litany of Saints. There were some 130 Jesuit neophytes here, mostly in late adolescence and, at this stage in their training, very much creatures of the classroom, where mastery of Latin, Greek and Hebrew was required. They might as well learn the full extent of what could be required of them as missionaries: these images show that extent.

Even the untutored eye can see that the paintings of Santo Stefano were not lavishly done: the very pigments seem stinted and thin. So let this stand as didactic and truly anaesthetic art. Or if the notion of anaesthesia, 'unfeelingness', is too coarse, then let us accept that the frescoes of Santo Stefano do not numb the spirit, but put iron in the soul. Cumulatively, the martyr subjects create an adrenalin-raising effect of kinship and triumph. One elder of the College noted that many of the scenes 'could not be viewed without tears'. But these are the happy tears of the Ignatian spiritual gymnast: for whom 'the voice of misery is the voice of God'.

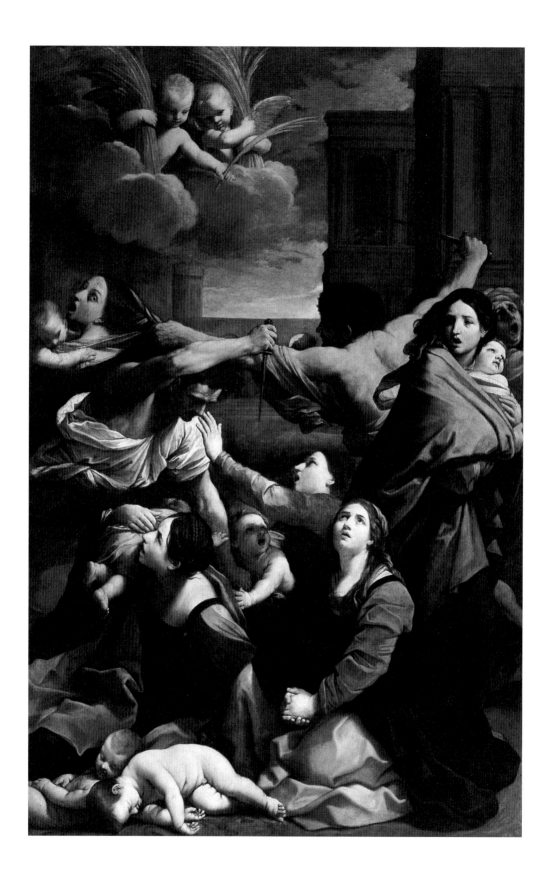

8 SALVETE FLORES MARTYRUM

. . . behold the angel of the Lord appeared to Joseph in a dream saying: arise, and take the child and his mother, and fly into Egypt, and abide there till I bring the word. For Herod will seek the child to destroy him. Then Joseph arose and took the child and his mother by night, and departed into Egypt, and was there unto the death of Herod, to fulfill that which was spoken of the Lord, by the Prophet which sayeth, out of Egypt have I called my son.

Then Herod perceiving that he was mocked by the wise men, was exceeding wroth, and sent forth and slew all the children that were in Bethlehem, and in the coasts thereof, as many as were two year old and under, according to the time which he had diligently searched out of the wise men.

Then was fulfilled that which was spoken by the Prophet Jeremiah saying: On the hills was a voice heard, mourning, weeping, and great lamentation: Rachel weeping for her children, and would not be comforted, because they appeared no where.

(MATTHEW 2.13–18; AFTER WILLIAM TYNDALE'S
TRANSLATION OF 1534).

Several 'Wise Men', or Magi, following a star; the escape of the 'Holy Family' on donkeyback into Egypt; a furious tyrant descending upon the town of Bethlehem in Judaea. The story is lodged preciously in traditional Christmastide songs and celebration, and to pose the question, 'Did it really happen?' is irrelevant. For those who must know, the historian's petulant answer is: 'Of course not!' Matthew is the only one of the four Gospel writers to carry the tale; Jewish-Classical sources, quite open to attesting the dictatorial cruelties of King Herod 'the Great', say nothing at all of this remarkable, gross infanticide at Bethlehem; and from the definitive confusion that is the date of Christ's nativity, we can only presume that the Herod made infamous by his 'Massacre of the Innocents' has been unfairly charged – he passed away in 4 BC. Matthew, as an exponent of Hebraic *midrash* – the 'seeking' for confirmation of sacred texts – preferred the events of his Gospel to echo prophecies of old: the slaughter at Bethlehem was very likely confected in order to 'fulfil' that part of the Book of Jeremiah (31.15) concerning 'lamentation heard in Ramah' from Rachel, mother of Joseph and Benjamin – Rachel whose burial-place was at Bethlehem (Genesis 35.19). 'Hark,' says Jeremiah, '. . . Rachel weeping for her sons. She refuses to be comforted: they are no more.'

A few New Testament scholars have occupied themselves with hypothetical computations of the infant death toll at Bethlehem, yielding estimates of between a dozen and 144,000. In effect, whether Matthew invented or reported the Massacre does not matter. The momentum of evangelistic outrage was begun. In the fourth century, fervent Prudentius was already praising the 'little ones' (*parvuli*) of Bethlehem as 'flowers of the Martyrs' (*flores Martyrum*), and by the fifth century, veneration of the 'Holy Innocents' was part of most liturgical calendars. As the 'Mass-book', or Catholic Missal, justifies it:

82 THE MASSACRE OF THE INNOCENTS
Guido Reni, *c.*1610–12

Above blood-dipped stiletto blades, cloud-borne cherubim appear. They carry, and are already dispensing, the palms of martyrdom.

137

**83 THE MASSACRE OF
THE INNOCENTS**
Wall-painting in the church
of Panaghia Kera at Kritsa
(Logari), on the island of
Crete. Thirteenth century.

In the upper right-hand corner
Elizabeth, mother of John
the Baptist, shields her son.
In the lower right-hand corner,
Rachel laments her lost sons,
their heads collected in the
folds of her cloak.

*The children massacred by Herod on account of the God-child deserve their place of
honour at Jesus' crib. The Church, true Mother that she is, weeps today over their death
as over a cruel bereavement and wears the colours of penance; but at the Octave [the
eighth day after the festival], leaving aside what appertains to time to consider only
the eternal triumph of heaven, she will wear red vestments and honour these innocent
victims as true martyrs.*

From the fifth century, too, the Holy Innocents join the repertoire of Christian
iconography. Visual consolidation, making a 'factoid': an event with no more
than mythical plausibility, rendered into a firm bollard of credence. Typical of this
consolidation process is a wall-painting within a Byzantine church on Crete (83).
In keeping with other early representations of the scene – a mosaic in Santa Maria
Maggiore at Rome, for example – it is not done in a style we should say was 'sensa-
tional', despite the extra specification of death by beheading. Herod's men carry
the decapitated babes skewered on their spears, but with neither grimacing nor
glee. So the registers of the painting seem simply to declare 'This happened'.
There is more concept than illusion. The image wants to convey the happening in
terms of *what* occurred instead of *how* it unfolded.

The affective force here is primal, as the moguls of modern media well know.
Slaughtered children: from cradle to grave so suddenly. What catastrophe hurts
us more? The Innocents of Bethlehem become the milky deputies of all innocence
itself. Harmlessness harmed; very life nipped in the bud. The involuntary nature
of the sacrifice of Bethlehem's babes was no block to their posthumous status
as martyrs.

Prudentius likened the fate of the infants to rose-blooms snatched by a storm,
a metaphor which nicely diverts the mind from envisioning the business of search

and execution. (Charles Péguy, in his poetic homage to both the Innocents and Prudentius – the *Mystère des Saints-Innocents*, 1912 – reused the same image of *naissantes roses*.) But Prudentius also, if briefly, dwells upon the mode of killing. Daggers, he says, were used: daggers too big for the job in hand – Herod's butchers could scarce find their target, on such tiny frames. Or the children were swung around, slung around, and their heads dashed against stone: '*O barbarum spectaculum!*'

Oh barbarous sight. 'Barbarous' is one way of accounting for it: the sort of action that identifies its perpetrators as people who do not speak our language; or who belong

84 HEROD
Painting attributed to Giuseppe Arcimboldo, *c.*1566 (one of several versions of this grotesque).

Herod's reputation as a 'monster' was compounded in further legends of the Massacre of the Innocents (as given, for example, by Jacobus da Voragine), which claimed that Herod unwittingly included his own offspring in the slaughter.

to some rude uncivilized age. We may admire Prudentius for his restraint in specifying further details of the Massacre. We are aware, after all, of the condition known as 'compassion fatigue'; and we know also how suddenly art may reveal itself for what it is (the artist goes 'too far': we cease suspending disbelief). Historically, though, the subject was not to be avoided. In Giotto's Arena Chapel frescoes at Padua, depicting the Massacre seems to anticipate, on the other side of the church, the scene of the Crucifixion; it is also part of a sequence that includes the Adoration of the Magi and the Flight into Egypt. Accept the Wise Men, with all their finery and dromedaries, and so take on the narrative sequel of their disclosure to Herod of a new king born at Bethlehem; thereafter, this Herod is the archetype of all jealous and jittery autocrats. As W.H. Auden framed it in his mordant 'Epitaph on a Tyrant' (1939):

> When he laughed, respectable senators burst with laughter,
> And when he cried the little children died in the streets.

It seems like a warning to all monarchs when Giuseppe Arcimboldo, sixteenth-century court artist to the Habsburgs in Vienna and Prague, creates a composite fantasy-portrait of Herod made from an intricacy of writhing toddler-bodies (84), ironically decked with gold-tasselled headgear. But how should artists otherwise manage the aesthetics of mass infanticide?

The following selective survey of attempts to resolve that question extends from early medieval times to the mid-seventeenth century. At this stage of the book, regarding the aesthetic problems of pain's representation, such a survey may answer the question, 'How far have we got?'

Or, as in the case of Pieter Brueghel's rendition of the subject – the last surveyed: 'How far can you go?'

**85 THE MASSACRE OF
THE INNOCENTS**
Nicola Pisano, 1265–68

Panel of carved marble pulpit in
Siena Duomo. Herod, cradling
his sceptre, is in the upper left-
hand corner of the scene.

**86 THE MASSACRE OF
THE INNOCENTS**
Giovanni Pisano, 1297–1301

Panel of carved marble pulpit
in the church of Sant'Andrea,
Pistoia. In Giotto's fresco of the
Massacre (for the Arena Chapel,
Padua, c.1306–13), Herod directs
the killing from an ironically
pilastered 'pulpit' such as the
Pisano family had decorated.

**87 THE MASSACRE OF
THE INNOCENTS**
Domenico Ghirlandaio,
1485–90

Fresco in the Cappella Maggiore
(Tornabuoni Chapel), Santa
Maria Novella, Florence.
The number of Massacre scenes
painted in Italy around this time
has sometimes been supposed
as an effect of events in Otranto
during the summer of 1480,
when Turkish raiders captured
the South Italian port and
allegedly carried out violent
purges of the civilian
population.

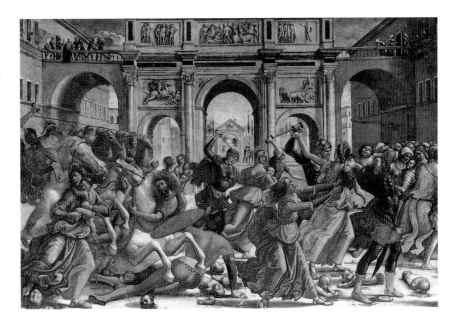

**88 THE EMPEROR RIDES
AGAINST BARBARIANS**
Marble frieze originally attesting
a victory of the emperor
Trajan (second century),
and subsequently utilized for
the Arch of Constantine,
Rome (fourth century).

Close to the Colosseum in
Rome, this is the best-preserved
and most visible of all
Roman triumphal arches.

One strategy for effectiveness was to get angry about the event; and let that anger
rise, blisteringly, in the very stamp and finish of the work.

This seems to be apparent when comparing the respective essays at the Mas-
sacre by a pair of Tuscan sculptors, father and son. Nicola Pisano carved the scene
in marble relief for his pulpit in the cathedral of Siena, in the late 1260s: smooth,
almost hieratic work, putting protagonists on three registers, the effect was one
of some complacence (85). The son, Giovanni, if only to upstage his father, cuts
the scene more deeply and more cursively (86). His composition has fewer figures
and greater frenzy. Above a tide of bewilderment and imprecation – bearded royal
counsellors join the protest, amazed – King Herod sits in a directorial throne,
clenching his fists. Faces of mothers and soldiers are strangely alike in their

distortions, as if meeting at the extremes of violent loss and seizure. But above all that, there is a rawness left on the medium: we have an event, as it were, defiant of polish. A twentieth-century sculptor, Michael Ayrton, recognized the force of Giovanni Pisano's device here: 'Terror is hacked into the stone so that the forms of dead and doomed children seem bloat [sic] and thick and their mothers suffer the sculptor's hammer blows, beating them into anguished submission.'

Some tried another route. It was the Classical archaeology of mass slaughter, as probed by Domenico Ghirlandaio in the Tornabuoni Chapel of Santa Maria Novella, Florence. (The Florentines, it might be noted in passing, put piety towards the 'Holy Innocents' to practical effect: witness the commission of Brunelleschi's handsome Ospedale degli Innocenti in 1419, perhaps Europe's first dedicated orphanage. Blue-white tondo plaques by Luca della Robbia on its exterior represent, not the Bethlehem martyrs, but cherubic foundlings saved by the institution.)

Using his own antiquarian notebook, Ghirlandaio glossed the Massacre as a piece of Roman history (87). It becomes a mêlée in which the doll-bodies of the dead would seem indistinct, if they were not so conspicuously passive – the more so when swaddled. By placing it under the monumental backdrop of a Roman triumphal arch, Ghirlandaio has acknowledged the source of his 'pathos formula'. It is readily recognized as a frieze showing the emperor Trajan in the mode of irresistible victor, inserted on the Arch of Constantine in Rome (88).

'Una baruffa bellissima' is how Giorgio Vasari describes Ghirlandaio's painting, in his *Life of Ghirlandaio*: 'a most beautiful bust-up'. Before we castigate him for this, let Vasari explain himself:

> It is done with judgement, shrewdness and great art. See there the impious determination of those who, on Herod's orders, set about the poor little boys with no regard for their mothers. Among them note one yet attached to the breast, dying from wounds sustained to its throat – so it sucks, not to say drinks, as much blood as milk from the breast. This is done so convincingly . . . it would resuscitate pity wherever pity was dead. There is also a soldier who has grabbed a child by force: as he makes off to kill the babe by crushing it against his chest, you see the mother tearing at his hair in desperate fury, and making him bend backwards like an arch. So there are three most lovely effects [*tre effetti bellissimi*] here – first in the child, as it dies; second in the savagery of the soldier who, feeling himself dragged back so unexpectedly, is shown expending his rage on the child; and thirdly in the mother. She sees the death of her little son; she mixes anger, grief and indignation in her effort to stop the murderer escaping unscathed. All this seems not so much the work of a painter, rather some amazingly wise philosopher.

Vasari's admiration is evidently unqualified by any worries as to precisely how 'beauty' might be extracted from this subject. And it is futile, retrospectively, to denounce Vasari for heartlessness here. He comments as one who would himself eventually attempt to depict urban carnage (see 56). So he is sensitive to

89 MASSACRES UNDER THE TRIUMVIRATE

Antoine Caron, c.1562–63

Historically, under the terms of their 'three-man' alliance, Octavian, Mark Antony and Lepidus were allowed to licence the killing of political enemies particular to each of them.

the inherent problems of composition and effect. And from the vantage of a Counter-Reformation view, the topic was sacrosanct not so much as an absolutely horrific event, but rather as a first instalment in the serial process of death for the cause. Individually, or ten thousand at a time: many martyrs were to follow where these babes unwittingly led. *Salvete flores martyrum*. Hail, flowers of the martyrs. Not only flowers but nursling shoots – and harbingers.

Ghirlandaio's 'historicizing' of the Holy Innocents as victims of a Roman cavalry charge is, strictly, unfair to the Romans. Herod's father, Antipater, had gained control of the administration of Judaea with Roman support, and Herod himself ruled at Galilee as a Roman citizen; but scripture says nothing of Roman involvement in the Massacre of the Innocents. Possibly some effort to soothe clerical or general concern over a 'strong' picture is reflected in Ghirlandaio's decision to give the Massacre a Roman setting. This, it says, is how the ancient Romans were; the past is a foreign country, and all that. In sixteenth-century France there was to be a minor vogue for similarly distanced or patinated scenes of bloodbath in the forum (89). These paintings may have been allegorical of tumults in France at the time, but were sedulously located in antique history and topography, drawing especially upon the 'proscriptions', or political hit-list killings, of the later Roman Republic. What, however, are we to make of this process in reverse?

A painting by Lucas van Valckenborch, datable to 1586, demonstrates what lies behind that question (90). Van Valckenborch was a lesser Flemish painter who usually confined himself to landscapes. Here, his landscape is unmistakably a Netherlandish or North German village, and there are darkening events set

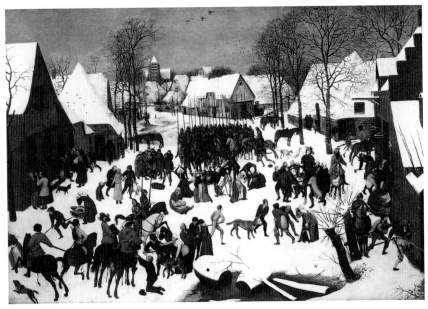

within its snowy frame (the snow assists in remembrance of the feast-day of the
Innocents, 28 December). Soldiers – Spanish halberdiers, to judge from their bat-
tledress – are conducting a door-to-door search of the village. Their quarry is plain
enough: a mound of little corpses is collected in the foreground. One mother
escapes over ice with her child, and their pursuer takes a tumble. But it is a grim
scene: the Massacre of the Innocents has become a bulletin of late sixteenth-
century news.

The historical context of this picture is what we call 'the Dutch Revolt': the
regional uprising of parts of The Netherlands against the rule of the Habsburg

monarchs based in Spain. From 1572 until 1648, with one intermittent truce lasting twelve years (after 1609), Spanish troops were conducting a sort of 'holy war' in these parts. Certainly, as long as orders were issued from Philip II – Habsburg monarch of Spain from 1543 to 1598 – Dutch Protestants were categorized as heretics, and punished accordingly. In their turn, Dutch partisans and Protestants alike propagated raw accounts of Spanish cruelty, with many 'atrocities' imputed to Philip's deputy in the Low Countries, the Duke of Alba (who arrived there in 1567). This painting by Van Valckenborch makes a bid to stand aligned with the rebels' cause. It makes of Philip – or Alba – a second Herod.

There is a well-known precedent for Van Valckenborch's scene. Pieter Brueghel the Elder appears to have painted *The Massacre of the Innocents* as a formal 'winter piece' at least four times, with a number of close copies also produced by one of his sons or associates. With Brueghel, the anti-Spanish element is not readily proven. In one variant of his composition (in Vienna's Kunsthistorisches Museum), a detachment of mounted knights with a long-bearded leader has been cautiously supposed as a direct reference to the Duke of Alba and his henchmen. Some elements of heraldry in the several paintings conceivably relate to escutcheons and titles claimed by Philip II, though they more likely serve to denote the royal power of Herod. However, Brueghel did not disturb the collectors of his work (who included Philip) by any implied detraction of Habsburg rule. It was not *what* happened that seems to have upset one owner of the Brueghel *Massacre*; rather, the unnerving pathos, or ugliness, with which it was shown.

Hence the curiosity which hangs in the British monarch's Royal Collection at Hampton Court: a 'Massacre of the Innocents' without the Innocents (91).

The picture was purchased in 1660 by King Charles II as a 'village with soldiery landscape', and attributed to 'Old Brueghel, of his best manner'. Previously it seems to have been in the possession of Queen Christina of Sweden (1626–89); and, prior to that, at the Habsburg court of Prague with the 'Holy Roman Emperor' Rudolf II (1552–1612: readers may need to be reminded here that Habsburg rule divided in 1558 between Central Europe and Spain). We cannot say precisely when the obliteration of the Innocents happened: it was carried out, most likely, sometime between Brueghel's death (c.1569) and 1621, when the scene was noted as a *Dorfblinderung*, or 'plunder of a village'.

An act of mitigation or 'toning down', then; done 'presumably at the request of a squeamish owner', as the compiler of the Hampton Court catalogue observes. X-ray and infra-red photography of Brueghel's original brushwork reveal what we should expect from the artist's several variations of this subject (92). And Brueghel looses Herod's rage upon a populace made familiar by previous appearances in the painter's *oeuvre*. Strewn in the snow, the same dumpy toddlers who would otherwise be cavorting as jockeys of the broom-handle horse, or testing pies to finger-depth. Hunched over body-parcels, or staggering with grief: those heavy-skirted matrons who would be forming a ring and stomping their clogs in the local *kermess*. No collector would have expected Brueghel to be the sort of artist who glazed his rustic folk with the sugary vision of pastoral ease. But the sight of such defenceless simpletons and their small fry, beset by steely-cool militia-men, was apparently too painful to keep as a gallery-piece.

So we have it in altered state: an attack upon domestic livestock, chickens and crockery. Some flames (now removed) were also added, to support the new 'Sacking of a Village' title; and the sign of the inn (on the right of the picture), originally a star, was overpainted – to help shake off the suggestion of Bethlehem. If the picture was once intended as a pendant, to pair with Brueghel's vision of another Nativity text, the *Numbering at Bethlehem*, now in Brussels, which illustrates Luke 2.1 ('And it came to pass in those days, that there went out a decree from Caesar Augustus . . .'), then its original coherence was thwarted.

The Hampton Court 'Massacre' is not the only Brueghel to have been 'censored' in such a fashion: the artist's panorama of *The Battle between Carnival and Lent* (in Vienna) had expunged from it, seemingly, one dead body and several cripples on the Lenten side. Since, in either case, we are not privy to the precise circumstances of the repainting, we may be content with assuming a measure of delicacy ('squeamishness') upon the part of a connoisseur who liked Brueghel only up to a point. But what if we shift our attention from beholder to painter; what if Brueghel himself were held responsible for the eventual reworking of his art?

That is not to suggest that Brueghel entertained regrets and acted upon them. It is rather to speculate upon the possibility of artistic 'failure' in depicting violence of a sort almost unimaginable. (It is a contingent question whether the 'corrections' of Brueghel's panel should themselves now be corrected, and the picture therefore 'restored'.)

If Brueghel painted to solicit pity, and secured only evasion, to the extent of erasure, then we might conclude: here is an artist who knows how to shock – to a fault.

* * * * *

During the early seventeenth century an important Classical text was diffused beyond the scholarly confines of Italian humanist circles (where it had been known and discussed since the late fifteenth century), into wider European awareness, especially in France. This was the *Poetics* of Aristotle, compiled from lectures given by the Greek philosopher in the fourth century BC, and whose rules for achieving the 'peculiar pleasure' of tragedy were put into practice by the seventeenth-century 'Classical' French dramatists Pierre Corneille and Jean Racine. Aristotle's guidelines were open to interpretation, but in his advice regarding the artistic inducement of mingled pity and terror – the conduit of emotional 'purging' by tragedy – he made it quite clear that no poet or playwright could hope to secure this effect by mere 'spectacle' (*opsis*), however horrible to view. Plot, characterization, diction – the subtle narrative bricolage we call a 'build-up' – were essential means towards the end of 'moving' an audience.

Aristotle's instructions had the effect, in certain quarters, of throwing down a challenge. Take a hideous, truly dreadful subject. Can art be made of it? Can artistry then alchemize sheer horror into rare beauty – such that would transport all sensible souls beyond repugnance, to tears of vivid empathy?

One writer who accepted the challenge was the Italian poet Giambattista Marino (1569–1625). We do not know exactly when he composed his grandiose verse-epic of *The Massacre of the Innocents* (*La Strage degl' Innocenti*): it seems to have

been mostly written by 1605, and immediately esteemed within Marino's own circle or clique, though fully published only posthumously, in 1631. The poem then became a celebrated piece, at least in the three cities where Marino was variously resident: Paris, Rome and Naples. That its modern editor frankly dismisses La Strage as 'entirely sterile' should not obscure a one-time apogee.

Marino certainly accomplished a great act of amplification. He turned one passage of St Matthew's Gospel into several libretti, each with over a hundred rhyming eight-line stanzas. There had been 'poetry of the oratory' before (notably amid the torrential output of Pietro Aretino, the sixteenth-century scribbler based first in Rome and then Venice); but nothing sustained on quite this scale. In Marino's pneumatic mode there is a long preamble characterizing the innate cruelty of Herod, followed by meandering accounts of the Journey of the Magi and the Flight into Egypt. But of course the rhapsode's real test arrives when the Massacre itself must be described – and spun out, for strain after strain.

Whether or not Marino's effort satisfies Aristotelian criteria should hardly be judged from one small excerpt, plucked at random from the pages of slaughter. But perhaps the following lines will prove more than enough:

> *Altro non veggio ch'una orribil massa*
> *Di frammenti avanzati agli altrui sdegni*
> *Altro ch'un mucchio di sanguini e monchi*
> *Squarciati brani e dissipati tronchi.*
> (*LA STRAGE DE GL'INNOCENTI*, BOOK III, STANZA 72)

'I saw none other than a horrible mass of fragmentary remains,' relates Marino's imaginary witness, 'a pile of bloodied, mutilated, torn-off limbs and butchered torsos.' Marino heeds the counsel about not describing 'spectacle' alone, but that does not mean he will stint on its visualization as the need arises. Ornate, profuse and meticulously focused upon violent extremes, Marino's verse quite matches the tenor and style of seventeeth-century painting in Naples, the city of his first and last years.

In fact, a more precise connection can be made between Marino and his painter-contemporaries. While in Paris, Marino met and befriended Nicolas Poussin, to whom he became something of an intellectual mentor. Did the poet give the painter recitations of his work? Very likely. In any case, Poussin also took up the challenge. As we have noted (see 79), he was not one to shirk graphic thoroughness in scenes of grievous bodily harm. Poussin could make a panorama of communal suffering (such as his Louvre canvas, The Plague at Ashdod). In his version of the Massacre, however, Poussin choreographed a pictorial drama dominated by three 'characters' (93).

Inspired as he may have been by Marino, Poussin here seems to be anticipating the literary rigour of Racine. Eliminate all distracting or superfluous characters. Keep the stage-setting to a bare minimum. Concentrate formally upon emotional action at its most intense pitch. The lamenting woman behind the trio may serve as the tragic chorus. Mother, child and assassin are fixed in an eternity of imminent bloodshed.

**93 THE MASSACRE
OF THE INNOCENTS**
Nicolas Poussin, *c*.1629–30

The twentieth-century painter
Francis Bacon considered this
picture to contain the 'best'
scream ever painted – at least
prior to his own endeavours
(see 1).

In Italy the panoramic view of the Bethlehem slaughter, such as Ghirlandaio
produced, was long prevalent; of one Sienese painter in the late Quattrocento,
Matteo di Giovanni, the subject of the Massacre thus depicted could be said to have
been a personal forte. Raphael (or rather his printmaker Marcantonio Raimondi)
created a vision of the event in which our principal attention wanders to the sinews
of nude soldiers in action (94), or else to a backdrop of distinctly Roman appear-
ance (95). It was not until Guido Reni tackled the subject that its scope for primal-
howling emotionalism, so abrasively demonstrated by Giovanni Pisano three
hundred years earlier, was regained.

Reni may not have invested much of himself in the picture: he claimed he only
undertook it in order to prove his ability to manage an 'historical' set-piece. Cer-
tainly he did not follow Pisano's path of leaving rough edges in the very execution
of the scene. But Reni's Massacre is no less powerful for being a smooth and cal-
culated sight (82). Two *putti*, coming down clouds like escalators and brandishing
the palm-sheaves of martyrdom, hardly soften the force of the central stiletto-
blade: pointedly scarlet.

The stiletto was an instrument typically associated with Baroque Italy.
It evoked street-fighting, banditry, reckless bravado and casual homicide. The
legend of Caravaggio says he slept every night wearing his dagger (credible of an
artist once charged with using a plate of artichokes as an offensive weapon). And
the lore of seventeenth-century (*Seicento*) Naples claims that city to have been pre-
eminent as the home of knifings carried out with impunity. If Caravaggio's artistic
achievement was to show (in Burckhardt's words) 'that the sacred events of the
beginning of time had unfolded in exactly the same way as in the alleys of the

southern cities towards the end of the sixteenth century', then perhaps it is no surprise that *Seicento* Neapolitan painters, the spiritual epigoni or 'disciples' of Caravaggio, attended to the fate of the Holy Innocents with particular verve.

Andrea Vaccaro (1605–70) gives us this flavour: his Massacre is made memorable by the motif of the child held up, almost teasingly, from a mother's imploring grasp (96). But it was Vaccaro's contemporary, Massimo Stanzione, who most assiduously mixed the active ingredients of local *gusto*: Marino's heated verse, Caravaggio's bolts of horror from shadowland, and the daily ferment of blood-spill upon cobblestones (97).

To be quite accurate, Stanzione enacts the violence on a tiled floor, thereby suggesting a domestic interior. Light wrestles hard with shade, but one object is perfectly discernible in the foreground.

It is a tiny severed hand. It is the relic of a true Innocent – an unclenched fist – a hand as yet incapable of doing harm.

* * * * *

Why paint over Brueghel and leave Stanzione?

As far as that question admits a straight answer, it is possible to argue for a divide of sensibilities between one European city and another. Naples gave rise to Salvator Rosa and pictures of witchcraft and thieves. Naples was sanctuary to Jusepe de Ribera the Spaniard ('Lo Spagnoletto'), whose brush was stirred (as Byron put it) 'with all the blood of all the sainted', and not only the sainted: Ribera's painting of the satyr, Marsyas, punished by Apollo (98; compare also 10)

149

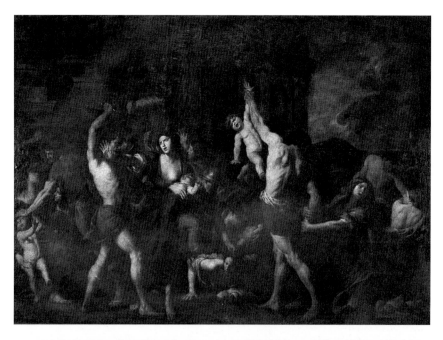

96 THE MASSACRE OF THE INNOCENTS
Andrea Vaccaro, *c.*1650–60

The muscular postures of butchery contrast with the cherubic plump forms of infant innocence.

97 THE MASSACRE OF THE INNOCENTS
Massimo Stanzione, *c.*1640

In Stanzione's composition, the viewer's gaze must settle upon the foreground's prime display – the lopped-off, chubby and opened juvenile fist.

has nothing to do with Christian fortitude. A picture sometimes attributed to Caravaggio (and now in Florence) shows several people round a table, craning to watch a man who is having one of his teeth yanked out by a hack dentist. It could almost be Caravaggio's commentary on stock Neapolitan voyeurism of pain. And the distribution of injury in Naples enjoyed a sacred logic too. Inquisitional

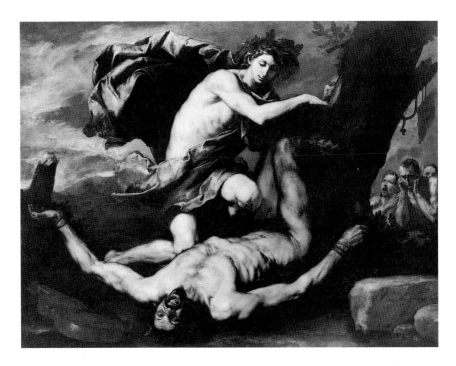

98 APOLLO AND MARSYAS
Jusepe de Ribera, 1637

Behind the tree, the satyr-company of Marsyas plays witness to the upshot of their fellow's overweening pride. While Marsyas yells, Apollo is serenely amused.

torture within the city was both routine and inventive. In the absence of Protestants to hand, sentries of the Counter-Reformation turned upon free-thinking renegades in their own fraternities. The Franciscan poet and philosopher Tommaso Campanella (1568–1639) passed twenty-seven years of his life in Neapolitan dungeons, and solitary duress was the least of his punishments.

But we can hardly mark out some equatorial line of aesthetic delicacy regarding images of suffering, whereby fastidiousness lies north of the Alps. Naples as an enclave of melodramatic disorder may have fostered a particularly sharp local appetite for 'sensational' art (Ribera was declaredly out to 'astonish' his public), but Naples held no monopoly upon subjects of emphatic violence, nor, for that matter, a unique partiality for Caravaggistic naturalism. There is no cause to suppose that interference with Brueghel's painting of the Massacre of the Innocents was ordered on any religious pretext. The reason why Brueghel's Massacre was subdued must devolve to an issue of art's integrity as art. The picture now in Hampton Court was plainly valued as 'a Brueghel', not as an exposition of scripture. Possibly an owner was sensitive to elements of partisan politics, and had the picture altered on account of such sensitivity. If not, then the only explanation is that whoever changed the painting thought he knew better than its creator.

A comparable case, from the history of theatre, suggests itself here. In 1681, during the reign of the same King Charles II who brought the Brueghel to England, an impresario and dramatist called Nahum Tate produced a 'rectified' version of Shakespeare's *King Lear*. This was not meddling for the sake of audience-amusement. Tate seriously thought that Shakespeare's original tragedy was flawed: for him, the 'innocent distrest Persons' who die in the final scene (meaning Lear and his daughter Cordelia) simply did not deserve to die. Hamlet, Othello, Coriolanus and other heroes of Shakespearean drama brought down due suffering

151

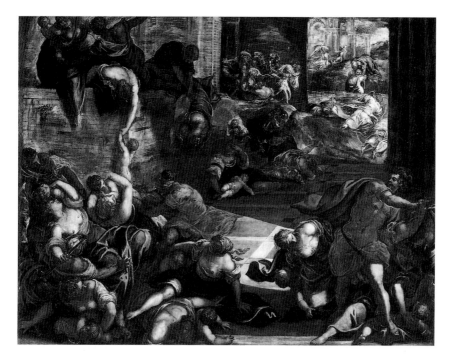

99 THE MASSACRE OF THE INNOCENTS

Jacopo Tintoretto, *c.*1583–87

Fresco in the Scuola di San Rocco (Lower Floor), Venice. Unlike the Neapolitans, Tintoretto leaves details of the killing unclear. Plenty of action – but the heart of his vision is the *pietà* of a mother isolated on a staircase with her child, as the struggle whirls all around and beyond.

on themselves, but why should this crazed old man, and his one loving daughter, be driven to the end? So Tate rewrote the play, excising one of its most significant original characters (the Fool), and introducing a sub-plot of romance (between Edgar and Cordelia) to yield the most satisfying finale (as Jane Austen would confirm) of union in marriage – which Lear, in Tate's production, remains alive to bless.

Samuel Johnson, editing Shakespeare in the second half of the eighteenth century, admitted that he was 'so shocked by Cordelia's death' that he could scarce endure to re-read the final scene of *Lear*. Johnson's friend, David Garrick, was renowned as a Shakespearean actor, but all the same he performed the part of Lear according to Nahum Tate. In fact, Tate's happy version prevailed until 1838. (Victorians looked to perform surgery elsewhere within the play: they took out the blinding of Gloucester.)

Nahum Tate found Shakespeare's *Lear* 'a heap of jewels', which needed polish and order, so that 'the Tale conclude in a Success'. On the grounds of adding 'poetic justice' to Shakespeare's play, Dr Johnson condoned what Tate rewrote. We are more strict in our devotion to the authentic. Nobody nowadays would want to see the happy-ending *Lear*. *Howl, howl, howl* is how it must be.

This, surely, illuminates Brueghel's implicit 'error' of representation, at least as far as it was perceived by those who had the Hampton Court picture 'corrected'. If we glance at one further example of how the Bethlehem Massacre was graphically rendered in the sixteenth century, we may be able to utilize Nahum Tate's critical factor of applying some poetic justice. Witness Jacopo Tintoretto's grand canvas in Venice, painted just two decades after Brueghel's scene (99). At a distance it could be taken for some other subject of mass attack (the Rape of the Sabine Women, or suchlike), because Tintoretto has generalized the Massacre into a sprawling ruck of hand-to-hand tussles. As in Ghirlandaio's fresco, the

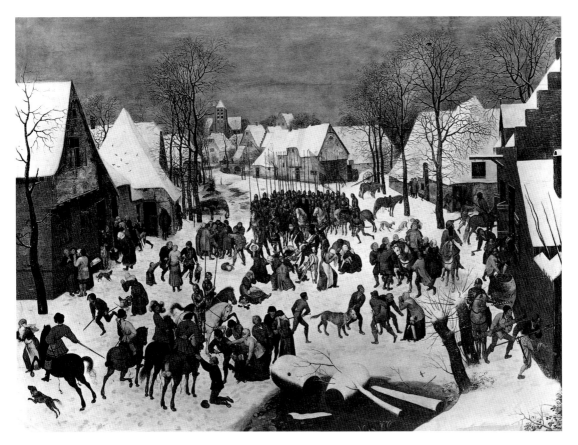

100 THE MASSACRE OF THE INNOCENTS

Pieter Brueghel, c.1566

The Vienna panel, once very similar to the Hampton Court version. As with Tintoretto's scene, the killings here seem centrifugal to one mother left sitting alone with her murdered child.

agents of Herod have caused not only panic and distress, but also a mayhem from which they will not escape unscathed. The mothers – as they would – are fighting, tooth and nail.

We mark the contrast with Brueghel's village; as Brueghel originally saw it (100).

He saw horses, quietly tethered to tall old trees.

He put some rather dandy cavaliers in the foreground; they seem to be amused. One soldier is urinating at the side of a house. The main band of warriors remains in close formation: sentinel, unneeded.

It is, as we might say, a doddle. A walk-over.

The Hampton Court picture includes two geese flapping over the treetops: preoccupied wildfowl, with 'somewhere to get to'.

And in the centre of Brueghel's tableau, there is a red-dressed woman sitting down in the snow. Her feet are splayed out. She holds clasped hands up to her face. A miniature body lies upon her apron-lap (see 92).

How far can you go? What gasp, what shake of the head, could begin to indicate such a distance – which is the extent of the hurt that human beings can trade with one another?

So instinctively we know why one owner of this scene of mass infanticide had it painted over. Brueghel peered into the deepest darkness of all: horror's final nullity – numb, dull, petrifying. It lies beyond anger, it lies beyond belief. And worst of all: it is lodged in its own unique and utter void of solace.

101 THE STONING OF ST STEPHEN

Signed 'Rembrandt Harmenszoon', 1625

As related in the Acts of the Apostles (chapters 6 and 7), Stephen's death comes about after a dispute with the High Priest and other elders in Jerusalem – who are denoted here by turbans and beards. Scripture describes an impetuous lynching, carried out just beyond the city walls – as made evident in Rembrandt's composition.

102 DETAIL OF THE STONING OF ST STEPHEN

Rembrandt's features peer out centrally (although, as one gazes at the painting, other heads also seem to loom with elements of the painter's own physiognomy).

9 REMBRANDT'S ELEPHANT EYES

The death of St Stephen, first of martyrs. This was the subject of what appears to have been Rembrandt van Rijn's debutante picture (101). He was then aged about nineteen, emerging from apprenticeship. Whether the subject was ordained by a teacher we do not know. But whatever magisterial advice Rembrandt was given for the composition of *The Stoning of St Stephen*, we can see that the young Dutch painter quite literally threw himself into it.

There he is, bobbing amid the bystanders (102). He is not aiming any rocks, nor attentively watching the martyr's plight; rather grimacing out towards us – the viewers of his painting – with a hot and bothered expression. It is a naïve form of 'involvement' in the scene; extra animation, then, for anyone who can recognize the painter's features, and accordingly indulge his whimsical claim of 'I was there'. As a flash of eye-contact, however, it makes a more direct appeal: 'Look at me!'

Through all the fluctuations of Rembrandt's subsequent career as an artist in Holland, this appeal is a constant.

There are biographies of Caravaggio, but defining how Caravaggio looked is guesswork; whereas we know our Rembrandt, some might claim, 'intimately'. We can suppose what we like of the fact that Rembrandt makes himself attendant upon the lynching of a hero for Christ: conceivably enough, it might attest to the artist's own sense of religious engagement. This was not, however, an isolated experiment. Again and again, Rembrandt propelled himself into his own pictures. It became the habit of a lifetime. Vanity and idleness may have helped to foster that habit. But even if it is belittled as an 'ego-trip', Rembrandt's revelation of Rembrandt conspires towards a peculiarly plangent understanding of creative individualism – in a way matched by no other artist before or since.

The signals of genius were more or less set into code in Renaissance Italy. The 'divine' Michelangelo scripted sonnets of his soul's desire; Leonardo da Vinci left decipherable memoranda of the workings of his mind; Benvenuto Cellini wrote a full and self-preening confessional. In the seventeenth century, writers such as Giovanni Bellori, Carlo Ridolfi and Karel van Mander continued Vasari's provision of lives of eminent artists: Vasari himself had shown how an entire personality could be gathered in one sentence. (What more could one need to know about the disposition of Piero di Cosimo after Vasari reports that 'he could not bear the crying of children, the coughing of men, the ringing of bells and the chanting of friars'?)

But Rembrandt is different. Rembrandt puts himself before us not as a demigod, a guru, or some extravagantly gifted eccentric. He presents himself as an object of unblinking, undazzled regard. 'Look at me' remains a plea for mindfulness, care and admiration: but not on account of any charisma or poise about his person. The perplexed young man we see present at a martyr's death is claiming no halo of special piety: he is simply there; as he would be – angry and afraid.

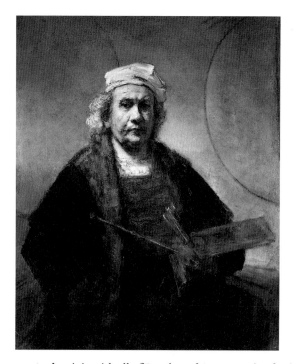

And so it is with all of Rembrandt's successive depictions of himself. However much he dresses up, he is always undisguised. The more he vaunts his profession as artist, the less we resent the fence of artifice between himself and us.

This is paradoxical. It is also a peculiarly humane achievement. Rembrandt, in the course of painting himself, engenders in his admirers a distinct impulse of compassion for others. For others who are pouched, shabby and sad; the shufflers and the bundle-bearers; the lumps of ordinariness. We have no evidence that Rembrandt set himself up as a painter of the virtue of charity. Though Christian subjects dominate his output, the precise tenets of his faith are nowhere made explicit. All the same, Rembrandt's reputation largely rests upon the investment of images with profound fellow-feeling. This is his claim to our attention here.

★ ★ ★ ★ ★

'He stops people in their tracks, the old master. . . and nails them to the floor.'

It is an observed phenomenon. Making the tour of Kenwood House, by Hampstead Heath in north London – an English eighteenth-century 'stately home', now democratized for general access – visitors do pause and heed the painter's appeal: 'Look at me'. In the light neo-Classical surrounds of Kenwood – relics of chinoiserie, Ionic pilasters by Robert Adam, and so on – the picture seems endowed with gravitational force. An 'old master', indeed, it shows the artist in his senior years: holding his palette, brushes and rag; plus, like some tenuous sceptre, the knobbed maulstick used for supporting the hand that paints (103). The image is self-referential (the edge of a canvas is glimpsed); it is also, undeniably, a form of self-heroization, with the two circles in the background hanging like the bossy shields of some Etruscan warrior. But why does it halt people in their tracks?

103 SELF-PORTRAIT WITH TWO CIRCLES
Rembrandt, c.1665–69

The tondo shapes in the background of the portrait have been variously interpreted: they may symbolize the legendary capacity of an artistic 'genius' to draw – freehand – a perfect circle.

104 SELF-PORTRAIT AT THE AGE OF 63
Rembrandt, 1669

On the basis of such images, Rembrandt has become a byword for self-revelation. (As one philosopher of 'personal identity' has noted: 'What we see in Rembrandt's face is surely not all illusory... we are looking at an extremely perceptive man, honestly portrayed by a brilliant painter who knows him from the inside.')

Can it be simply because the image is an icon of steady value and esteem – a reflex of reverence accrued through the centuries-long use of 'a Rembrandt' as the very archetype of 'Old Mastery'?

The Kenwood portrait may plausibly represent the paradigm of artistic vocation. Subsequent artists, such as the eighteenth-century English Academician Sir Joshua Reynolds, would use Rembrandt's image as a sort of expressive template, posing themselves in Rembrandt's modes ('Every painter,' said Picasso, 'takes himself for Rembrandt.') And it should also earn respect as a show of painterly skills. There are forty years of practice behind this picture, and the years of practice tell, right down to the trick of indicating fine hairs by scratches with a nib. This old master does not put on fancy headgear for the sake of dressing-up: he knows the value of a hat's elliptical shape for adding to the illusion of volume and space on a flat surface. Here, his white cap has clearly been rendered by just several swipes or lunges with a loaded brush, and experts wonder if the canvas should be catalogued as 'unfinished'. Yet who would alter a speck of it? Some of Rembrandt's self-portraits were painted in such heavy impasto, they say you can pick them up by the nose. This picture gives off that same impression of solid state: like relief-sculpture in oils.

'Mastery' in this sense may suffice to gain our respect. Some viewers here may also feel intimations of being present at a transcendental event in the history of art. Rembrandt's self-portraiture has been described as 'the epiphany of the face'; treated, no less, as the announcement of 'modern individuality'. But Rembrandt the usher of modernity is for scholarly regard. If a poll were taken of everyone else pausing by this picture, the majority would surely express their veneration of it in terms of mutual sympathy. For what is discerned in Rembrandt's gaze – here clouded, unsmiling – is an assessment not only of self, but the universe. We may know that the painter moved from Leiden to Amsterdam and thence scarcely beyond the confines of his studio. Yet we feel, from his presence on canvas, that he knows us, and much more. This is why the aged Rembrandt stops us in our tracks. It is as if all the cares of common humanity were collected in the kindly porches of his carved yet malleable face.

We take him in, and potter on.

As if reassured by a truth.

'*About suffering they were never wrong, the Old Masters. . .*'

* * * * *

Here is one way of putting it. Rembrandt revealed by Rembrandt makes a *memento mori*: a nudging intimation of the claims of death. A portrait painted during the last year of his life (104) is, credibly, the image of a man who has suffered the loss of both his wife (Saskia van Uylenburgh) and subsequent partner (Hendrickje Stoffels); two daughters (both dead within months of their birth); and two sons (one in infancy; the other, Titus, aged 26 – shortly before this self-portrait was done). A man acquainted with grief, then; a man who has taken the slings of fortune at full pelt. From the contours of such a fate-battered face we are naturally tempted to 'read' a life.

A life can be made of Rembrandt; for centuries he has enjoyed a mythical life too. This mythical life follows a standard formula that will be familiar to anyone raised on the notion that genius is defined by personal oddity, or a general refusal to conform to normal expectations. It tells of Rembrandt the miller's son who forsakes grain for art; has immediate 'meteoric' success with his painting; marries into money and flourishes further, despite profligate spending; then is brought down hard. Saskia, his bright-eyed and sweetly double-chinned wife, is prematurely claimed by the grave; around the same year, 1642, one of Rembrandt's most ambitious paintings – the portrait ensemble of Amsterdam guardsmen known as *The Night Watch* – is a flop. No one wants his work. The painter is eventually declared bankrupt, and his possessions are seized. He compounds the crime of poverty with the disgrace of maintaining (to censorious neighbours) a 'whore'. He dies alone: robbed of family, and unloved by those who once so keenly sought his work.

105 REMBRANDT AND SASKIA, OR THE PRODIGAL SON
Rembrandt, *c.*1635

Whether or not a parable of prodigality is intended here, Rembrandt shows himself in a stereotype of the quaffing cavalier, and Saskia perches on his knee in the mode of some notorious courtesan.

So much for that – Rembrandt's 'Ur-myth' – a story stripped of all nuance or historical *chiaroscuro*. It carries the formulaic constituent of tragedy: a character raised to glorious heights, then felled low by some flaw of over-reaching pride. And – of course – it is fantasy. Much rummaging in Dutch archives by those dissatisfied with myth has not been fruitless. Yes, Rembrandt was a miller's son (the ninth child, to be exact; born in 1606) and his person would indeed strike some as 'coarse and plebeian'. But the miller planned to send Rembrandt to Leiden University, until the lad – unrebelliously, as far as anyone can tell – chose a studio apprenticeship. Soon enough, Rembrandt was taking on his own pupils. It would be over-delicate to say that he married above his station: Saskia brought a handsome dowry, but she was, after all, a cousin of Rembrandt's dealer; and, in his turn, Rembrandt was good business. A picture of the couple in merriment can pardonably be construed as Rembrandt raising a toast to Vanity Fair (105). Art has triumphed over the grindstone: the miller's son has made it good. But even that interpretation fades, when the painting is taken as it seems it was originally intended: that is, as a biblical piece – showing the Prodigal Son.

Nor is the alleged failure of *The Night Watch* in 1642, and the painter's consequent loss of favour with Amsterdam patrons, borne out by the records. That Rembrandt's output slowed may rather be due to his affluence: he did not need to work (his estate in 1647 was valued at 40,750 guilders: a skilled artisan in this period might earn about 600 guilders a year). Bankruptcy was indeed declared in 1656: but in Rembrandt's application for bankrupt status, explicit mention was made of forfeits 'at sea'. The Amsterdam Bourse revolved on the axis of high risk, with little margin between vast profit and devastating loss. It appears that Rembrandt the speculator, in market jargon, got 'wiped out'.

Yet he was by no means finished as an artist. Commissions came in, from such worthies as the members of the Amsterdam Drapers' Guild. Contemporaries referred to him as 'the miracle of our age'. Even the Italians – most reluctant to acknowledge that any non-Italian could so much as handle a paintbrush or chisel – knew Rembrandt as 'the celebrated painter' (*pittore famoso*).

This prosaic correction of the Rembrandt myth can be extended further. Suppose we discount the sequence of bereavements in Rembrandt's life – allowing that infant-mortality rates were generally high, and few people expected to live beyond fifty. And suppose, then, that we introduce the element of masquerade in Rembrandt's self-portraiture. As far as we can judge, there was a ready market for these self-portraits. None was part of Rembrandt's studio stock when the bailiffs made an inventory of his possessions in 1656. He did not paint them to please himself. Among the distinguished contemporary owners of Rembrandt self-portraits were Charles I, King of England, and Cosimo de Medici, Grand Duke of Tuscany. What gratification was it to them – to boast one Dutchman's doughy, troubled visage?

The truth is that there was in Rembrandt's time prestige attached to sadness. To look afflicted was a fashionable trait, much affected by scholars, lovers and gentlemen. In England the fashion was made articulate in a learned, prolix but entertaining study by Robert Burton, *The Anatomy of Melancholy*, first published in 1621, and running to eight editions by 1676. It may be a blessing ('All other joys

to this are folly,/None so sweet as melancholy'), it may be a curse ('All my griefs to this are jolly,/Naught so damn'd as melancholy'), but this pensive gloom is shown to be a characteristic of wise or gifted individuals since the ancient Greeks, and Burton's search for a 'physic' to cure the melancholic state is ironically eager. Contentment was for fools.

Rembrandt knew the 'genius' figures of the Italian Renaissance by reproductions and such works of theirs as passed through the Amsterdam dealers; he may also have known of their flowery repute as personalities. The Renaissance genius was typified in Vasari's portrayal of Michelangelo: difficult, moody, and cast with that forbidding

106 'SELF-PORTRAIT' AS A BEGGAR
Rembrandt, 1630

The extent to which Rembrandt himself was eventually 'ruined' is debatable. But he never lived rough: this etching is an image of the artist 'dressing-up'.

aspect of countenance the French call *farouche*. Was Rembrandt posturing in some similarly affected way: laying a claim to insight and sagacity by pushing the self-portrait beyond a reflective vigil – towards tragic or Saturnine introspection?

Role-playing certainly had its place in a Dutch society conceding 'the embarrassment of riches': the predicament – as historian Simon Schama has defined it – of sensing disgust and unease in the midst of plenty. Rembrandt's etchings of beggars are sometimes explained by reference to a 'taste' for depictions of the vagrant state as 'picturesque', made popular as such by the French draughtsman and engraver Jacques Callot (1592–1635). But Rembrandt's self-projection as a baggy-trousered vagabond, once with a caption of complaint ('It's perishing cold'), may also pander to a particular Calvinist conceit among his moneyed patrons (106): 'On earth we are beggars, as Christ himself was.' The image may or may not have acted as a compunction to charity; but perhaps it steeled the soul of anyone who had just gambled away his entire savings on a vessel to the Indies.

Identifying such histrionic elements in Rembrandt's art is neither fantastic nor unduly cynical. Nor, perhaps, is it unnecessary to point out the mundane advantages of self-portraiture as a painter's penchant. No desperate roaming for fresh subjects; not even the cost of hiring a model. Yet it is a dispiriting exercise, to survey Rembrandt's eighty-odd surviving self-portraits as so many market-driven promotions of egotistic ingenuity. Of course he was *pictor economicus*, an artist making money: only in Giorgio Vasari's bourgeois imagination does the great artist care nothing for cash (Leonardo da Vinci, who preached contempt for worldly riches, privately kept almost maniacal ledgers of expenditure and gain). There is no reason not to honour the Rembrandt famed as engraver of 'the hundred guilder print'.

The Rembrandt who paints what he sees in a mirror also sold his work. In saying that Rembrandt thereby 'commodifies himself', or becomes an 'entrepreneur of the self', we risk misunderstanding the very purpose and genre of making portraits. Why is a portrait commissioned? Invariable answer: because its subject

is admired – or desires admiration. And how is a portrait executed? Now that depends. There is no invariable answer. But what devolves upon the portrait-maker is essentially a task of analysis. And, in the course of that analysis – physiognomical, pseudo-surgical, 'psychological', as it may be – admiration may dissolve. The work is finished all the same. The finished work is delivered with a shrug. If it fetches a price, so it fetches a price.

To allow for 'the embarrassment of riches' in Rembrandt's historical ambience is not to demean that artistic transaction. If the sentiment of self-unease was itself a commodity in seventeenth-century Holland, that does not cheapen its moral appeal. We might even concede that some people truly value what it is that they pay for.

<p style="text-align:center">★ ★ ★ ★ ★</p>

Portrait of the artist as a young man: a rosy, tousled, roustabout (107).

It looks quickly done. Yet this is an etching, not just a sketch: intended for multiple print-offs and diffusion. Or, at least, it was no private memorandum.

Anyone who saw it would say: here is no Adonis. Where are the clean jawline, the fine profile; the groomed hair tumbling to resolute shoulders, and the noble brooding brow? The Grecian stereotype was not unknown in Holland: antique Classical busts and copies were around (and would figure among Rembrandt's personal collection of *objets d'art*); or else that stereotype was perceived as 'reborn' in the ideal courtiers and musclemen of Italian High Renaissance art. From the very outset of his self-depicting enterprise, Rembrandt records no image of Classical handsomeness, or canonical male allure.

This observation should caution us against treating the succession of Rembrandt self-portraits as one man's chronicle of creeping decrepitude. His face in old age has been described (by John Berger) as 'ravaged by debt, drink and grief'. But the man of sixty-three is recognizably the same person as the lad in his early twenties, given some shifting of jowls and accumulation of lines. There was no metamorphosis here, no grim residual soaking-up of gloom and disillusion-ment. This is no vaunting of mournfulness for lost golden youth. A late self-portrait in which Rembrandt appears to impersonate the ancient Greek painter Zeuxis is surely heaped with irony. Zeuxis, by legend, died of a fit of laughter while painting a gnarled old woman: a choking fit caused by his reputation, for Zeuxis was famed as creator of the image of Helen of Troy, the world's most desirable woman ever . . . Although the Venetian Giorgione preceded Rembrandt with a lively study of senior femininity (*La Vecchia*), in general, no artist ever painted old women more tenderly than Rembrandt.

The miller's son was no Adonis. It is tempting, then, to scrutinize Rembrandt's

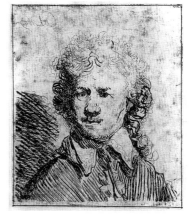

107 SELF-PORTRAIT, BAREHEADED
Rembrandt, 1629

'Bareheaded' is a useful tag to the title of the etching – given that few artists, historically, have matched Rembrandt's passion for hats.

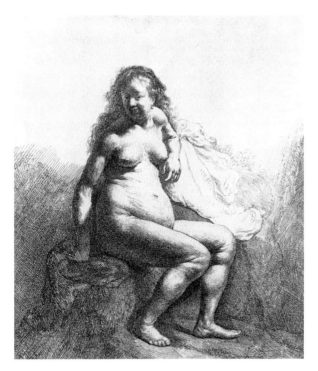

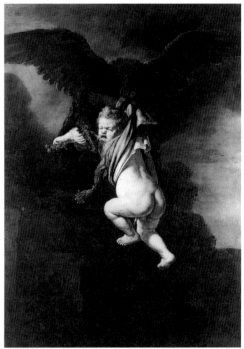

output for a studied anti-Classicism, and not only in the self-portraits. The Classical ideal of female beauty was firmly but generously fleshed, and Rubens had carried that generosity to new extremes of cellulite celebration: but neither Rubens nor any Classical artist ever showed a 'model' slumped in flabbiness such as Rembrandt drew (108). The artist seems wilfully to have set out to subvert the norms of pulchritude; as if he would antagonize not only Classically-schooled souls but all those for whom 'the nude' constitutes a separate species of humanity.

And see what he does when a subject truly calls for the Adonis type. In Greek mythology it is a charming episode, half camp and half bucolic, when cloud-shaking Zeus summons the lissom mortal Ganymede to join him on Olympus. From 'Ganymede' we derive our term 'catamite': the Greeks did not conceal the pederastic compulsion which had Zeus swooping down, eagle-wise, to take Ganymede as his 'cup-bearer'. And for the shepherd-boy this is not so much rape as supreme accolade. In Classical Greek eyes, Ganymede's adolescent beauty wins him divine homage, albeit in subservient role, with a place at the table of the gods.

Rembrandt – whose access to the story was, we presume, through Book 10 of Ovid's *Metamorphoses* – will have none of this (109). His Ganymede is reduced to a porky babe, squalling tears and pissing with terror when seized by the talons and beak. Rembrandt's (sub)version of the myth is so out of sympathy with its Classical erotic roots that some commentators have wondered if it were not indeed painted to suit some Calvinist disgust at homosexual love.

But the Rembrandt who forsook his Latin lessons for painting did not limit himself to a programme of debunking Classical ideals. The Bible – whimsically, but often, supposed to have been the only book the painter ever read and revered – was equally prone to Rembrandt's 'earthy' packaging. Rembrandt's rendition of

108 NAKED WOMAN ON A MOUND
Rembrandt, 1631

The artist used a similar somatotype for his vision of the goddess Diana bathing: both images were copied and evidently admired in Rembrandt's day.

109 THE ABDUCTION OF GANYMEDE
Rembrandt, 1635

Since the patron of this painting is unknown, and no documentation attaches from the artist, we cannot say for sure that it was supposed to 'debunk' Classical homoeroticism; some scholars speculate that the imagery may have an allegorical religious meaning.

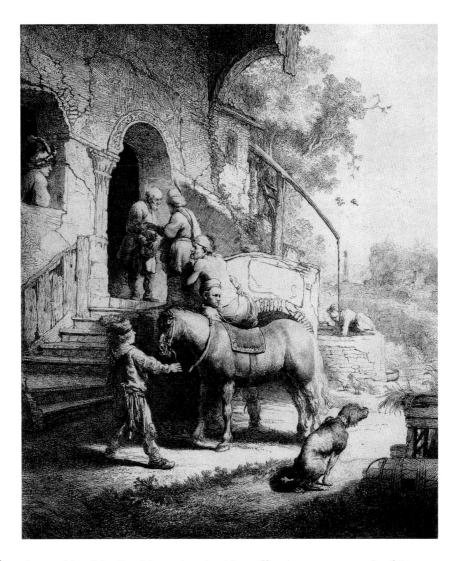

110 THE GOOD SAMARITAN
Rembrandt, 1633

The dog 'is there to remind us that if we are to practise the Christian virtues of charity and humility, we must extend our sympathy to all natural functions' (Kenneth Clark).

the parable of the Good Samaritan (110) has offered a strong example of this ever since, in 1831, J.W. Goethe used it to demonstrate the qualities of 'Rembrandt as a thinker'. In this etching, Goethe implied, Rembrandt has not so much 'illustrated' Christ's homily, as taken it beyond its scriptural basis (Luke 10.30–7). Scripture speaks of a man attacked by robbers on the road from Jerusalem to Jericho and left, stripped and battered, by the wayside. His plight is ignored by two passing Judaic priests; it is a traveller from Samaria who stops to give assistance. The parable arises from the query, 'Who is my neighbour?' – and the parable's teller was well aware that Jews and Samaritans had a history of ethnic friction. The 'good Samaritan', relates Jesus, not only tended the wounds of the victim, but took him to an inn, saw him settled there, and vouchsafed to pay all ensuing costs of convalescence.

Rembrandt chose to show the moment at which the Good Samaritan reaches a rustic hostelry. There seem to be negotiations on the threshold – a spot of Oriental 'haggling', perhaps. The assaulted man is being awkwardly lifted from

163

the Samaritan's shaggy pony. A young man looks on from a window. By Goethe's intuitive reading of the scene, this nonchalant onlooker is one of the brigands: hence, for Goethe, 'the most perfect expression of helplessness' upon the countenance of the injured party.

In the background, a woman stoops to draw water from a well.

In the foreground, there is a dog; and the dog is defecating.

There is no evidence to suggest that this dog was a mischievous addition to the plate by one of Rembrandt's pupils. The artist intended it. A large mongrel-retriever, haunches straining, so becomes part of the picture of the Good Samaritan.

This is Rembrandt trying, perhaps, to out-Caravaggio Caravaggio: the Caravaggio who 'returned again and again to the permanent and paradoxical fact of human animality' in 'the everyday world that God became man to redeem.' In this sense, touches of everyday and contemporary 'reality' may contrive to present a persuasive imagining of Christianity's 'perpetual passion'. We are helped to measure the infinite suffering of Christ on the Cross when we see, assisting in a scene of Deposition, the painter, or one of the painter's drinking-mates. By the same logic, a visual tale of a parable-event in dusty Palestine is all the more holy when it includes an ill-trained hound.

Goethe conspicuously refrained from comment on the canine detail. Yet it belongs to the engraving, no less than it belongs to the world-view of 'Rembrandt the thinker'. Dogs defecate as they do and must. Rembrandt's depiction of one such hound is not equivalent to the child who runs into an adult gathering and blurts a rude word to solicit shocked reaction. Nor does it seem akin to that fastidious scruple of Jonathan Swift, the writer who, in the early eighteenth century, was apparently horrified that women who used make-up also needed lavatories ('Oh! Celia, Celia, Celia s--ts!'). It is rather the claim of Rembrandt's art that it sees and portrays the world as it is. No special and sanitary preserve labelled 'art' should exist. Dogs lead their doggy lives. Humankind is humanbound.

A great revelation? It hardly seems so, when stated like that. But French playwright Jean Genet saluted it as 'Rembrandt's secret'. Genet himself was on a train, in 1953, when the force of that secret struck him with piercing clarity. Sitting in a carriage, he unintentionally made eye-contact with a stranger, 'a frightful little old man' (un épouvantable petit vieux). And there descended upon him a tremendous human truth: 'each man is worth exactly the same as another'. Genet records this as a 'dolorous' dawn of universal comprehension. 'Anybody can be loved, I said to myself, however ugly, wicked or stupid. . . .'

Genet's fellow-countryman, essayist Michel de Montaigne (1533–92), may have intimated as much when he observed that 'every man carries the whole form of the human condition'. Genet puts the sentiment into direct carnal language. We live in bodies. Each of us is a carcass: made up, in Genet's words, 'of blood, tears, sweat, shit, intelligence and tenderness'. This is the 'secret' or rather the object-lesson of Rembrandt's 'non-Adonis' men, unangelic infants, and women run to fat. His very brushstrokes may be seen to connive in imitating 'the wrinkled intricacy of things, life itself'. The same secret underpins the quintessential benevolence we find in Rembrandt's portraits of himself. Genet looked at the

latest self-portraits (103 and 104) and concluded: 'A man has just passed entirely into his work.'

If so: this is the very opposite of vanity's self-regard.

<p style="text-align:center">* * * * *</p>

Other artists, as diverse as Dürer, Giorgio de Chirico and Stanley Spencer, exposed their bodies. The states of bodily nakedness or partial nakedness that they recorded were acts of self-study and self-revelation that might be taken to deliver a 'complete' self-portrait.

Rembrandt dwelled only upon his face: and yet we feel that there was nothing else he could tell us about himself. His face becomes his all.

There is a way of explaining that odd 'metonymy' of self-representation, whereby a part stands for the whole. Rembrandt's images of self implicitly affirm a philosophical belief, that human faces are the sole proprietors of individual identity. To understand this belief requires that we briefly wander to an earlier phase in the Western tradition of portraiture.

By its very truncated form a 'portrait bust' also makes the same declaration. Portrait busts went through various manifestations in Egyptian, Greek, Etruscan and Roman art. It was in one particular period of Roman art that emphatic attention was directed by portrait-makers not merely upon the face as a physiognomic curiosity, but on the face as a harbour of lifetime experience. This phenomenon has annexed a special art-historical term, 'verism', to denote its overt impression of truthfulness. It occurs almost exclusively during the last two centuries of the Roman Republic (up to the Battle of Actium in 31 BC, which cleared the way for autocracy under the emperor Augustus). A compound of factors created this 'verism' of deep-ploughed brows, scowl-pocked jowls and eyes framed by crease-spreading deltas of age. This compound includes: the high social and political status reserved for those senior in years; a national consciousness of the virtues bound up in *gravitas* and toil, combined with a partisan suspicion of any affected Greek-style 'beauty'; and probably, also, a funerary custom of parading the masks of deceased ancestors. The result may display, in the American novelist John Updike's memorable description of one such bust, 'putrefying individuality' (111).

But the Roman Republicans who projected themselves in this 'veristic' manner were not dissenters from a widespread ancient acceptance of the fact that facial physiognomy contained the individual's true 'characteristics'. Since at least the time of Aristotle there was a science of deducing an individual's nature, or predicting personality, from the shape and contours of the face. Plutarch, introducing his *Life of Alexander* to a second-century readership, uncontroversially excuses his own fascination with Alexander's

111 ROMAN REPUBLICAN PORTRAIT HEAD

The sort of Roman portrait for which the term 'verism' is reserved – as the antithesis of physical idealizing evident in Classical Greek renditions of the human face and frame.

112 'SELF-PORTRAIT' OPEN-MOUTHED
Rembrandt, 1630

The artist made up a repertoire of self-portraits in various expressions, which he could deploy for the range of narrative situations demanded by his work.

charisma by referring to common practice among artists, 'who get portrait-likenesses from the face and the expression of the eyes, wherein character [*ethos*] shows itself'. The Greek *charisma* may nowadays be vaguely understood as a sort of personal magnetism, but ancient philosophers wondered precisely how it came about. In the fourth century, neo-Platonic writers such as Plotinus and Porphyry proposed that bodily grace (which they called *charis*) stemmed immediately from the nature of the soul (*psyche*). For the neo-Platonists, it was the eyes in particular that appeared shiningly 'soulful' – in the best people, positively phosphorescent.

This axiomatic Classical faith in the sole capacity of the face to reveal the soul was revived in Rembrandt's time. Rembrandt's erstwhile pupil, Samuel van Hoogstraten, composed a substantial treatise on the making of art, in the course of which he instructed all portraitists to look upon eyes as 'the mirror of the heart . . . in which can be seen and read favour and envy, love and hate, joy and sorrow, and as many emotions as stir the heart'. Karel van Mander, the Dutch art-theorist and biographer of artists, prescribed (in 1604) a series of facial 'affects', such as lines and furrows in the forehead 'showing a melancholy spirit within us, entrapped and care-worn'. And it is clear that Rembrandt himself regarded facial expressions as germane to understanding what was 'going on' in any sort of narrative picture. A number of his earlier self-portraits seem specifically executed in order to furnish his studio with a stock of expressions for use in graphic stories: Rembrandt registers how he looks when startled, annoyed, cheerful or in anguish (112).

'The face is the soul of the body.' That is the tenet here – not as expressed in any Classical doctrine, but by Ludwig Wittgenstein (1889–1951), a philosopher who embodied its truth well enough himself. The more Wittgenstein strove for a sort of self-effacement – volunteering, during the First World War, to serve on the Russian Front; subsisting as menial gardener; later (when a distinguished Cambridge don) serving as dispensary porter in a London hospital – the more, it seems, his face loomed as a lantern of austerity, candour, and denial of ease (113).

Wittgenstein admitted: 'We all want to be admired.' It is the universal egotistic constant. But it seems that for Wittgenstein the guru-philosopher, as for Rem-

brandt the *pittore famoso*, admiration harvested at the expense of honesty was a paltry hoard.

One should be admired as one was: the face that meets the mirror first thing in the morning, unadorned and bleary – and inexorably closer to death.

* * * * *

We conclude where perhaps we should have started: with a theory to explain the actual practice behind Rembrandt's self-portraits.

A self-portraitist, obviously, relies upon a mirror. This naturally produces a sensation of complicity or 'double-bind': the painter observes, and paints a returned observation. Superficially, this seems like a contract of individual vanity, which risks ignoring the rest of the world. In the Greek myth of Narcissus, a lovely youth catches sight of himself reflected in a pool and is so entranced that he cannot leave the image, and so dies of wasting away. But intuitively we sense that Rembrandt's gaze has nothing in it that is 'narcissistic'. So it has been suggested that the painter referred to a mirror only at the outset of each self-portrait. Having taken in what he saw reflected there, he covered it up; and worked on the image using, as it were, insider information. John Berger, the writer who advances this theory, empathizes with Rembrandt's supposed reason for working in this way. It breaks the privacy of absolute self-regard; it becomes both an appeal, and a meditation. The artist entrusts this hope to posterity: that 'later it would be others who would look at him with a compassion that he could not allow himself'.

In old age – his ironical sniggering Zeuxis excepted – Rembrandt left off pulling faces. It seems as if it were quite enough to contemplate the facial landscape weathered by years of muscular custom. But he made one return to the place where, in spiritual terms, his career as a painter began.

At the stoning of St Stephen there was, by New Testament tradition, 'a young man named Saul' (Acts 7.58). Saul went directly from Jerusalem, where the martyrdom had taken place, to Damascus. *En route* occurred the vision which transformed Saul, the zealous Roman citizen, into Paul, the ardent apostle of Christ.

As we saw (101), Rembrandt first showed himself at the scene of Stephen's death. Two years before his own demise, the painter reappears as the apostle Paul – fellow-witness, as it were, and likewise advanced in years (114). Eyebrows punctuate a face that is patently wearied, quizzical and wise. It is not the image of an evangelist triumphant. Rembrandt-Paul is holding a text indicated as the Letter to the Ephesians; but another Pauline statement of faith suggests itself for this picture. The chapter and verse would be II Corinthians 12.10. It may be taken to epitomize the odd and consolatory truth that Rembrandt discovered by painting himself, unto his last mortal year.

'For when I am weak, then am I strong.'

114 SELF-PORTRAIT AS THE APOSTLE PAUL
Rembrandt, 1661

A rare case of the artist assuming a known historical 'persona'. We may be intended to treat this as an image of the apostle in captivity; and the sword-hilt projecting from the robes as an allusion to St Paul's eventual martyrdom by beheading.

Note on the body and soul (ii)

Rembrandt never painted a portrait of the French philosopher René Descartes. But, for all we know, the two men might have passed each other on the street. Descartes lived in Holland, on and off, from 1628 until 1649 – years in which his most important philosophical works were published.

The works of Descartes resist crude summary, and Descartes himself regarded them as only preliminaries to some wider exploration of the potential benefits of science, medicine and technology. But the slightest knowledge about what Descartes proposed is useful. And if we admit to such slight knowledge, it will probably reduce either to a motto of personal security – 'I think, therefore I am' – or to an affirmation of mind/body dualism, according to which the human body is a machine, largely governed by its own mechanisms; while the human mind is something else, lodged in the body, but operating to its own independent rules.

This 'Cartesian' dualism was certainly formulated with more scientific reasoning than the dualism of philosophers in the Classical world. Plato, like all Greek academics, and doctors too, was not privy to any information about the human body gained by dissection: in Plato's age, any post-mortem with a knife was taboo. Descartes, by contrast, lived in an age when anatomical dissection was not only practised (mostly on executed criminals), but conducted by professors and surgeons as a sort of theatrical event, to which students and intrigued members of the public alike could gain admission by buying a ticket. Since 1537, when Clement VII relaxed papal prohibitions upon dissection, the investigation of human physiology and structure had gained rapid momentum: notably with

the publication of a handsomely illustrated folio
'On the Fabric of the Human Body' by Andreas Vesalius
in 1543, but with many other empirical discoveries
too – such as those relayed, in 1628, by William
Harvey's theory of the circulation of blood.

That the practitioners of anatomy claimed
celebrity status in the time of Descartes is indicated
by Rembrandt's picture of one Amsterdam doctor,
Nicholas Tulp (115). Tulp is shown in mid-exposition
of a forearm's flexor muscles to some senior students:
it all looks surprisingly immaculate, as a procedure.
And in this respect of cleanliness, Rembrandt seems
to conspire with what we have characterized as
a Cartesian scheme of the human body. The inside
of a man's lower arm is revealed as a contraption;
a piece of nice engineering in tissue, elastic and
bone (to us, it may rather suggest a set of
electronic wires – like revealing the innards
of a household appliance).

Behold a man – as a system. And, in the view of
Descartes, it *was* a system that was excavated by the
surgeon's scalpel: a system which demythologized
the ancient and medieval understanding of mysterious
'humours' that permeated through the human frame
like seasonal phenomena. And what eluded the reach
of the anatomist – the human 'soul', *anima*, mind,
or psyche – had to find a place somewhere in this
system. For Descartes, the soul's habitat lay in the
brain's pineal gland, from where a sort of monitoring
operation was maintained. Far from denying the soul's
existence, Descartes understood that any physiology of
sensations required some psychic 'grey eminence'
to be invoked. In a tract on *The Passions of the Soul*,
first published in Amsterdam in 1649, Descartes noted
that the 'titillation' (*chatouillement*) of the senses was
usually followed by happiness, while the onset of
pain usually made us morose; however, since it was
also possible to suffer pain with delight, and be
titillated to displeasure, then some 'judgement'
or arbitration by the soul must intervene.

Nevertheless, this Cartesian model of a network
of nerves reporting to the pineal gland was, as it were,
a 'no-nonsense' explanation of how human bodies
functioned. No one was cheery or doleful by
disposition, or according to some deterministic sign
of the zodiac. Pursue the sort of research demonstrated
by Rembrandt's Dr Tulp, and all should become clear.
Machines could be made to run smoothly, 'like
clockwork'. What should prevent the engineering
of the human body from being adjusted to
ensure that everyone ticked over in a state
of earthly contentment?

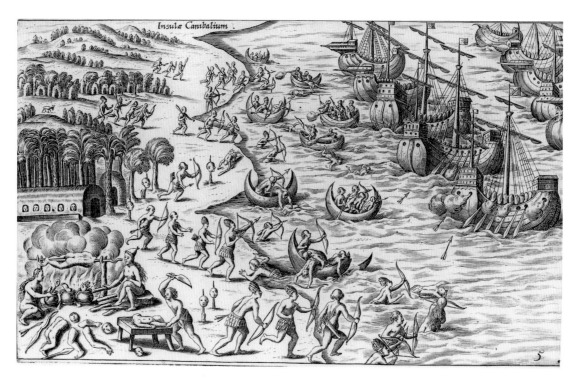

5

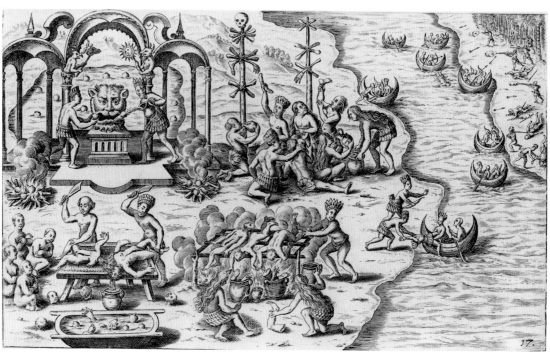

17.

10 WE ARE SORRY BUT UTOPIA HAS HAD TO BE POSTPONED

No picking of noses.
No breaking of wind.
No spitting.
No speaking with mouth full.

Children have long been commanded to obey these rules of public comportment – but not since time immemorial. Fastidious principles about self-presentation in company – the formal definition of 'good manners', and the raising of an 'embarrassment threshold' – may have prevailed in other societies and in other times (for example, the ways of *gentilesse* understood by Geoffrey Chaucer and his contemporaries in fourteenth-century England); but they are first properly chronicled in the courts of sixteenth-century Europe. And, alongside a code of sensibilities about the disposal of bodily odours and fluids (no more peeing against the tapestries; neither adults nor children), arose some distaste for the habitual recourse to violence. 'Courtliness', or 'courtesy', impinged upon the feudal custom of settling trivial differences with knives and staves. Consequently, aristocrats, or 'better people', came to consider themselves above such uncouth behaviour. They educated their offspring in the precepts of etiquette. They then legislated norms and standards for others. A *habitus* or environment was created. Self-constraint was made a matter of social constraint.

This is 'civilization'.

Such is the line of reasoning proposed by the sociologist Norbert Elias (1897–1990). As a thesis seeking the criteria to mark 'civilization' from its negative ('barbarism', or 'savagery'), it need be qualified only by the circumstances surrounding its inception. *Über den Prozess der Zivilization* was composed by Elias as a Jewish academic who left Germany when the Nazis took power in 1933; it was published in Switzerland in 1939. Neither of the author's parents survived Nazism. Hermann Elias died in Breslau in 1940; Sophie Elias ended at Auschwitz in 1941.

Hermann Elias had stayed in Germany because he believed it to be a *Rechtsstaat*, a 'lawful state'.

We may hesitate, given those circumstances, to upbraid Norbert Elias for nursing some roseate vision of human perfectibility, or a quaint understanding of 'civilization'. Implicit in every stage of the 'civilizing process' as described by Elias is its reverse 'decivilizing' momentum: wars and pogroms, therefore, do not become 'civilized' if they are waged by fastidious chemists who would faint at the sight of blood. What Elias strove to provide was a set of historical data for the modern understanding of the term *civility*. When, for example, did it appear unseemly to eat food at the table with one's fingers? For Elias, the charted minutiae of tact and sociability provided measures of a new twist in human evolution – the survival of the gentlest, as it were. An instinct for violence was becoming

116 CANNIBALISM IN THE WEST INDIES

As imagined by an Iberian monk, Honorius Philoponus ('Honourable Work-Lover'), and published in his account of New World discoveries and missions, *Nova typis transacta navigatio novi orbis Indiae Occidentalis* (Venice 1621).

173

tamed as soon as the doughtiest warrior felt obliged to put meat in his mouth with a fork.

Elias acknowledged that what he described was a process 'under way' (or at least, 'not yet terminated'). Mankind, he supposed, could probably count upon inhabiting the planet earth so long as the sun lasted: about four hundred thousand million years. That ought to be time to get it right; to find a way of living together happily and well.

<p style="text-align:center">★ ★ ★ ★ ★</p>

What follows here is a protracted sequence of meditations upon that sentiment as it has surfaced in the imagery of those centuries we are schooled to regard as 'modern'.

There are some errant loops of chronology and theme in this survey. It is implausibly 'epochal'; and recklessly wrong, if it ever implies that no one prior to the sixteenth century had been troubled by the problems of group violence, individual suffering and social justice. The terms 'Utopia' or 'Utopianism', too, may prove futile covers for the will to 'civility' that Elias sought to chronicle. But some summary is required; and perhaps the following lines will carry it.

In Classical antiquity most people believed that the cosmos was ordered by deities and that those deities knew what was best for mortal beings. In the Middle Ages most people in Europe went about their lives convinced that a single deity had created the world and intended whatever occurred upon its surface. In modern times – conventionally regarded by Eurocentric tradition as beginning with a voyage across the Atlantic by Christopher Columbus in 1492 – such faith began to pale. Divine superintendance, or else the rule of a deity administered on earth by a priesthood (the kind of system which some would call 'theocracy'), gave way to the belief that humanity might raise itself by its own boot-straps; that life on earth might be made better or worse not by heavenly intent, but according to human conduct, human government, and human ingenuity.

That belief, or 'world-view', is peopled with names. Rousseau, Voltaire, Marx and others: the ideologues of human 'progress' without God will shadow us here, made noisy by mere snatches from all their earnest argumentation. Our survey lies not so much with them as over the concurrent flow of visual polemics. As we shall see, images were no less essential in campaigning for a secular cause than they were when at the service of a religious decree. But art as an expression of intellectual censure was hedged with its own problems of 'good taste' and 'civility'. Voltaire, with his books and pamphlets, could reason a case, point by point, against the practice whereby certain human beings were institutionally empowered to burn, stretch, degrade and dismember other human beings. The artist who similarly deplored torture was both better and worse equipped than the writer. Unveil that chamber of horrors, the rack and the screws and all: a single picture might count for page after page of vehement prose. But how should disapproval be made clear? What if the picture had viewers more obsessed than repelled by its sight? What if the world's most gloating torturer adored to see his profession laid bare?

These are questions more readily asked than answered; they may stay as unresolved now as they were in centuries past. But the persistence of a problem need not deter us from our search for its beginning.

X.i Savagery begins at home

When the master navigator set sail in 1492 he carried with him self-appointed powers of nomenclature.

To name was to bless; to bless was to appropriate, by right of hallowed destiny.

There was an island known to its inhabitants as 'Guanahani': 'I called it *San Salvador*, in commemoration of His Heavenly Majesty, who so marvellously has bestowed all this.' On a subsequent voyage, another island came into view in the form of three mountains, as if the very land mass incorporated God the Father, the Son and the Holy Spirit. He duly called it 'Trinity' – Trinidad.

He was on a mission to which, it seemed, he had been born. Christopher: name of the patron saint of all travellers, *Christum-ferens* the 'Christ-bearer'. *Columbus*: Latin for 'dove', the seeker of land and vegetation; emblem and porter of peace.

The question of 'What's in a name?' works well with Christopher Columbus; so, too, with the decidedly post-Columbian concept of 'Utopia'. Utopia is a Greekism whose meaning is ambivalent, as commonly transcribed. Utopia from *ou-topos* is 'no place', and 'nowhere' is sometimes how it wants to be understood. Utopia from *eu-topos* is 'fine place'; the land of undisturbed felicity, a Paradise on earth. When Sir Thomas More composed his description of the imaginary isle of Utopia, in 1516, he coyly let the ambivalence linger. Ever since, the term 'Utopian' has attached itself promiscuously to diverse enterprises of practical philanthropy, futile dreaming and lethal schemes for mass contentment.

More's *Utopia* tends to be misapprehended by those who know it only by repute. Its readers soon recognize a literary *jeu d'esprit*, not an earnest sociopolitical tract. But the making of this Utopia was not pure fantasy. The author clearly drew upon the tales of travellers beyond Europe, such as those published in the mid-fourteenth century under the name of Sir John Mandeville. Sir John wrote for those who wanted primarily to know what might be seen in Jerusalem, and how their peppercorns grew; but he included some notice of Earthly Paradise, where Adam and Eve had been so briefly established. 'Of Paradise can I not speak properly,' he admits, 'for I have not been there, but that I have heard I shall tell you.' He relates the description of a high mossy wall, and a spring enclosed there which supplies the four great rivers (Ganges, Nile, Tigris and Euphrates), and ruefully concludes: 'no man may pass there but through special grace of God.' Still – it *is* there . . .

Columbus agreed; he surmised that the whereabouts of Earthly Paradise lay approximately in the land we know as Venezuela. But, like Mandeville, he did not go there. Signs from the archipelago of the Indies indicated that he was close enough. Those paradisical signs twinkle throughout the pages of the diaries of Columbus. Everything verdant, marvellous and lush; a brimming cornucopia, an enclave of the Golden Age once defined by Classical poets. And as the people of the Golden Age knew nothing but endless abundance, so these natives had no

cause to fear the visitor. Once they have overcome their nerves at the arrival of Columbus – he says they think he has come from heaven – the Indians are munificent. In their canoes they paddle out to greet Columbus and his men with blossom-crowns and baskets of fruit.

Timorous, pacific, intelligent. What first-rate slaves these 'Caribs' should make. And with what absurd ease should a small detachment of musketeers take possession here.

In fairness to Columbus, his transformation from dove to hawk was not self-engineered. He settled for a generally benevolent paternalism, whereby it was in the Indians' best interests to enter Spanish service and the bourn of Christianity. Qualms about the annexation of near-Paradise were offset more aggressively by certain fellow-travellers. Diego Chanca, ship's physician on the second voyage of Columbus, compiled a spicy dossier of regular cannibalism among the islanders – women maintained like battery hens, youngsters bred and fattened expressly for the pot – which made them so brutish ('*tan bestial*') that they deserved the most severe programme of domestication. Meanwhile Amerigo Vespucci, who explored along the east coast of South America, pruriently described the sexual proclivities rife amid the Amerindians – providing further reason for conquest on the back of moral urgency.

Once the *conquistadores* set to work – Hernán Cortés confronting the Aztec kingdom of Montezuma in Mexico in 1519–20, and Francisco Pizarro invading the Inca domain of Peru in 1531–33 – the trade in 'atrocities' was as brisk as in any field of conflict. Stories of Montezuma's men pouring molten gold down the throats of Spanish prisoners are sufficient to symbolize the clash between Europe and Utopia's borderlands. Some European commentators – such as Bartolomé de Las Casas, and Francisco de Vitoria – worried openly about the ethics and justice of colonization. Others were more obliquely perturbed to wonder what indeed it was that marked off 'savagery' from 'civilization'. Indians were brought back to Europe as side-show freak exhibits (as seen by Montaigne); Columbus himself delivered several junior specimens to the court of his royal patrons Ferdinand and Isabella, to be schooled in Spanish civility. The sensational twin taboos of eating people and committing incest were neither of them reliably documented, but images of the cannibalism were greedily savoured by European book-buyers (116). Columbus himself was rather disappointed not to find astonishing kingdoms and monumental centres of empire. But was there truly an ocean of difference between the New World and the Old?

Columbus had given firm anecdotal testimony to an 'instinctive' good-heartedness among the Taino Indians and other 'savages' he encountered on his way. Such testimony was quite disregarded when the English philosopher Thomas Hobbes delivered, in 1651, his assessment of the natural state of mankind as an 'ill condition' of 'continuall feare, and danger of violent death; And the life of man, solitary, poore, nasty, brutish and short'. In the same section of his *Leviathan* (Part I, ch. 13), Hobbes alleged that 'savage people in many places of *America* . . . live at this day in that brutish manner' – all for the lack of belonging to a sovereign state.

Hobbes wrote with no experience of New World anthropology. He had, by contrast, ready knowledge of civil war, religious massacres and the public

execution of a head of state. These happened in the Britain of his lifetime. And as for whatever might lie across the Atlantic – well, Hobbes could simply have looked over the English Channel to find a case-study of descent into the ill condition of continual fear. It was the Europe of the Thirty Years War.

Conventionally that period (1618–48) is characterized in terms of widespread lawlessness, devastation and depopulation – in C.V. Wedgwood's phrase, 'the outstanding example in European history of meaningless conflict'. The field of battle was Europe's heartland – then a patchwork of principalities and protectorates, mostly German-speaking but militantly either Protestant or Catholic as it suited their respective princes and protectors. In the course of the nominally 'religious' disputes of these territories, Sweden, Denmark, Russia and Poland contested with Brandenburg for control of the Baltic Sea; while English, Dutch, Spanish, French and other forces intervened according to their particular interests.

Historians now dispute the extent of the damage wrought across a continent by this endemic conflict. But it is probably true to say that we are haunted by the tradition of bleak degeneracy as theatrically rendered in Bertolt Brecht's *Mother Courage and her Children* – subtitled 'A Chronicle of the Thirty Years War', written in the late 1930s, and hardly ever off the world's stages since its main Berlin production in 1949. A tough old camp-follower, dragging her wagon in war's squalid entourage, Mother Courage was a figure taken from the pseudo-memoirs of a participant in battles of the Thirty Years War – *Der abenteuerliche Simplicissimus, Teutsch*, by Hans Jakob Christoph von Grimmelshausen, published in 1669.

Grimmelshausen saw action on both Catholic and Protestant sides – in itself an indication of the cynicism with which religious faith was manipulated as a cause of hostilities. His accounts of pillaging with Croat mercenaries can be selectively used to substantiate the historical overview of the Thirty Years Wars as a prolonged period of moral recession (though the worst event befalling 'Simplicissimus' seems to be a dose of the clap; and the hero shows little desire to return to his shepherd's state of innocence before the wars began). But a more immediate and ultimately more influential protest was lodged in the engravings recorded by a non-combatant – Jacques Callot.

Callot's early success as an artist was cultivated in Italy. At the Florentine court of the Dukes of Tuscany his graphics belonged to the conjuring of masques and carnivals. He returned to his home town of Nancy in the independent Duchy of Lorraine in 1621. War spread along the Rhineland in that year; by 1633, Lorraine had been invaded by French troops.

Callot had come home to promises of generous patronage from the Duke of Lorraine. But a court stipend never quite materialized. So Callot turned to an alternative mode of making his draughtsmanship pay. He made sets of prints which could be stitched together and put up for sale; a collaborator in Paris, Israel Henriet, served as 'publisher'. A market was there, or was created; and buyers could be given a run for their money if a set of prints were broken up and retailed separately. Already, by the end of the seventeenth century there was a recognizable type of person desperate to complete this or that Callot-sequence.

This was something of a novelty at the time: an artist beholden to no one in particular, issuing images to a marketplace of unknown potential collectors. The cost of this procedure to the artist was the possible risk to his livelihood; the gain, a new independence of voice. In the past – going back at least as far as the Roman emperor Trajan and his campaigns in Dacia (modern Romania) during the early second century – artists had joined a war effort. Accompanying a campaign, taking sketches, working sketches into commemorative paintings and reliefs: since warlords were the paymasters, such commemorative art was invariably triumphal. Trajan's war-artists conveyed reassuringly precise details of logistics and equipment, to boast their actual presence in the army columns: insinuating, then, the same degree of verisimilitude in their accounts of Trajan's glorious victories in the field. But they were Trajan's artists, and therefore constrained to depict their patron bathed in glory. Likewise, ancient Egyptian artists had been bound to show pharaoh Rameses III as unstoppable champion; and the makers of the Bayeux Tapestry were obliged to recount the deeds of William 'the Conqueror' from the perspective of one of the Norman bishops supporting him.

So this was where the voice of independence told. Setting aside any question of inclination, which artist prior to Jacques Callot was ever at liberty to pursue a project called 'The Miseries and Misfortunes of War'? It was in 1633, the year of the seizure of Nancy and the occupation of Lorraine by French troops, that Callot and Henriet issued an eighteen-print series under that title ('Les Misères et malheurs de la guerre') – usually abbreviated to 'The Miseries of War'.

It is misleading and pointless to describe this work as 'the first graphic protest against war' – if such a phrase implies that Callot gazed with strikingly piteous concern upon war's destruction of bodies, property and countryside. His set of engravings presents more of a homily, a succession of cause and effect that might be flippantly captioned: 'Advice to those thinking of joining the army – don't!' Callot gives us one battle-scene, done conventionally enough; prior to that, he has documented the plumes and pomp of a recruiting drive. Thereafter, the artist charts a moral slide whose downward momentum indeed harms marginal innocents, but spells even greater misery for those soldiers who signed up with dreams of trophies and acclaim. The many-splendoured knight-at-arms or *miles gloriosus* meets his match in Callot. There is no specification of time or place: this is generic war, 'structural and symbolic', which ruins or rewards its protagonists according to their comportment off the battlefield.

Ruin comes when discipline is lost. Soldiers turn to plunder – farmsteads, churches, convents, villages (117); they torture householders for details of the whereabouts of savings, they operate like bandits on the highways. This is the reckless pillaging of the Thirty Years War that Simplicissimus describes. But Callot, perhaps with more wishful thinking than a true sense of documentary record, reveals justice enacted. His etchings illustrate the marauding soldiers as subject to both military and civil authority, and specify the various punishments which follow capture. The firing-squad, the stake and mass-hangings (118) are duly recorded; also, before a great crowd, a victim stretched out upon a cartwheel for a limb-by-limb smashing to pulp. Crippled soldiers are shown miserably begging alms from the people they once assailed. But the most vindictive violence is

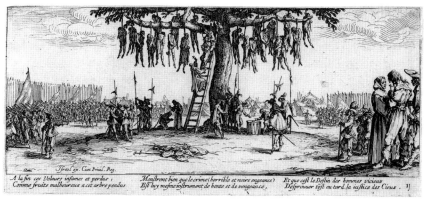

117–119
THE MISERIES OF WAR
Jacques Callot, 1633

Taken from Callot's sequence
of etchings, we see first
'The Plundering and Burning
of a Village' by wayward troops;
then 'A Hanging' to punish
such misbehaviour; finally,
the further justice meted out by
locals, by way of an ambush
in the woods ('Peasants
Avenge Themselves').

reserved for Callot's penultimate plate (119), *la revanche des paysans* ('the country-folk strike back'). In a glade of stately trees, a cohort of soldiers is ambushed by locals; and these backwoodsmen are not in the mood to show mercy. One exultantly lifts a handful of intestines from the body of his victim.

The recruiting officer never said anything about this.

In Callot's vision there is a marked sense of gentle nature gone awry; the quiet integrity of agricultural life suddenly wrecked by war. The tree festooned with its grotesque fruit of dangling corpses is eloquent of this. Callot himself may have succumbed to a plague outbreak resulting from continued fighting in the Lorraine;

at any rate he did not live to witness the signature of the 'Peace of Westphalia' in 1648. Contemporary draughtsmen, such as the Italian Stefano della Bella (1610–64), took up Callot's lead in giving graphic expression to a generalized, or impartial, antipathy towards warfare, and in due time (as we shall see) Francisco Goya (1746–1828) would exploit further the printmaker's power to 'comment' upon war's exposure of the depths of human nastiness. But the art of Callot should not be seen as a commercial experiment in horror-mongering. It was a part of European self-doubt: the revelation of 'savagery' in a landscape that may not have been anywhere in particular – but was quite clearly part of the continent.

The stirrings of international law belong to this period. In 1625 Hugo Grotius, saluted as 'umpire to the nations', published his tract 'On the Law of War and Peace' (*De iure belli ac pacis*). Within his programme of universal juristic theory, Grotius attempted to proscribe the 'liberties' (*licentia*) of itinerant armed forces. His intentions were peaceful, though he wanted to justify, like Callot, punitive redress against crimes of devastation and pillage. He also compiled a list of people whom it should be 'illegal' to attack in times of war. (Grotius named not only children, civilian women and the elderly, but also the clergy, farmers, merchants, artisans and 'men of letters'.)

Grotius was a Dutchman, and not ashamed to belong to a people (in his own words) 'unsurpassed in their greed for honourable gain'. His early work *Mare liberum* ('Open Sea', published in 1609), made a defence for exploratory navigation and 'free trade'. For Grotius, this was not equal to a benediction of the colonizing process. He believed in the universal reasonableness of his species, amongst whom there existed a 'hunger for society' (*appetitus societatis*) which yielded an instinctive understanding among humans to respect the 'natural rights' of fellow humankind. So Grotius disagreed with Hobbes. Nature was not the breeding-ground of brutes.

The Hobbesian view was to be countered even more vehemently by Jean-Jacques Rousseau (1712–78). In his *Discourse on Inequality* of 1755, Rousseau argued that man in the natural state was 'perfectible', and that it was *l'homme sauvage* who enjoyed liberty; *l'homme civil*, by contrast, found himself everywhere restricted, under duress – 'in chains'. Rousseau's faith in the 'noble savage' was not shared by all contemporary *philosophes* in France. His one-time friend, Denis Diderot, commenting upon customs recorded among the South Sea islanders of Tahiti, exposed the looseness of the term 'savage' when applied to primitive or tribal societies – which were, after all, 'societies'. But in Rousseau's works, the moral, social and economic weave considered by Europeans to be 'civilization' was persuasively displayed as a tenuous fabric. And Diderot needed no gloss of ethnographic relativism when he admitted, or prophesied, or teased, in 1771: 'It is a thousand times easier for an enlightened people to return to barbarism than for a barbaric people to take a single step towards civilization.'

X.ii 'The Shaftesburian gentleman'

Now across the English Channel: to the people for whom the concept of 'fair play' would become a matter of ethnic self-definition.

Anthony Ashley Cooper, 3rd Earl of Shaftesbury (1671–1713), spent only three

years at Winchester College (motto: *Manners maketh Man*) before demanding to be removed: the tauntings and drunken behaviour of the other boys were too much for him. He then toured Europe with a private tutor, including a visit (in Holland) to the philosopher and family friend John Locke, before taking up his public duties in the British Parliament, aged twenty-four.

120 DAVID GARRICK
Thomas Gainsborough, 1770

In eighteenth-century England, Garrick was the closest thing to a Hollywood star – the leading Shakespearean actor and impresario.

Eventually, the Shaftesbury name would become associated with practical measures for the amelioration of the lives of women and children in Britain; it was the 7th Earl of Shaftesbury who in the nineteenth century pressed for legislation to remove child labour from heavy industry. The 3rd Earl, whose asthma was irritated by too much business at Westminster, issued more cerebral instructions for the well-being of mankind. Like Grotius, he was an optimist. He had a sense of Nature's essential goodness. Accordingly, in his *Inquiry concerning Virtue* (published in 1699), Shaftesbury deplored people's 'UNNATURAL *and* INHUMAN DELIGHT *in beholding Torments*, and in viewing Distress, Calamity, Blood, Massacre and Destruction, with a peculiar Joy and Pleasure'.

It was 'horrid and miserable' behaviour, and Shaftesbury deemed it 'barbarous' – yet also 'wholly and absolutely unnatural'. 'Such is the Nature of what we call *good Breeding*,' he continued, 'that in the midst of many other Corruptions, it admits not of INHUMANITY, or *savage Pleasure*.'

This is the voice of 'courtization'; confident and clear. The word 'polite' begins to be used in its modern English sense in the mid-eighteenth century largely as a result of Shaftesbury's influence; and a new type of hero appears, 'the Shaftesburian gentleman' – urbane, amiable, and considerate of others. The type is heroized by a style of portrait in which the subject is shown to be patently well-mannered, well-informed and therefore 'civilized' company. An image by Gainsborough of the Shakespearean actor David Garrick exemplifies such a hero (120). The book that Garrick holds may contain lines of Shakespeare, or it may not; at any rate, the celebrated actor is not going to bore us with a declamation. He leans slightly forward with eyebrows alert and lips about to smile, or deliver some nice remark. We would perhaps believe from this image what Gainsborough himself thought of its model: 'Garrick is the greatest creature living . . . Every view and every idea of him is worthy of being stored up for imitation.'

A code of aristocratic duty (*noblesse oblige*) may eventually have saved English gentry from the tumbrils of popular revolution; but the Shaftesburian gentleman did not actually have to be blue-blooded. It was with lively reverence, not mockery, that William Hogarth painted the ruddy 'plebeian' features of Thomas Coram, in pseudo-regal pose (121). Coram, a self-made shipping magnate and retired naval officer, was a generous and efficient philanthropist, who secured the king's

charter – which he holds for our attention in this portrait – to build London's first proper refuge for un-wanted babies. The same hospital was a cause with which Hogarth himself was deeply involved, so the image brims with its maker's affection and approval for a truly exemplary sub-ject. Those who commission portraits are generally individuals with money. Here, says Hogarth, is one who wor-ked hard for his money – and then disposed of it in an enlightened fash-ion for the benefit of others.

'In an enlightened fashion' is a loaded phrase: it calls for explanation.

We who style ourselves as living in the 'postmodern' age are inclined to deny the definite article to any epoch claiming the label 'enlightenment'.

121 CAPTAIN THOMAS CORAM
William Hogarth, 1740

Coram was a sea-captain: hence the globe, and other signs of his profession (and source of his wealth) included in the portrait.

Nonetheless, some historians would argue that many of the *practical* measures undertaken to alleviate pain and suffering in the world were installed, if not con-ceived, during that passage of the eighteenth century known in Europe and America as 'the Enlightenment'; a period probably best characterized by one philosopher (Voltaire) ridiculing another philosopher (Leibniz) for proposing that humans already find themselves 'in the best of all possible worlds'.

The word 'polite' elides with the same cognate origins as the word 'police': both seem to arise from a meaningful English muddle of the Greek term for 'citizen-state' (*politeia*) and the Latin participle for 'elegant' or 'polished' (*politus*). That etymological note is a small token of what the influential French thinker Michel Foucault (1926–84) identified as an insidious historical feature of the Enlightenment: the building of 'carceral society' in schools, hospitals, asylums, prisons and places of work – not so much with the aim of liberating individuals from chaos and pain, as snagging them within a fussy web of 'moral technologies'. 'Policies' must therefore be devised in order to restrain those individuals who fail to be 'polite' members of such a controlled society; and 'police' forces set up in order to ensure docile obedience to the rules. For Foucault, the Utopian projects advanced by Enlightenment writers and 'politicians' were trajectories for totalitarianism.

But whether we regard the Enlightenment as glowingly absolute or not, we may at least admit that our latter ancestors – or some of them – were articulating a new set of sensitivities about the definition of 'humane' behaviour. Socrates had extolled the value of 'the examined life', but neither he nor any other Classical thinker was seriously troubled by the practice of one human being enslaving another. Medieval preachers beseeched their congregations to share in the pains of Christ under flagellation: but no medieval theologian was much exercised, it seems, by the routine application of torture to interrogate presumed wrongdoers

and heretics. It is during the Enlightenment that we first register the voices of protest, the moves for abolition; or simply intimations that slavery and torture were neither necessary evils nor indelible traits of human nature.

It may hardly need adding that principles of religious toleration were not installed immediately after John Locke presented a philosophical case for them; and of course, the existence of a 'politics of decency' did not, in itself, entail legislative action. But it is not fanciful to propose the historical development of something tantamount to an intellectual 'guilt complex' developing through the eighteenth century. And whatever else that guilt complex may imply, this is where ethics and aesthetics meet and clash as they never have before.

The English politician Horace Walpole lamented preciously, but acutely too, in a private remonstrance against the slave trade written in 1773:

> Alas! Dare I complain of gout and rheumatism, when so much a bitterer cup is brewed for men as good as myself in every quarter of the globe! Can one be a man and not shudder at all our nature is capable of! I welcome pain: for it gives me sensibility, and punishes my pride. Donatello loses his grace when I reflect on the million of my fellow creatures that have no one happiness, no one comfort!

Donatello loses his grace . . . As post-Holocaust people we know that it is possible both to adore Mozart and to administer gas chambers. In the eighteenth century, 'culture' was more strictly connected with the same 'courtliness' that despised violence. A whip-wielding slave-trader who also admired Donatello's Early Italian Renaissance sculpture was inconceivable. John Keats declared, in 1819, that he would detest the award of poetic glory 'because women have cancers'. What was poetry – what was art – if it did not work from the knowledge of a world (in Keats' words) 'full of Misery and Heartbreak, Pain, Sickness and Oppression'? Composing odes in desertion of his training as a surgeon, Keats may have been unduly sensitive to the artist's perceived burden of social responsibility. But he was not alone.

'It is always a writer's duty to make the world better,' ruled Dr Johnson in 1765. It was a moot point whether poets and playwrights could improve the world more effectively than painters and sculptors. What was not in doubt, however, was the effort of sympathetic engagement required as a basis for moral concern. The Scottish philosopher David Hume (1711–76) defined the power of sympathy as being a principle of human nature, and held that this power not only deeply influenced 'our taste of beauty', but also brought about 'all the artificial virtues' – including 'justice, allegiance, the laws of nations, modesty, and good manners'.

Hume's fellow-countryman and contemporary, Adam Smith, is now chiefly known as an economist, but Smith was once Professor of Moral Philosophy at Glasgow University; and his treatise on *The Theory of Moral Sentiments*, first published in 1759, was no less cogent in its time than his advocacy of free trade. Smith enlarged upon Hume's humanistic reasoning. Just as two strings must be equally wound up to achieve mutual resonance (or, in Newton's laws of motion, as opposing forces make an equilibrium), so, Smith argued, the spectator of

suffering must project imaginatively into the situation of that suffering if true sympathy is to occur: 'Though our brother is upon the rack, as long as we ourselves are at our ease, our senses will never inform us of what he suffers . . . it is by the imagination only that we can form any conception of what are his sensations.'

The rack was not, in the mid-eighteenth century, outmoded in Europe: only a few states had by then followed Sweden's example and abolished the practice of judicial torture. A case of the use of the rack in attempting to extract a confession was hotly publicized by Voltaire in 1762. It concerned one Jean Calas, a murder suspect in Toulouse, and Voltaire pitched in with polemic, but not only because the case offered further opportunity to explode on the topic of religious fanaticism (Calas was a Huguenot, tried by a Catholic court; he denied the murder-charge up to his death, which was by battering on the wheel). Voltaire's wrath concerned the call for national shame. How could any country think itself 'enlightened' so long as it kept pulleys and thumbscrews in its system of law?

For his part, Adam Smith did not quit his professorial dictate on sympathy as mainspring of virtue before he had delivered a broadside against the slave trade. He had read the accounts of travellers among Africans and Amerindians and considered those 'savages' to be 'nations of heroes'. Those stalwarts were now made subject to slavers who were, as Smith described them in the fifth book of his treatise, 'the refuse of the jails of Europe . . . wretches who possess the virtues neither of the countries which they came from, nor of those which they go to. . .'

Smith was never the champion of completely unfettered market forces, or *laissez-faire*. Beneath all measures of deregulation lay the groundwork of moral and legal codes that sympathy must construct.

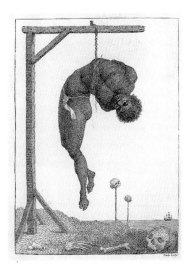

Groping for Utopia; building the new Jerusalem. In the *Songs of Innocence* and other 'crisis lyrics' of William Blake (1757–1827) we hear the pleadings of an eccentric, but not a freak:

> Can I see another's woe,
> And not be in sorrow too?
> Can I see another's grief,
> And not seek for kind relief?

Blake simply borrowed the logic of active sympathy when he deplored the common domestic practice of using urchin boys to clean chimneys; and his graphic attacks upon slave-trading were entirely consonant with Adam Smith's heroization of slavery's victims. A Captain John Stedman, with whom Blake was acquainted, had written an eye-witness account of how a slaves' rebellion had been put down in South America. Blake supplied vignettes of Stedman's evidence in such a way as to heighten the inspiring fortitude of the rebels (122). They were consigned to deaths of drawn-out agony: but unlike Laocoon (a figure which Blake loathed, as he loathed all 'imperialist' and war-glorifying Classical art), these powerful

122 'A NEGRO HUNG ALIVE BY THE RIBS TO THE GALLOWS'
William Blake, 1796

This engraving was done as an illustration to J.G. Stedman's *Narrative of a Five Years' Expedition against the Revolted Negroes of Surinam, in Guiana, on the Wild Coast of South America* (1796).

Africans contain their grimaces. Noble savages became truly exemplary victims.

Blake lived and worked in London, where he mixed with political 'Radicals' such as Mary Wollstonecraft, and joined certain civil disturbances, swiftly quelled. He hailed America as the land of democratic hope. He also gazed expectantly towards the land of Rousseau and Voltaire. Could Paris raise the banner for universal suffrage in Europe?

X.iii Condorcet's omelette

Our Lord Shaftesbury was not unknown in France. His Inquiry was translated into French by none other than Denis Diderot, in 1745. This was the same Diderot who later coined the rallying-cry adopted by the 'Jacobins' who gathered at an old Parisian convent of St Jacques (Jacobus) in order to agitate for the cause of radical democracy: 'Let us strangle the last king with the guts of the last priest!'

Hardly the sort of sentiment one might consider appropriate from a Shaftesburian gentleman.'Violence is the midwife of every old society pregnant with a new one,' Karl Marx would later ordain; or, as the French politico-culinary proverb states, eggs must be broken for omelettes to be made ('On ne saurait faire une omelette sans casser des oeufs'). Shaftesbury's ideal of 'good breeding' could surely have been claimed by Marie Jean Antoine Nicolas de Caritat, Marquis de Condorcet (1743–94). Yet this aristocrat was happy to discard his pedigree; and, as plain Condorcet, to volunteer as one of the most eager supporters of the Jacobin Revolutionaries who took control of France in 1789.

Too eager, it seems: Condorcet's enthusiasm for a properly thought-out National Constitution brought him into conflict with more precipitate agitators. Eventually, in 1793, they had him charged with treason and put under house arrest in Paris. Condorcet escaped, making his way, incognito, to an inn at Clamart, where he asked for an omelette. The landlord enquired how many eggs he required. 'Twelve,' replied Condorcet. The quantity specified may have been prompted by hunger, but it raised suspicions of lordliness. Condorcet was searched for his identity papers, and was found to be carrying only a copy of Horace's Epistles. His guise as a commoner slipped; he was rearrested.

It seems that Condorcet evaded beheading at the guillotine by committing suicide in his cell. Before his end, however, he had scribbled one last statement: a testimony written in the near-certainty of premature death, but not remotely desperate.

Condorcet's 'Sketch of Human Progress' (or Esquisse d'un tableau historique des progrès de l'esprit humain, as fully titled) is not the most accomplished monument of the Enlightenment, but the conditions of its composition make it one of the most poignant pleadings ever made for the sake of global happiness. Condorcet was a mathematician, with an unbendingly linear mind; he was also one of the philosophes, with an unshakable faith in the bountiful power of science. For Condorcet, humanity was not a piece of irredeemably 'crooked timber'. He had seen a monarchy overthrown, which in turn betokened his own end as a privileged member of the 'old mode' or ancien régime. So be it. This was as Diderot had forecast: the kings must go, along with all their aides, and their most pernicious accomplices, the clergy. Let people then be governed by reason; reason based on recognition of

the natural rights of every individual and the statistical sciences of human society. Nothing was impossible, least of all 'perfectibility' in human affairs. Once science was put to the service of agriculture and medicine, everyone upon the planet could expect to lead long lives; lives free of privation, violence and pain.

Condorcet envisioned himself as a second Socrates, martyred for the cause of good sense. But he saw, too, that the Athens of Socrates had fallen far short of perfection. Classical Athens had fostered imperialism, the denigration of women, and slavery – perhaps the worst 'crime against nature', which to Condorcet's dismay had been revived in America, the country of his greatest hopes.

And, however sceptical we may be of the measures in which he placed his faith, we might concede the perceptive grace of Condorcet's view. He foresaw the emancipation of women and the abolition of slavery. He predicted the advent of old age pensions and state education. From a prison cell he grasped at chinks of radiance. Yet even outside, as Condorcet admitted, we see that 'the light occupies only a small part of the globe . . . heavy shadows still cover an immense horizon'.

In English it is 'Enlightenment'; German speaks of 'Clarifying' (*Aufklärung*); the French refer to 'the century of illuminations' (*le siècle des lumières*). Amid this pictorial language of light and clarification there is an obvious call to artists, to envisage and symbolize the fervent sense of advancement or 'progress' alive in Condorcet – and alive, too, in those who called for Condorcet's head. During 'the Terror' of the French Revolution there was much destruction of art, and not only art associated with church and crown: some called for all 'emblems of feudalism', all 'spoils of prejudice and arrogance', to be eradicated – even 'ruins' to be

123 *AU GÉNIE DE FRANKLIN*
'To the genius of Franklin', Jean-Honoré Fragonard, 1778

In the years 1747 to 1752, Benjamin Franklin gained international fame as the scientist who explained the phenomena of lightning. He went on to represent the American Congress in France, enlisting French support for the cause of American independence.

swept aside. But what should rise up in place of all the ripped-down trappings of the *ancien régime*? How should artists represent the new ideals of liberty, equality and fraternity?

A premonition of the problems posed by this challenge came with Jean-Honoré Fragonard's homage to Benjamin Franklin, the United States ambassador to France 1776–85 (123). A painter better known for feathery evocations of amorous dalliance, Fragonard played upon the unusual combination embodied in Franklin, of politician and pioneer of electricity, to present the American Founding Father as a prophetic figure who has assumed the powers of Olympian Zeus. 'He has snatched from the sky its thunder,' reads the Latin caption to this picture, 'and from tyrants their sceptres.' But the stylistic message here is unclear. This is not Franklin the diligent and self-chastising Calvinist; nor Franklin the Republican whose hero was Roman Cato, the consul 'called from the plough'. Still less is it Franklin the scientist, whose idol was Isaac Newton. An unhappily imperious figure sits there instead: he looks suspiciously enthroned.

The confusion is forgivable. Revolution had yet to happen. When ideology erupted into action Fragonard struggled to engage with it before heading south to retreat at Grasse. Fragonard's close contemporary, landscapist Hubert Robert, caught some scenic aspects of mob violence – such as the burning of the solid Royal detention centre that was the Bastille – before being himself incarcerated. Strong nerves were required of any artist close to the epicentre of the Revolution and its purges – a strong stomach, too, if street affrays were to be described. The Marquis de Launey, the governor of the Bastille, was among the first wave of victims during the summer of 1789, and his hacked-off head, mounted on a pitchfork, was sketched, along with others, by Anne-Louis Girodet (124). The other heads belonged to Paris tax commissioner Bertier de Savigny and the king's finance minister Foulon, who was suspected of hoarding grain. 'Let the rabble eat

124 DECAPITATED HEADS OF MARQUIS DE LAUNEY, FOULON, AND BERTHIER DE SAUVIGNY
Sketches attributed to Anne-Louis Girodet, 1789.

The folio is inscribed '*Depuis nature, Par Girodet*', implying that the artist watched the lynch-mob in action.

hay,' Foulon had said. 'Horses like it well enough.' The rabble stuffed his decapi-
tated head with stable-fodder, which in Girodet's drawing sprouts from the
minister's cheeks like a walrus-moustache.

The artist *par excellence* of the Revolution was Girodet's mentor, Jacques-Louis
David (1748–1825). Though David seems to have moved fluently between succes-
sive careers as painter in the court of Louis XVI, then director of Revolutionary art
and pageants, and, finally, propagandist for the military dictatorship of Napoleon
Bonaparte, there is a political consistency to his work. In paintings commissioned
under the *ancien régime* David was already relishing 'Republican' themes; like
Robespierre, the eloquent 'tribune of the people' during the Revolution, David
nourished himself upon the heroics of notable Romans – paragons of the Roman
Republic, such as Brutus and the Horatii brothers, who had been prepared to sac-
rifice themselves for the common good. And, in keeping with the anti-clericalism
of the *philosophes* and the Revolutionary zeal for 'de-Christianization' throughout
France, David stayed clear of religious themes. Ancient philosophers were steadily
preferred. Seneca and Socrates calmly showed how death was to be met (125).

But the Revolution was a creed in itself. Like all creeds, it spawned martyrs.
David painted several of them. One was an adolescent boy called Joseph Bara, who
had died *pour la Patrie* ('for the Fatherland'), fighting against anti-Revolutionaries
in the western region of the Vendée, south of Nantes. Robespierre grindingly
manipulated the youth's death as an instrument of propaganda to salvage – in vain
– his own popular status; David simply isolated the image of Bara wounded and
naked as an epitome of broken Revolutionary esperance (126). But the more

**125 THE DEATH
OF SOCRATES**
Jacques-Louis David, 1787

In the summer of 1794, when
he found himself indicted by
political enemies, Robespierre
shouted, 'There is nothing
left for me but to drink the
hemlock', which David had
seconded: 'If you drink the
hemlock, I will drink it with
you!' ('*Je boirai la cigue avec toi*').
The following day, Robespierre
attempted suicide with
gunshots, and bungled it;
he was finished off at the
guillotine. David refrained
from joining this messy
route to self-eclipse.

substantial saint of the Revolution's 'civic religion' had already been given his apotheosis by David's art: Jean-Paul Marat, prime spokesman of the militant faction known as the *sans-culottes*.

'Without knee-breeches' is how the *sans-culottes* translate: not attired, that is, like gentlemen. To British critics of the French Revolution, Marat's constituency was a stripy-trousered horde, sub-human, depraved and cannibalistic (127). So the news that Marat had been assassinated in July 1793 was joyfully greeted in Britain; and Charlotte Corday, the lady from Rouen who stabbed Marat while he lay in his bath, immediately became – for the British – a fragrant stately heroine.

David, in his salutation 'To Marat' (128), chose not to make any figure of the assassin. Charlotte Corday is indicated only by two traces of her treachery: the bloodied kitchen knife she used for the murder, and a letter of spurious entreaty to 'citizen Marat' (which she had carried in order to gain access to her victim, though she had not in fact needed to use it). The expiring Marat still holds a quill; and from a legible note upon his wooden-box of a desk, we see that he was attacked while in the process of despatching some money to a certain 'mother of five children' lately bereaved of a husband who 'died for his country'.

To die in a bath was evocative of Roman Stoic virtue. If he was going to slit his wrists, the good man showed consideration for others by doing it in a readily cleansed receptacle. Marat suffered from psoriasis or some such skin complaint, which he eased by soaking in water. Whatever his reputation for inciting violence – some historians have put the case for him being an astute and well-meaning activist – Marat, in David's painting, is utterly vulnerable, a man labouring with pen and ink for the good of the people. The artist had seen Marat alive like this only the day before his murder; it was also David's responsibility afterwards to have Marat's corpse embalmed and displayed for public veneration in a still-functioning Parisian church.

126 THE DEATH OF JOSEPH BARA
Jacques-Louis David, 1794

Crying 'Long live the Republic!', Bara was killed by a bayonet-jab to the groin. David heightened the innocence of the boy by laying him out naked, while avoiding depiction of his genitals.

Some Jacobins claimed Jesus Christ as first of the *sans-culottes*. How far David's image may be regarded as a secular Pietà, with Marat assimilated as 'the Suffering Servant', is open to speculation. David composed and painted the picture rapidly, but it shows no signs of haste. David knew exactly what had to be done. The clutter of streetwise tricolours and weaponry that Marat kept in his room was eschewed, as the artist emphasized the 'honourable indigence' that was Marat's estate. So the scene of crime becomes an inner sanctum, dark yet not ill-lit.

It is the strange void-light of a part eclipse. In passing, Marat shines.

What David made of Marat was a type of heroization, given to posterity in an image layered with hints of past stereotypes. The pagan show of strength and resolve; the shimmering nimbus of Christian martyrdom – these play upon our reading of the picture, and may obscure the fact that we have stumbled into a new terrain for the glorification of violence. Here is the monument to a man murdered in his bath, but a man who all the same dealt in blood and death. Marat may then be seen as hero of the Enlightenment's own brand of savagery. He died needlessly – the individual who, that we might live in a better world, summoned one massacre after another.

A young English poet was in Paris around this time. 'Bliss was it in that dawn to be alive. . .' William Wordsworth's retrospective chronicle of exultance turning to dismay – in Books X and XI of his autobiographical poem *The Prelude* – acknowledges the failure of the Revolutionaries: those 'who throned/The human understanding paramount'. But Wordsworth also allows the exhilarating sense of promise and regeneration that was Revolution's motor. The Irish writer and politician, Edmund Burke, charged the likes of Robespierre and David with having invented 'a system of homicidal philanthropy'. That is a paradox handily

127 *'UN PETIT SOUPER A LA PARISIENNE'*
'A little Parisian supper'; or, 'A family of Sans-culottes refreshing after the fatigues of the day', by the English political cartoonist James Gillray, 1792.

128 À MARAT
'To Marat'; also known as
'Marat at his Last Breath'
(*'Marat à son dernier soupir'*),
Jacques-Louis David, 1793.

The date is inscribed on the
painting as l'an Deux, 'Year
Two' – according to the
new calendar imposed
by the Revolutionaries.

encompassing the ideals and actualities of what happened in France. Did not Robespierre, who caused so many to go the guillotine, come into politics campaigning for the abolition of capital punishment?

So close, so close they sometimes seemed to reach the state of Future Perfect. Robespierre voiced and embodied that hope-drunken procrastination – 'one more little purge, only a little one, and we will be there'; just as his own ignominious death symbolized its failure.

Burke predicted that the Revolution in France, having abolished the supreme authority of a monarch, would lay down the conditions for one charismatic individual to take command of the army. Burke was right. Ten years after the Revolution began, Napoleon Bonaparte was declared 'First Consul' of the Republic. He would ascend in due time to 'Emperor'. In fact Napoleon put no limits on his aspirations of power, so long as he was successful in the activity which gave him most happiness and satisfaction: making war.

X.iv *'No se puede mirar'*

Making war; unmaking war. Napoleon and his chiefs of staff, poring over maps and orders of battle, supposed they knew what they were doing. The view from within the ranks was never so clear.

In Stendhal's novel *The Charterhouse of Parma* there is a description of what happened at Waterloo in 1815. What happened is as Stendhal relates: anything and nothing; everything, whatever. There was a rumble of cannon somewhere not so far away. Otherwise, men could only stagger through a descended murk of uncertainty. Where are we? Who is in charge here? Was *that* the Emperor? You there – how did *you* come by that horse?

Are those chaps with us or them?

Has anyone got anything to eat?

To wander towards or away from invisible conflict; to lose one's unit; to be ignorant, or simply careless, whether one was on the side of victory or retreat – these are the peculiar fringe disorientations of Waterloo that Stendhal describes; Waterloo, the encounter generally regarded as 'decisive' in closing down the ambitions of Napoleon. Of course there were formations, and charges, and many individual and collective acts of military renown. There *was* such a thing as 'the Battle of Waterloo', even if its strategic aspects were never properly represented in the many patriotic paintings made by way of commemoration.

Yet Stendhal's narrative of chaos convinces. The true tragedy of war – that is, its waste of human promise – is embedded in that hesitation, 'Whose side are you on?'

Attack or embrace: which shall we do?

Why are we doing this to each other?

To resume brisk narration of the 'great-men-of-history' who orchestrate these tragic confrontations.

In 1808 Napoleon installed his brother, Joseph Bonaparte as king of Spain. Napoleon expected little resistance from the Spanish: neither Charles IV, the Bourbon monarch whom Joseph supplanted, nor the crown prince Ferdinand enjoyed much popularity. But the billeting of French troops in the peninsula provoked local resentment. British forces, glad of any opportunity to spike

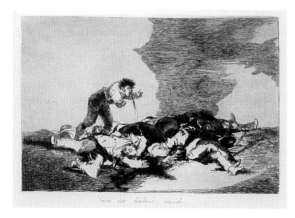
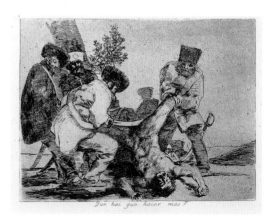

Napoleonic plans, colluded with Spanish guerilla rebels. A sporadic but steady state of war prevailed in Spain until 1814.

The senior painter of the Bourbon court – which had replaced the Habsburgs in Spain since 1714 – was Goya. He was the salaried *pintor del rey*; too distinguished for dismissal according to any change of dynasty. Though it seems he did not draw his stipend during Joseph's reign, Goya nevertheless took commissions from the new order. He painted their enemies, too – notably the Duke of Wellington, whose military mission it was to 'hustle' the French out of Spain. To have asked the painter whose side he was on might have raised a shrug of sheer ambivalence. But in the autumn of 1808, Goya, aged sixty-two, undertook a journey from Madrid to Saragossa which carried him through the ragged landscape of resistance and reprisals. How much he himself witnessed and how much he gathered by hearsay we cannot be sure. But, like Stendhal's prose of disillusionment, Goya's etched account of 'The Disasters of War' intrinsically smacks of truth.

The more so, perhaps, because the vignettes of action that Goya produced were like private memoranda, not made public till decades after his death. Goya died in 1828; only in 1863 did the Spanish Academy release the album of eighty prints known as '*Los Desastres de la Guerra*'. Goya's own title had been: 'The Fatal Consequences of Spain's Bloody War with Bonaparte; and other Emphatic Caprichos' – *Caprichos* being the painter's term for his 'unofficial' output of mordant sketches and satires of Spanish life and institutions.

Capricho carries the sense of something whimsical, unexpected; giddy-minded. To gaze at Goya's souvenir of the Napoleonic occupation of Spain is to understand why the artist qualified his caprice here with the word 'emphatic'. Dashed off, perhaps; piecemeal; sometimes indistinct. But not – not at all – to be taken lightly.

A figure arrives at a place of corpses, lurches, and spews blood into the pile (129).

Four soldiers have a man stripped and yanked into an upside-down position. One, with his sabre, carves a course down through the prisoner's groin (130).

A gibbet in the hills. Bodies trussed to the trunk of a wind-blown tree. A dismembered torso swinging from a branch – like a parody of gymnastic skill. A brace of severed arms hangs there too. And there too is the head: absurdly proud in its impaled prominence (131).

Men and women huddling, crawling, hand-wringing: before a poky intrusion of bayonet-tipped rifles. '*No se puede mirar*', the artist inscribes – 'One cannot look at this' (132).

(But one does.)

All the etchings carry the artist's captions: ironic more often than not. To only one image – of refugees streaming along with children and bundles – does he add 'I saw this' (*Yo lo vi*). The whiskered hussars of Napoleon's army bristle ubiquitously throughout the series, but Goya does not seem obsessed with demonizing them. His recourse to the tonal effects of

129–131
LOS DESASTRES DE LA GUERRA
'The Disasters of War', Goya, 1810–20

The first engraving is entitled *Para eso habeis nacido*: 'This is what you were born for'; the second, *Qué hai que hacer mas?*: 'What more could possibly be done?'; and the third, sarcastically, *Grande hazaña! Con muertos!*: 'Great deed! With the dead!'

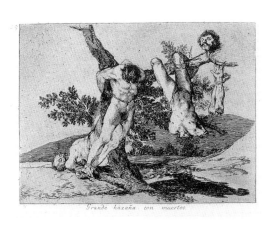
Grande hazaña con muertos.

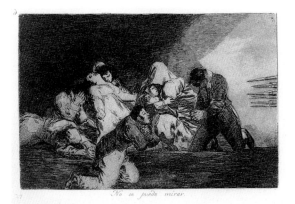

aquatint etching allows him to cast most episodes into varying pockets of penumbra. These 'disasters' are miniatures which absorb an enormous spreading gloom. The gloom hangs under urban arches. It quickens over open slopes.

War is an anarchy where nuns and monks join the scrabble for food. But it is also worse than that. The finality is nihilism: penumbra reducing to nothingness. These are darkened events. We cannot look at them; we can hardly make them out. In the foreground of a grainy, nightmarish mess of hatchings and gaping heads, there lies a half-buried, twisted figure; his arm is thin and limp, but holding a quill. The sheet or parchment where the quill has been says 'Nada', 'nothing' (133). The title as rendered later, in 1863, is: Nada. Ello dirá (Nothing. Time will tell). This was the Academy's reworking of Goya's original manuscript, which did not entrust the judgement to posterity: Nada. Ello lo dice (Nothing. That's what he says).

And there is nothing more to say.

'Officially', to greet the Bourbon restoration of Ferdinand VII in 1814, Goya painted (at his own request) two canvases to mark successive events in Madrid on the second and third of May, 1808. That was when Napoleon's General Murat entered the city, with some 25,000 French soldiers; there was protest and rioting from citizens around the central precincts of the Puerta del Sol; and, subsequently, a series of executions carried out by the French. Goya showed the riot: citizens pulling knives and throwing themselves at the cavalrymen of the French Imperial Guard. Then he painted the consequence: the shooting, probably in the early hours of the next morning, of whoever was deemed guilty of joining the tumult.

The *Executions of the Third of May* is celebrated as a mythic statement of Spanish self-determination – albeit that Goya never stooped to flagrant patriotism (134). The image takes its compositional cue from the etching entitled No se puede mirar. There, the place of execution seems to be a cave; here, it is a hill on Madrid's outskirts called Principe Pio, where over forty *Madrileños* are known to have been shot by order of General Murat. To judge by such names and occupations as are listed of those condemned, it had genuinely been a people's uprising; or else the French had arrested citizens at random in the trouble-spots. The roster included some building-site workers and a carpenter; a royal groom and a palace gardener;

132–133
LOS DESASTRES DE LA GUERRA
Goya, 1810–20

Further engravings. The first, *No se puede mirar:* 'One can't look on this'. The second, *Nada. Ello dirá:* 'Nothing. Time will tell.'

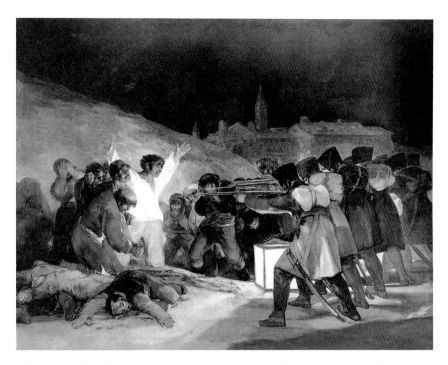

134 THE EXECUTIONS OF THE THIRD OF MAY, 1808
Goya, 1814

Goya's concern with war remains firmly fixed on a single aspect: those military actions which affect the civilian population.

a beggar; a friar. In Goya's canvas they file up to the hump that is the firing-place, and the foremost of the approaching victims covers his eyes with his hands. (*One cannot bear to look.*) Another casts a sidelong glance, nervous and hunted. He will see what we cannot: the executioners' faces, as by their lantern-light they crouch and concentrate their aim.

The man in the white shirt who flings his arms askance – he is, as many have noticed, making a Christlike attitude. His hands are stigmatized; the friar kneels beside him like St Francis at the foot of the Cross; and behind, on the hillside, there seems to linger the symbolic apparition of Mary and Child. The regime of Joseph Bonaparte had been self-proclaimedly 'enlightened' and secular in its policies; Goya could expect to appease the restored Ferdinand by putting his partisan martyrs on the side of Catholic piety, and reducing 'enlightenment' to a box lantern by which hapless citizens may be shot dead by militia-men. He stopped short, however, of making them the sort of roseate pain-transcending heroes that some of his artistic predecessors in Baroque Spain – El Greco, or Bartolomé Murillo – would have shown. Before the fusillade these ordinary people drop to their knees to crave mercy, not posthumous honours. They are fear-filled while alive; marooned in blood, and disfigured, when dead.

Goya was not himself delighted by the return of Ferdinand. Already without his hearing, he became reclusive; and in his rural retreat, *La Quinta del Sordo* (The Deaf Man's House), he diverted himself with painting oils directly upon the interior walls of his dining-room and studio. These were his 'Black Paintings' (*pinturas negras*), so-called as much on account of their subjects as for their chromatic sombreness. Slobber-lipped and slack-jawed, the human species or Spanish *pueblo* has never looked so shamblingly out of sorts. Goya makes it plain that foolish mortals conjure terrors for themselves. But monsters also loom

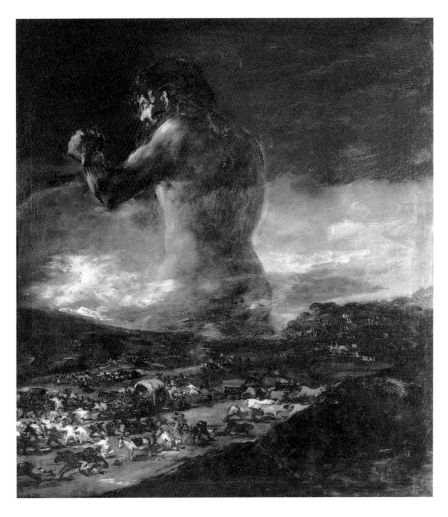

which would have anyone shaking and afraid (see 159). Very much in the mode of the Black Paintings is a canvas done by Goya around the same time as he composed *Los Desastres*. Like many of his images, it is ultimately enigmatic: what it appears to show is a valley of people and animals scattering in panic, as beyond the mountain ridge looms a great hairy-shouldered giant (135). Conceivably this giant is roused from slumber to protect the fleeing people; or else it is a hulking 'personification' of War; or it may indeed present what Goya's earlier interpreters took it to be – an allegory of Napoleon, who was referred to by contemporary admirers and detractors alike as 'colossal' in his ambitions of power.

If this monster is Napoleon, then Goya's logic through *Los Desastres* is worked out. War is a 'sleep of reason'; it is the hellish collapse of civility. Napoleon's private secretary, Bourienne, tells us that even on the march his master was always impeccably turned out – quite the dandy, or *gentilhomme* no less. But for Goya, the 'great man' who covets the glory of war is not the dauntless Alpine conqueror that David painted, nor the richly-robed *Imperator* portrayed by David's student, Jean-Auguste Ingres. Goya's superman is a shaggy ogre of swiping, cumbrous destruction.

135 *'EL GIGANTE'*
'The Colossus',
Goya, *c*.1808–12

Whatever its meaning, the image must ultimately relate to a motto once tagged by Goya to his work: 'The Sleep of Reason Gives Rise to Monsters'.

X.v Lord of the flies

For the sake of completing a fable, we had better see the colossus off.

After Waterloo they put him on an island, St Helena in the mid-Atlantic, where he stayed under British surveillance until his death in 1821.

In France, meanwhile, the Bourbons crept delicately back to their throne. The king who returned in 1814, Louis XVIII, was accorded a fraction of the powers enjoyed by the monarchy prior to 1789. Still, Louis liked to think that he had, metaphysically, been the king since his brother's execution. And in many ways he behaved as in the days of the *ancien régime*. He did not consider that a new parliamentary system should inhibit his powers to indulge in nepotism – and proceeded to hand out ministerial jobs to his family and friends, regardless of their competence.

It was as a direct result of such practice that Théodore Géricault produced the picture that has been held up as the answer to the question, 'How do you turn catastrophe into art?'

In July 1816 a French convoy was sailing to the West African colony of Senegal, headed by a flagship called the *Medusa*. The captain of the *Medusa* was a staunch Royalist, and that was how he came to his post; neither navigation nor running a tight ship were in his expertise. As a result of his ineptitude, the ship ran aground on reefs south of Cape Barbas, on the western coast of the Saharan desert. The *Medusa* was not carrying lifeboats sufficient for her passengers and crew. A large raft was therefore improvised from ship's timbers, and 150 persons crammed upon it. The promise was that the raft would be towed to shore by those senior officers and sailors who had secured places in the lifeboats.

Almost immediately the raft – with its occupants waist-high in water, and most provisions immediately sodden or lost – seemed too burdensome for towing. Those on the lifeboats let the tow-ropes go, in the knowledge that the raft and all aboard would drift out to sea and probably never be seen again.

The raft was duly borne away by high waves. Soon there was confusion, mutiny and fighting on its planks, in the course of which sixty-five men died. It drifted further. By the third day cannibalism had already begun. There was no shelter from sun and salt; only a rationed quantity of wine, which had to be supplemented by sea water and urine. At a certain point the decision was taken by the stronger survivors to push their wounded fellows overboard.

At length, another ship from the broken convoy, the *Argus*, came into sight. That was when the raft was on its thirteenth day adrift. By then, of the 150 who had been put aboard the raft of the *Medusa*, only fifteen had survived.

The episode was hushed up by government officials, and no great censure passed upon the bungling captain of the *Medusa*. But two of the survivors, Henri Savigny and Alexandre Corréard, sued for compensation. Their appeal only earned them dismissal from their posts. So they determined to make public all that had happened. Their book, entitled *Naufrage de la Frégate la Méduse* ('The Shipwreck of the Frigate Medusa', published in 1817), became a *cause célèbre* not only in France but throughout Europe.

Géricault's decision to paint the disaster came after it had receded as a political scandal. He met with Savigny (who had served as ship's doctor), and for a

**136 THE RAFT
OF THE MEDUSA**
Théodore Géricault, 1819

To the end of his life (in 1824),
the artist remained embittered
by the disparaging or feeble
reaction elicited by this huge
canvas; within decades, though,
it was saluted as a masterpiece.

while he mused over which part of the Savigny-Corréard narrative to depict.
The drunken mutiny and fighting? The resort to cannibalism? In the end Géricault
chose to show the moment of the epic at which delirious hope and exhausted
resolve divided those clinging to the raft (136). It is the first sighting of the sister
ship, the *Argus*. The hopefuls make a vigorous pyramid, pointing and waving,
aching to be seen – by a vessel which is hardly a dot on the horizon. Others do
not so much as lift their heads. They are with the dead and dying; in the ashen
hours of waiting to die. One of them – a grave bearded elder – may be construed
(from Géricault's sketches) as a father meditating on the prospect of eating
his own son.

Géricault worked all-consumingly on the enormous canvas for eighteen
months. He had lately been in Rome, and had studied the monumentalism of
bodies by Michelangelo. Now he went along to the Beaujon hospital in Paris, to
contemplate bodies in states of wasting and decay (137). He went further: visitors
to the large studio hired by Géricault for the sake of this massive composition
found that the artist was acquiring body parts of criminals decapitated by the guil-
lotine, and keeping them about his premises (138). It was a well-established rule
for painters submitting historical subjects to the critical scrutiny of the annual
Paris exhibition or *Salon* that the many components of such paintings be individu-
ally accurate and 'studied'. However grandiose the theme and overall vision, its
details – the *morceaux*, the 'mouthfuls' of history – must show an artist's diligent
hours of preparation. So Géricault's studio doubled as a temporary morgue. The
bits and pieces he had to live with were the rotting dead.

137 STUDY OF AN EMACIATED ELDERLY MAN
Théodore Géricault, 1818

A pencil drawing presumably made by a hospital bed.

138 STUDY OF THE SEVERED HEADS OF A MAN AND A WOMAN
Théodore Géricault, 1818

The painter collected such items from the residue of public executions.

Hence the snap ephemeral judgement of *La Gazette de France* when Géricault's *Raft of the Medusa* was hoisted for display: 'A work for the delight of vultures.' Fellow-artists were hardly more sympathetic, with Ingres declaring that he hated this image 'of the dissecting-room'. The picture was not exhibited to its own advantage: Géricault watched helplessly as it was positioned high above view. Historical paintings were supposed – in the tradition of David and others – to be 'lofty' in their moral importance. Géricault had previously shown that he could make Napoleon's cavalrymen and *cuirassiers* look magnificent even when wounded in the field. Now what had he done? Brought a sharp and oversize focus to bear upon humanity as flotsam, awash in unknown lines of longitude and latitude; darklings of waves and clouds, of indeterminate nationalities – 'all at sea', and out of time.

When Columbus and his associates came back with tales of cannibalism as practised in remote places by remote 'savages', that had been worth visualizing. In Canto XXXIII of his *Inferno*, Dante recounted the story of one Count Ugolino who, in the thirteenth century, had been punished for treachery in Pisa by being shut up in a tower with four of his sons or grandsons. Ugolino watched them die – upon which, in Dante's laconic explanation, 'hunger overcame grief'. Sculptors and painters had not heeded G.E. Lessing's decree (in 1766) that the story of Ugolino was 'loathsome, horrible and disgusting, and as such thoroughly unfit for representation'; Joshua Reynolds in England and, later, Jean-Baptiste Carpeaux in France were among the many artists who attempted to prise open the horror enclosed in that old Pisan tower. What Géricault presented, however, was something rather short of 'loathsome'.

We can see how Géricault sought to extract some residual essence of hope, even from the resort to filial cannibalism: that is precisely his transformation of 'catastrophe' into 'art'. After all, the 'delight of vultures' jeer of the critic in *La Gazette de France* looks frankly inaccurate. Any viewer of the *Raft of the Medusa* can see that however much Géricault practised the depiction of rotting or moribund bodies, his final results owe much more to Michelangelo than to the dissecting-room. The dead on the raft are unmarked by fighting; the survivors are not the blistered, suppurating and skeletal forms of men reduced to chewing their own belts and others' bodies. So what was the offence against taste?

In the Salon, the picture was given a generic title: *Scene of Shipwreck*. But contemporary Salon-goers knew the story painted there; and knew precisely what that story told of people's natural inclinations towards liberty, equality and fraternity.

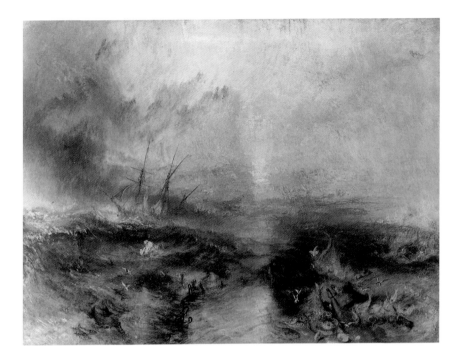

The tale of the *Medusa* was more than a sorry episode of maladministration in early nineteenth-century France: it reads like a case-study of utter social breakdown; with egotism uppermost at every turn, under duress, each member of the species will squirm and fight to survive. Géricault stopped short of depicting the true moral squalor of that situation: what dominates one's memory of his picture is surely not the sprawled forms of those who have succumbed to their end, but the pinnacle of bodies straining for salvation's slender chance.

But we have the benefit of hindsight here. Our great-great-grandparents may have cherished a tale in which a group of boys find themselves shipwrecked in the Tropics, and it is Paradise (R.M. Ballantyne's *Coral Island*, published in 1857). We were reared on the revised version, William Golding's *Lord of the Flies* (1954): boys – choir boys, to be precise – set down in the Garden of Eden with a peacock-blue lagoon. They do not flourish; they fight for their lives. The ship that comes to rescue them finds an island ransacked and blazing; with whatever ideals of liberty, equality and (most emphatically) fraternity all alike reduced and spoiled. Golding's island marks the 'end of innocence'; not Utopia, but the domain that is the heart's darkness and the heart of darkness ruled by Beelzebub, 'lord of the flies'.

Géricault never recovered from his dejection at the indifference, or dislike, that the *Raft of the Medusa* produced. One can imagine his hollow laughter had he seen how an English contemporary, J.M.W. Turner, would handle a similar sort of subject. The British, having shipped several million Africans into slavery on plantations in the West Indies and elsewhere, finally abolished their trade in 1833. One of those responsible for the legislation, Thomas Clarkson, had optimistically written a *History of the Abolition of the Slave Trade* in 1808, the second edition of which Turner may possibly have read in 1839. It contained an account of how, in 1783, the

139 SLAVERS THROWING OVERBOARD THE DEAD AND DYING – TYPHOON COMING ON
J.M.W. Turner, 1840

This painting was exhibited at the Royal Academy along with verses (by Turner) on the coming of a storm and slaves being jettisoned, ending with the sentiment, 'Hope, fallacious Hope! Where is thy market now?'

captain of a slave-ship called Zong had ordered slaves suffering from an epidemic to be cast overboard, because the terms of his insurance policy allowed claims for 'loss at sea', but not disease. Turner subsumed this event into the rising of a typhoon-storm (139). A ship begins to labour in purple waves, its masts gone bloody into sunset. The waves seethe and crest, and in their midst are manacled hands; surrounded by a bright shoal of John Dory and other fishy nibblers, a single negro leg flaunts its chains – with two large and voracious sharks ploughing forward.

The colours are extraordinarily rich; and, in John Ruskin's estimation, symbolic ('that fearful hue which signs the sky with horror, and mixes its flaming flood with the sunlight . . .'). Ruskin was Turner's most ardent apologist; he thought this picture Turner's best, and at one stage owned it – before deciding that it was 'too painful to live with'. Turner himself vaguely categorized the scene as being illustrative of what he termed 'the fallacies of hope'. Perhaps Géricault would not have disapproved the effort. In its burnished bravura fashion, Turner's sea-scape with discarded slaves superficially 'beautifies' a ghastly event – so extracting 'art' out of catastrophe.

One young artist directly involved in Géricault's Medusa was Eugène Delacroix, who posed as a model for one of the flung-aside corpses on the raft (Delacroix is the swarthy figure with moustache in the left-hand corner). Delacroix records how, when he saw Géricault's finished canvas in the studio, he took to his heels and ran all the way home – whether in panic or rapture is not clear. However ennobling the end result, and despite his own experience as the live model for the image of a days-old corpse, Delacroix understood the challenge of Géricault's method. To depict horror was to investigate its reality: visit the morgue, stand by the scaffold; talk to survivors. Delacroix's preferred method of inspiration was to sit down safely with a copy of Lord Byron's swashbuckling verse. 'Courage is needed,' Delacroix wrote, 'to make a god of a beauty which is unquiet.' He tried, however. News came through in April 1822 that Turkish forces had conducted a purge of Greeks on the island of Chios. Delacroix began to do some research in the Géricault manner. Through a family contact he met a French officer who had served on the Greek side and was able to report what had happened on Chios. He also borrowed a wardrobe of 'Oriental' costumes. Numerous 'studies' were made, in various media. And in further emulation of Géricault, Delacroix put his final composition into the Salon of 1824 as an extra-large canvas, over twelve feet high (140).

The Massacres de Scio remains a curiosity which gives meaning to the phrase, 'flawed masterpiece' (which may in turn equate to the Salon award of 'Gold medal, second class', which it won). Delacroix's own account of its making allows easy insight into the development of the picture, but also reveals an artist who – despite the research – was uncertain of what took place on distant Chios. Delacroix's hero Byron died in the same year that the picture was exhibited, and died while supporting the cause of Greek independence from Turkish rule; Delacroix intended his image to be an expression of liberal sympathy for the Greeks. But his martyrs here seem stunned into abject lassitude. One of them rises to remonstrate with a Turk who has tied a semi-naked woman to the back of his horse; the turbaned soldier reaches for his scimitar with ease and scorn.

The other Greeks lie in a limp and voluptuous surrender. The fury of attack and resistance is a blurred tumult in the background. From afar there is the smoke of a burning town. Below a vacuous horizon, Delacroix has endeavoured to put down all that he knows, through hearsay, about a certain historical event. It is not enough; and yet it is too much.

Salon commentators saw this: they were unanimously agreed that what the picture lacked was focus.

Lack of focus was at that time deemed a compositional fault.

Few could have imagined then that a machine would soon appear which gave an entirely new meaning to such terms of critique.

X.vi 'The Inventory started in 1839'

Delacroix welcomed it. The box-camera, devised by Henri Daguerre in 1839, was for Delacroix a boon to all painters. The 'daguerreotype' should be seen, he argued, 'as a translator commissioned to initiate us further into the secrets of

140
THE MASSACRE OF CHIOS
Eugène Delacroix, 1824

The painter's original title for this canvas was *Scènes des massacres de Scio: familles grecques attendant la mort ou l'esclavage*: 'Scenes of massacres on Chios: Greek families awaiting death or slavery'.

nature'. It was an indiscriminate tool, inclusive to a fault. But it was, he believed, of more benefit than threat to art.

Others – most famously the poet and Salon critic Charles Baudelaire, in a raging essay of 1859 – denounced all the claims of photography to be 'art'.

Art or not, there is a sense in which every photograph is forlorn. If photography compiles a visual list of everything in the world, it is always a passing permanence. When the lens falls shut the flux goes on. For seconds, or fractions of a second, we clutch at eternity.'Photographs state the innocence, the vulnerability of lives heading toward their own destruction,' as Susan Sontag noted in her meditation *On Photography* (1977), 'and this link between photography and death haunts all photographs of people.'

Beyond the plangency intrinsic to the medium, however, there is the camera's claim upon verisimilitude. Géricault was not accurate in the number of bodies he put on the raft of the *Medusa*, and Delacroix never went to Chios; but both artists, in their way, intended some sort of documentary 'credibility' in the scenes of disaster that they portrayed. Goya let it be known by using the tag,'I saw this'; those appraising the work of Géricault and Delacroix were overtly made aware that both artists had interviewed eye-witnesses to the events commemorated on canvas. Was photography the brusque new route to such conviction; the ultimate mechanistic seal on the claim, 'I saw this'?

Most of us know now what our forebears were less inclined to suspect: that photographs can be staged, faked and otherwise distorted; that the medium carries no absolute assurance that it is safe for us to suspend disbelief. Still we are prone to accept that a photograph will 'expose' truth with raw immediacy. So it is a curious fact that, in the early days of photography, on the first occasion that a camera was sent to war, it was to undertake a cover-up mission.

The context was the Crimean War of 1854–56. In this campaign, by the shores of the Black Sea, Britain, France and Turkey jointly acted against Russia following a 'breakdown of diplomatic relations'. It was a conflict whose causes now seem remote and trivial; a conflict significantly remembered in Britain for curious items of clothing designed to provide extra insulation (cardigan, balaclava). For the British, its heroes were the 'noble six hundred' who made the Charge of the Light Brigade during the battle of Balaclava in 1854 – a classic instance of blundering, ludicrous action – and the heroine Florence Nightingale, 'the lady of the lamp', who arrived in the Crimea ten days after the Battle of Balaclava to reorganize the military hospital facilities at Scutari. These had been revealed as abysmal by a reporter for *The Times* newspaper, W.H. Russell – a pioneer 'war correspondent' whose journalistic eye for a stirring story was matched by shrewd observation of the logistical and managerial shortcomings within the British military. It was to counter the damning reportage of Russell – relayed by a vivid new device, the telegraph – that government officials colluded with a commercial picture agency, Thomas Agnew and Sons, to manipulate the vivid new device that was photography. The photographer despatched to the Crimea was Roger Fenton; his instructions were to take no pictures of dead or wounded men, no pictures of cholera victims (of which there were many thousands, due to wretched conditions behind the lines) – nor, indeed, any images that suggested winter's deathly cold.

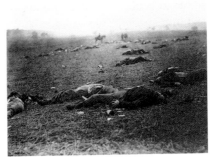

Whatever investigative spirit Fenton may have possessed was thereby blocked off. Records show that he made friends with senior officers, and obediently produced gentle sepia scenes of life behind the front: ships unloading; camps settled; soldiers at ease, puffing on their pipes and raising their canteen-mugs. In fairness to him, it should be remembered that Fenton's equipment was a cumbersome box-camera, with large plate-glass negatives requiring an exposure time of at least three seconds; rattling around in a horse-drawn van with this gear, he could hardly have crouched furtively amid the heat of battle. His sole attempt to render the bleakness of the war remains the best-known image of the Fenton record: it shows the Woronzoff Road, hard by where the Charge of the Light Brigade was made – the so-called 'Valley of Death' (141). No bodies, men or horse. No guns nor wreckage of them. Only the scree of cannonballs: which was a landscape rendered elegiac by understatement.

It was during the American Civil War (1861–65) that photographers engaged in what was, ostensibly, more direct commentary upon events; or, at least, were subject to fewer restrictions, as the freelance possibilities of selling their work to journals and newspapers proliferated. Foremost in the field was Mathew Brady, who had established a portrait studio in New York in 1844. From the main opening of hostilities – the Battle of Bull Run, Virginia, in July 1861, where Confederate forces prevailed – Brady co-ordinated several posses of cameramen, with a view to supplying such popular papers as *Harper's Weekly*, as well as mounting public exhibitions. Brady was on the Union side (and was known as 'Mr Lincoln's camera-man'); and it has been shown that in some of his work there is an element of imposture, with assistants playing the parts of those fallen in the field. Yet Brady's claim to be the impartial 'eye of history' during the Civil War – amassing some 8,000 images over four years – is cogent. Gettysburg in July 1863 was a three-day battle claiming around 40,000 casualties; the dead were hastily interred, and it was Abraham Lincoln who, arguably, 'disinfected' the site with his brief but 'historic' and influential address. The images gathered by Brady's team present what Lincoln's stately rhetoric left unsaid – 'the tragedy of macerated bodies, the many bloody and ignoble aspects of this inconclusive encounter' (142). There was an express endeavour on Brady's part to reveal the war shorn of glory, and essentially degrading; quite distinct, as such, from the more studiously heroic or hygienic images produced by artists and draughtsmen commissioned to 'illustrate' the war – including Winslow Homer, also working for *Harper's Weekly*. In the words of one of Brady's associates, Alexander Gardner, the photographic record

141 THE VALLEY OF THE SHADOW OF DEATH
Roger Fenton, 1855

'Half a league, half a league,/Half a league onward,/All in the valley of Death/Rode the six hundred' – the opening lines of Tennyson's verses for the *Examiner* journal in December 1854.

142 THE BATTLEFIELD AT GETTYSBURG
Timothy O'Sullivan, 1863

The photograph was also symbolically titled 'The Harvest of Death'.

served to caution the future: photographs should 'aid in preventing such another calamity falling upon the nation'.

Desolate images of the internees discovered in the Confederate prison-camp at Andersonville in Georgia (143) were, however, calculated to indicate the 'righteous' side in the war. The Northern States that made up the Union side were ideologically more or less united by the conviction that slave labour was abhorrent. The Southern States of the Confederacy stood by slavery. The documented fate of Union soldiers in Confederate hands seemed to confirm why the war had been fought: 'inhumane' treatment had been meted out to Union prisoners just as it had been to slaves.

The potential for photography to propagandize by shock tactics was further exploited in France, during the insurrection of 1871 known as the Paris Commune. Newspapers were by now claiming photographic immediacy for most of the images appearing in their pages, though the mechanical processes for 'faithful' reproduction were not yet diffused. The Communards – diverse partisans of socialist reform, with figureheads such as Pierre-Joseph Proudhon – created a revolutionary enclave in Paris; and it was, in journalistic terms, 'good copy'. Proudhon's slogan, 'La propriété c'est le vol' ('property is theft'), coined in 1840, appeared to condone the spectacular vandalizing of palaces and monuments, the Louvre museum included. Great street barricades were erected, and there was fierce skirmishing between Communards and government troops. But photographers were still too encumbered by their apparatus to show 'action' as such. Eugène Appert, acting with government permission, used a form of photomontage to make an illustrated series called 'Crimes de la Commune': he took pictures of captured or executed Communards, and then cut

143 UNION PRISONER FROM ANDERSONVILLE

Photograph from the studio of Mathew Brady, 1865. An image 'undoctored' in any sense.

144 PARIS COMMUNE: BODIES OF INSURGENTS

Photograph attributed to Adolphe-Eugène Disdéri, 1871.

The market for postcards illustrating Communard actions was lively not only in Paris itself, but also abroad (especially England).

out the heads, transferring them to fit the bodies of photographed impersonators wearing 'Communard' costumes but in a 'genuine' setting. The entire assemblage was finally rephotographed and passed off as an authentic record. Of events such as the toppling of the column in Place Vendôme, picture-postcards were manufactured in large quantities, for a public, at home and abroad, which wanted to 'witness' revolution at a safe remove.

Appert's portrait-record of incriminated Communards had a secondary use, of course – in police archives. But the pathos of the movement itself – a desperate episode, in which some 20–30,000 Parisians died – was captured in an apparently undoctored image of Communards as corpses, lined up in simple cradle-coffins like so many half-swaddled infants (144).

X.vii Saint Vincent's dream

Less than two decades after the *débâcle* of the Commune, a thirty-three-year-old Dutch painter arrived in Paris from Antwerp. He was, in his way, a sympathizer with the Communard cause: it was during his stay in Paris that Vincent van Gogh (1853–90) made his studies of workers' well-worn hobnailed boots, redolent of decent toil and lives dressed in coarse fustian. He saw the city in its moods of the conventional picturesque – the dappled walkways in the park of the Tuileries; yet he also painted the smoking industrial compounds in the suburb of Asnières.

Van Gogh believed in art for all people, whether well-heeled or clad in clattering boots. He also believed, as we shall see, in the direct benign powers of artists and art-dealers to broadcast delight in the world. To such an extent Van Gogh might be counted as a socialist and an idealist of the times. But other names are clamouring for attention here: we had better acknowledge them first.

Chafing in London – when *would* the artisans of Britain organize a full-blown revolution? – Karl Marx saw the Paris Commune as the prototype of 'working-class government'; a laudable experiment in the ideals of democratic socialism which could be applied to 'the smallest country hamlet'. It was a test, then, of Marxist aims, as published in *The Communist Manifesto* of 1848.

The Communards did not define themselves as 'Communists'; they owed more to the local tradition of anarchical Jacobinism than to any commitment to a Marxist 'dictatorship of the proletariat'. However, the Communards were proclaimedly anti-bourgeois in their stance. And an active participant in their uprising was Gustave Courbet – the painter historically credited with devising a form of 'Realism' built upon Socialist principles.

Courbet was widely blamed – and for a while, inprisoned – for instigating the damage to the triumphal Bonapartist monument in Place Vendôme. But his revolutionary colours had been signalled decades earlier, in a large canvas depicting a pair of peasants reduced to the virtually penal labour of breaking stones (145). It caused outrage at the Salon of 1850–51 – as Courbet intended. The painter knew well enough what he had offered urbane critics: a large study, as he recorded it, of 'two very pitiable figures . . . One is an old man, an old machine grown stiff with service and age . . . The one behind, a youth of fifteen years or so, suffering from scurvy.' The older man is wearing wooden clogs or *sabots*, and in due time the clog-wearers would become known for *sabotage* – defined in the Oxford

145 **THE STONEBREAKERS**
Gustave Courbet, 1849–50
(destroyed during the
Second World War)

In Courbet's native region of
Franche-Comté, stonebreaking
was the ill-paid resort of
dispossessed or redundant
farm labourers.

English dictionary as 'organized destruction' by 'dissatisfied workmen'. One Salon commentator saw the class-antagonism in Courbet's art, and declared *The Stonebreakers* to be angrily humming like 'the engine of revolution'. Courbet himself perceived his artistic vocation in terms of political agitation. It was, in his words, the effort to 'arrive at the complete emancipation of the individual and finally at democracy'.

This was 'Realism', which Courbet explained as 'the negation of the ideal': it was art with a proud redemptive agenda. But it does not require an unduly cynical analysis to prove that what Courbet achieved was not the opposite of 'idealism'. The artists of the Revolution in 1789 had stayed with a canon of human form that was essentially indebted to the Classical heroic tradition. It was in keeping with this tradition that David had endowed the scab-raddled Marat with lambent fine limbs; and Géricault gave the starveling victims of a shipwreck bodies worthy of Apollo. Now Courbet put into practice another of Proudhon's sayings, to the effect that no subject was 'too ugly' for art. Courbet took two hunched anonymous workers from the roadside and had them pose in his studio, tattered clothes and all. He glorified their toil. He bestowed upon stonebreaking the status of ideal.

Medieval artists had made vignettes of feudal chores through the seasons. But never before had the dulling grind and haul of manual work been heroized like this.

Courbet's picture marks a new sensibility, and a new obligation, on the part of an artist, to engage with the suffering of drudgery; or – if we remember a subject depicted by Courbet's contemporary, Honoré Daumier – to consider the lives of those who travelled third class. That an artist might ennoble rustic tasks, or make some muscular paragon of the industrial navvy, does not alter this point. The mid-nineteenth century work of Jean-François Millet and Jozef Israëls, for example, patently sentimentalizes the lives and duties of the peasantry in France and the Low Countries respectively: nonetheless, these are images of work-weary

peasants, not comfortable proprietors (146). A similar observation might be made about the controversial success, in the United States and abroad, of *Uncle Tom's Cabin* by Harriet Beecher Stowe, published in 1851–52 (the first American novel to sell a million copies). The story is overtly evangelizing, and makes pious caricatures of Southern slaves. Still, it is unthinkable that any author earlier in the century – Jane Austen, say – would have constructed a popular novel around such stalwarts of servility.

Art critic and champion John Ruskin saluted the Paris Communards in the course of his open letters addressed 'To the Workmen and Labourers of Great Britain' (the sequence is entitled *Fors Clavigera*, 'the hammer-wielding force', 1871–77; see nos. VI and VII) – going so far as to say 'I am myself a Communist', though confessing that the burning of the Louvre prevented his full support for the rebels. Around the same time, William Morris propelled his fellow English enthusiasts for medieval and Gothic style, known as 'Pre-Raphaelites', towards the socialism of Earthly Paradise. Morris – whose own 'artisanal' skills were tried on various crafts and trades – was fond of quoting a rebellious couplet that first surfaced in medieval England, during the Peasants' Revolt of 1381: 'When Adam delved and Eve span, who was then a gentleman?' He openly aspired to be 'the Laureate of the sweating classes'.

Meanwhile, some of the French painters grouped (during the 1870s) under the term 'Impressionists' made images with 'proletarian' content. Hence the factories and gasometers which bulk gauzily in scenes by Seurat, Signac and Pissarro; we may think too of how Degas captured the yawning exhaustion of backstreet laundry-women. There were, it would seem, tacitly acknowledged limits to such 'realistic' endeavour: painters of the period (most notably, Henri Toulouse-Lautrec) made many frolicsome images of Parisian prostitutes, but none ever delineated the facet of the sex-trade revealed at the close of Emile Zola's novel *Nana* (1879–80): a courtesan's corpse, raddled with venereal disease. But the individual who would eventually seize the world's imagination as the archetype of the-artist-who-suffers (both for his art, and on behalf of the ignominious in general) was the painter whose haloed name we have already mentioned: Vincent van Gogh.

Unlike Courbet and William Morris, Van Gogh never participated in street politics. His path to becoming a 'peasant painter' was steered by the Christian Gospels, not Karl Marx. It was a pastoral vocation that took him, in 1878, to work among the coal-miners of the Borinage in southern Belgium. Van Gogh's sense of mission did not evaporate when he gave up preaching in order to dedicate himself to art. Whether from his self-imposed exile in the peatlands of Drenthe, in the north of Holland (147), or while seeking out the weavers and potato-farmers in the Brabant area (where his father served as minister), the trail of letters left by Van Gogh solidly attest his credo that 'Christ was the greatest of all artists'. Those letters, at least, give reasons for going among the labouring poor that lay beyond

146 *'BÛCHERONNES REVENANT CHARGÉES DE FAGOTS'*
'Woodcollectors', Jean-François Millet, c.1868–74

Part of a cycle of images symbolizing the Four Seasons: this unfinished painting shows the chore of winter.

a quest for the picturesque. Van Gogh admitted that he did find beauty in the sight of a hovel 'made only of sods and turfs and sticks'; and that he appreciated a landscape 'where progress has got no further than stagecoach and barge'. But he also argued that making images of people 'from the depths of the abyss' was a sublimated form of action at the barricades.

We know that Van Gogh read and admired *Uncle Tom's Cabin*; also the works of European novelists with 'social conscience' – in particular, Charles Dickens, Leo Tolstoy, George Eliot, Victor Hugo and Emile Zola. We know, too, that Van Gogh aspired to the same campaigning power of those writers. When he portrayed a Brabant family sitting down to a dinner of boiled tubers (*The Potato Eaters*, 1885), the artist wanted to 'publicize' both the squalor and the decency of peasant life – to 'give an impression', as he wrote, 'of a way of life quite different from us civilized human beings'. The traditional dramatization of Van Gogh's life as that of a madman or Bohemian purist tends to obscure this zeal on his part to secure attention. Yet there is much evidence throughout Van Gogh's letters that the fate of neglected genius was not what he coveted.

He wanted to change the world with art.

Van Gogh had a strong sense of calling. His behaviour was eccentric. He was consistently ascetic, and practised not only self-denial, but occasional self-mutilation. He led a fugitive and sometimes isolated life, and could be said to have been misunderstood by his contemporaries. Accidental or not, his death may be seen (and has since become tantamount to such) as a sort of martyrdom. In these respects, the figure of Van Gogh accords with the core expectations of sainthood. This explains why his images are often treated like a scatter of sacred relics: at once the residue of genius *and* the clues to psychiatric diagnosis. One twentieth-century German philosopher, Karl Jaspers, used the works of Van Gogh to show the links between schizophrenia and creativity. Another – Martin Heidegger – used one of Van Gogh's Parisian paintings of gnarled footwear to demonstrate the universal 'genesis of a work of art' as an urge 'to let truth originate' (148).

By pairing Van Gogh's letters with his pictures, it is feasible to invest certain images with a symbolic power that may not be readily apparent. How many viewers would guess, for instance, that the canvas known as *Starry Night* (149) was

147 SKETCH FROM LETTER 330
Vincent van Gogh, October 1883

'I want to do drawings which touch some people ... to express not sentimental melancholy, but serious sorrow... This is my ambition ... I see drawings and pictures in the poorest huts, in the dirtiest corner. And my mind is drawn to these things by an irresistible force.'
From Letter 218.

148 BOOTS
Vincent van Gogh, 1887

In Heidegger's phrase: 'From the dark opening of the worn insides of shoes the toilsome tread of the worker stares forth.' Van Gogh painted some half-dozen of these still-lifes of shoes while he was in Paris (1886–88).

149 STARRY NIGHT
Vincent van Gogh, 1889

As Van Gogh wrote to Emile
Bernard in December 1889:
'One can try to give an
impression of anguish without
aiming straight at the historic
Garden of Gethsemane.'

Van Gogh's vision of the garden of Gethsemane – the place where Christ agonized in prayer before his betrayal and arrest? But if we follow the letters as faithful statements of the artist's programme, we are bound to consider Van Gogh not so much as one of the latter Christian martyrs – the 'Saint Vincent' for whose former neglect and rejection we seek atonement by exquisite shows of generosity in the art market – but rather one more thwarted modern Utopian.

Van Gogh sought company, recognition, success: all according to his own ideal terms. His dream was of art with the power to alleviate misery – bring colour into dulled, mechanical lives – on a grand and global scale. This would be a panacea created by syndicates of artists, and distributed by dealers working in an international commonwealth. In a letter of 1888, Van Gogh nominated his brother Theo as one such 'dealer-apostle'. In the same letter, he reassured and perhaps unnerved Theo with the declaration: 'I feel that we are working in a great and good enterprise, which has nothing to do with the old kind of commerce.'

The Midi – the South of France – was Paradise enough to some. Paul Cézanne had been in Paris around the time of the Commune: his painting thereafter could be viewed as the celebration of escape and landscape in the Midi. Van Gogh went to Arles from Paris in early 1888, and cajoled select other painters to join him in its Provençal enchantment. In particular, he pressed Paul Gauguin to serve as 'abbot' of a projected pseudo-monastic order of artists. For a while, in two notorious months of autumn 1888, there was a little Arlesian commune of two. Gauguin recorded an abrasive fellowship, whose end came with Van Gogh first menacing Gauguin with a razor, then turning its blade upon his own ear.

Gauguin had tried to go 'native' in Brittany, but eventually he sought beyond Europe for his Utopia. In 1890 he resolved to emigrate to the French island colony

of Tahiti in Polynesia, affirming as he went: 'I cultivate in myself a state of primitiveness and savagery.' Cultivated savagery was the essence of this enterprise. The paintings and sculptures from Gauguin's two sojourns in the South Seas (1891–93, and then from 1895 until his death in 1903) were remitted to Paris to be sold and to impress those left behind – including perhaps the 'childlike' (naïf) painter Henri Rousseau, who had to content himself with painting exotica on display at the municipal zoo. So Gauguin stated his new identity while affecting self-extinction; and worked industriously in an ambience which delighted him for its feckless attitude of 'Onatu' – 'what does it matter?'

Meanwhile, Van Gogh's final Utopia was at Auvers, a village on the River Oise to the north-east of Paris. Auvers was already conscious of itself as a pretty location in the Ile de France. Cézanne had lived and painted there (1872–74), as had Camille Pissarro at nearby Pontoise. It was the gentlest of rural scenes: thatched cottages; longstanding vineyards; neat gardens; cornfields; and many of those immaculate shrines of herbs and vegetables, decked out with marigolds, that the French know as 'soup-gardens' (potagers).

This was not the blistered landscape of the South; still less the silty flatlands of Van Gogh's place of birth. It bore no trudging, downtrodden sons and daughters of the earth. The seventy or so canvases that Van Gogh painted at Auvers within two months of arriving in May 1890 – a steady rate of about one a day – range from panoramas of seemingly limitless grain-crops to studies of tree-roots. In none of them do working people figure other than as bundles of rustic contentment.

There were also some portraits of a local doctor and his family: Paul-Ferdinand Gachet, who sympathized with and encouraged Van Gogh's idyll of a community of artists.

In 1890, Auvers-sur-Oise was a countryside that bourgeois Parisians could accept: fertile and prosperous, with no 'dark side' of deprivation to be dragged into the Salon – as Courbet had done with his Stonebreakers, located around Ornans, down in the hardy Alpine foothills of Franche-Comté. Moreover, the international art market was showing interest in vignettes of rural decency. The previous year, Millet's Angelus – a maudlin image of two rural labourers bowing their heads in prayer at the distant beck of church bells – had sold (to an American buyer) for over half a million francs. Van Gogh and his brother Theo – whose salary as employee of an art-dealing firm in Paris was some 7,000 francs per year – could reasonably hope that at last the time was ripe.

For years Theo had supported his brother financially. Hardly a letter from Vincent to Theo does not begin without thanks for some remittance of cash. If Theo was to be repaid, while also becoming the great 'dealer-apostle' that Vincent's dream required, a substantial stock of paintings for display and sale must be made. It was, as Theo's sentiments to Vincent in this period make evident, a joint struggle; Theo likened the two brothers to a pair of yoked oxen ('we shall draw the plough until our strength forsakes us . . .'). This refreshed fraternal unity and sense of purpose explains the 'feverish impasto' activity of Vincent's two months at Auvers.

In January 1890 the first critical notice of Van Gogh had been made. It signalled an approach to his work that would become almost de rigueur in any subsequent discourse about the artist. 'Here is a fanatic,' observed one Albert

Aurier, art critic, 'a terrible and maddened genius, often sublime, sometimes grotesque, always rising to a level that comes close to pathological states.'

It is unlikely that Van Gogh shot himself at Auvers entirely by accident. It is possible, however, that he aimed (as with his ear) not to do irreparable damage.

What else was a 'terrible and maddened genius' supposed to do? Aurier had announced Van Gogh as 'an enemy of bourgeois sobriety', but the friendly rustle of bourgeois banknotes in Theo's gallery was what Vincent sought – as much, it should be added, from his decent concern for Theo's family health and welfare, as for the sake of his own success. Was that what it took, then, to secure attention and fame – borrow a shotgun to fire at crows, and turn the gun on oneself?

But whether or not the shooting in the cornfield was planned as a publicity stunt, the rest of the story ends rather more tragically than the traditional myth of Van Gogh's 'suicide'. The artist-fanatic caused a chest wound, perhaps as intended. But he had not counted, it seems, upon his friend Dr Gachet being firmly committed to the practice of homeopathic medicine, and a somewhat inept local practitioner. Crisp surgical intervention would have had Van Gogh fit within weeks.

As it was – by misadventure – the injury became infected, and infection caused death.

Theo died six months later; quite plausibly of heartbreak. The paintings had been done. The public was almost primed. Vincent's dream – of his art touching the lives of common people all over the world – had never been, while he was alive, closer to its realization.

X.viii 'We are making a new world'

'A map of the world that does not include Utopia is not worth even glancing at,' wrote Oscar Wilde in 1891, 'for it leaves out the one country at which Humanity is always landing.'

Most of Oscar Wilde's sayings can be turned around without losing piquancy of wit and application: this one included.

So, conversely, it might be said: a map of the world which does not include Hell is not worth a glance, either. For although general religious emphasis upon Hell as a place of damnation had withered by the nineteenth century – 'Universalist' theologians argued that if Christ died for all, then all must be either saved, or at least capable of being saved – new secular candidates for the title of 'Hell' were not lacking.

So Jack London, American author and adventurer, reported to the travel agency Thomas Cook and Son at the beginning of his trip, in summer 1902, 'to measure the life of the underworld'. The agency could assist with expeditions to inner Tibet; it was not helpful, however, towards a voluntary plunge into the slumland that lay hardly a stone's throw from its offices. The writer was undeterred; and so the waifs, derelicts and 'fallen ladies' and other specimens he found in the city of London's East End duly became Jack London's *The People of the Abyss* – a book whose first chapter is predictably entitled, 'The Descent'.

Victor Hugo said of his novel *Les Misérables* (1862), which was partly set in the revolutionary Paris of 1848: 'Dante made an Inferno out of poetry; I have tried to

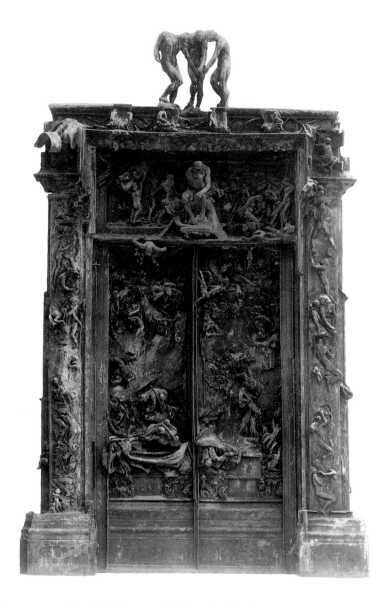

150 THE GATES OF HELL
Auguste Rodin, 1880–1917

Bronze sculpture. The project
was originally undertaken as
a government commission for
the Museum of Decorative Arts
in Paris, but up to his death
(in 1917) Rodin did not consider
it complete – though most of
the figures or figure-groups
had been excerpted and
produced separately on
a larger scale.

make one out of reality.' Auguste Rodin, who dominated European sculpture by
the end of the nineteenth century, could have claimed something similar for his
monument known as *The Gates of Hell* (150). Hell might have become indistinct as a
destination for the posthumous torment of sinners; but in Rodin's hands, the
hellishness of human experience lent itself to a grand plastic drama. Transgres-
sive passions, violence, degradation, nullity, unfulfilled yearnings: the pains of
what in French was known, at least since Montaigne and Rousseau, as *la condition
humaine*. André Malraux diffused that phrase in the form of a book-title in 1933,
translated then as 'man's estate'. But 'the human condition' will cover Rodin's
intentions well enough here. Inchoate, fluid, sprawlingly sensual: the *Gates of Hell*
was a project prompted by the copy of Dante that the sculptor customarily carried
in his pocket, and those who know what to look for will find some of Dante's pro-
tagonists of agony there – Count Ugolino, clambering on all fours; or Paolo and
Francesca, draped in mingling bliss and shame. But for the rest, this is a window
upon the busy isolation of naked humankind, above which the triple figures of
'Shade' hang heads and pool their fists of condemnation.

Rodin was no modernist. He indulged his own penchant for objects of the past – touring the great Gothic cathedrals, acquiring Etruscan vases to trick out his studio. In the eyes of certain of his contemporaries, this respect for historical culture was enough to make an anachronism of the sculptor. There he was, bearded and venerable, labouring to shape the entrance of what many would regard as some figment of medieval superstition. Rodin worked, legendarily, 'from life'. But where in Rodin's work was the world as it turned in the early twentieth century?

Motor cars – electric lights – telephones – aeroplanes? Railways? Ocean liners? Where was the art that celebrated the new glories of rapid transport and global communication?

It is not recorded whether Rodin sat down with a copy of the Paris-based newspaper *Le Figaro* on 20 February 1909. Had he done so his blood must have boiled, or his guffaws rocked the room. The leading article – unmissable on the front page – announced, without regret, the death of the past. Museums, libraries, academies: all so many cemeteries of spent effort and 'crucified dreams'. The past was *passé*, was it not? Then why not leave it at that – and admit that a roaring automobile or a screaming machine-gun was more beautiful than some lump of Classical sculpture in the Louvre? The world was in flux; hectically so. Then let its inhabitants celebrate change – and revel in all the surges of adrenalin that must come with newness and the danger-clad unknown.

Le Figaro was not a revolutionary broadsheet. But nor was this a spoof. It was presented as a manifesto, with the by-line given to F.T. Marinetti, who was introduced as 'a young poet . . . of remarkable talent', and founder of a new movement. A serious newspaper was obliged to carry tidings of a clique whose ambitions were noisily populist and overtly approving of riots in the streets. This clique was the group of Italian writers, artists and musicians gathered under the faith that was 'Futurism'.

The Futurists stand close to the source of the modern understanding of the term 'avant-garde'. Retrospectively that term has become flexible – making it possible, for example, to describe Courbet as 'the first real avant-garde painter' – but strictly it does not enter the discourse of art history until the twentieth century. In military usage *avant-garde* means the part of an army that goes on ahead, like an expeditionary force – into the enemy's country perhaps. The nineteenth-century French historian Jules Michelet used the phrase metaphorically to denote political 'forerunners'. But of all the many artistic statements and adventures that have subsequently been labelled as avant-garde in this risk-taking, forerunning sense, none bear it so aptly as the Futurists. For the Futurists were not only prepared to make a metaphorical 'advance guard' in seeking beauty from the industrialized world: they signed up for direct action.

The Futurists would not merely hymn the sleek efficiency of a machine-gun: they would demonstrate it too.

'*Nous voulons glorifier la guerre – seule hygiène du monde*', insisted Marinetti in his salvo of 1909. 'We want to glorify war – the only hygiene of the world'. This was not entirely original bombast: the previous year Georges Sorel, a French engineer, had published his *Reflections on Violence*, in which violent struggle was reasoned to be the

only means of effecting genuine social change; and Sorel, in turn, was influenced by Friedrich Nietzsche's concept of the heroic or superhuman 'will to power' that handed success to audacity. Nietzsche (1844–1900) sang of the need to 'live dangerously'. Another philosopher influential at the time, Henri Bergson, hymned the *élan vital* or free-flowing spirit of life that energized human development and arguably licensed anyone's freedom to disregard the past. Intuition was all.

But where Sorel advocated strike action by labour unions, Marinetti fused an appeal to aesthetic revolution with a sheer overdose of testosterone. 'No work without an aggressive character can be a masterpiece,' Marinetti ordained. Nietzsche had said that women were fit for nothing but man's pleasure, or else they were chattels to be whipped; Marinetti made his glorification of war and warriorhood expressly dependent upon 'contempt for women' and all 'feminine' values.

We may note that for individuals who cleaved so enthusiastically to upheaval and the promise of 'the Future', Marinetti and his accomplices were signally backward-looking with respect to the campaign for women's rights. Not only was the pressure for female suffrage growing, but the traditional hindrances placed between women and the production of art were beginning to be lifted. For example, the American painter Mary Cassatt had affirmed, by her contributions to Impressionist shows at Paris between 1879 and 1886, not only that women could paint, but that women of bourgeois or even genteel status could be made the subjects of an artist's interest and sympathy. And in Russia, some of the most spirited exponents of a new basis for pictorial composition – the 'Abstract' – were women: such as Alexandra Exter and Olga Rozanova, admiringly described by one male contemporary as 'Scythian riders' of the avant-garde.

It is easy, in retrospect, to hold up the statements and personalities of Futurism as puerile and preposterous. Nor is it difficult to concoct a story whereby Nietzsche, Sorel, Bergson, Marinetti and others (including the German composer Wagner) belong to the same plot that culminates with Fascism and the Holocaust in Europe. But explaining the unrepentant Futurist eagerness for war and destruction is not so simple. Marinetti participated in both street fisticuffs and formal combat; he cannot be said to have enthused about bloodletting because he knew nothing of it. 'War is beautiful,' the Futurists maintained, 'because it creates the new architectural forms of big tanks, geometrical flight formations, smoke spirals from burning villages.' They were not idly dreaming, nor teasing purely for the sake of mischief. So the mystery is: how could 'creative', 'intelligent', 'sensitive' individuals commit themselves to such a credo? And did they not see that the desire to do away with all museums must one day extend to the repositories of their own work?

Marinetti urged his devotees to perform the daily gesture of spitting upon 'the altar of art'. Provocation was his theatrical forte: he was proud to be booed on the stage. But the stage remained a necessary premise. This is the paradox or inconsistency of the movement. The Futurists wanted to be shot of art: that was their attitude – of which they made an art.

In 1914, the European establishment gave the Futurists what they most desired. During high summer, war was declared between Austria and Serbia. Other national powers – Russia, France, Germany and Britain – pitched in, with only the slightest of hesitation. Marinetti was exultant, announcing in 1915 that

'the present war is the most beautiful Futurist poem that has appeared up to now'. That same year, his ardent wish for Italy to enter the conflict was gratified. As part of the Italian Futurists' effort to goad their countrymen to intervene (against Austria), Umberto Boccioni – self-appointedly the greatest talent in Futurism when it came to painting and sculpture – produced a collage entitled *The Charge of the Lancers* (151). This is an image of impulsive movement, directed by the angle of guns and lances away from the cavalry and towards the upper right-hand corner, where a fragment of a press-cutting is lodged. The newsprint speaks of French exploits in Alsace, 'pugnacity intact'. So this, it appears, is what is longed for by the artist and his sort: to feature in the events of the day, to enter the tumult; to make history.

Boccioni, like Marinetti, joined the army as soon as possible.

In Britain, Marinetti was mostly known for his booming and honking stunts at vaudeville-style shows, making what he advertized as 'the Art of Noises'. But some young British artists had also pledged themselves to the Futurist cause. One of them, Percy Wyndham Lewis, preferred to annex his own version of the ideology, calling it 'Vorticism'. But another, C.R.W. (Christopher) Nevinson, echoed pure Marinetti sentiments when he spoke, on behalf of a certain 'Rebel Art Centre', to the *Daily Express* newspaper in February 1915: 'This war will be a violent incentive to Futurism, for we believe that there is no beauty except in strife, and no masterpiece without aggression.'

Nevinson, too, enlisted forthwith to serve king and country; and art.

Only in Britain, perhaps, could such a tidy niche exist in strategic thinking for a brigade called The Artists' Rifles.

In France there was conscription, so Futurist sympathizers were drafted whether they liked it or not: including Fernand Léger, who discovered himself in the Engineer Corps among 'workers in metal and wood . . . inventors of everyday poetic images'. Léger's style would accordingly celebrate his respect for the shimmering deftness and geometric practicality of machines; presumably he would have approved the ingenuity of a fellow artist in French ranks whose contribution was to devise camouflage.

Artists around Europe joined the war. War, however, was not respectful of the alliances of art.

Futurists or Cubists or Abstract Suprematists, or whatever artistic loyalty they claimed: the French sculptor Henri Gaudier-Brzeska (Vorticist) and the Bavarian

151 *CARICA DEI LANCIERI*
'Charge of the Lancers',
Umberto Boccioni, 1915

Collage and painting done at the height of Futurist euphoria of inciting the Italians to declare war upon Austria.

152 '**LA PATRIE**'
C.R.W. Nevinson, 1916

Strictly speaking, Nevinson was in his time the only British artist who could be called 'Futurist'.

painter Franz Marc (co-founder, with Wassily Kandinsky, of the Blaue Reiter – the so-called 'Blue Rider' Group), when they went to their deaths, had been drawn into opposing lines.

An ignoble end was reserved for the maestro of *The Charge of the Lancers*. Boccioni was nowhere near the battlefield when he fell off his horse and died. By then – 1916 – the machine-guns idolized by Marinetti's first Futurist manifesto were proven efficient inventions on a terrific scale. The numbers of men lost at the show-downs of entrenched armies around Europe rattled into millions. The usual mode of describing how victims of the guns went down is 'in swathes'. On the first day of the Battle of the Somme in July 1916, their collective howls were heard and likened (in the phrase of one survivor) to 'enormous wet fingers screeching across a pane of glass' – worthy, perhaps, of Signor Marinetti's Art of Noises.

And it was, sure enough, a ditching of the *passé*. An English writer, Edmund Blunden, remembered how he and his company marched down towards the site of the Somme battlefield: 'through wooded uplands, under arcades of elms, past millstreams and red and white farms'. Just what the *passéiste* artists loved to paint. And one can still crouch, wonderingly, over the maps used in the field at the Somme, and muse at the naming of places there. Hawthorn Ridge, Willow Patch, Pigeon Wood, The Dingle; even 'Row of Apple Trees'.

All dragged and blasted into the mire.

Marinetti's disciple Nevinson was propelled into the trenches of the Western Front: those lanes carved across Belgium and France which turned to gutters of ochre and blood-brown slime. So Nevinson saw for himself where the Futurist rout of cornfields and bucolic decorum would end. As Edmund Blunden concluded, on behalf of everyone who died or survived in the Battle of the Somme: 'War had been found out, overwhelmingly found out.'

A revelation, then. But as revelations go, this one was kept conspicuously covered up. It soon dawned upon Nevinson – as it dawned upon the poets Siegfried Sassoon, Wilfred Owen and others – that he was in the thick of a conflict that was denied authentic reportage. Photographers, though their equipment no longer had to be trundled around in tank-like vehicles, were generally kept clear of the morass. Newspapers connived (as they are prone to) with national governments and suppliers of munitions. From what had become death's festal kermess, no images were officially to be released.

'All a poet can do today is warn.' A motto which was Wilfred Owen's demure way of claiming for poetry no place of consolation – but, at least, the keen accuracy of open eyes.

Nevinson, for his part, very soon became convinced of the painter's equivalent urgency here: to warn, and above all inform. His canvas of wounded men in the train of retreat from fighting at Ypres is typical of his vision and revision of Futurism's splendid faith in guns (152).

War – sole hygiene of the world? Warriors – steeped in the honour of acting on their stalwart masculinity? No, Marinetti. That was not how it was.

It was one grown man after another, lain on stretchers, or left in the mud, raising the same forsaken cry – *mummy, mutti, ma mère, maman* – like so many tender nurslings.

D.H. Lawrence, a writer at first sympathetic to Futurism's essential contempt for custom and bourgeois decencies, saw from the margins where the logic of cleansing-through-war had gone askew. He reached for a grim sardonic utterance from the sixth-century BC Greek 'Pre-Socratic' philosopher, Herakleitos, and wished it could be set out 'on tablets of bronze':

153 GASSED

John Singer Sargent, 1919

It is a massive canvas, commissioned to decorate an official 'Hall of Remembrance' – a grand project never realized.

154 VICTIMS OF GAS

Anonymous photograph of British soldiers at an advanced dressing-station, Béthune, April 1918.

'THEY VAINLY PURIFY THEMSELVES BY DEFILING THEMSELVES WITH BLOOD.'

'Gas! GAS! Quick, boys!' A shrieked line in Owen's best-known poem ('Dulce et decorum est') may echo in our minds as we gaze on one of the few 'negative' photographs taken during this war (154). There they go, the boys, filing like a crocodile of infants; made sightless by the latest offensive technology – projectile canisters of a gas which blinded or poisoned its human targets. When the American-born painter John Singer Sargent was commissioned, in 1918, to make a picture on an 'epic' scale for a proposed 'Hall of Remembrance', it was this brusque intrusion of chemical treachery that he chose to record (153). The lads link up and step feelingly, in the mime of slow-processional, on to duckboards that lead to the guy-ropes of a field-dressing station. Their khaki blends with the thin fine light of a setting sun; whose brighter beams pick out, in the background, a football game.

'Kind old sun', as Owen noted, in his verses entitled 'Futility' –

> *Think how it wakes the seeds, –*
> *Woke, once, the clays of a cold star.*
> *Are limbs, so dear-achieved, are sides,*
> *Full-nerved, – still warm, – too hard to stir?*
> *Was it for this the clay grew tall?*
> *– O what made fatuous sunbeams toil*
> *To break earth's sleep at all?*

Sargent, a slick and successful portraitist of society lions – and lionesses – was commissioned by a British government office that called itself the Ministry of Information.

Information, when ministered, was as one might expect. Military officials steadfastly restricted 'documentary' evidence of what was happening at the front (and behind the lines, too). When the British Commander-in-Chief, Sir Douglas Haig, invited the poet-balladeer John Masefield to 'chronicle' the Battle of the Somme, permission to describe acres of churned-up mud was not withheld (Masefield settled for 'such a hell of desolation all round as no words can describe'). But access to brigade and battalion diaries? That was out of the question.

One of the officially directed British 'war artists' was Paul Nash. Nash was a landscapist; still he was frustrated by the prohibition laid upon him, not to show any corpses – when faced with a scene which was, as he put it, 'one huge grave'.

So Nash resorted to the device of the 'pathetic fallacy' – the investment of inanimate scenery with human personality, sensibility. The 'pathetic fallacy' was first recognized as a feature of Romanticism by Ruskin in 1856, and then disapprovingly. Here we may accept that the chiefs-of-staff in Flanders left a landscape painter with no choice but to exploit it (155).

No flying shells ('Five-Nines'; 'Whizzbangs').

No gunnery: the Vickers, the Maxim, the St-Étienne tripod-mounted, water-cooled barrels; five hundred rounds per minute.

No aircraft. No tanks.

No men; nor any scattered parts thereof.

Only Earth's cold clay: pocked, crumpled and ridged; and sodden – as if with its own tears.

And trees. Gassed trees. Amputated trees, maimed trees, stumpy trees. Or trees simply blown to nothingness.

'We are Making a New World.'

In 1918 this was the state of the art of 'Utopia: Postponed'.

155 WE ARE MAKING A NEW WORLD
Paul Nash, 1918

The scene seems universalized; however, it was composed from a particular battlefield sketch entitled 'Sunrise, Inverness Copse'. Inverness Copse lay in the Ypres Salient, off the Menin Road: its mine craters may be seen to this day.

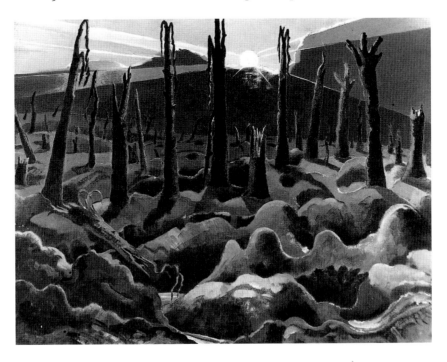

11 THE COMFORTS OF UNHOMELINESS

Whatever terror is, we dole it out to those of tender age.

Wolves have not slunk through our local woodlands for centuries or more. Yet still they bristle large in bedside tales intended to lull and pacify the young.

In 'Little Red Riding Hood', for instance – a tale collected in the seventeeth century by Charles Perrault, who was deviser of masques, and more, for the French king Louis XIV – a small girl is sent to wander alone through a forest, bearing a basket of gifts for her grandmother. A wolf accosts her on the way, lopes ahead and devours the grandmother; half-deceives the girl by dressing in grandmother's clothes; then gobbles the girl too.

The end could be worse. A passing huntsman, or log-chopper, catches the wolf, slits open its gizzards and releases – quite undigested – both grandmother and girl. But all the same, this is the stuff of which bad dreams are made.

Why do we do it?

So little ones are toughened for the world? Is this the place that they should expect – with ogres looming from the fells, hobgoblins stored by every bush, and evening the dominion of spooks and bogeymen?

Or do we think that frights are sweetly taken, now and then? That bed is all the cosier, if horror has been raised outside; that sleep comes more deliciously, when it steals over shivering flesh?

One influential study of traditional childhood stories, by Bruno Bettelheim (himself no stranger to awfulness at first hand: he was a young survivor of the Nazi concentration camp at Dachau) argues that 'fairy tales' act therapeutically to voice the doubts and problems of juvenile sexuality. So, for Bettelheim, the yarn of Little Red Riding Hood is about a young girl's traumatic passage into womanhood. The colour of her cape is enough to symbolize the onset of menstruation; the entire tale relates, in Bettelheim's summary, 'a pubertal encounter with Oedipal attachments'.

Specialists might call this approach 'Bettelheimian'. Inasmuch as it derives, however, from the premiss that children are, from birth, erotically fixated by their parents, then we might be more generally inclined to call it 'Freudian'. And however much we are, as individuals, inclined to put trust in the explanations of the human psyche formulated by Sigmund Freud (1856–1939), it is true that a 'Freudian' view of our sentiments and behaviour has become a sort of modern norm – even if that amounts to no more than a collective garrulity about sex. Convinced followers of Freud will maintain that there is barely anything in the sphere of human experience that cannot be explained by reference to medical psychology's founding father. Certainly it is hard to keep him out of discussion here, where our task is to comprehend horror's dogged appeal.

The question of why we widen the eyes of our children with the story of Little Red Riding Hood ('Grandma . . . what BIG TEETH you've got . . .') belongs to a jostle of queries that have followed us throughout this book: they are demands

which, had we put them to Freud, would surely have brought forth some smooth and learned response from the Viennese doctor. 'How can the *Laocoon*, or any picture of St Sebastian, be a delight to look at?'; 'Why do we weep at Shakespeare's *Lear*?' – and so on. This is not to say that Freud's reasoning counts as definitive. But he shaped a theory; and a theory that was consistent, as theories go.

And so it is with Freud that we begin the narrative here; although, as we shall see, the particular phenomenon of revelling in horror must be traced through the period we call 'Romantic' – and beyond.

<p style="text-align:center">⋆ ⋆ ⋆ ⋆ ⋆</p>

In 1919 – a year in which so many homes around the world were sites of bereavement after a war termed 'The Great War'; 'each slow dusk' as Wilfred Owen wrote, 'a drawing-down of blinds' – Freud published an essay entitled 'The Unhomely' (*Das Unheimliche*). It appeared in a journal called *Imago*, meaning 'Image', but Freud was not concerned with visual evocations of the sensation he diagnosed as 'unhomeliness'. His essay instead begins with an exercise in dictionary research. He shows how the term 'the unhomely', at least in its German usage, developed its meaning in a very curious way, to the effect that 'the unhomely' came to coincide or merge with its opposite – 'the homely', or 'familiar'. The standard English translation of the German adjective *unheimlich* is 'uncanny', a description which we may apply to any event that surprises or unsettles us; yet we too might feel unsure about how to define the opposite of something uncanny. As Freud reasoned: 'This uncanny is in reality nothing new or alien, but something which is familiar and old-established in the mind and which has become alienated from it only through the process of repression.' Repressed – but not entirely banished, nor, it seems, wholly unwanted. How else to explain the tendency of some people, no sooner than they are ensconced beside a cheery hearth, to start telling 'ghost stories', or to inflict upon themselves all the prickles of a 'horror film'?

Anticipating the cinema formulaics of Hollywood horror – whereby ghastly surprises are sprung not in remote Gothic castles, but within the regular clapboard housing of American suburbia – Freud indicated that the essence of making a person's flesh creep was to describe terrifying events happening in surrounds of domestic normality. No one, he argued, could become thrillingly scared by reading Dante's *Inferno*: all the lost tormented souls there occupy some distinct, poetic and uninhabitable fantasy. Dante depicts a nether place so far removed from 'home' that we do not fear its reality – still less its nearness to our lives.

Then back to the question: why do we put ourselves out to find and invite the frissons of feeling 'horrified'?

Freud's concept of *das Unheimliche* has an answer to that too. There is, he says, one unalterable fact of life: which is, that we were born to die. Each of us must owe the world, sooner or later, the debt of our death. That is nature's certainty. It was a later cynic, the English twentieth-century poet Philip Larkin, who described all religion as 'That vast moth-eaten musical brocade/Created to pretend we never die'. Freud did not accuse religion; but he did maintain that the unconscious

tendency in modern humans was to resist the inescapability of death, and cleave to life eternal.

So 'civilized' adults, according to Freud, were particularly inclined to hush over the fact of death – or else make death a matter of chance, not necessity. In an earlier essay, he maintained that the war in Europe had (by 1915) begun to demonstrate that 'people really die . . . often tens of thousands, in a single day'. Freud's comment on the escalation of casualty figures – which at the time of his writing were mainly on the Eastern Front, and already running into a state of countlessness – may then appear callous. In households throughout Austria, Germany and Russia, death was no longer remote. Freud noted: 'Life has become interesting again; it has recovered its full content.'

Death – or rather the awareness of death – was, for the psychoanalyst, germane to feeling alive: 'Life is impoverished, loses in interest, when the highest stake in the game of living, life itself, may not be risked.' This is Freud stating a bald clinical truth. But in his explanation of unhomeliness, he also allows that we who suppress the fact of death – or some of us – are occasionally pierced by the need to remind ourselves of our mortal fate. From time to time, we sense a twinge of death-awareness, an intimation of mortality, and we dabble in the lake of darkness. What might it be like, we ask ourselves, to bleed – to decline – to pass into the gloom of 'the other side'?

The global death toll of the Great War is estimated at over eight million. In Britain – where a single city street might have lost all its young menfolk during several minutes of this or that infantry 'push' or 'offensive' – many of the bereaved sought solace in spiritualism: belief that the spirits of dead persons can communicate with the living, either directly or through a certain 'medium'. Some of the bereaved went further, and supposed that the dead not only appeared as spectres in the world of the living, but could even be caught on camera. 'Psychic photographers' flourished. Arthur Conan Doyle – a medical practitioner, if better known as the creator of fictional detective Sherlock Holmes – saw the 'immense practical importance' to 'a tortured world' of such paranormal services (Conan Doyle had himself lost a son, a brother and a brother-in-law in the fighting). Certain artists entrusted with commissions of remembrance were not unduly peculiar in imagining spectral parades of lost souls – such as Stanley Spencer's *Resurrection of the Soldiers*, painted between 1928 and 1932 for a family memorial chapel at Burghclere, in Berkshire.

Many men who came through the war chose the decorum of silence. Maurice Bowra, an Oxford don otherwise famous for his ebullience and repartee, was typically unforthcoming on the subject of his experience in the trenches. 'Whatever you hear about the war,' he told the critic Cyril Connolly, 'remember it was far far worse: nobody who wasn't there can ever imagine what it was like.'

Indescribability was not a plight acknowledged by quite all survivors, however. The German artist Otto Dix served on both Western and Eastern fronts, and was decorated for his bravery in battle. He made sketches throughout these years of close experience, mostly in charcoal or soft dark pencil – blackened snatches of action and destruction which were subsequently worked into a sequence of etchings and aquatints presented as 'The War' (*Der Krieg*) in 1924. Dix had volunteered

**157 DEAD MEN BEFORE
THE POSITION AT TAHURE**
Otto Dix, 1916–24

Dix put the portfolio of etchings
to which this belongs in the
category of 'still-life'; it was
issued around the same time
as the launch of the movement
known as the 'New Objectivity'
(*Die Neue Sachlichkeit*).

with the same martial enthusiasm voiced by the Italian Futurists, and he carried in his rucksack an emboldening copy of Nietzsche. Yet neither his images from the front line nor the post-war Dix repertoire – notable for images of veterans reduced to pavement beggary – attest the Nietzschean glory of warriorhood. Nietzsche had commanded his followers to despise the state of peace. But Nietzsche never saw what Dix knew truly cheek by jowl: the rot of bodies in craters of mire; the eye-sockets of an infantryman's skull teeming with maggots (157).

Among the artists who endured the Great War – including Max Ernst, George Grosz and Oskar Kokoschka – Dix stands out as a draughtsman who catalogued what other combatants preferred to pass over in nauseous silence. Dix could itemize the experience: 'Lice, rats, barbed wire, fleas, shells, bombs, underground caves, corpses, blood, liquor, mice, cats, artillery, filth, bullets, mortars, fire, steel: that is what war is.' It is an irony of 'art group' identities that Dix may be considered a part of 'Dadaism', because the Dadaists originally gathered in Zürich in 1916 with the declared aim of creating aesthetic refuge from the 'slaughter-houses' of trench warfare. Echoing, perhaps, the Slavonic assent of *Da, da* (*Yes, yes*), or simply a childlike cry (*Dada* was juvenile French for 'toy horse'), Dadaism was only aggressive in its nihilism and playfulness. As Kurt Schwitters (1887–1948) showed, litter could be garnered from the streets and disported in a collage, and that was Dada's 'art': art for fun, art by chance – an absorbing *jeu d'esprit*.

Jean Arp – one of Dadaism's most vociferous personalities – said Dada would release Laocoon and his sons from the snakes that had held them fast for so many centuries. So Dada, as a movement originally reacting against the actuality of so many lives churned into mud, or left tangled in barbed wire, claimed a retrospective power over 'horrifying' art.

Dada stood for the reinvention of art as a route of escape, the bliss of juvenile naivety. But it was too late. Infancy was no longer to be equated with simplicity. What Freud's psychoanalytic method had presented was a more or less hidden component of every human being – the 'unconscious'. Grown-up humans might think they had put their childhoods behind them. Freud, on the contrary, based his therapies upon the belief that experiences at a very early age – especially unpleasant experiences – remained latent in the adult 'unconscious', and caused psychological problems ('neuroses') so long as they were not teased out for conscious acknowledgment. Everyone, in Freud's eyes, was 'neurotic' – to a greater or lesser extent.

Specialists will dispute how Freud's 'unconscious' part of the mind operates; some deny it exists at all. But Freud's scientific standing now, and the precise dissemination of 'Freudian' theories during his own lifetime, are beside the point. Already in the 1880s the 'unconscious', as an emerging psychological concept, was being invoked by artists and writers loosely grouped as 'Symbolists', such as the French painter Odilon Redon (1840–1916). 'Everything takes form,' claimed Redon, 'when we meekly submit to the uprush of the unconscious.' As if to connect that 'hidden knowledge' to the apprehension of phenomena regarded as spectral or 'paranormal', Redon dedicated a series of provokingly curious lithographs to the Romantic 'master of suspense', Edgar Allan Poe. But it was a post-war art fraternity, the 'Surrealists', that most exuberantly seized upon the Freudian diagnostic science of lurking notions and neuroses. As Jean Arp made himself spokesman of Dada, so Surrealism's active courier was André Breton, who had served behind the lines as a medical orderly with the French army at Verdun. While Freud put his patients upon a couch and encouraged them, by a process of 'free association', to let their unconscious rise to the surface, Breton simply observed the behaviour of soldiers made uninhibited by the shock of bombardment or other frights of combat; and found himself attempting to help these stunned men by interpreting their dreams. Breton came away from his hospital service convinced of 'the omnipotence of dreams'. Dreams were the perception of another world, and what society deemed madness was simply a state of automatic access to that world. The images of dreams came into the mind's eye neither mediated nor blocked by reason, logic or morality. So these images, according to Breton, mingled with the 'normal' world to create an 'upper reality' – or, in the term first coined in 1917 by the poet and critic Guillaume Apollinaire, a *sur-réalisme*.

Breton paid Freud the homage of a personal visit in 1921; later (in 1938) Surrealism's best-known exponent, Salvador Dalí, arranged an audience with the aged psychoanalyst – then domiciled in London, a refugee from Nazism. Freud's published theory on *The Interpretation of Dreams* (which first appeared in 1900, and was translated into Dalí's native Spanish in 1922) markedly influenced some of Dalí's most scandalizing works, such as *The Lugubrious Game* of 1929 (158) – a fluid concoction in which reverie clearly blends with the memory of at least one infantile 'trauma' (soiling one's clothes) and a puerile crisis of 'shame' (at masturbation). Dalí spoke of sitting fixated at his easel and allowing 'automatism' to fill his imagination. Contemporary comment on *The Lugubrious Game* was mostly expressed in terms of disgust, except when it came from Surrealism's apologist,

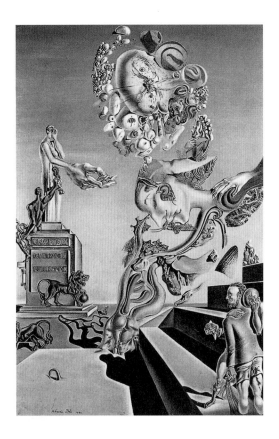

French theorist Georges Bataille, who identified in the painting a Freudian theme (male fear of emasculation, or 'castration complex') and praised Dalí for his ability to convey 'a terrifying ugliness' (*une laideur effroyable*).

Georges Bataille we shall encounter again: for it was largely thanks to his efforts that the writings of the Marquis de Sade were revived for publication, and his defence of Sade is in itself a phenomenon of twentieth-century intellectual curiosity regarding 'the bizarre'. But when Bataille compliments Dalí on producing 'a terrifying ugliness', a tradition of aesthetic response is not being invented, merely developed. The Surrealists were not the first to make art from dreams and nightmares. Nor was André Breton newly subversive when he proposed that mania and 'derangement' be regarded as vehicles of the truth. Madness, ugliness, terror: these had already been admitted as aspects of 'the Sublime' by that tendency, attitude or era which we denote as Romanticism.

<p style="text-align:center">★ ★ ★ ★ ★</p>

'Romantic' may denote for some people a bunch of flowers. Others will allow the term to cover whatever sort of scheme or behaviour that seems visionary, passionate, fantastic or extravagant – in short, anything worth weaving into a story, which is precisely what the French root of the word (*roman*, a tale) implies. And in the formal terminology of art and literature, 'Romanticism' is strictly opposed to 'Classicism'. So, if Classicism bears the ramifications of order, rules, symmetry,

158
THE LUGUBRIOUS GAME
Salvador Dalí, 1929

Georges Bataille, after analyzing the 'transgressive' elements of this picture, concluded: 'I lift my heart to Dalí, and grunt like a pig before his canvases.'

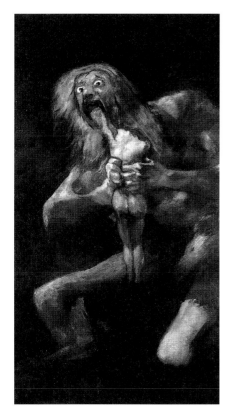

159 SATURN DEVOURING ONE OF HIS CHILDREN
Goya, 1820–23

According to Classical cosmology, Saturn (the Greek Kronos), one of the Titan-offspring of Heaven and Earth, knew that he was fated to be outdone in power by one of his divine children, and accordingly ate all of them up – except Zeus, concealed by his mother.

160 THE NIGHTMARE
Henry Fuseli (or Füssli), 1790–91

Psychoanalytic approaches to nightmares were made rather later, most significantly by Freud's follower, Ernest Jones.

control and reasonable composure, then Romanticism must amount to more than a surprise bouquet. A Romantic flourish will go beyond caution. It will ignore the voice of reason. It will reach for giddy transcendence – the all-surpassing and soul-stirring gratification that is the Sublime.

Romanticism – conventionally regarded as manifest by the end of the eighteenth century, and characterizing in particular the first few decades of the nineteenth – is the history that stands behind both Freud and the Surrealists. It includes those novelists we describe as 'Gothic', such as Mary Shelley, whose story *Frankenstein* appeared in 1818, and Mrs Radcliffe, across whose pages thunder and lightning boom operatic duets. Romanticism yields poets so particular in their brooding that they are sometimes referred to as 'the graveyard poets' (Thomas Gray's 'Elegy Written in a Country Churchyard', published in 1751, may be considered as plangently announcing some 'spirit of the age'). And although there was never anything that could be formally defined as a 'Romantic style' in art, it is true to say that Romanticism as a 'gusto' – a taste, a pneumatic preference – suffused the output of artists extensively throughout Europe and North America.

If we come to Romanticism with any vague idea of its effect upon art, we probably think of it as having been mainly influential upon landscape painting. Snow-stark mountain crags – the wind-thrashed moor – a waterfall's effortless surge – old lonely fortresses – these are the stuff of a typically 'Romantic' view. But, as Romantics prospected for whatever was terrible or terrific in the natural environment, so they also searched for what might be called the darker sides of

human nature. Eighteenth-century connoisseurs admired the example of Salvator Rosa, the Neapolitan painter who had shown that a fearful landscape might breed fearsome figures – covens of witches, or swarthy gangs of bandits. Goya, as we have noted, quite literally darkened his palette to make an iconography of 'the sleep of reason': in his 'Black Paintings', both the folkloristic macabre and mythically monstrous are made alarmingly palpable (159). In London, the Swiss-born painter Henry Fuseli privately explored his own psychosexual temperament through a series of drawings which look to be proto-masochistic male fantasies of female domination; neither did his exhibited work shy from suggestive eroticism, as evident from Fuseli's best-known picture, *The Nightmare* (160) – in which some pointy-eared ghoul of the Gothic imagination perches in predatory eagerness by a recumbent but sexily arched female form.

<p style="text-align:center">⋆ ⋆ ⋆ ⋆ ⋆</p>

It was an ancient Greek writer of no fixed identity – we give him the name 'Longinus', and locate him either in the first or the third century – who originally gave rise to the term 'the Sublime'. He produced a tract of literary criticism entitled *Peri Hypsous* ('On Height', or 'About Loftiness'), which set out to define how the effects of greatness were achieved in terms of poetic style, subject and structure. In the course of his discussion, Longinus allowed that certain phenomena of the natural world were sufficient in themselves to arouse feelings of awe and astonishment: such as the smouldering of Mount Etna, Sicily's sulky volcano.

Much else of what is prescribed by Longinus for the achievement of 'grandeur' in composition goes generally unheeded now. But translations of the tract in the seventeenth century – beginning with that by Boileau into French, in 1674 – gave a particular modern impetus to the influence of shadowy Longinus. The hunt for heights in rhetoric and in nature was intensified, and extended in scope. 'The Sublime' was not only to be found in massive objects, such as elephants and mountains; it also arose from all the diverse causes of awe, fear and horror. John Dennis, an Englishman who made a crossing of the Alps in 1688, proposed that it was a poet's business to generate terror – by writing of 'Gods, Daemons, Hell, Spirits and Souls of Men, Miracles, Prodigies, Enchantments, Witchcraft, Volcanoes, Monsters, Lions, Tygers, Fire, War, Pestilence, Famine, &c.' Dennis claimed that his Alpine scrambles had lured him 'upon the very brink . . . of Destruction' – and admitted that the same experience made him at once both exultant and trembling. It was, he confessed, 'a delightful Horror, a terrible Joy'.

Delightful horror, terrible joy. In due course we shall apply the contradictory logic of these sentiments to the curious but not recondite erotic pleasures known as sadism and masochism – both of which allow the apparent oxymoron of 'exquisite suffering'. Here, however, there is a little more to be said about the apprehensive embrace of natural wildness and magnitude as it is offered by 'Romanticism'. Samuel Johnson, sitting upon a heathery bank to contemplate the 'rudeness, silence and solitude' of Scottish moorland scenery in 1773, may have been one of the first writers in English to spell out his sensations as suitable for the narrative fabric of 'Romance'. The more precise analysis of 'the Sublime' came from a less

**161 TWO MEN
CONTEMPLATING
THE MOON**

Caspar David Friedrich, 1819

A canvas in Dresden. An earlier
painting by Friedrich, given the
same title, is in Berlin. Samuel
Beckett's claim of inspiration
for *Waiting for Godot* appears to
conflate the two pictures.

adventurous spirit, the German philosopher Immanuel Kant (1724–1804).

In his *Critique of Judgement* – published in 1790 – Kant specified the mathematical criterion of 'the Sublime' as 'that which makes everything seem small'. Then Kant described certain stimulants to the imagination – 'bold, overhanging rocks . . . thunderclouds piling up in the sky . . . volcanoes . . . hurricanes . . . the boundless ocean . . . the high waterfall of a mighty river' – each one, he argued, appearing 'all the more attractive the more fearful it is, provided we are in a safe place'. The philosopher drew the aesthetic moral: 'We like to call these objects sublime because they raise the soul's fortitude above its usual middle range.'

In other words, 'the Sublime' is a test of spirit and nerves.

Kant himself conducted a meticulously quiet life 'in a safe place' within the town then known as Königsberg (subsequently Russian Kaliningrad), on the Baltic coast. This was a coastline well known to Kant's fellow-countryman Caspar David Friedrich (1774–1840), in whose paintings we seem to be presented with a distinctly Kantian sense of 'negative pleasure'. One of Friedrich's scenes, for example, shows a ship foundered in pack-ice. That Friedrich once helplessly watched as his younger brother perished under ice may render the death-chill of this image particularly poignant, but in any case the death-chill is there.

Friedrich was a pantheist: which means he perceived the presence of God within and throughout the natural world, making each landscape 'awful' in the strict connotation of being awe-filled or awe-inspiring. But with religious reverence came dread and terror too; and the fear of utter loneliness amid the mightiest manifestations of divine power. So it happened that Friedrich's vision eventually provided the direct conceptual prompt for Samuel Beckett's *Waiting for Godot* (1952/55), a play often taken as the definitive dramatization of modern

'existential' uncertainty. Two cloaked figures watch the moon (161). In the moon's light there is no warmth, however splendidly it shines. Wherever they are – whoever they are – these onlookers are puny things. They seem to have stolen into a region that is vast, and cold, and unpeopled.

Creepy: and yet it is a beauteous sight.

The same mist-steamy German mountains that supplied Caspar David Friedrich with much of his holy art-horror were sought out in person by two influential English Romantics, William Wordsworth and Samuel Taylor Coleridge. Coleridge debated the definition of sublimity as he walked to the summit of the Brocken, a lumpen peak in the Harz region made piquant by its poetic folk associations with occult and witchery. Wordsworth's verse urges the reader time and again to recognize, from mountain scenery, the 'very littleness of life', or to intuit an 'underpresence' amid so many towering crags and glimpses of infinitude. Hiking up the Brocken, Coleridge pronounced sublimity 'to consist in a suspension of the powers of comparison'. But it was the project of those artists and writers whom we consider as 'the Romantics' to give expression to just that feeling of glorious intimidation – even if it ran to describing only the hopeless, groping loss for words. Wordsworth, in Book VI of his autobiographical poem *The Prelude*, recorded this sense of blockage or bafflement as it struck him in 1806 while crossing the Alps, by the Simplon Pass. 'Our destiny, our nature, and our home,' he concluded, 'Is with infinitude, and only there.'

If it was not quite obligatory for Romantic poets to stake their credentials by making the full Alpine transit, then at least they should cast their eyes towards Mont Blanc. Coleridge, in 1802, was moved to write a hymn of praise to the 'stupendous Mountain', taking it to show a grand example of the handiwork of God; Percy Bysshe Shelley, in 1816, by contrast found every part of the panorama a harrowing confirmation of 'awful doubt'. Both Coleridge and Shelley took their stance in that valley of Mont Blanc which now contains the ski resort of Chamonix. With its five torrents spilling down the mountainside, and springtime quilt of blue gentians, 'the Vale of Chamouni' became firmly mapped upon the Romantic itinerary of terrifyingly 'picturesque' places. The late eighteenth-century watercolourist John Cozens was one of the first British artists to exploit the scenery; but it was John Ruskin who, as it were, canonized the landscape. Ruskin went to the Alps while in his early teens. It would be misleading to say that this visit was his most formative experience (he never, after all, wrote a book called *The Stones of Chamonix*); but ultimately Ruskin's dogmatic faith in the dependence of good art upon the study of 'Nature' was based upon his introduction to the Alpine Sublime – and it was love at first sight.

Wordsworth resigned himself to the 'sad incompetence of human speech': the gush of Ruskin's prose about both 'mountain gloom' and 'mountain glory' seems to mock such wan verbal surrender. But perhaps it is significant that Ruskin abandoned the project of composing a poem in the shadow of Mont Blanc, in favour of making drawings and pictures: as if graphic description, conducted with due diligence to detail, were indeed the more telling medium (162).

Ruskin (as we have previously noted) distrusted the investment of Nature with human qualities – the 'pathetic fallacy', whereby it is erroneous just to say that the

162 **LA CASCADE DE LA FOLIE, CHAMOUNI**
John Ruskin, 1849

An image to match Ruskin's prose-poem and sermon, 'The Mountain Gloom' (in *Modern Painters*, Vol. IV).

water in a lake does not look 'inviting' for a swim (what does a lake care if you swim in it or not?). Yet it was a central enterprise of Romanticism to infiltrate scenery with emotional cues – and to enlarge, hugely, the range of temperamental responses that could be classified as 'aesthetic'.

'Aesthetic' is a word we have so far used uncritically: this seems a fitting juncture at which to bring about some finesse of meaning. 'Aesthetic' comes from the Greek *aisthetikos*, 'that which is perceived by the senses' – entailing those things that are 'felt', as opposed to those things that are thought of or 'known' by the brain. Philosophers from antiquity onwards had occupied themselves with such problems as how to define the sensation of beauty, but it was not until the eighteenth century that 'aesthetics' was proposed as a particular philosophical discipline. (It was in 1735, to be precise, when a young German scholar called Alexander Baumgarten submitted to Halle University a dissertation now known as *Reflections on Poetry*.) And so it was, during the eighteenth century, that 'aesthetics'

became a formal preoccupation beyond the assessment of beauty in the arts. This was why the definition of 'the Sublime' taxed so many minds at the time. If the sensation of pleasure gained from a picture or a poem could be analysed with the same philosophical rigour as a proposition in logic, ethics or metaphysics, then what conclusion was to be made of an individual who admired or even 'liked' a picture or a poem whose subject was, for example, the sacking of a city?

A youthful Edmund Burke addressed this question with the same trenchant energy that he would subsequently bring to his 'Reflexions' on the French Revolution. In his tract of 1755 entitled *A Philosophical Enquiry into the Origin of our Ideas of the Sublime and Beautiful*, Burke noted the 'strange wickedness' of the desire to witness some scene of mass destruction – and predicted that if ever a public execution were announced in the vicinity of a theatre, you could be sure that within moments the theatre would be empty. Charles Dickens and his fellow-novelist William Thackeray separately witnessed a hanging at Newgate in 1840, and both testified eloquently to the 'brutal curiosity' of the popular concourse to the event; while Leo Tolstoy, in 1857, memorably recorded an execution in Paris which drew an estimated crowd of 12,000.

The penal law in force in Britain during the period of George III (who reigned from 1760 to 1811) was known as 'the Bloody Code'. According to its statutes, men and women could be condemned to death for such misdemeanours as shoplifting and petty poaching. So in the late eighteenth century there was no shortage of occasions on which to share in the spectacle of a hanging. And so the aestheticians of the time asked themselves: why the vulgar compulsion to participate at such scenes? Was it with a view to making personal contrast with the victim; to congratulate ourselves on not sharing the unhappy fate? Was it, perhaps, derived from some deeply benevolent sense of duty to give moral support to the condemned wretch? Unlikely. As Burke's contemporary, the Scottish moralist James Beattie, decided: folk were impelled to gather at the gallows 'because a sort of gloomy satisfaction, or terrific pleasure, accompanies the gratification of that curiosity which events of this nature are apt to raise in minds of a certain frame'.

'Terrific pleasure' – once again. And though Dickens campaigned vehemently against public executions, he knew all about the 'fiendish enjoyment' to be had from concocting not-so-unreal stories about sinister villains and serial killers. In his youth he had been voracious for such tales; and the bookstalls of Victorian Britain were abundantly stocked with gaudily-illustrated parlour-books about men who turned their wives into meat pies, and other homely terror tales. We may

hesitate to dignify this mode of sensationalism as an art-form, but in France it could be said to have risen to that level: the adroit draughtsmanship of Honoré Daumier, certainly, could turn to supplying the popular appetite for pictures of any flesh-creeping item of recent news – even when lodging a political protest (163).

163 THE MASSACRE IN THE RUE TRANSNONAIN
Honoré Daumier, 1834

Government troops had broken through barricades erected in certain militant streets of Paris in April 1834; Daumier's lithograph of the subsequent killing of 'proletarian' activists first appeared on display in a shop window in the autumn of that year.

164 WEYMOUTH BAY
John Constable, 1816

In one of his lectures, the artist advised painters of such scenes to include sea-birds, whose imagined cries would 'add to the wildness and to the sentiment of melancholy always attendant on the ocean'.

According to Burke, 'the passions belonging to self-preservation' were the strongest of all passions. Yet Burke and others appreciated that the instinct for self-preservation did not preclude the active enjoyment of personal risk – or at least, the imaginative visualization of life-threatening scenarios. Had Burke been dragged into the future and made to watch one of Hollywood's favourite horror-*tableaux*, the hijacked aeroplane, he would have apprehended its double source of 'terrific pleasure': directly mingling the fear of flying with the fear of political subversion.

The eighteenth-century theorists of the Sublime may have recognized this method of amusement: that is not to say they *approved* of it. And it is ironic to find writers, in the age of 'Enlightenment', commending 'obscurity' – vast caverns, dense forests, befogged valleys and dripping grottoes – as a natural means of enchantment (clarity, observed Burke shrewdly, was 'an enemy to all enthusiasms'). Ruskin later tried to modify the strain of delight derived from 'the agony of terror', arguing that the excitement yielded by Sublime prospects came 'not while we shrink, but while we defy'. But whether it caused shrinking or defiance, this sensual courtship of frightfulness became almost a defining aspect of vocation for anyone claiming the status of artist, poet or raconteur. Even John Constable, a painter cherished for his reassuringly gentle records of the English landscape, sometimes strayed into evocations of the danger zone. His vision of angry waves off the south coast (164) anticipates the well-known poetic statement of nineteenth-century incertitude by Matthew Arnold, for whom the swell viewed from Dover, calm though it was, dragged in an 'eternal note of sadness . . . the turbid ebb and flow/Of human misery'. Once upon a time the earth had been surrounded and made safe by what Arnold termed the 'Sea of Faith'. Now it seemed to have withheld all such cosy protection, peace, and relief of hurt:

> *And we are here as on a darkling plain*
> *Swept with confused alarms of struggle and flight*
> *While ignorant armies clash by night.*

Arnold would eventually repent of such 'morbid' poetry, and indeed all art that conjured circumstances in which 'suffering finds no vent in action . . . in which everything is to be endured, nothing to be done'. He echoed Schiller's belief that art's purpose was to alleviate despair and to heal the harm of disillusion.

But one English critic, however influential, was powerless to reverse the wider spread of that particular Romantic feasting upon agony which is sometimes referred to as a manifestation of 'Decadence'.

<p style="text-align:center">⋆ ⋆ ⋆ ⋆ ⋆</p>

And, without doubt, no one has better claim to be the founding father of Decadence than the Marquis de Sade (1740–1814).

Sade was a child of the eighteenth century; some would say he carried 'Enlightenment values' to their logical end. If Rousseau had sanctified the primal instincts of mankind in the 'state of nature', Sade was arguably not unreasonable in claiming that if 'natural' desires and impulses occurred within human beings, then they were to be obeyed and satisfied. But Sade's own pursuit of this theory soon enough rendered him a social menace, and an embarrassment to his family, who successfully petitioned Louis XVI to keep the rogue esquire in prison. It remains a nice irony of the French Revolution that the Bastille was stormed for the sake of releasing an aristocrat such as the Marquis de Sade (if actually he gained freedom shortly before the final act of 'liberation'). Though Sade joined the Revolutionary cause for a while – he gave the funeral oration for Marat in 1793 – again his 'libertine' reputation led to internment – this time in an asylum at Charenton, where he was confined from 1801 till his death.

The prolix stories for which Sade remains notorious were written during some thirteen years of detention at Vincennes and the Paris Bastille. It may amount to a gesture of some pardon to remember that *One Hundred and Twenty Days of Sodom* was composed by a man with no access to carnal extravagance beyond his own imaginary fantasies; even so, it seems sufficiently clear that the historical and unrestricted Marquis de Sade was not a man to whose castle anyone would have sent their niece for a wholesome weekend.

And what of those stories? The general sentiment is that if they are not so vile as to be unprintable, then they are so boring as to be unreadable. A latter-day 'master' of erotic literature, Henry Miller, used to refer to women as three holes where phallic gratification might be sought; all pornographers find that the themes and variations of this three-hole approach are soon exhausted. Sade's fraternities of pleasure-seekers turn to other games, messing about with excrement, and exploring those diversions which we now understand as 'sadistic': whipping, bondage and lacerating; but also outright dismemberment, paedophilia and infanticide. Mario Praz, the Italian scholar who gave currency to the term 'the Romantic agony', defined Sade's credo as 'a sort of cosmic Satanism', whereby

decency and 'virtue' are regarded as a set of rules that are there to be broken. Sadistic pleasure is then inconceivable without some element of rule-breaking; and our word 'corruption' retains from its Latin origin just such a sense of 'breakage' or intention to destroy.

To be a libertine and to campaign for *volupté*, sensual self-indulgence, every bit as eagerly as for political self-expression, *liberté* – this makes some connection between Sade and the ideology of the French Revolution. From a purely political point of view, Sade might be considered the ultimate anarchist: all constraints of law and government he denounced as tyranny. But it might also be observed that the trails of corpses left by Sade's protagonists and the Jacobins are comparably alarming; and most verdicts on Sade would match his mode of terror ('a sexual concentration camp') with 'the Terror' of the Revolutionaries. ('In the groves of their academy,' wrote Burke, 'at the end of every vista, you see nothing but the gallows.') But suppose we lay aside, for a moment, our normal distaste for Sade's person and prose. Would we admit that there was a quality of 'automatic' behaviour in Sade – a trait not entirely reprehensible? And that 'Sadism' was not invented by Sade, but subsists, not unnaturally, in the reaches of human sensibility?

Georges Bataille argued as much, in his campaign, during the 1920s, to rehabilitate Sade's literary reputation. Bataille subsequently collected his own thoughts on the nexus of eroticism and death in a short illustrated treatise known (in its translated version) as *The Tears of Eros*. The 'violence of an embrace', Bataille maintained, was as old as mankind. The Marquis de Sade should be applauded for giving voice to instincts of danger and voluptuousness that were universal to the species – but suppressed as 'perversions' by bourgeois morality.

Thanks largely to the mediation of Bataille, Sade proved a hero-figure to Breton and the Surrealists. In turn, the Surrealists transmitted Sadean influence to the stage, through the erratic personage of performer and playwright, Antonin Artaud. It was in 1932 that Artaud issued his manifesto for a 'theatre of cruelty' (*théâtre de la cruauté*), whereby the purpose of drama became unnervingly 'dramatic'. The theatre should plunge its audience into 'a bath of fire'; people coming to a play must be made to believe that their lives might end, catastrophically, any day – and by this experience of crisis learn the truth that evil is like a gravitational pull in the world, while good depends upon human effort.

The homeopathic logic of this attitude is not so distant from Kant's rationalization of Romantic adventurism. To walk along a precipice fortifies the soul; to have our hair raised on end by shrieking in the theatre constitutes that dose of horror which steels us for the worst reality. And when the works of Sade were publicly re-examined in Paris during the 1960s, with a view to censorship, the aged figures of Breton and Bataille came forward as defendants of Sade, taking that same Kantian approach. Yes, they agreed, many of the acts described by Sade were putrid and murderous. But to read Sade was to apprehend as much; and therefore, Sade's work should not be banned.

So Sade comes and goes in print. Whether Sadean-style accounts of homicide and 'sexual abuse' serve as cures or encouragements to homicidal and abusive action is a topic still debated in the law-courts and elsewhere. But the existence of a Sadean or sadistic 'taste' in literature and the visual arts is hard to deny. In the

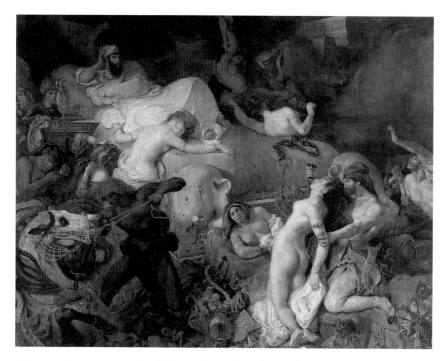

nineteenth century, as Mario Praz showed, Sade's influence was palpable even when Sade's writings were mostly out of bounds. The English poet A.C. Swinburne – now probably as neglected as he deserves to be – embedded his ecstasies of lust and bloodshed in verse-dramas mostly evoking myths from Classical antiquity. Before Swinburne, Delacroix preferred to locate such debaucheries in the East, with what seems in retrospect a deplorably facile 'Orientalism'. Sadism, for Delacroix, goes with the territory of turbans and scimitars. In his oddly titled canvas *Death of Sardanapalus*, a stereotypical Eastern despot lies propped on the elephantine couch which will be his funeral pyre, apparently suffering no more than chronic *ennui* as the numerous concubines of his harem are knifed and strewn all around (165). If Antonin Artaud would immerse a theatrical audience into a bath of fire, then Delacroix (as his admiring contemporary, the poet and critic Charles Baudelaire, phrased it) offered viewers a 'lake of blood' (*lac de sang*).

Since Sade himself was committed as insane, it is perhaps no surprise that the diagnosis of mental disorder – that branch of medicine we call psychiatry, which emerged during the nineteenth century – created a clinical condition or deviation called 'sadism'. Richard Krafft-Ebing, the German neurologist who first used the term (from around 1880 onwards), also coined a name for those individuals who gained pleasure not so much from inflicting pain, but from receiving it. Again, it was a writer who proved eponymous: in this instance a Slavonic scholar, Leopold von Sacher-Masoch (1835–95).

Sacher-Masoch was not consigned to a lunatic asylum. That is not to say he balked at realizing his fantasies: documents survive, for instance, which attest that Sacher-Masoch drew up a contractual agreement with his first wife, Wanda, requiring her to assume him as a slave. However tedious this may have been for Wanda, it posed no pestering threat to society at large. And although blood is

165 THE DEATH OF SARDANAPALUS
Eugène Delacroix, 1827

Sardanapalus was a legendary Assyrian despot whose 'tragedy' (as it was styled in a drama by Lord Byron, published in 1821) was to have tried all the pleasures in the world, and become bored with them. Neither Byron nor the ancient myth of Sardanapalus, however, makes any mention of this massacre of *houris*.

drawn in the pages of Sacher-Masoch's most widely circulated story, *Venus in Furs* (1870), the brink of death is always remote; and sexual connections, inasmuch as they happen at all, are never explicitly described. Or perhaps this literature has been less vilified than Sade's novels simply because so many gentlemen in high office were – and are – covert aficionados of the masochistic mode.

Rousseau may again be cited: in the course of his *Confessions* (published posthumously in 1781) the sensual pleasure of entering a state of pseudo-servitude to a commanding female or mother-figure is delicately observed. And it was John Keats who put into verse the male masochist's dream of a fair woman – 'la belle dame sans merci'. As the capricious Salome who calls for the head of John the Baptist, this diva without mercy was a favoured subject for pictorial idolizing in the nineteenth century (by Aubrey Beardsley in Britain, and Gustave Moreau in France).

Lynx-eyed, languid, implacable – since she has become globally typified as the 'dominatrix' of modern erotica, Sacher-Masoch's Venus-in-furs does not seem like an isolated figure of fetish (Sacher-Masoch identified Titian's *Venus with the Mirror*, painted *c*.1555 and now in Washington, as inspiring his title). If Sade was not the first sadist, nor did masochism begin with Leopold von Sacher-Masoch. But in a patently autobiographical passage of *Venus in Furs*, the author relates a detail of his hero's 'masochistic' formation which may directly illuminate some of the images and issues we have confronted in this book. Aged about ten or eleven years old, he dwelt upon every book about the Christian martyrs he could find. St Sebastian, St Lawrence and others we have gazed upon as the stalwarts of apostolic witness. For Sacher-Masoch they were something else: true gourmands at the feast of pain.

★ ★ ★ ★ ★

> *I was walking along a path with two friends*
> *the sun was setting*
> *I felt a breath of melancholy*
> *Suddenly the sky turned blood-red*
> *I stopped and leant against the railing,*
> *deathly tired*
> *looking out across flaming clouds that hung*
> *like – blood and a sword over the*
> *deep blue fjord and town*
> *My friends walked on – I stood there trembling*
> *with anxiety*
> *and I felt a great, infinite scream pass*
> *through nature.*

This is the painter's 'text' for his most celebrated image (156): it may, as the phrase goes, 'say it all'. Edvard Munch (1863–1944) not only suffered, as a person, from a motley of chronic fears; as an artist, he meditated the most effective means of giving them figurative expression. We know that Munch was concerned by Lessing's treatise *Laokoon*, deploring the shortcomings of art when called upon to depict intense emotions. *The Scream*, and the entire stylistic trend to which

Munch's work became ascribed – 'Expressionism' – may be seen as attempts to prove that Lessing was wrong. Munch's image of a sound indeed has powers of reverberation: its colours ring about like a sort of visual tinnitus.

But it is, for all that, a *pleasing* picture.

At the risk of invoking something so vague as a Scandinavian *angst* by ethnic characteristic, it might be pointed out that the Norwegian Munch is sometimes reckoned to reflect ideas from the Danish philosopher Søren Kierkegaard (1813–55). Kierkegaard's articulation of the concept and experience of 'anxiety' yields many quotable lines. 'All existence makes me nervous,' he noted in a well-known journal entry. Or, as he wrote more formally: 'Deep within every human being there still lives the anxiety of being alone in the world, forgotten by God, overlooked among the millions and millions in this enormous household.'

But Kierkegaard was a Romantic. Anxiety was definable as 'a desire for what one fears'. Psychologically, then, anxiety may operate as a 'sympathetic antipathy', or an 'antipathetic sympathy'. And more than this. In terms of aesthetics, according to Kierkegaard, any form of torment undergone by the artist or the poet became sublimated as soon as it gained expression. To explain this theory, Kierkegaard resorted to the story in Pliny about the bull of Phalaris (see also p. 96). This is the anecdote about the hollow bronze bull devised for an ancient Sicilian tyrant (called Phalaris), in which victims could be concealed and then subjected to heat. The victims screamed, but their screams failed to sound appalling; rather, it seemed as though the bull were making a quaintly bovine noise. Similarly, Kierkegaard argued, a poet will sigh from the depths of profound sorrow, and his sighing will be applauded and appreciated. When the crowd asks for more then it is demanding, by Kierkegaard's logic, fresh draughts of that sweet-sounding pain. '"Sing again soon" – in other words may new sufferings torture your soul, and may your lips continue to be formed as before, because your screams would only alarm us, but the music is charming.'

This is the lasting bequest of Romanticism: to give value to despair. In the nineteenth century, that valuation could be absurdly raised, with terminal illness – especially 'consumption', or tuberculosis – being paraded as an almost necessary qualification of the artistic spirit (the French poet Théophile Gautier once commented that he could not accept 'as a lyrical poet anyone weighing less than ninety-nine pounds'). Those Romantic poets and artists who were not so afflicted, or hypochondriac, scaled cliffs and sought chasms, literally to gauge the littleness of human life. In one of his most influential verbal images, Kierkegaard compared anxiety to the sensation of looking over a precipice, and the head going dizzy.

This was the 'dizziness of freedom' that later became the essential crisis of the twentieth-century philosophy known as 'Existentialism'. But what makes us go to the edge in the first place?

When faced with a question like that, wiry mountaineers are inclined to shrug, and say: 'Because it is there!' But we can now make the connection between the Romantic Sublime, Kierkegaard's anxiety, and the psychological tenets of Freudian diagnosis. We take ourselves to vertiginous brinks because we know we might fall. It is a measure of our drive to death. It may scare us to our wits' ends. But it is, at heart, a sensation that does not truly displease us.

To come to this drop – this point of topple or retreat – is to arrive where Longinus, progenitor of the Sublime, might have predicted. Longinus identified Mount Etna as an inspiringly lofty volcano: he would have known the legend that told of one fifth-century BC Greek philosopher, Empedocles, climbing to the lip of its crater and hurling himself from the edge. Empedocles, the story went, wished to prove himself divine; or else he was afflicted (as Matthew Arnold glumly assumed) by that 'hurt for which courage is not the cure': the knowledge of humanity perpetually bound in suffering and woe.

Whether or not we share in such pessimism, we too have come to a terminus here. To make the leap of immolation, like Empedocles, is to affirm a spectacularly abrupt finality. But the understanding of human nature that is created by Kierkegaard, Longinus, the Brothers Grimm, Romantic artists, the Marquis de Sade and Freudian analysts alike, presents a peculiar impasse of its own. If we court danger for fun; if we raise amusement when we take risks, and make shows of recklessness – then what is the value attached to a safety warning? And if, as Kierkegaard argued, the plaintive self-expression of an artist in distress gives *pleasure*, and has us calling for *encore* – then where is the true fulfilment in humans feeling happiness?

These are demands born of perplexity, and what follows is not a sequence of resolving answers. (If only it were: one would claim, with Empedocles, to be God). But thematically, and historically, our journey is now closing towards the place which was its point of departure. In this sense, there is not much more to say. We have, in sight, a 'familiar' locale.

There it is: the huts and barns, the deer-cropped sward, the ruined chimney piles – of Auschwitz-Birkenau.

* * * * *

It is an epochal commonplace to say that the Great War brought an 'abridgement of hope'. Poet, 'Vorticist' and Fascist Ezra Pound gazed on the world after 1918 and described what he saw as a 'botched civilization'. Like the young Adolf Hitler, who had served with distinction on the Eastern Front, Pound was inclined to blame this damage upon the Jews. So too, for that matter, was Pound's protégé and fellow-poet, T.S. Eliot, whose 1922 sequence, *The Waste Land*, captured for many of its contemporary readers a widespread sense of post-war malaise. The anti-Semitism of Pound and Eliot was, in relative terms, rather mild; their sense of post-war embitterment strong – perhaps *because* neither had served in the trenches, not despite their marginal roles. It seemed that death had harvested a generation of men: so, for the epigraph of *The Waste Land*, Eliot quoted a Classical tag, '*apothanein thelo*' ('I want to die'), as if it were a general desideratum on the part of those who felt left out. Freud's 'death-wish' was joined by boredom and hopelessness: what was there left to achieve? In a poem of 1940 ('East Coker', eventually gathered as one of the *Four Quartets*), Eliot described the decades between two world wars as so many years spun out with the dispiriting struggle of 'trying to use words'. But even when Eliot lamented the 'failure' of his efforts, the lamentation was applauded. It reached an appreciative public. Kierkegaard would have nodded in approval:

166 **NOSTALGIA OF THE INFINITE**
Giorgio de Chirico, 1911–14

A vaguely urban space, barely populated by mannikin-figures casting long shadows – typical of the artist's work just before and during the First World War.

if the nightingale trills exquisitely with complaint, we adore her no less for complaining – whatever the cause.

Another writer of the period, Virginia Woolf, bemoaned the shortcomings of the English language for expressing pain and ill-ease. Beggars made mere hieroglyphs of misery, which most passers-by preferred to ignore; while victims of a migraine (she wrote, feelingly) could not begin to convey to others the quality of the pain that was lodged in their head. So Woolf demanded 'a new language ... primitive, subtle, sensual, obscene'.

Gauging the desperation of such sentiments composed after the Great War, we may – in passing – think to ourselves: if the resources of language were exhausted *then*, whatever would happen when the next test came – the Nazi *Endlösung*? What words would withstand the 'Final Solution' as attempted after 1941: when anti-Semitism grew into the passionate, mechanized insistence that all Jews be hauled to extermination from wherever they could be seized – the Carpathian mountains; the streets of Thessaloniki; the ghetto of Lodz; the petite, gingham-windowed villages of the Vaucluse?

Or how encompass, poetically, the conception and detonation (on 6 August 1945) of an atomic bomb whose flash would burst more brightly than the sun and whose heat would instantly melt away the flesh of whatever beings were caught in its vicinity?

'The horror! The horror!' In his original manuscript of *The Waste Land*, Eliot had used for an epigraph this exclamation from Joseph Conrad's story, *Heart of Darkness* (1902). The horror at centre of human existence: this, for Eliot, was the 'complete knowledge' that *The Waste Land* contained. But because it said too much about the poem, Pound advised Eliot not to keep the line. Pound's improvements to *The Waste Land* were manifold, and mostly in the cause of an euphonic finish to its strophes. It seems Pound also understood that, in all art, horror is better left suggested than defined.

That lesson may yet be instructive to anyone making 'art after Auschwitz'; it could be exemplified by reference to many artists of the twentieth century. The sense of lost innocence, of being troubled even amid habitual surroundings – which was Freud's 'uncanniness' – is what, for instance, lastingly marks the work of the renegade Surrealist painter Giorgio de Chirico. De Chirico overtly hymned the inspiration of 'The Disquieting Muses', and drew time and again upon their enchantments of suggestive melancholy (166). Throughout his work runs the thread of menace and estrangement: the neat urban arcade that runs to its vanishing-point, and so leads to nowhere, or disorientation; the child who innocently bowls a hoop towards a looming armed shadow.

167 THE WIDOW II
Käthe Kollwitz, 1922

Kollwitz strove with her art for the quality of abbreviated form – in order that, as she stated, 'all that is essential is strongly emphasized and all that is unessential denied'.

De Chirico, as far as can be judged, did not create his 'melancholic' art from any basis of religious faith – by contrast to his contemporary, the French Expressionist Georges Rouault; nor yet from any political conviction – by contrast to Dix, Grosz, Max Beckmann and others in Germany, and elsewhere, who regarded the Great War as an imperative for communistic action and a new artistic sensibility towards 'the masses'. Yet it is instructive to heed the aesthetic self-justification given in this period by Käthe Kollwitz, who was probably the most consistent of all twentieth-century artists in her socialist-Christian endeavour to depict the lives of manual workers, especially working women. Kollwitz lost her son Peter in Flanders early on in the fighting; her insights into the state of acute personal grief are distinctly free from posture and sentimentality (167). As an artist, though, she was also candid about the motives for what impelled her to seek out the toilers, the decrepit people, the homeless of Berlin. 'Pity and sympathy,' she confessed, 'were only minor elements leading to representation of proletarian life; rather, I simply found it beautiful.'

'Beauty is truth, truth beauty': the dictum of Keats the Romantic poet (from his 'Ode on a Grecian Urn', 1820) might well have been wrenched into service by any of the German Expressionists, and indeed by any artist of the twentieth century who recognized that a canonical or 'Classical' beauty no longer existed. If the Romantics had searched for beauty in far-off tracts of wilderness, then their twentieth-century successors showed that elemental wilderness was on anyone's doorstep, close to home.

To be in man-made surroundings, and feel utterly desolate: such 'unhomeliness' must be counted as a primary component of 'American Realism', most conspicuously in the work of Edward Hopper (1882–1967), whose images of lobby-rooms and gas-stations are quite as disconcerting as any view of mountainous scree by Caspar David Friedrich. Some painters can make a canvas seem loud with noise: Hopper orchestrates silence, a silence piercingly aligned (in the words of one commentator) 'to the always enigmatic force of imminent

168 THE HOTEL ROOM
Edward Hopper, 1931

It may be a letter that the woman wearily studies here – or just a railway timetable.

annihilation'. In Hopper's study of a woman sitting down in a hotel room (168), the artist has at least graced the scene with an opened letter. This human being is not entirely overlooked and forgotten – even if, as many viewers of the picture have supposed, the letter she holds bears unpleasant news. But how perfectly Hopper evokes that very particular sense of isolation that besieges anyone who checks into a modern hotel alone. Footsteps down a corridor;

the groans, at all hours, of the hidden murmurous plumbing-system; squeaks of a chambermaid's trolley – the combination of troublesome noises that seems to lock one inside a stale cubicle of transit, exile and restlessness.

For Kierkegaard there was dizziness of freedom; for those twentieth-century 'Existentialists' who heeded Kierkegaard, notably Jean-Paul Sartre (1905–1980), such personal liberty merely caused an anguished frustration in every individual who apprehended it. Who can count themselves free in a world filled with other people, on the collision course of self-seeking and indifference? ('No need of a gridiron,' runs the arid one-liner by which Sartre is best known. 'Hell is other people.'). And so unhomeliness was compounded by the sense of being trapped. Sartre's equation of l'Enfer with les Autres came in a play (Huis-Clos) published in 1944. Around the same time, the English painter Francis Bacon began to produce his blurry images of human faces squared at screaming pitch. In the ultimate (or best-known) picture of this series we see how much is owed here to a sense of worldly claustrophobia (1). Unlike Munch's precedent, it is not so much the scream that resonates in our vision. It is the box-like fence or frame that Bacon throws around the scream's escape. This is a howl from one who wears the purple of distinction, but it is also every yell in the wake of the intolerable. And in Bacon's visual translation of them, these screams do not happen in wide open spaces, under desert skies. They are raised from thrones and chairs – or some domesticated, hedged-around, 'homely' place.

Bacon had a few favourite texts with which he would sometimes explain his work: one of them was The Waste Land. And some residue of Romantic motivation was there too. When asked what prompted his art, Bacon shruggingly replied: 'exhilarated despair'.

<p style="text-align:center">★ ★ ★ ★ ★</p>

Jewish children transported in 1942 to the ghetto-Lager of Theresienstadt (Terezín, thirty-five miles from Prague) met there an architect and teacher, Friedl Dicker-Brandeis. She had been associated with the Modernist school of design known as the Bauhaus. Apart from her Jewishness, that was further cause of her persecution by the National Socialists. The Bauhaus creed of modernism, internationalism and rationalism was compatible with neither the Nazi fetish for massive, neo-Classical sites of pomp, nor the Nazi nostalgia for cosy Teutonic cottage-housing.

Theresienstadt was itself a 'model' concentration camp, open to international inspection (though it largely served as a hub of transit for internees destined for death elsewhere). Once she arrived, Dicker-Brandeis made herself useful as perhaps a trained architect and pedagogue might naturally do. Prior to her own extermination at Auschwitz in 1944, she had the children of Theresienstadt drawing pictures of ideal homes and habitats.

Some of this improvised schoolwork survives: and what the imprisoned children drew were pictures of the place that held them, made gaudy with what they never saw in the camp – flowers, butterflies. Their barrack-rooms – the numbered bunks and all – became cosy.

Some of these little ones survived; more were eventually led to the gas and the flames. But with their crayons they made Theresienstadt *wie heimlich*: home as home is.

'Aliens did not make the Holocaust.' That was a truth we absorbed while touring Auschwitz Museum, and it returns to haunt us here. There have been many attempts by artists since the Holocaust to record, envisage or commemorate its horror; perhaps the reason why most attempts seem to be failures is because most artists have imagined something extraordinary, like Dante's Inferno, when they should have stayed closer to home, and seen (with the children of Theresienstadt) the enclosing surrounds: the façade of tidiness and presentability; a common, sociable logic.

'Holocaust' means, literally, 'a burning of everything'. So we might forgive the penchant, evident in much of the Holocaust's pictorial memoranda, for visions of blazes that scorch the human form into a puppetry of clinker and ash. In the end, however, no visualization seems as effective as this: a generic, pseudo-folksy rendering of the cross-beams and pitched roof of German vernacular architecture, whether it is an empty studio or one of the huts at Birkenau (169).

The artist has planted a sword in the woodwork, but it is not a necessary addition. Stripped bare, this attic retreat is house to the true comforts of unhomeliness.

It is doom and shelter: both at once.

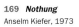

169 *Nothung*
Anselm Kiefer, 1973

Title and inscription ('My father promised me a sword') relate this image to the saga of Wotan, Siegmund and Siegfried in Wagner's opera-cycle, *The Ring*. The space depicted was the attic (*Dachboden*) of an abandoned schoolhouse.

12 FINALE: UNENDING

Andante

As the Buddha dies, so he enters the state of 'Perfect Nirvana' (*parinirvana*).

Nirvana is not extinction: rather a 'going out'. It is the final attainment. 'It is the end of woe.'

Nirvana is an inexpressible state. But a Japanese scroll, of the late fourteenth century, depicts the moment at which the Buddha quits earthly existence (170). Streaming down upon a cloud comes the Buddha's mother Maya, with her heavenly handmaidens. From a tree hangs the Buddha's begging-bowl, wrapped in a red cloth. Around the altar-bier on which the Buddha lies are ranked the representatives of all grades of Buddhahood. Primary amongst them are the Bodhisattvas and Arahats: those who are advanced along the path to supreme enlightenment (the word *Buddha*, often translated as 'the enlightened one', more accurately means 'one who has woken up'). The descent in order includes gods and ordinary mortals, down to animals, insects and worms.

Grief grows to its full in the foreground. The worm writhes in agony. The elephant is crouched and wailing. The tiger paws the ground. Some humans, too, prostrate themselves, clasp heads in hands, or turn away in tears. But closer to the bed, serenity prevails. It is the quiet of the enlightened state. The higher their spiritual attainment, the less they feel sorry. For they understand where Buddha now belongs.

So the trial of bereavement is left to worms, and to all beings that lack true understanding.

And it is not only his death that fails to perturb the Buddha's best disciples. During the Buddha's life, mortification of the flesh had been practised, and it had been put aside. As Sakyamuni, the Buddha once imposed upon his body the most severe of austerities, rendering his ribcage a stark comb of spindle-twigs (171). But what was proven by such drastic self-punishment? No tremendous gain of insight; no superhuman knowledge. It was an experiment. It was not repeated.

Serenity in death, superiority over pain – from Socrates onwards, there are records of spiritual leaders and philosophers worldwide who have gone barefoot over the earth's crust and taught such detachment. Possibly none so thoroughly as the Buddha; or at least, it is hard to find parallels for the conspicuously unscreaming intent with which, during the Vietnam war, young

170 SAKYAMUNI'S ENTRANCE INTO PERFECT NIRVANA

Hanging scroll, in silk, from Japan, 1392.

A Buddhist text relates the moment: 'When the Blessed One died, of those of the brethren who were not free from the passions, some stretched out their arms and wept, and some fell headlong on the ground, rolling to and fro in anguish at the thought... But those of the brethren who were free from the passions ... bore their grief collected and composed.'

171 EMACIATED BUDDHA

Schist stone sculpture, *c.* second-third century, from Gandhara (around the area of modern Pakistan).

 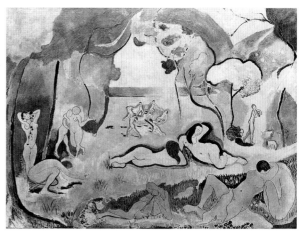

Buddhist monks performed acts of self-immolation. Cross-legged, doused in petrol, they changed their flame-orange robes for crackling shirts of fire.

In 1963 those were statements of protest, and occasions for photojournalism. The iconography of Buddhist devotion itself is without stress upon suffering. Buddha emaciated is a rarity; generally the Buddha is manifest replete and smiling. This has its logic. The faith assures perfect happiness for its committed adherents. What call is there, then, to labour the images of injury and sorrowful death?

Adagio con brio

Some say that the end and the purpose of all art is such blessed repose.

They say art is an ear attuned to harmonies that dwell within some latent spirit. That is how Wassily Kandinsky, and other pioneers of 'abstract' art in the early twentieth century, conceived their task: to clear human vision of the figurative dross of 'stories' and events – including the Trojan War, the Passion of Christ, the Buddha's ascetic trial – and let 'the pure inner working of colour' perform its musical mystique (172).

It follows that pathos has no place in art that is truly abstract. For pathos happens when feeling is transferred from subject towards object. Abstraction – if it is strictly so – implies the withdrawal of all subjective elements from the object of perception.

('Abstract Expressionism' is virtually a contradiction in terms).

Others maintain that art should serve as a comfortable piece of furniture.

As Henri Matisse wrote, in 1908: 'I dream of an art of balance, purity and tranquillity, free of troubling or depressing subject matter . . . a soothing, calming influence on the mind [*un calmant cérébral*], something like a good armchair which provides relaxation from physical fatigue.' In 1905 Matisse had been grouped with a pride of painters referred to as 'wild ones' (*Fauves*). But this wildness was no threat to civilization. 'Luxury, calm, voluptuousness': the title of a Matisse view along his chosen habitat, the French Riviera, itself conveys what every tired body wills from a good armchair.

And why not? It is the stubborn, eternal *joie de vivre* (173).

And it is what many of us might prefer to have in our apartment: a Matisse.

172 FRAGMENT 2 FOR COMPOSITION VII
Wassily Kandinsky, 1913

The obligatory caveat here is that since Kandinsky stressed the emotive powers inherent in pure colour, it is always unfair to judge his work in monochrome.

173 THE JOY OF LIVING
Henri Matisse, 1905–06

The very landscape subjects chosen by Matisse at this time – notably Saint-Tropez on the French Riviera – would become bywords for luxurious relaxation and 'escape'.

Or a Monet ('*Consider the lilies of the field*'); or a Bonnard, a Chardin, a Renoir, a Vermeer, a Canaletto, a Watteau, a Cassatt – *sans* blood, *sans* harm, *sans* death.

Fortissimo appassionato

Guernica. A small town in the north of the Basque country of Spain, bombed from the air for three hours or so on the afternoon of 26 April 1937.

Guernica: a large painting by Pablo Picasso which has entered collective consciousness as a plea for respite from all bombs, war and bloodshed: 'the most powerful invective against violence in modern art' (177).

Officers of Hitler's Condor Legion reported their operation as 'a complete technical success' – though by some accounts they were trying to hit a bridge, which stayed intact. If it *was* launched as the bombardment of a civilian population, then it could be counted as a pioneering sort of mission – something of a first for Fascism. The concept, however, was not entirely new; and, if damage and fatalities were measured on a relative scale attached to warfare during that period, it was not an absolutely horrific event.

Guernica the event was front-page news for a matter of days.

Guernica the painting endures.

Picasso was not there, 'on the spot'. He learned about this 'atrocity' as most of us nowadays do, though journalists' reports. His painting does not disguise that source of information, with its mono-chrome overtone and suggestions of newsprint. At the time when this news came, Picasso was preparing to paint a picture for display in the Spanish hall of the International Exposition at Paris in 1937. It was going to be a more or less typical subject of the artist in that period, a subject that would have had the approval of Picasso's friend

174–176
STUDIES FOR GUERNICA
Pablo Picasso, 1937

Picasso made (and kept) numerous preparatory sketches for the Guernica canvas, each meticulously dated (though the titles here are provisional). Set out here, in chronological order: *Horse*, 1 May 1937 (IV); *Head of Horse*, 2 May 1937 (II); *Head of Weeping Woman*, 24 May 1937.

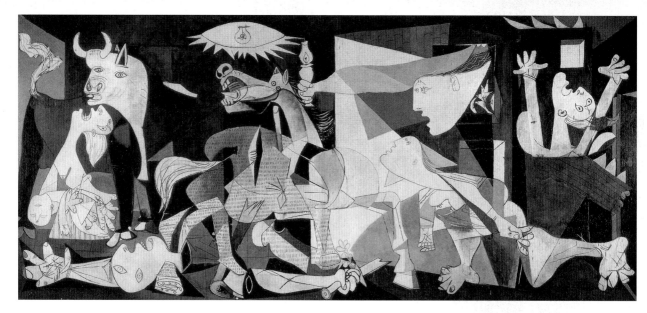

177 GUERNICA
Pablo Picasso, 1937

Made for the Spanish pavilion
of the 1937 International
Exposition in Paris, on behalf
of the Spanish Republic,
but only 'repatriated' to
Spain in 1981.

Matisse: 'a peaceful studio scene', we learn, 'with artist and reclining nude model' – *bonheur de vivre*, and all that.

Guernica appeared instead: and the official German guidebook to the Paris Exposition duly noted one clumsily large painting in the Spanish section which a four-year old child could have painted.

Just so, perhaps. For Picasso was, if anything, too skilled a draughtsman to accommodate what he had learned of events at Guernica. The Parisian left-wing broadsheet *L'Humanité* carried images of victims and ruins that were graphic enough. Within days of seeing them, Picasso, as we would say, went back to the drawing-board.

He was trained as an artist; he knew his craft, and the work of his predecessors, and there was no way of ridding his mind of that. Analysts and commentators have played a tireless game with *Guernica* as it finally appeared, guessing Picasso's debts within the Western tradition (many of the paintings discussed in this book are reckoned to have influenced the work). But to mark Guernica the event, Picasso began to draw as if he were at the beginning of art, like a child; he tried to unteach himself.

A horse, a concept of horse, C for *caballo*: four-legged, with a tail and a mane; eats grass (174).

A horse hit by a bomb. How would it whinny and turn? (175).

And people. People when they are maimed are literally disfigured, and that is that. And people when they grieve cannot control the muscles around the face. They slide, squirm, shade and twitch.

So we make a mess of ourselves (176).

It has happened before. In our time – under the glare of electric light – it happens again.

Coda

In the end . . .

In the end what rides over all is the remorseless
iconoclasm of reality. Nothing prepares us
for the assaults on our flesh when they
come, and images of suffering are what
they are: beyond first aid. At an
image's remove, what can we do
for the man dressed in barbs,
or for the child who is
napalm-ablaze? And yet
we shall go on as if
we were sustained
by what we
have seen

REFERENCES AND SUGGESTIONS FOR FURTHER READING

The following bibliography – to borrow a phrase of Evelyn Waugh's – 'is not intended as a display of industry nor as a guarantee of good faith'. It supplies as many of my incurred debts as I can remember, plus recommendations of such books and articles as I have read, or would wish to read. References follow the lines of argument as they unfold in each chapter. Some texts only given a mention in the main narrative are cited more expansively here. Translations are my own unless otherwise indicated.

There remain several books which informed the conception and shaping of this one in a near parental way. In the beginning was Primo Levi's final account of Auschwitz, as meditated in *I sommersi e i salvati* (Turin 1986: translated as *The Drowned and the Saved*, New York and London 1988). The moral precision and candour of Levi's recollections still seem to me matchless, amid so much (and why not?) 'Holocaust literature'. Then there was the cursive but considered essay by John Keane, *Reflections on Violence* (London and New York 1996); a set of lectures by A.D. Nuttall, published as *Why Does Tragedy Give Pleasure?* (Oxford 1996); and finally, Jonathan Glover's *Humanity: A Moral History of the Twentieth Century* (London 1999), whose tenor and reasoning prove that the words 'trenchant' and 'liberalism' can be yoked together.

PRELUDE

p. 6 Anthropologists and the tribe without sympathy
The investigation of the Ik people is related in Colin Turnbull's *The Mountain People* (New York 1972; reissued, London 1994). Turnbull's account of 'the end of goodness' among the Ik – a small, isolated tribe, scavenging existence in northern Uganda – was so dramatic that it was indeed dramatized (by Peter Brook). For use of the study in a recent sociological survey of compassionate routines, see C. Clark, *Misery and Company: Sympathy in Everyday Life* (Chicago 1997).

It should be clear from the moral I draw from Turnbull's observations that this single and parochial example of pity's

abeyance is not a matter of ethnicity, less still 'primitivism'. A similar caveat is made by E. Valentine Daniel when introducing his essays about the phenomenon of 'ethnic' violence in Sri Lanka, *Charred Lullabies* (Princeton 1996). There is not, he argues, any such thing as an 'ethnography of violence'; since all humans are susceptible to the eddies of attack and revenge, we must speak instead of an 'anthropography of violence'.

p. 7 Newshounds seeking carrion
This, too, has its scholarly literature – e.g. J. Taylor, *Body Horror: Photojournalism, Catastrophe and War* (Manchester 1998). But whether press coverage of terrible events causes more indifference than concern is yet unclear, as is implicit in both the title and text of B. Zelizer's *Remembering to Forget: Holocaust Memory through the Camera's Eye* (Chicago 1998).

1 STEPPING WORSTWARDS

p. 14 *Alle Kultur nach Auschwitz ... ist Müll.*
Adorno's phrase may be too often and too loosely bandied – as implied by S. Jarvis, *Adorno: A Critical Introduction* (Cambridge 1998), 1 – but its force as an epitome remains. The prohibition of 'poetry after Auschwitz' appears at the end of Adorno's 1949 essay 'Kulturkritik und Gesellschaft' ('Cultural Criticism and Society'), which emerged, in English, as part of *Prisms* (London 1967). Further citations of Adorno in this chapter come from his *Minima Moralia*, translated by E.F.N. Jephcott (London 1974): 'There is nothing innocuous left ...', 25; 'Anyone wishing to find the *Fledermaus* beautiful ...', 223; and *Negative Dialectics*, translated by E.B. Ashton (London 1973) – 'Perennial suffering has as much right to expression ...', 362.

Adorno was capable of understating his case, as when he comments: 'Hegel's thesis that art is consciousness of plight has been confirmed beyond anything he could have envisioned'. See T.W. Adorno, *Aesthetic Theory* ed. G. Adorno and R. Tiedemann (Minnesota and London 1997), 18. But generally he remained reluctant to soften the message of 'no poetry after Auschwitz': he openly

scorned, for example, the 'Death-Tango' sequence of Paul Celan (as noted in J. Felstiner, *Paul Celan: Poet, Survivor, Jew* [Yale 1997], 225).

Echoes of Adorno's stance (and phraseology) are too many to itemize. The following is typical enough: 'Auschwitz is very precisely ... the useless residue (*le déchet*) of the Western idea of art, that is to say, of *techne*': P. Lacoue-Labarthe, *Heidegger, Art and Politics* (Oxford 1990), 46.

Robert Nozick's likening of the Holocaust to the Fall of Man comes in his musings on *The Examined Life* (New York 1989), 237-38. Beyond Primo Levi's own account and analysis of what happened at Auschwitz, a number of biographies of Levi have begun to appear. I have used Myriam Anissimov's *Primo Levi ou la tragédie d'un optimiste* (Paris 1996: translated as *Primo Levi: Tragedy of an Optimist* [London 1998]), which will not be the last word, but which tries to collate Levi's record with the memoranda of other survivors.

p. 17 'Post-Auschwitz *homo sapiens*'
George Steiner's phrase comes in the course of his various essays on *Language and Silence* (London 1967). The observation that 'no one wrote tragedies in the extermination camps' also comes from Steiner, and is lodged at the end of his essay, 'Tragedy, Pure and Simple', in M.S. Silk ed., *Tragedy and the Tragic* (Oxford 1996), 534-46. Oscar Wilde's declaration of art's uselessness is the last line of the preface to his 1891 novel, *The Picture of Dorian Gray*; Schiller's line about the restorative powers of art comes from his epistolary essay *Über die ästhetische Erziehung des Menschen* (On the Aesthetic Education of Mankind, 1795), specifically letter no. 9. There is an annotated and translated edition of these letters by E.M. Wilkinson and L.A. Willoughby (Oxford 1967).

p. 18 *Entartete Kunst*
On the overweening cultural ambitions of the National Socialists, see J. Fest, *The Face of the Third Reich* (New York 1970: I have quoted from p. 225); J. Petropoulos, *Art as Politics in the Third Reich* (North Carolina 1996), also has pertinent material and comment. Probably the handiest introduction to the 'Degenerate Art' fiasco (as it surely was) is given in Berthold Hinz's

contribution to the exhibition catalogue, edited by D. Ades *et al.*, *Art and Power* (London 1995), 330-33; otherwise see P.K. Schuster ed., *Nationalsozialismus und 'Entartete Kunst'* (Munich 1987).

p. 19 'Masterpieces' in Madrid
The caption to Brueghel's *Triumph of Death* carries the phrase 'secular apocalypse', which derives from the discussion of the painting in W.S. Gibson, *Pieter Brueghel the Elder: Two Studies* (Kansas 1991), 53-86.

Tolstoy's furious insistence upon art's eirenic *raison d'être* is contained in his 1898 essay, *What Is Art?* (ed. R. Peaver, Harmondsworth 1995).

The reception of 'Las Meninas' down the ages is carefully charted in C. Kesser, *Las Meninas von Velázquez* (Berlin 1994).

Note on the meaning of words (i)
The passage is taken from Milan Kundera's novel entitled in English *The Unbearable Lightness of Being* (London and New York 1984), 19-20.

Kundera's statement may owe some of its force to earlier meditations on the power of compassion, notably Schopenhauer's analysis of *Mitleid* in his 1818 treatise known as *The World as Will and Idea*. See the use of this in the biologist George Klein's essay 'Pietà', in G. Klein, *Pietà* (MIT 1992), 253-88.

2 THE AUDITION OF LAOCOON'S SCREAM

p. 25 The Laocoon Group as icon of pathos
The 'typical reaction' quoted here is from Dr John Moore's *View of Society and Manners in Italy* (London 1781), Letter 46. The art-historical rationalization of the emblematic effect of the Laocoon – the statue acting as an almost Pavlovian trigger of response – was made by Aby Warburg, with his notion of a 'pathos formula' (*Pathosformel*: see pp. 118-19).

Charles Darwin, in Ch. VII of his 1872 monograph on *The Expression of the Emotions in Man and Animals*, observes that severe distress is signalled by wrinkles that gather in the middle of the forehead, rather than traverse (as with Laocoon) the entire breadth of the brow (an observation first made, as Darwin notes, by the French physiognomist Duchenne de Boulogne, in 1862).

p. 25 Winckelmann, Sadoleto and Laocoon's 'sigh'
Literary reactions are collected in M. Bieber, *Laocoon: The Influence of the Group Since its Discovery* (Detroit 1967): for Sadoleto's ekphrasis, see pp. 13-15. The text of Winckelmann's response from which I have cited perhaps deserves fuller quotation here:

'As the sea-bed lies peaceful beneath a foaming surface, so a great soul rests sedate beneath the strife of passions in Greek figures.

This soul shines out in the face of Laocoon, and not only in the face, in the midst of his most agonized sufferings. Pain invades every muscle and sinew of his body; we have only to gaze at the terribly twisted torso virtually to feel that pain contagious, let alone the face and other parts. But that pain, as I see it, does not assert itself as true vulnerability in Laocoon's features and posture. He lets out no heaven-rending scream, like Virgil's Laocoon: that is not what his gaping mouth yields. It is rather an anxious, heavy-burdened sigh, the groan described by Sadoleto. The pain of the body and the greatness of the soul [*der Schmerz des Körpers und die Grösse der Seele*] are opposed throughout the construction of the figure, indeed creating its balance. Laocoon suffers, but he suffers like the Philoctetes of Sophocles: his misery cuts us to the quick, but we yearn for the hero's exemplary strength to endure it.'

J.J. Winckelmann, *On the Imitation of the Painting and Sculpture of the Greeks*, IV (1755).

For Winckelmann's effect upon aesthetic discourse in Germany, see S. Richter, *Laocoon's Body and the Aesthetics of Pain: Winckelmann, Lessing, Herder, Moritz, Goethe* (Wayne State 1992); and further nuanced discussion in Richard Brilliant's *My Laocoon* (California 2000).

p. 26 Pliny and the Laocoon
I follow here the logic established in J. Isager, *Pliny on Art and Society* (London and New York 1991), 168-74. The state of scholarly speculation on this and other Laocoon problems may be measured from R.R.R. Smith's review of B. Andreae,

Laokoon und die Gründung Roms (Mainz 1988) in *Gnomon* 63 (1991), 351-58.

p. 27 Palaeolithic pacifism
The apparent tranquillity of vision and existence reflected in prehistoric cave-paintings is exaggerated – scenes of hunting and mortal combat are not unknown – but we may allow G.K. Chesterton his rhetorical point, as made in the title essay of *The Everlasting Man* (London 1925).

p. 27 Egyptian 'clichés of desolation'
The scenes of mourning in the Royal Tomb at Amarna were recorded by a French Egyptologist (U. Bouriant) towards the end of the nineteenth century; they have subsequently deteriorated beyond much recognition, though an outline of their original quality is evident from illustrations in Vol. 2 of G.T. Martin, *The Royal Tomb at El-'Amarna* (London 1989). (I am grateful to Barry Kemp for help here.)

The iconography of grieving in Egyptian art is surveyed in M. Werbrouck, *Les Pleureuses dans l'Égypte ancienne* (Brussels 1938).

p. 29 Greek epic and 'pathos'
Simone Weil's essay 'The Iliad, Poem of Might' was composed in Paris during 1939–40. It is translated and reprinted in her *Intimations of Christianity Among the Ancient Greeks* (London 1987), 24-55. For 'the fall of Troy as the first great metaphor of tragedy', see G. Steiner, *The Death of Tragedy* (London 1961), 5.

I mention Sophocles' *Philoctetes* in passing: it ought to be acknowledged here as a thematically peculiar tragedy, whose extraordinary force was elegantly outlined by Edmund Wilson ('Philoctetes: The Wound and the Bow', in *The Wound and the Bow*, London 1952, 244-64). The 'centre stage' domination of a 'howling and malodorous hero' is explored in G.W. Bowersock, *Fiction as History: Nero to Julian* (California 1994), 55-76.

p. 30 Timanthes' Iphigeneia
Whether Timanthes showed discretion or simply accepted graphic failure in attempting to depict the extremities of grief was a matter of debate even in antiquity. For that debate, and its subsequent history, see J. Montagu, 'Interpretations of Timanthes' *Sacrifice of Iphigeneia*', in J. Onians ed., *Sight and Insight* (London 1994), 305-19;

also T. Crow, *The Intelligence of Art* (North Carolina 1999), 81-93.

p. 31 Lessing and the limits of art
The text of Lessing's 1766 essay is given with full annotation in G.E. Lessing, *Laokoon*, ed. D. Reich (Oxford 1965).

p. 31 Hellenistic sculpture
as heroically pathetic
See A.F. Stewart, *Greek Sculpture: An Exploration* (Yale 1990), 185; R.R.R. Smith, *Hellenistic Sculpture* (London 1991), 108.

p. 32 Pity and the Greek philosophers
Plato's attitude concerning the effeminacy of grief – expressed, for example, in his *Republic*, 605d-606b – was not eccentric: see K.J. Dover, *Greek Popular Morality in the Time of Plato and Aristotle* (Oxford 1974), 167-69. Plato's suspicion that tragic drama fortifies the human 'weakness' for pity (including self-pity) was more curious, and is discussed in T. Gould, *The Ancient Quarrel between Poetry and Philosophy* (Princeton 1990), Chs. 4, 6, 8; see also M. Nussbaum, 'Tragedy and Self-Sufficiency: Plato and Aristotle on Fear and Pity', in *Oxford Studies in Ancient Philosophy* 10 (1992), 107-59; and S. Halliwell, 'Plato's Repudiation of the Tragic', in M.S. Silk ed., *Tragedy and the Tragic* (Oxford 1996), 332-49.

'All that men fear in regard to themselves excites their pity when it happens to others.' Aristotle's definition of pity – gainsaying La Rochefoucauld's dictum that '*dans l'aversité de nos meilleurs amis, nous trouvons toujours quelque chose qui ne nous déplaît pas*' – is also echoed in his *Poetics* (1453a): an exposition of which is to be found in S. Halliwell, *Aristotle's Poetics* (London 1986), 174-84. The literature on the purpose of *catharsis* is large, as may be gathered from modern contributions to the subject, such as W.B. Stanford, *Greek Tragedy and the Emotions* (London 1983), or E.S. Belfiore, *Tragic Pleasures: Aristotle on Plot and Emotion* (Princeton 1992).

p. 32 Sophoclean Laocoon
Assembly and exegesis of the play's relics in R.C. Jebb and A.C. Pearson, *The Fragments of Sophocles* Vol. II (Cambridge 1917), 38-47; further on the myth, H. Kleinknecht, 'Laokoon', in *Hermes* 79 (1944), 66-111. That Laocoon is acting 'selfishly' is a concern attributed to one William Locke of Newbury by Dr Johnson's friend Mrs Piozzi, in her *Observations and Reflections*

(London 1789), 216. The notion is mentioned – dismissively – by Joshua Reynolds in *Discourses on Art* 10, 170: see R.R. Wark's edition of the *Discourses* (Yale 1975), 180.

p. 33 Epictetus, Epicurus *et al.*
As Elizabeth Carter notes in the Introduction to her *Epictetus* (London 1759), xxviii, the story of Epictetus calmly enduring torture was circulated as a paradigmatic explanation of the philosopher's lameness. The more prosaic of the supposed causes was rheumatism.

On Epicurean and Sceptic attitudes to the tolerance of pain, see M. Nussbaum, *The Therapy of Desire* (Princeton 1994). The phrase 'Even on the rack the wise man is happy' comes from Diogenes Laertius 10.118. For Cicero's engagement with the topic – '*Neglige dolorem*', 'Ignore pain' – see Book 2 of his *Tusculan Disputations*.

p. 34 Greek theatres adapted
for bloodsports
Examples are known from around the Greek world, and include such primary pan-Hellenic sites as Delphi. Perhaps the most fully documented is Corinth: see R. Stillwell, *Corinth II: The Theatre* (Princeton 1952), esp. 84-98.

Compare this comment on the staging of tragedies written for a Roman audience by Seneca: 'We need not take seriously the old arguments that the horror and bloodshed were unactable (e.g. Thyestes' feast in the *Thyestes*, the mutilated body of Hippolytus in the *Phaedra*) ... the public were used to such sights in the arena of Neronian Rome' (C.D.N. Costa, *Seneca* [London 1974], 99-100).

p. 35 'Fatal charades'
On the *spectacula* of Roman arenas, see K.M. Coleman, 'Fatal Charades: Roman Executions staged as Mythological Enactments', in *Journal of Roman Studies* 80 (1990), 44-73. An apologetic note is sounded in T. Wiedemann, *Emperors and Gladiators* (New York and London 1992), 128-64. Further discussion and bibliography in A. Futrell, *Blood in the Arena* (Texas 1997); also D.G. Kyle, *Spectacles of Death in Ancient Rome* (New York and London 1998); and (for the case of Nero), R.C. Beacham, *Power into Pageantry: Spectacle Entertainments of Early Imperial Rome* (Yale 1999), 197-254.

I have played upon the uncertain chronology of the 'Farnese Bull' statue as allowed in C. Kunze, *Der Farnesische Stier und die Dirkegruppe des Apollonios und Tauriskos* (Berlin 1998). That the Laocoon Group might belong to the time of Titus was suggested by Carl Robert: see his *Bild und Lied* (Berlin 1881), 192ff. Ernst Gombrich also apprehended some consonance between the Laocoon and Roman *spectacula*, as evident from his comment in the course of *The Story of Art* (12th ed., London 1972), 75: 'I cannot help suspecting sometimes that this was an art which was meant to appeal to a public which also enjoyed the horrible sights of the gladiatorial fights.'

Note on the body and soul (i)
There are a number of anecdotes relating to the spiritual resilience of philosophers in Classical antiquity. The tale of Anaxarchus is located around the time of Alexander the Great (mid-4th century BC), and given in the *Lives of the Philosophers* by Diogenes Laertius, 9.10.

3 TEL EST MON PARADIS

To this chapter one is obliged to add the self-exonerating authorial clause devised by John Donne in his essay upon suicide, *Biathanatos* (published in 1646, some decades after it was composed). In describing the apparent instances of mass suicide by the early Christians, Donne allows himself the phrase, 'the disease of headlong dying', but then adds: 'God forbid any should be so malignant, so to mis-interpret mee, as though I thought not *the blood of Martyrs to be the seed of the Church*, or diminished the dignity thereof; yet it becomes any ingenuity to confess, that those times were affected with a disease of this naturall desire of such a death; and that to such may fruitfully be applyed those words of the good B. *Paulinus, Athleta non vincit statim, quia exuitur: nec ideo transnatant, quia se spoliant.*' [A sentiment from St Paulinus of Nola which may be paraphrased: 'An athlete does not necessarily achieve victory, although he is stripped for the contest; nor do all swimmers make it to the far shore, however they are prepared for the plunge.'] (From *John Donne: Selected Prose*, chosen by E. Simpson [Oxford 1967], 32.)

p. 39 'Death as decoration'
in Roman mosaics
A phrase borrowed from Shelby Brown's
essay 'Death as Decoration: Scenes from
the Arena on Roman Domestic Mosaics',
in A. Richlin ed., *Pornography and
Representation in Greece and Rome* (New York
and Oxford 1992), 180-211 (whence also
the citation from Jocelyn Toynbee).
The mosaics from the 'Sollertiana Domus'
in El Djem are fully published in C. Dulière,
H. Slim et al., *Corpus des Mosaïques de Tunisie*
Vol. III, Thysdrus Fasc. I (Tunis 1996).

Note the remark of Keith Hopkins
regarding the Roman enjoyment of
gladiatorial sports: 'We are dealing
here, not with individual sadistic
psychopathology, but with a deep
cultural difference' (M.K. Hopkins,
Death and Renewal [Cambridge 1983], 29).
No amount of apologetics for the
practice of 'scapegoating' arena victims
as condemned criminals (hence *noxii*,
or *katadikoi*) can erase that difference.

p. 41 Athletes of God
The literature of martyrdom is a sprawling
and uneven terrain. The standard selection
of evangelizing narratives is given in
H. Musurillo, *The Acts of the Christian Martyrs*
(Oxford 1972). See also R. Lane Fox,
Pagans and Christians (Harmondsworth
and New York 1986), 419-92; and P. Brown,
The Body and Society (New York 1988),
65-82. To the narrative of W.H.C. Frend's
Martyrdom and Persecution in the Early Church
(Oxford 1965) should be added the urbane
perspective of G.W. Bowersock's
Martyrdom and Rome (Cambridge 1995),
where the peculiar nexus of martyrdom and
suicide is unpicked; and brief but mordant
commentary in M.K. Hopkins, *A World
Full of Gods* (London 1999), 111-23.

p. 41 Pliny and the Bithynian Christians
Text (Book 10.96) in A.N. Sherwin-White,
The Letters of Pliny (Oxford 1966), plus
Trajan's reply, with valuable commentary
and discussion, 691-712 and 772-87.

p. 41 Tertullian and the
'pharmacy' of martyrdom
For a trenchant edition and translation of
Tertullian's best-known broadside, see the
Apologeticus as annotated by J.E.B. Mayor
(Cambridge 1917). It should perhaps be
noted here that in his essay *De Spectaculis*
Tertullian offered an eventual bonus to
those who shared his disgust with the

arena. This was the pleasure of watching
the persecutors of Christians scourged
with eternal torment or cast to flames
(*ad flammas*) on Judgment Day. See T.D.
Barnes, *Tertullian* (Oxford 1971), 95-6;
and on the Second Coming as a highly
satisfying and vengeful crowd spectacle
for the pious, A.E. Bernstein, *The Formation
of Hell* (London 1993), 228-47.

p. 42 Stoics and the Christian martyrs
Galen's admiration (echoing that of
Epictetus) may be connected to the fact that
Stoics, too, suffered rounds of persecution:
see M. Sordi, *The Christians and the Roman
Empire* (London 1988); also J. Perkins, *The
Suffering Self: Pain and Narrative Representation
in the Early Christian Era* (London and New
York 1995), 19. In his *The Decline and Fall
of the Roman Empire*, Gibbon chips
a characteristically flinty epigram from
the attitude of Marcus Aurelius: 'Marcus
despised the Christians as a philosopher,
and punished them as a sovereign'
(ed. J.B. Bury [London 1896], Vol. ii, 109).

p. 44 *Misericordia* for
elephants in the arena
See Cicero, *Ad Familiares* 7.1.3; also reported
by Pliny, *Natural History* 8.21.

p. 44 *Mors turpissima crucis*
'For Paul and his contemporaries, the cross
of Jesus was not a didactic, symbolic or
speculative element but a very specific and
highly offensive matter which imposed a
burden upon the earliest Christian
missionary preaching.' For the elaboration
and documentation of this point,
see M. Hengel, *Crucifixion* (London and
Philadelphia 1977), 18ff.; its doctrinal
background is summarized by M.H.
Shepherd, Jr., 'Christology: A Central
Problem in Early Christian Theology and
Art', in K. Weitzmann ed., *Age of Spirituality:
A Symposium* (New York and Princeton
1980), 101-20. The modern theological
'classic' here is Jürgen Moltmann, *The
Crucified God: The Cross of Christ as the
Foundation and Criticism of Christian Theology*
(New York 1974); or readers might like to
follow the glorification of Christ crucified
as originally couched in the Fourth Gospel,
and expounded in the commentary of
John Marsh, *The Gospel of St John*
(Harmondsworth 1968). 'Blessed are those
who have not seen and yet believe,' the
'doubting' apostle Thomas was told (John
20.29): on the specifically iconographical

problem posed by the paradox of a 'living
corpse', see H. Belting, *Likeness and Presence*
(Chicago 1994), 269-71.

p. 45 St Paul's theology of the Cross
St Paul's visionary apprehension of the
Cross as central to faith is expressed most
candidly in his Letter to the Galatians
(I have quoted from 2.19-20). Of the
Synoptic gospels, Matthew (27.39-43)
seems most sensitive to the humiliation
attached to Christ's mode of execution,
but (like John, 19:28) also eager to gloss
the mockery by reference to Old Testament
prophecy, in particular Psalm 22 ('All they
that see me laugh me to scorn', etc.).
See M.A. Screech, *Laughter at the Foot
of the Cross* (London 1997), 28-32.

p. 46 'The earliest Christians
took little interest in art'
From S. Runciman, *Byzantine Style and
Civilization* (Harmondsworth 1975), 17.
For survey of 'earliest' and subsequent use
of symbols, and a succinct account of the
Iconoclasm episode, see J. Lowden, *Early
Christian and Byzantine Art* (London 1997).
It is also worth consulting F. van der Meer
and C. Mohrmann, *Atlas of the Early Christian
Church* (London 1959).

p. 52 Martyrdom of St Stephen
Byzantine hymn quoted in H. Maguire,
*The Icons of Their Bodies: Saints and Their
Images in Byzantium* (Princeton 1996), 60.

4 TEARS OF DEVOTION:
A MEDIEVAL GLOSSARY

The point of departure here was suggested
by the opening remarks on 'The Medieval
Aesthetic Sensibility' in Umberto Eco's
essay, *Art and Beauty in the Middle Ages* (Yale
1986). For Abbot Suger the standard edition
is E. Panofsky, *Abbot Suger on the Abbey Church
of St-Denis and its Art Treasures* (2nd ed.
by G. Panofsky-Soergel, Princeton 1979).
The 'opposition' of St Bernard is
summarized by Meyer Shapiro, 'On the
Aesthetic Attitude in Romanesque Art', to
be found in his *Romanesque Art: Selected Papers*
(London 1977), 1-27. For further
exploration of the issue, especially its
theological background, see C. Rudolph,
*Artistic Change at St-Denis: Abbot Suger's
Program and the Early Twelfth-Century
Controversy over Art* (Princeton 1990); also
various contributions to P.L. Gerson ed.,

Abbot Suger and Saint-Denis: A Symposium (New York 1986).

William Langland's appeal for frugality – 'the poorest folk are our neighbours, if we look around us' – appears in Text 'C' of *Piers Plowman*, Book 10, lines 71-97; here quoted as it appears in the translation and edition of J.F. Goodridge (Harmondsworth 1966), 260.

If I have characterized the Cistercians as austere with regard to decoration, then it is only fair to point out that their asceticism was in other respects distinctly humane – as indicated in Père Louis Bouyer's *La Spiritualité de Cîteaux*, translated as *The Cistercian Heritage* (London 1958), 123-60, on Aelred of Rievaulx and his positive evaluation of friendship and the passions.

For the nexus of Gothic style and Scholasticism – through the unity of a 'mental habit' – see E. Panofsky, *Gothic Architecture and Scholasticism* (Latrobe 1951). Otto Pächt's observation about the dominance of 'miraculous' subject-matter in medieval art is lodged in the translated edition of his *The Practice of Art History* (London 1999), 45.

On the medieval reception and generation of images relating to the Christian Passion, see H. Belting, *The Image and its Public in the Middle Ages* (New York 1990), and by the same author, *Likeness and Presence* (Chicago 1994); and for a microcosmic study of the visual culture of one medieval convent, J. Hamburger, *Nuns as Artists* (California 1997). The renewed availability of the work of Emile Mâle, the French scholar who did so much to illuminate the pieties behind medieval imagery, should also be mentioned: his cumulative studies of *L'art religieux ... en France* have been collected, in three volumes, as *Religious Art in France* (Princeton 1978–86).

Citations from Johan Huizinga are drawn from the translation of the second Dutch edition (1921) of his *Herfsttij der Middeleeuwen*, by R. Payton and U. Mammitzsch, entitled *The Autumn of the Middle Ages* (Chicago 1996): see esp. 220-33. For further contextual background, see R.N. Swanson, *Religion and Devotion in Europe c.1215–1515* (Cambridge 1995).

p. 57 Assisi
Much has been written on the Franciscan patronage and shaping of art in Italy; much is summarized and refined in A. Derbes,

Picturing the Passion in Late Medieval Italy (Cambridge 1996), subtitled 'Narrative Painting, Franciscan Ideologies, and the Levant' – though the connection of the *Christus Patiens* type with Byzantine precursors remains guesswork. The connection between the comforting 'familiarity' of Franciscan preaching and the 'realism' of Italian Renaissance narrative painting was fundamentally made by Henry Thode in his *Franz von Assisi und die Anfänge der Kunst der Renaissance in Italien* (Berlin 1885). For pictures and brief essay on the decoration of San Francesco – with firm claim for Giotto's own presence – see E. Lunghi, *The Basilica of St Francis at Assisi* (London 1996). On the Stigmatization image: C. Frugoni, *Francesco e l'invenzione delle stimmate: Una storia per parole e immagini fino a Bonaventura e Giotto* (Turin 1993).

G.K. Chesterton's monograph, *St Francis of Assisi* (London 1926), remains one of the most sympathetic of introductions to Franciscan piety.

p. 61 Black Death
Still valid: M. Meiss, *Painting in Florence and Siena after the Black Death* (Princeton 1951); for survey of subsequent debate, see H. van Os, 'The Black Death and Sienese Painting: a problem of interpretation', in *Art History* 4/3 (1981), 237-49. For Bartolo's cycle at San Gimignano (and typical qualms about the Meiss thesis) see C.K. Fengler, 'Bartolo di Fredi's Old Testament Frescoes in San Gimignano', in *The Art Bulletin 63* (1981), 374-84. Primo Levi's remarks on the paradigmatic value of the story of Job are attached to his personal anthology *La ricerca delle radici* (Turin 1981), 5. For the medieval 'art of dying' generally, see P. Binski, *Medieval Death: Ritual and Representation* (London 1996).

p. 63 *Christus Patiens*
For Bonaventure's Passional writings, see T. Bestul, *Texts of the Passion: Latin Devotional Literature and Medieval Society* (Philadelphia 1996). The 'Gothic' imagery of Christ's suffering amid the punishment of the Two Thieves is discussed in M.B. Merback, *The Thief, the Cross and the Wheel: Pain and the Spectacle of Punishment in Medieval and Renaissance Europe* (London 1999). It is still also worth consulting G. Francovich, 'L'origine e la diffusione del crocefisso gotico doloroso', in *Jahrbuch der Bibliotheca Hertziana* (or *Römisches Jahrbuch für Kunstgeschichte*) 2 (1938), 143-261.

p. 64 Crusades
J. Riley-Smith, *The First Crusaders, 1095–1131* (Cambridge 1997) gathers the fruits of recent research upon the circumstantial and ideological background of those who participated in the launch of the Crusading wars, though the author claims that most modern minds cannot hope to 'encompass' the yoking of piety and violence in the intentions of the Crusaders. I am grateful to Jonathan Riley-Smith for supplying me with the text of *La Chanson d'Antioche*: citations here are from stanza 9 in the edition by S. Duparc-Quioc (Paris 1976), 26.

The nexus of Jerusalem, Crusades and pilgrimage in the medieval imagination is explored in P. Alphandéry, *La Chrétienté et l'idée de croisade* (Paris 1954), Vol. I, 9-56.

On the element of Judeophobia in the Crusades, see R. Chazan, *In the Year 1096: The First Crusade and the Jews* (Philadelphia 1996); and on prevalent medieval European 'delusions' about Jewry, G.I. Langmuir, *Toward a Definition of Antisemitism* (California 1996). Identifying the Jewish figure at Autun: D. Grivot and G. Zarnecki, *Gislebertus: Sculptor of Autun* (London 1961), 27. There is more on anti-Semitism in Romanesque sculpture in H. Kraus, *The Living Theatre of Medieval Art* (London 1967), 139-62.

p. 67 Dante and the Damned
Modern scholarship on medieval eschatology is reflected in the essays collected by C.W. Bynum and P. Freedman eds., *Last Things: Death and Apocalypse in the Middle Ages* (Pennsylvania 1999). The iconography of the Damned is surveyed in M. Barasch, *Gestures of Despair in Medieval and Early Renaissance Art* (New York 1976), 1-56. The phrase describing Purgatory as 'blessedness within pain' comes from Paul Tillich: see the discussion of this in J. Macquarrie, *Principles of Christian Theology* (London 1966), 328-29. Dante's importance in defining Purgatory is duly hailed in J. Le Goff, *The Birth of Purgatory* (Chicago 1984), 334. On Dante's sense of pity – or rather its necessary evaporation – in the *Inferno*, the exegesis of Charles Williams is worth quoting: 'Pity is to become like the hard grey rock itself; nay, it is that, for the divine Compassion itself is now known only as rock. We have to imagine ourselves into that state where sin is, more and more terribly, merely sin. The punishments are, more and more clearly, simply the sin itself. This is the

steady exploration of the great Romantic vision betrayed: the damned, one may say, have passed beyond anything that can be humanly understood' (C. Williams, *The Figure of Beatrice* [London 1943], 137).

For the Arena Chapel, see G. Basile, *Giotto: The Arena Chapel Frescoes* (London 1993), 275-317. 'Giotto's great poem of the Redemption': phrase from A. Smart, *The Dawn of Italian Painting 1250–1400* (Oxford 1978), 49.

p. 71 *Decensus ad Infernos*
I have here overlooked the distinctions to be made between 'Hell' as 'the Underworld' (the Classical Hades) and 'Hell' as 'place of punishment' (the Hebrew Gehenna), simply because precise signposts were not commonly supplied to viewers of images 'describing' such posthumous destinations. For further discussion of beliefs and iconography, see P. Camporesi, *The Fear of Hell: Images of Damnation and Salvation in Early Modern Europe* (Oxford 1990; Pennsylvania 1991) and R. Hughes, *Heaven and Hell in Western Art* (New York 1968).

For Thomist thought about 'the power of the sword', see J.M. Finnis, *Aquinas: Moral, Political, and Legal Theory* (Oxford 1998), 275-93. Aquinas as sanction for Stauffenberg: P. Hoffmann, *Stauffenberg: A Family History, 1905–1944* (Cambridge 1995), 152.

p. 72 *Devotio moderna*
'Devotion is a certain tenderness of heart ...', cited in Huizinga *op. cit.*, 222. For a rather dull account of the movement at Deventer and elsewhere, see A. Hyma, *The Christian Renaissance: History of the 'Devotio Moderna'* (2nd ed. Hamden 1965). Its impact upon art is sufficiently demonstrated in Henk van Os et al., *The Art of Devotion in the Late Middle Ages in Europe 1300–1500* (London and Amsterdam 1994). See also A.A. MacDonald et al. eds., *The Broken Body: Passion Devotion in Late Medieval Culture* (Groningen 1998). Citations of Thomas à Kempis are drawn from the translation of the *Imitation of Christ, or The Ecclesiastical Music* by C. Bigg (London 1903).

For Dürer's conceit of Christlike self-portraits, see J.L. Koerner, *The Moment of Self-Portraiture in German Renaissance Art* (Chicago 1993), 241-42. The subject of Dürer and *homo melancholicus* was a pet topic of Erwin Panofsky's, most readily accessible in his monograph

The Life and Art of Albrecht Dürer (4th ed. Princeton 1955), 156-71.

p. 74 'Gastly Gladnesse'
(Alternatively transliterated as 'Ghostly Gladness'.) For Margery Kempe, see C.W. Atkinson, *Mystic and Pilgrim: The Book and the World of Margery Kempe* (Cornell 1983) and K. Lochrie, *Margery Kempe and Translations of the Flesh* (Philadelphia 1991). The references to Richard Rolle, 'Hermit of Hampole' (Hampole is in South Yorkshire) are taken from H.E. Allen's collection, *English Writings of Richard Rolle* (Oxford 1931). Allen dates the 'Gastly Gladnesse' meditation to 1343.

If links between South Yorkshire and Umbria were needed, Rolle's indebtedness to St Bonaventure is outlined in M. Deansley's edition of *The Incendium Amoris of Richard Rolle of Hampole* (Manchester 1915).

p. 75 *Lazaretti*
On the Chichester scenes, see G. Zarnecki, 'The Chichester Reliefs' in *Archaeological Journal* 110 (1954), 106-19; facsimile reprint as Ch. 12 of G. Zarnecki, *Studies in Romanesque Sculpture* (London 1979). For further discussion of the programme at Autun, see L. Seidel, *Legends in Limestone: Lazarus, Gislebertus, and the Cathedral of Autun* (Chicago 1999).

p. 76 *Mater Dolorosa*
The attribution of the *Stabat Mater* lyrics to Jacopone is not proven, but generally accepted. The theatrical ambience of Mary's lament is efficiently explored in S. Sticca, *The Planctus Mariae in the Dramatic Tradition of the Middle Ages* (Georgia 1988). I quote from a curious essay by Julia Kristeva first published in *Tel Quel* in 1976, in which Mary's sorrow is made pendant to Kristeva's own ordeal of giving birth: this is collected as 'Stabat Mater' in K. Oliver ed., *The Portable Kristeva* (Columbia 1997), 308-31; which in turn acknowledges a debt to M. Warner, *Alone of All Her Sex: The Myth and Cult of the Virgin Mary* (London 1976).

Distaste for Jacopone, and suspicion of visionaries both male and female, is rife in the passing remarks of G.G. Coulton's edition of the writings of a thirteenth-century Franciscan friar called Salimbene, *From St Francis to Dante* (London 1906). Coulton was a Puritan, and made little attempt to disguise the fact.

p. 79 Minutiae:
the *Meditationes Vitae Christi*
See the sample French edition of the text presented as *Meditations on the Life of Christ: An Illustrated Manuscript of the Fourteenth Century*, translated by I. Ragusa and edited by I. Ragusa and R.B. Green (Princeton 1961). A measure of the influence of the *Meditationes* upon artists may be gauged from the Passion-tableaux included among the devotional effigies for the Sacro Monte shrine at Varallo in Piedmont: see A. Nova, '"Popular" art in Renaissance Italy: Early Response to the Holy Mountain at Varallo', in C. Farago ed., *Reframing the Renaissance: Visual Culture in Europe and Latin America* (Yale 1995), 112-26.

p. 79 Mystics
Making Mary Magdalene's exclamation the 'key text' of mysticism follows Michel de Certeau, who would extend that phrase, 'I do not know where they have put Him', to underpin the entire structure of 'apostolic discourse'. In De Certeau's words: 'an initial privation of body goes on producing institutions and discourses that are the effects of and substitutes for that absence'. See his (unfinished) project *The Mystic Fable* (Chicago 1992), 81-2.

The illumination of the body as the mystic's 'instrument' comes from Caroline Bynum: I quote from p. 194 of her essay 'The Female Body and Religious Practice in the later Middle Ages', in *Fragmentation and Redemption: Essays on Gender and the Human Body in Medieval Religion* (New York 1991), 181-238. See also further explorations by the same author in *Jesus as Mother* (California 1982).

The characterization of Dame Julian's *Showings* as 'an artless masterpiece' comes from David Knowles: the entirety of his *The English Mystical Tradition* (London 1961) illuminates. I have also drawn upon the exposition of F.C. Bauerschmidt, 'Julian of Norwich – Incorporated', in *Modern Theology* 13 (1997), 75-100. For the 'intimacy' of Julian's style, see D.N. Baker, *Julian of Norwich's Showings: From Vision to Book* (Princeton 1994), 49. The standard text is E. Colledge and J. Walsh eds., *A Book of Showings to the Anchoress Julian of Norwich* (2 vols., Toronto 1978).

p. 81 'Perpetual Passion'
For this section generally I am indebted to an essay on Bosch's 'Christ Carrying the Cross' by Gordon Marsden in *History Today*,

April 1997, 15-21. The citation from Margery Kempe is adapted from section 72a of *The Book of Margery Kempe*, as rendered by W. Butler-Brown (London 1936), 222-23. The violence of German and Netherlandish tracts descriptive of the Mocking of Christ is documented in J.H. Marrow, *Passion Iconography in Northern European Art of the Late Middle Ages and Early Renaissance* (Kortrijk 1979).

p. 83 Pilgrimage

This short note lifts an apophthegm from an anthropological study by V. and E. Turner, *Image and Pilgrimage in Christian Culture* (Oxford 1978), 7. For a general sketch, see S. Coleman and J. Elsner, *Pilgrimage* (London 1995), esp. 78-117; and on the importance of miraculous traditions to pilgrim routes, B. Ward, *Miracles and the Medieval Mind* (Aldershot 1987), 110-26. The piquant analysis of J.J. Jusserand, *English Wayfaring Life in the Middle Ages*, first published in 1889, remains valuable: see Ch. 3 of Part III (192-240 of the Methuen edition of 1961).

In the twelfth century the clergy at Compostela compiled a hefty *vademecum* for the cult of St James: part of this *Liber sancti Jacobi* ('Book of St James') has been made available by A. Stones *et al.* eds., *The Pilgrim's Guide: A Critical Edition* (2 vols., London 1999).

The documents related to the cult of Ste Foy at Conques have been translated in a useful edition by P. Sheingorn as *The Book of Sainte Foy* (Philadelphia 1995). In my description of the 'Doom' on the portal-tympanum of the Conques church I have echoed a passage from Freda White's *Three Rivers of France* (London 1952), 92.

5 VASARI AND THE PANGS OF ST SEBASTIAN

The story of Bonsignori and the duke is to be found in Part III of Vasari's *Lives of the Painters, Sculptors and Architects*, under 'Di Fra Giocondo, di Liberale e di altri veronesi'. In the Everyman Edition translated by de Vere and edited by David Ekserdjian (London 1996) the story appears in Vol. 2, 28-9. (I am indebted to David Ekserdjian for first drawing my attention to this story.) The iconography of St Sebastian has received little specialized attention since D. von

Hadeln, *Die wichtigsten Darstellungen des h. Sebastian in der italienischen Malerei bis zum Ausgang des '400* (Strasbourg 1906).

p. 88 Mantegna's St Sebastians

J.G. Caldwell – see *Journal of the Warburg and Courtauld Institutes* 36 (1973), 373-77 – abstracts Mantegna's general intention from the Latin tag unfurled in the Venice painting: to depict Sebastian as *stabilitas* or even obduracy personified. It has been attractively suggested that this canvas served as 'a Christian pendant' to Mantegna's *Triumph of Caesar* series: see E. Tietze-Conrat, *Mantegna* (London 1950), 199.

For the possibility that Mantegna modelled the facial expressions of his Sebastians on antique tragic masks, see M. Barasch, *Imago Hominis* (Vienna 1991), 66-7. A speculative iconology of the Vienna *operetta* is given by M. Levi D'Ancona, 'An Image Not Made by Chance: The Vienna St Sebastian by Mantegna', in I. Lavin and J. Plummer eds., *Studies in Late Medieval and Renaissance Painting in Honor of Millard Meiss* (New York 1977), 98-114.

p. 90 Vasari's St Sebastian

A pen and ink drawing in the Louvre, attributed to Vasari, looks very much as though it is intended to represent the saint's fatal flogging before an enthroned emperor: see P. Jacks ed., *Vasari's Florence* (Cambridge 1998), 93.

p. 91 Antonello's St Sebastian

Samuel Beckett's admiration for the Dresden painting is noted in J. Knowlson, *Damned to Fame: The Life of Samuel Beckett* (London 1996), 253 and 752 n. 146. See also D. Arasse, 'Le corps fictifs de Sébastien et le coup d'oeil d'Antonello', in *Le corps et ses fictions* (Paris 1983), 55-72.

p. 91 Symonds on Il Sodoma's St Sebastian

J.A. Symonds, *The Renaissance in Italy* (London 1877), 500-1. Elsewhere Symonds – himself a tortured English homosexual 'liberated' by Italy – defines the particularly carnal appeal of Sodoma's figure by describing it as 'hermaphroditic': see his *Life of Michelangelo* Vol. I (London 1893), 274.

p. 91 Clark on Piero's St Sebastian

K. Clark, *Piero della Francesca* (2nd ed. London and New York 1969), 25.

p. 92 St Sebastian and the Plague

See discussion of Giovanni del Biondo's altarpiece for the Florence Duomo, in Diana Norman's essay 'Change and Continuity: Art and Religion after the Black Death', in D. Norman ed., *Siena, Florence and Padua: Art, Society and Religion 1280–1400* Vol. I (Yale and Open University 1995), 177-95.

The most complete contrast to Del Biondo's 'hedgehog' Sebastian is perhaps to be located in several versions of the subject by Van Dyck, where arrows are altogether eschewed; see J.R. Martin, 'Van Dyck's Early Paintings of St Sebastian', in M. Barasch and L.F. Sandler eds., *Art the Ape of Nature* (New York 1981), 393-400.

p. 94 Painters and public executions

In his gallery-folio entitled *Torment in Art: Pain, Violence and Martyrdom* (New York 1991), Lionello Puppi argues that European painters between 1400 and 1800 would have had virtual 'familiarity' with certain modes of execution, including hanging, decapitation, drawing and quartering, and bone-breaking (see also notes to Ch. Four). A similar taste for 'realism' in pictures of violent death – no less than a 'Cinquecento lust for human dismemberment' – is documented by S.Y. Edgerton, Jr., in his *Pictures and Punishment: Art and Criminal Prosecution during the Florentine Renaissance* (Cornell 1985), whence reference to the story of Gentile Bellini and the Sultan's slave (152, n. 138).

p. 95 Parrhasius and the Olynthian

The credibility of Seneca's tale is expressly challenged by the editor of the Loeb edition of the *Controversiae* (Michael Winterbottom). For further discussion and exposition of its importance, however, see H. Morales, 'The Torturer's Apprentice: Parrhasius and the Limits of Art', in J. Elsner ed., *Art and Text in Roman Culture* (Cambridge 1996), 182-209 – whence (209) the description of Parrhasius as 'an anti-artist'. On the development of this tale as a trope in the later historiography of artistic eccentricity or mania, see E. Kris and O. Kurz, *Legend, Myth, and Magic in the Image of the Artist* (Yale 1979), 118-19.

p. 96 The bull of Phalaris

The story of Perillus and his bronze bull for Phalaris, the tyrant of Agrigento, is told in a number of Classical sources, including Ovid (*Tristia* III.xi, 39-54) and Valerius Maximus (*Nine Books of Memorable Deeds and*

Sayings, IX.ii, 9); Pliny's allusion to it comes in his Natural History 34.89. Dante makes indirect reference to the fate of Perillus in Canto XXVII of the Inferno, lines 7-12.

p. 97 Vasari's frescoes for the Sala Regia

The Massacre scene is largely neglected in Paola Barocchi's 'complete works' of Vasari Pittore (Milan 1964). For an annotated sketch of the paintings and their patronage, see J.L. de Jong, 'Papal History and Historical Invenzione: Vasari's Frescoes in the Sala Regia', in P. Jacks ed., Vasari's Florence (Cambridge 1998), 220-37, where it is concluded that 'the message of the scenes belongs too strongly to its own era to have much appeal for modern audiences'. More pointedly, Philipp Fehl has argued that Vasari's artistic mediocrity here is compounded by acute moral myopia: see P. Fehl, 'Vasari's "Extirpation of the Huguenots": The Challenge of Pity and Fear', in Gazette des Beaux-Arts 84, 257-84.

p. 98 The Golden Legend

W.G. Ryan's two-volume The Golden Legend: Readings on the Saints (Princeton 1993) provides a complete translation of the text as established by Graesse in 1845. (St Sebastian will be found in Vol. I, 97-101.) The three-volume edition of Emile Mâle's Religious Art in France (Princeton 1978–86) has already been noted: Mâle's reference to the Légende dorée as a generic explanation of French medieval art should be understood passim; see also his The Gothic Image (New York 1972), 273.

On the fortunes of the book itself: S.C. Reames, The Legenda aurea: A Reexamination of its Paradoxical History (Wisconsin 1985), and G.P. Maggioni, Ricerche sulla composizione e sulla trasmissione della 'legenda aurea' (Spoleto 1995).

p. 99 The sexy St Sebastian

Vasari's note about Fra Bartolommeo's sin-provocative St Sebastian is to be found in Vol. I of the Everyman Lives, 676. The citations of Yukio Mishima are from his autobiographical novel Kamen no Kokuhaku (1949), translated as Confessions of a Mask (Peter Owen, London 1998). For Mishima's mimesis of the Reni image, see R.E. Spear, The 'Divine' Guido: Religion, Sex, Money and Art in the World of Guido Reni (Yale 1997), 67-76. As Spear notes, Mishima's was not the first gay salutation

of Reni's painting in Genoa: Oscar Wilde also adored it (R. Ellmann, Oscar Wilde [London 1987], 68).

6 THIS IS MY BODY

p. 101 Holbein's Christ as 'blasphemy'

'It is distressing to see that even Holbein could, without a shock of horror, present to the world so ghastly and irreverent a mockery as his "Dead Christ" in the Basle Museum. It is a dead body outstretched at full length; the limbs attenuated, the mouth horribly open; the lank, meagre hair streaming backwards, the eyes unclosed, the details revoltingly realistic, evidently a nude study from the corpse of a drowned man. Yet Holbein thinks to turn this offensive horror into a solemn religious picture by inscribing above it, "Jesu, Nazarenus, Rex Judaeorum!" [sic]. It is only less offensive than Castagno's because it is not livid: but that it should have been held permissible, and even laudable, to paint such pictures, should furnish a solemn warning to the daring irreverence of Art, and the erringly morbid thoughtlessness of professedly devotional thought.' (From Dean Farrar, Christ in Art [London 1894], 426.)

More sober assessment of 'secular' intentions on Holbein's part is given in A. Woltmann, Holbein and His Time (London 1872), 132-33. The concept of the painting as part of an altarpiece – so envisaged in P. Ganz, Holbein (London 1950), 219 – is now generally dismissed.

p. 102 Dostoevsky in the Basel Museum

His wife leaves it unclear how far Holbein's painting brought on an epileptic attack in Dostoevsky as viewer: see Anna Dostoevsky, Reminiscences, trans. B. Stillman (London 1976), 133-34; and J. Frank, Dostoevsky: The Miraculous Years 1865–1871 (Princeton 1995), 220-21. For the symbolic place of the Holbein image in the narrative of The Idiot, see J. Meyers, Painting and the Novel (Manchester 1975), 136-47. Dostoevsky's credo that 'Christ redeems mankind with his beauty' (following J. Meier-Graefe, Dostoevsky: The Man and His Work [London 1928], 147) is deduced from a ringing declaration in a letter to his niece Sofia Alexandrovna, dated New Year's Day, 1868: 'There is in the world only one figure of absolute beauty:

Christ.' (Letters of Fyodor Michailovitch Dostoevsky, trans. E.C. Mayne [London 1914], 142).

For the practice of Russian icon-painters eschewing ostentatious pain in devotional images, see L. Ouspensky and V. Lossky, The Meaning of Icons (New York 1982), 27.

p. 103 'Metaphor of severance'

See J. Kristeva, Soleil Noir (Paris 1987), Chs. 5 and 7; also Fragments for a History of the Human Body, ed. M. Fisher (New York 1989) Vol. 1, 238-69.

p. 106 Indulgences (abuse of)

The background to Luther's revolt is summarized by B. Moeller, 'Religious Life in Germany on the Eve of the Reformation', in G. Strauss ed., Pre-Reformation Germany (London 1972), 13-42.

p. 108 'Christian paganism' and 'Erasmian art'

The former phrase was coined by Fritz Saxl: see his essay 'Holbein and the Reformation' in Lectures (London 1957), 277-85; the latter is used in O. Bätschmann and P. Griener, Hans Holbein (London 1997), 88ff.

p. 108 Erasmus on religious images

See R.H. Bainton, Erasmus of Christendom (London 1970), 285; also D. Freedberg, 'Johannes Molanus on Provocative Paintings', in Journal of the Warburg and Courtauld Institutes 34 (1971), 229-45 (esp. 240-43). Luther's ambivalence regarding images is explored in S. Michalski, The Reformation and the Visual Arts: The Protestant Image Question in Western and Eastern Europe (London and New York 1993).

p. 109 Luther's kenotic theology

The essential Pauline text for kenosis is Philippians 2.6-8: '[Christ Jesus], subsisting in the form of God, did not think to vaunt equality with God; rather he emptied himself [eauton ekenosen], and took the form of a slave. So he assumed the likeness of humanity, and in human likeness he humbled himself and became obedient unto death – even death on a cross.'

The timbre of Luther's preaching of this theme may be gauged from the following excerpt from his Meditation on Christ's Passion, 1519:

'If pain or sickness afflicts you, consider how paltry this is in comparison with the thorny crown and the nails of Christ. If you are obliged to do or to refrain from doing things against your wishes, ponder how Christ was bound and captured and led hither and yon. If you are beset by pride, see how your Lord was mocked and ridiculed along with criminals. If unchastity and lust assail you, remember how ruthlessly Christ's tender flesh was scourged, pierced, and beaten. If hatred, envy and vindictiveness beset you, recall that Christ, who indeed had more reason to avenge himself, interceded with tears and cries for you and for all his enemies. If sadness or any adversity, physical or spiritual, distresses you, strengthen your heart and say, "Well, why should I not be willing to bear a little grief, when agonies and fears caused my Lord to sweat blood in the Garden of Gethsemane? He who lies abed while his master struggles in the throes of death is indeed a slothful and disgraceful servant."

So then, this is how we can draw strength and encouragement from Christ against every vice and failing. That is a proper contemplation of Christ's passion, and such are its fruits. [...]

Those who thus make Christ's life and name a part of their own lives are true Christians. St Paul says, "Those who belong to Christ have crucified their flesh with all its desires." Christ's passion must be met not with words or forms, but with life and truth. Thus St Paul exhorts us, "Consider him who endured such hostility from evil people against himself, so that you may be strengthened and not be weary at heart." And St Peter, "Since therefore Christ suffered in the flesh, strengthen and arm yourselves by meditating on this." However, such meditation has become rare, although the letters of St Paul and St Peter abound with it. We have transformed the essence into semblance and painted our meditations on Christ's passion on walls and made them into letters.'

Translation by M.H. Bertram, in Vol. 42 of *Luther's Works*, ed. M.O. Dietrich and H.T. Lehmann (Philadelphia 1969), 13-14.

p. 109 Luther at Marburg
See H. Sasse, *This Is My Body* (Minneapolis 1959). For Luther's theology causing 'a crisis of Christian vocabulary', see G. Rupp, *The Righteousness of God* (London 1953).

p. 111 'High Renaissance' –
'a developed use of the human body'
Phraseology from H. Wölfflin, *Classic Art* (London 1952), 268.

7 PATHOS BY FORMULA, HORROR BY DECREE

The introductory account of Baglioni-Oddi hostilities at Perugia is taken from a text attributed to Francesco Matarazzo (or Maturanzio) and known as *Chronicles of the City of Perugia 1492–1503* (trans. E.S. Morgan [New York 1905]): see pp. 138-39 for the Atalanta-Grifonetto death scene. Jacob Burckhardt's digest of the tale comes in the opening pages of his *Civilization of the Renaissance in Italy*, first published in 1860: in Ludwig Goldscheider's illustrated compact Phaidon edition (London 1944), 17-21.

p. 113 Raphael's preparatory sketches
For the compositional history of Raphael's *Deposition*, see generally R. Jones and N. Penny, *Raphael* (Yale 1983), 37-47; also S. Ferino Pagden, 'Iconographic Demands and Artistic Achievements: The Genesis of Three Works by Raphael', in C.L. Frommel and M. Winner eds., *Raffaello a Roma* (Rome 1986), esp. 19-23. Further speculations – for example on the role of Raphael's assistants in the painting, and the possibility of a portrait of Grifonetto in the picture – will be found in Carlo Ragghianti's monograph, *La Deposizione* (Milan 1947). On the drawings specifically: J. Shearman, 'Raphael, Rome and the Codex Escurialensis', in *Master Drawings* 15 (1977), esp. 133; and P. Joannides, *The Drawings of Raphael* (Oxford 1983), 18-19, 58-9, 163-69. The phrase 'Madonna Atalanta' is used by Raphael in a letter to Domenico Alfani on the *verso* of a drawing in Lille: reproduced in the exhibition catalogue, *Raphael dans les collections françaises* (Paris 1984), 224-25.

p. 115 Raphael's antiquarianism
The artist's predilection for Classical antiquity is briefly surveyed in C. Vermeule, *European Art and the Classical Past* (Harvard 1964); see also R. Weiss, *The Renaissance Discovery of Classical Antiquity* (Oxford 1969), 93-6.

p. 115 Alberti 'On Painting'
See (for Latin text and English rendition) C. Grayson, *Alberti: On Painting and on Sculpture* (London 1972), esp. 72-5 (otherwise Book II of *Trattato della Pittura*, section 35*ff.*). Alberti's consonance with Humanist theory about 'expressiveness' in painting is noted in P. Burke, *The Italian Renaissance* (Oxford and Cambridge 1987), 148-50: for more about Bartolomeo Fazio, see M. Baxandall, 'B. Facius on painting', in *Journal of the Warburg and Courtauld Institutes* 27 (1964), 90-107.

p. 116 Meleager sarcophagi
Attempts to identify the actual sarcophagus alluded to by Alberti have been inconclusive: but for the general acquaintance with the Meleager myth in Renaissance imagery, see E. Paribeni, *Meleagros e la storia della sua fortuna nell'arte italiana da fra' Guglielmo a Michelangelo* (Milan 1975). Raphael's indebtedness to certain Meleager sarcophagi and perhaps other Classical antiquities was formally first presumed and explored by Arnold von Salis, in his *Antike und Renaissance: Über Nachleben und Weiterwirken der Alten in der neueren Kunst* (Erlenbach-Zürich 1947), 61-75. That Raphael's *Deposition* accordingly 'savo[u]rs of the Academy' is the judgment expressed in S.J. Freedberg, *Painting of the High Renaissance in Rome and Florence* (Harvard 1961), 70. For Rubens' study of a similar sarcophagus, see M. Koortbojian, *Myth, Meaning and Memory on Roman Sarcophagi* (California 1995), 143-44, and J.S. Held, *Rubens: Selected Drawings* (London 1969), cat. no. 23, pl. 22.

p. 118 'If you wish to make me weep...'
From Horace's *Ars Poetica*, 102-3 (*si vis me flere, dolendum est/primum ipsi tibi*).

p. 118 'Pathos formula'
E.H. Gombrich's distillation of Warburg's recorded thoughts on the *Pathosformel* notion is given in his monograph *Aby Warburg: An Intellectual Biography* (London 1970), where Gombrich notes (179) that the 'germinal idea' for Warburg's *Pathosformel*

came from Jacob Burckhardt. See also M. Barasch, '"Pathos Formulae": Some Reflections on the Structure of a Concept', collected in *Imago Hominis: Studies in the Language of Art* (Vienna 1991), 119-27. Art historians, if they use the term at all, tend now to apply it without particular Classical associations: so in the context of William Blake 'revising' Michelangelo, the following definition of 'pathos formula' is given – 'a limited range of body configurations and placements of the human form in space which communicates a definable range of mental and emotional states'. J. La Belle, in R.N. Essick and D. Pearce eds., *Blake in His Time* (Indiana 1978), 14-15.

In Warburg's terms: 'It is in the region of orgiastic mass-seizures [*Massengriffenheit*] that we must look for the original die which stamps upon the memory the expressive movements of the extreme flights of emotion – as far as they can be translated into gestural language – with such intensity that these "engrams" of the experience of passionate suffering persist as a heritage stored in the memory. They become exemplars, determining the outline shown by the artist's hand as soon as exaggerated values of expressive movement reach daylight via the artist's creativity.' See E.H. Gombrich, *op. cit.*, 244-45 and 293. Warburg's writings are further collected and translated in a volume from the Getty Research Institute, *Aby Warburg: The Renewal of Pagan Antiquity*, introduced by K.W. Forster (Los Angeles 1999).

p. 121 Laocoon's discovery and 'afterlife'
The literature is large, beyond the excellent summary given by M. Winner: 'Zum Nachleben des Laokoon in der Renaissance', in *Jahrbuch der Berliner Museen* 16 (1974), 83-121. See also F. Haskell and N. Penny, *Taste and the Antique* (Yale 1981), 243-47; on the statue's location in the Vatican, H.H. Brummer, *The Statue Court in the Vatican Belvedere* (Stockholm 1970); for the homage of sketches by sixteenth-century artists, P.P. Bober and R. Rubinstein, *Renaissance Artists and Antique Sculpture: A Handbook of Sources* (London and Oxford 1986), 152-55.

Artists urged to use Laocoon as a model for suffering Christian subjects: G.A. Gilio, *Due Dialoghi* (Rome 1564), 87 b; A. Possevino, *Biblioteca Selecta* (Rome 1593), 317 – as noted by L.D. Ettlinger in

'Exemplum Doloris: Reflections on the Laocoön Group', in *De Artibus Opuscula XL: Essays in Honor of Erwin Panofsky* ed. M. Meiss (New York 1961), 121-26.

p. 122 Michelangelo's Laocoon
That the Laocoon's effect upon Michelangelo has sometimes been exaggerated is true: see M. Hirst and J. Dunkerton, *Making and Meaning: The Young Michelangelo* (London 1994), 60; but Laocoon's shadow upon the Sistine ceiling perhaps falls heavier than many Michelangelo-specialists might care to admit. The influence of Laocoon upon Haman's punishment is briefly noted by Charles de Tolnay in his *Michelangelo. II. The Sistine Ceiling* (Princeton 1959), 181-82. For more on the Haman story and its context, see M. Bull, 'The Iconography of the Sistine Chapel Ceiling', in *Burlington Magazine* 130 (1988), 597-605; and for Laocoon among Michelangelo's Classical debts generally, see G. Agosti and V. Farinella, *Michelangelo e l'arte classica* (Florence 1987), 54-63.

p. 125 Titian's Laocoon
That Titian felt Laocoon's influence 'oppressive' was suggested by Kenneth Clark (*The Nude* [London 1956], 251); that Titian possessed a cast of the statue, by Erwin Panofsky (*Problems in Titian, Mostly Iconographic* [New York 1969], 141). For the woodcut of the artist's monkey-Laocoon, see H.W. Janson, 'Titian's Laocoön Caricature and the Vesalian-Galenist Controversy', in *Art Bulletin* 28 (1946), 49ff.

p. 125 Nollekens' Laocoon
The sculptor made a small terracotta model of the group: for his preparatory studies, see A.M. Hope, *The Theory and Practice of Neoclassicism in English Painting* (New York and London 1988), 94-5.

p. 125 Rubens' Laocoon
For the drawings, G. Furbini and J.S. Held, 'Padri Rerta's Rubens Drawings after Ancient Sculpture', in *Master Drawings* 2 (1964), 123-41. See also M. Jaffé, *Rubens and Italy* (Oxford 1977), 80-81; and W. Stechow, *Rubens and the Classical Tradition* (Harvard 1961). That the Antwerp altarpieces exhibit 'a quality of discipline and restraint that may properly be called Classical' is argued by J.R. Martin in his monograph *Rubens: The Antwerp Altarpieces* (London 1969): on specific Laocoon-echoes, see pp. 48-9.

p. 127 Rubens and 'exuberance *in sacris*'
Phraseology extracted from the sprawlingly informative two-volume study by J.B. Knipping, *Iconography of the Counter-Reformation in the Netherlands: Heaven on Earth* (Nieuwkoop and Leiden 1974).

p. 127 Art 'after the Council of Trent'
An elegant summary of Tridentine effects upon art and the literature of art was given by Anthony Blunt in his *Artistic Theory in Italy 1450–1600* (Oxford 1962), 103-36. In his *L'Art religieux ... après le Concile de Trente* (Paris 1932), Emile Mâle shows the centrifugal dynamism of Rome in applying the Council's edicts to art and propagation of the faith. See also F. Zeri, *Pittura e Contrariforma* (Turin 1957), for important modulations of the nexus between Jesuit ideology and 'the Baroque'; and, for a 'case-study', A.W. Boschloo, *Annibale Carracci in Bologna: Visible Reality after the Council of Trent* (The Hague 1974).

For more on the Inquisition quizzing of Veronese, see P. Fehl, 'Veronese and the Inquisition', in *Gazette des Beaux-Arts* 6:58 (1961), 325-54.

p. 129 Crashaw and St Teresa
The description of Crashaw as 'pre-eminently the English poet of the Counter-Reformation' is by D.J. Enright: see *The Pelican Guide to English Literature, 3: From Donne to Marvell* (Harmondsworth 1956), 156. The connection between Crashaw's *Hymn to St Teresa* and Bernini's *Ecstasy of St Teresa* was first made by Mario Praz: for further exploration of the similitude, see R.T. Petersson, *The Art of Ecstasy: Teresa, Bernini and Crashaw* (London 1970).

E.A. Peers' *Mother of Carmel* (London 1945) may be recommended as a tender and sympathetic introduction to St Teresa's life and work.

p. 129 Bernini's St Lawrence
The story of young Bernini testing the effect of heat is given in D. Bernini's *Vita del Cavaliere G. Lorenzo Bernini* (Rome 1713), as collected by G. Bauer, *Bernini in Perspective* (New Jersey 1976), 26. For Bernini's art as 'Jesuitical', Walter Weisbach's monograph *Jesuitismus und Barockskulptur in Rom* (Strasbourg 1909) remains useful. Bernini's isolation of the martyr's figure may be a sculptor's riposte to the disastrously body-cluttered fresco of St Lawrence produced in 1569 for the Church

of San Lorenzo in Florence by Agnolo Bronzino.

p. 130 'Systematic exploitation of the inordinate'

From A. Huxley, 'Variations on a Baroque Tomb', as collected in *Themes and Variations* (London 1950), 170. B. Boucher, *Italian Baroque Sculpture* (London 1998), 26, shows how modern prurience about Bernini should be answered.

p. 131 St Ignatius Loyola *et al.*

I have drawn upon H. Rahner, *Ignatius von Loyola als Mensch und Theologe* (Freiburg 1964). For a curious perspective on the saint, see R. Barthes, *Sade/Fourier/Loyola* (Paris 1971). The brief characterizations of the English martyrs Robert Southwell and Edmund Campion are taken from Father C. Devlin's *The Life of Robert Southwell* (London 1956).

p. 132 Poussin's St Erasmus

See L. Rice, *The Altars and Altarpieces of New St Peter's: Outfitting the Basilica, 1621–1666* (Cambridge 1997), 225-32; and R. Verdi, *Nicolas Poussin 1594–1665* (London 1995), 165-66. I quote from A. Blunt, *Poussin* (London 1995), 88.

p. 133 Jesuits and art

Francis Haskell made a case for dismantling the very concept of 'Jesuit art'; he argued that despite their rapid establishment and expansion, the early Jesuits had limited funds for art: see F. Haskell, *Patrons and Painters* (London 1963), 67. Possevino's tract on art is A. Possevino, *Tractatio de poesi et pictura ethica, humana et fabulosa* (Lugduni [Lyons 1593]); see also G.A. Gilio's *Dialogo* of 1564, collected in P. Barocchi, *Trattati d'arte del Cinquecento II* (Bari 1962), 3-115.

Caravaggio seems admittedly unlikely as a practitioner of *Spiritual Exercises*: the suggestion is made however in W. Friedlander, *Caravaggio Studies* (Princeton 1974), 121ff.

p. 134 Dickens at Santo Stefano

The quotation comes from Ch. 9 ('Rome') of his *Pictures from Italy* (London 1846). The Dickensian antipathy to papal ceremonies is evident enough in that book, but see also Peter Ackroyd, *Dickens* (London 1990), 455-56. Nathaniel Hawthorne's 1860 novel *The Marble Faun* records a gentler Puritanical response to Rome.

p. 134 Santo Stefano frescoes

Systematic catalogue and study given by L.H. Monssen, 'The Martyrdom Cycle in Santo Stefano Rotondo', in *Institutum Romanum Norvegiae: Acta ad archaeologiam et artium historiam pertinentia* 2 (1982), 175-317, and 3 (1983), 11-106. That they 'verge on anti-art' is the view of S.J. Freedberg, in his *Painting in Italy 1500–1600* (Harmondsworth 1971), 449. An essay by L. Kornick, 'On the Meaning of Style: Niccolò Circignani in Counter-Reformation Rome', in *Word and Image* 15 (1999), 170-89, proposes a certain 'Jesuit College style', whereby horrible martyrdoms are depicted in a manner 'explicit yet tidy'.

8 SALVETE FLORES MARTYRUM

Apart from St Matthew's Gospel, the apocryphal 'Book of James', or 'Protevangelium', also gives an account of Herod's fury with the Magi and subsequent order for infanticide (see M.R. James, *The Apocryphal New Testament* [Oxford 1924], 47-8). The fourth-century strophes of the Massacre of the Innocents by Prudentius, subsequently incorporated into the Catholic Missal, belong to his *Liber Cathemerinon* ('The Daily Round'), 12, 93-136. Daniel Halévy explains their importance to Péguy in *Péguy and Les Cahiers de la Quinzaine* (London 1946), 164-67. A little later than Prudentius, Paulinus of Nola also composed a hymnal salute to the Innocents (No. 31 of his *Carmina*).

Though it remains difficult to envisage as a scenario on stage, the Massacre of the Innocents figured in the repertoire of medieval liturgical plays: see K. Young, *The Drama of the Medieval Church* (Oxford 1933), Vol. 2, 102-24.

p. 141 Giovanni Pisano's 'angry' carving

The quote here is from M. Ayrton, *Giovanni Pisano Sculptor* (London 1969), 124. Subsequent sculptural representations of the Massacre – such as those on the doors of the Basilica of St Petronius in Bologna, made by Jacopo della Quercia during 1425–28 – never match the glyptic intensity of Pisano's effort.

p. 142 Ghirlandaio's 'antiquarian notebook'

As deduced by Aby Warburg, in his 1907 essay, 'Francesco Sassetti's Last Injunctions

to His Sons' – see A. Warburg, *The Renewal of Pagan Antiquity* (Los Angeles 1999), 247-49. The relish with which Ghirlandaio's contemporary Matteo di Giovanni (1435–95) painted the Bethlehem Massacre (especially an altarpiece for the church of Sant' Agostino, in Siena) has been noted by a number of commentators: see J. Pope-Hennessy, 'A Shocking Scene', in *Apollo*, March 1982 (N.S. No. 241), 150-57, and B. Cole, *Sienese Painting in the Age of the Renaissance* (Indiana 1985), 99-100. In Matteo's Sant' Agostino painting, the enthroned and choleric Herod wears a turban and looks distinctly like an Ottoman Sultan – which is one reason why some have been tempted to invoke the 1480 Turkish occupation of Otranto in Puglia as an historical resonance in Italian scenes of the Innocents at the end of the fifteenth century. The hypothesis is outlined in P. Schubring, 'Das Blutbad von Otrant in der Malerei des Quattrocento', in *Monatshefte für Kunstwissenschaft* 7/8 (1908), 593-601.

p. 143 Massacre scenes in sixteenth-century France

A succinct survey in J. Ehrmann, 'Massacre and Persecution Pictures in Sixteenth Century France', *Journal of the Warburg and Courtauld Institutes* 8 (1945), 195-99.

p. 145 The Hampton Court Brueghel

I have relied upon the history of the painting as far as it is tracked in Lorne Campbell's *The Early Flemish Pictures in the Collection of Her Majesty the Queen* (Cambridge 1985), 13-19. The painting is probably the one seen (in its unaltered state) by Karel van Mander, and praised in his *Schilder Boek* (1604) specifically for the expressions of the lamenting mothers.

p. 146 G.B. Marino

So far as I know, the entirety of Marino's *La Strage de gl'Innocenti* has never been translated into English. The poem's fall from critical favour is quite evident from G. Pozzi's edition, *Giovanbattista Marino: Dicerie Sacre e La Strage de gl'Innocenti* (Turin 1960).

p. 149 *Seicento* Naples

The apparent local favour shown to 'sensationalist' painters such as Mattia Preti, Ribera, Stanzione et al. may be partly explained by the following observation, taken from C. Whitfield and J. Martineau eds., *Painting in Naples 1606–1705: From Caravaggio to Giordano* (London 1982), 32:

'Naples was more a museum of the institutions of the Counter-Reformation than a centre of religious experience. It was the emporium of devotion, of exhortatory literature and hagiography, *but no socially innovative or provident institutions emerged during this period...*' (my italics).

p. 151 Re-writing of *King Lear*

The story of Nahum Tate's 'improvements' is summarized in D. Nichol Smith, *Shakespeare in the Eighteenth Century* (Oxford 1928), 20-5. Tate's own heed to the tragic muse may be judged: he provided (in 1689) the libretto for Purcell's operetta *Dido and Aeneas*, and took care to represent Dido's suicide as a simple swoon – not the violent immolation that Vergil's original story (in *Aeneid* Book IV) described.

9 REMBRANDT'S ELEPHANT EYES

The title adapts a phrase of Picasso's, jotted in February 1934: 'I had an etching plate which had an accident. I said to myself: it's damaged, so I'll draw any old thing on it. I started to scribble. It became Rembrandt ... I even did another one later with his turban, his furs, and his eye, his elephant's eye...' Picasso maintained that 'every painter takes himself for Rembrandt': see F. Gilot and C. Lake, *Life with Picasso* (New York 1981), 45.

In Ludwig Goldscheider's compilation, *Five Hundred Self-Portraits* (Vienna and London 1937), it is taken as axiomatic that 'Rembrandt stands out as the real master of self-portraiture among painters of all time' (43). Partisans of Rembrandt's 'outstanding' status uphold this creed vigorously: see, for example, Christopher Wright's monograph *Rembrandt: Self-Portraits* (London 1982), 38.

The documentary materials relating to Rembrandt's life were diligently collected in C. Hofstede de Groot, *Die Urkunden über Rembrandt (1575–1721)* (The Hague 1906). For titles and dates of the Rembrandt paintings discussed here, and biographical information about the artist, I have relied upon C. White and Q. Buvelot eds., *Rembrandt by Himself* (London and The Hague 1999). There are debts throughout the chapter to H.P. Chapman, *Rembrandt's Self-Portraits: A Study in Seventeenth-Century Identity* (Princeton 1990).

This chapter was written (and entitled) before I had seen Simon Schama's expansive study, *Rembrandt's Eyes* (London and New York 1999).

p. 156 'He stops people in their tracks, the old master …'

From a report by M. Kennedy in the *Guardian*, 11 February 1999, 10-11.

p. 157 Rembrandt and 'the epiphany of the face'

See J.L. Koerner, 'Rembrandt and the epiphany of the face', in *Res* 12 (1986), 5-32. 'Epiphany' means 'manifestation', but having coined this attractive phrase, Koerner is principally concerned to qualify what is indeed made manifest in Rembrandt's self-portraits; he ends by cautioning against 'too easy a passage from the represented face to its imagined interiority'.

In the philosophy of personal identity facial expression may be regarded as 'doubly distinctive of ourselves': meaning that every face has its natural contours, which are then host to the voluntary or involuntary patterns of expression. The quote in the caption of 104 comes from a discussion of this by Jonathan Glover, in his *I: The Philosophy and Psychology of Personal Identity* (Harmondsworth 1988), 70-1.

p. 159 The 'Ur-myth' of Rembrandt

A signal exercise in demythologizing was made by Seymour Slive in *Rembrandt and his Critics* (The Hague 1953). In ironic spirit Slive imagines the 'shock' of individuals portrayed in *The Night Watch* – 'Did they each pay Rembrandt one hundred guilders to be depicted as a dim piece of animated shade?' – then proceeds to document the bourgeois and critical esteem which the painting garnered during Rembrandt's lifetime.

p. 159 Fashionable melancholy

The social or stereotypical 'vocation' for artists to act or present themselves as afflicted by melancholy is charted in R. and M. Wittkower, *Born Under Saturn: The Character and Conduct of Artists: A Documented History from Antiquity to the French Revolution* (New York 1963), 98-132. See also the joint enquiry of R. Klibansky, E. Panofsky and F. Saxl, *Saturn and Melancholy* (London 1964).

p. 160 Rembrandt as beggar

The moralizing aspect of this conceit is examined in R.W. Baldwin, '"On earth we are beggars, as Christ himself was": The Protestant Background of Rembrandt's Imagery of Poverty, Disability and Begging', in *Konsthistorisk Tidskrift* 56 (1985), 122-35. 'The embarrassment of riches': after S. Schama, *The Embarrassment of Riches: An Interpretation of Dutch Culture in the Golden Age* (London 1987).

p. 160 Rembrandt as *pictor economicus*

On the market for Rembrandt's self-portraits, see G. Schwartz, *Rembrandt: His Life, His Paintings* (Harmondsworth 1991), 346-57. The phraseology of 'self-commodification' is taken from S. Alpers, *Rembrandt's Enterprise* (Chicago 1988), 118.

p. 161 'Anti-Classical' Rembrandt

The opening chapter of Kenneth Clark's *Rembrandt and the Italian Renaissance* (London 1966) states the case for Rembrandt's 'anti-Classicism' and roots it in the artist's 'love of humanity and hatred of shams' (41).

p. 163 'Rembrandt as thinker'

For the context and extent of Goethe's remarks on 'Rembrandt als Denker' (with a translation), see J. Gage, *Goethe on Art* (London 1980), 207-9.

p. 164 Genet's Rembrandt

I am indebted here to S. Wilson, 'Rembrandt/ Genet/Derrida', in J. Woodall ed., *Portraiture: Facing the Subject* (Manchester 1997), 203-16. The publication-history of Genet's thoughts on Rembrandt (which by transference Genet applied also to Giacometti) is complex. Despite its title, the essay *'Ce qui est resté d'un Rembrandt déchiré en petits carrés et foutu aux chiottes'* ('What remains of a Rembrandt torn into little squares and flushed down the toilet') is probably the clearest statement, to be found in Genet's *Oeuvres complètes* Vol. IV (Paris 1979), 21-31. Genet's writings on Rembrandt have also been collected in an edition simply entitled *Rembrandt* (Paris 1995). For the biographical context of Genet's interest in Rembrandt, see E. White, *Genet* (London 1993), 460-64.

The phrase 'the wrinkled intricacy of things, life itself' is from Paula Modersohn-Becker, as quoted in S. Alpers, *Rembrandt's Enterprise*, 146 n. 59. The citation from Montaigne is from his *Essais* of 1588, III.ii

(as rendered in John Florey's translation: 'every man beareth the whole stamp of human condition'); magisterial exposition is given within M.A. Screech, *Montaigne and Melancholy* (Harmondsworth 1991).

Rembrandt 'trying to out-Caravaggio Caravaggio': subsequent phrase adapted from an essay by Alan Jenkins in the *Times Literary Supplement*, 9 April 1999, 14.

p. 165 'Verism' in Roman portraiture
The complex of artistic and social factors that made 'verism' is sympathetically discussed in E.S. Gruen, *Culture and National Identity in Republican Rome* (London 1993), 152-82.

p. 166 Face as mirror of the soul
Classical theories are summarized in H.P. L'Orange, *Apotheosis in Ancient Portraiture* (Oslo 1947), 95-101. Wittgenstein's dicta come from those entries in his notebooks posthumously published as *Culture and Value* (ed. G.H. von Wright [Oxford 1980]): see 26e, also 56e.

According to John Berger, Rembrandt 'used a mirror only at the beginning of each canvas. Then he put a cloth over it, and worked and reworked the canvas until the painting began to correspond to an image of himself which had been left behind after a lifetime' (essay in the *Independent*, 3 June 1999). In respect of self-contemplation the following may also be pertinent: C. Goldberg, 'The Role of the Mirror in Human Suffering and in Intimacy', in the *Journal of the American Academy of Psychoanalysis* 12 (1984), 511-28.

I owe the link of the phrase from II Corinthians to the 'Self-Portrait as the Apostle Paul' to W.A. Visser 't Hooft, *Rembrandt and the Gospel* (London 1957), 132.

Note on the body and soul (ii)
I have here paraphrased from several lines of Descartes that may be cited in their original limpidity here: '...
le chatouillement des sens est suivi de si près par la joie, et la douleur par la tristesse, que la plupart des hommes ne se distinguent point. Toutefois ils diffèrent si fort, qu'on peut quelquefois souffrir des douleurs avec joie, et recevoir des chatouillements qui déplaisent.' (From J.-M. Monnoyer's edition of *Les Passions de l'âme, Précédé de La Pathétique cartésienne* [Paris 1988], 210.)

For discussion of Descartes' theory in its specific context of an *histoire de la douleur*, see Roselyne Rey's study of that title,

translated as *The History of Pain* (Harvard 1995), 72-77. The wider intellectual ambience of this Cartesian project is explored by Susan James, *Passion and Action: The Emotions in Seventeenth-Century Philosophy* (Oxford 1997). For Cartesian influence upon physiognomics, via the later seventeenth-century theories of Charles Le Brun, see J. Montagu, *The Expression of the Passions: The Origin and Influence of Charles Le Brun's Conférence sur l'expression générale et particulière* (Yale 1994).

10 WE ARE SORRY BUT UTOPIA HAS HAD TO BE POSTPONED

The two-volume study by Norbert Elias, *Über den Prozess der Zivilisation: Soziogenetische und psychogenetische Untersuchungen* (Basel 1939; republished Frankfurt 1988) is translated as *The Civilizing Process* (Oxford 1982), with Volume 1 *The History of Manners*, and Volume 2 *State Formation and Civilisation*. For a critical introduction to the work and influence of Elias, see J. Fletcher, *Violence and Civilization* (Cambridge and Oxford 1997).

The literature on Utopia is so large that it now qualifies as its own genre of study ('Utopics'). Manageable introductions are M.L. Bernieri, *Journey Through Utopia* (New York 1950); F. Manuel ed., *Utopias and Utopian Thought* (Boston 1966); and John Carey's anthology, *The Faber Book of Utopias* (London 1999).

For the confident assertion that we owe many of our 'civilized' institutions to the Enlightenment, see Alfred Cobban's *In Search of Humanity: The Role of the Enlightenment in Modern History* (London 1960). Michel Foucault's more circumspect view is epitomized in his commentary upon those 'Enlightened' eighteenth-century individuals who campaigned for penal reform. These do-gooders, claims Foucault, did not so much want to punish criminals less severely, as 'to punish better ... to punish with more universality and necessity; to insert the power to punish more deeply in the social body'. From M. Foucault (trans. A. Sheridan), *Discipline and Punish: The Birth of the Prison* (New York 1977), 82. See also his essay, 'What is Enlightenment?', in P. Rabinow ed., *The Foucault Reader* (New York 1985), 31-50, and in M. Foucault, *Ethics* Vol. I, ed. P. Rabinow (London 1997), 303-19.

p. 175 Savagery begins at home
For Columbus *verbatim*, see C. Jane ed., *Select Documents Illustrating the Four Voyages of Columbus* (London 1930: 2 vols.), and the same Cecil Jane's translation of *The Journal of Christopher Columbus*, revised and annotated by L.A. Vigneras (London 1960). The sense of enchantment in Columbus is explored in Stephen Greenblatt's *Marvelous Possessions: The Wonder of the New World* (Oxford 1991). On the issue of cannibalism, see W. Arens, *The Man-Eating Myth* (Oxford 1979), and P. Hulme, *Colonial Encounters: Europe and the Native Caribbean, 1492–1797* (London 1986). In sketching the effect of New World 'discoveries' upon the European concept of barbarism I have drawn upon A. Pagden, *European Encounters with the New World: From Renaissance to Romanticism* (Yale 1993).

Regarding the Thirty Years War, C.V. Wedgwood's judgment may be taken as the 'classic' view of a spiral of events that would 'make the angels weep': 'Morally subversive, economically destructive, socially degrading, confused in its causes, devious in its course, futile in its result, it is the outstanding example in European history of meaningless conflict.' (From C.V. Wedgwood, *The Thirty Years War* [London 1938], 526.) The counter-claim – that damage of all sorts was not so great – is argued in S.H. Steinberg, *The 'Thirty Years War' and the Conflict for European Hegemony 1600–1660* (London 1966).

The connection between Callot's *Miseries of War* and Grotius is nicely made by Y.-M. Bercé, 'Callot et son temps', in D. Ternois ed., *Jacques Callot (1592–1635)* (Paris 1993), 49-62. On the importance of Grotius as the founding father of modern natural rights theory, see R. Tuck, *Natural Rights Theories: Their Origin and Development* (Cambridge 1979); also O. Yasuaki ed., *A Normative Approach to War: Peace, War and Justice in Hugo Grotius* (Oxford 1993).

Diderot's comment ('It is a thousand times easier ...') comes from a letter he wrote to Princess Daskoff in 1771.

p. 180 'The Shaftesburian gentleman'
I have quoted from Shaftesbury's *An Inquiry Concerning Virtue, or Merit* as edited by D. Walford (Manchester 1977), 101-2. See also L.E. Klein, *Shaftesbury and the Culture of Politeness: Moral Discourse and Cultural Politics in Early Eighteenth-Century England* (Cambridge 1994); and for the expression of 'politeness' in portraits, Edgar Wind's

essay 'Humanitätsidee und heroisiertes Porträt in der englischen Kultur des 18ten Jahrhunderts', in *Vorträge der Bibliothek Warburg 1930–31* (1932), 156-229: rendered in English as the title essay of E. Wind, *Hume and the Heroic Portrait: Studies in Eighteenth-Century Imagery*, ed. J. Anderson (Oxford 1986), 1-52.

The phrase 'the politics of decency' is drawn from Peter Gay's two-volume survey, *The Enlightenment* (New York 1966–69): see Vol. II ('The Science of Freedom'), 396-447. It was La Rochefoucauld who said that 'decency is the least of laws and the most strictly followed': the complexities of defining the expectations of this law in eighteenth-century Europe are nicely sketched in a series of essays by Peter France, *Politeness and its Discontents: Problems in French Classical Culture* (Cambridge 1992).

Adam Smith's *Theory of Moral Sentiments* went through several editions, each modified: see the text as edited by D.D. Raphael and A.L. Macfie (Oxford 1976); and for the biographical circumstances of its composition and reception, I. Simpson Ross, *The Life of Adam Smith* (Oxford 1995), 157-94. D. Marshall, *The Surprising Effects of Sympathy* (Chicago 1988) follows some of the influence that Smith's work had upon French and English novelists.

The tale of Voltaire's involvement in the Calas trial is told in E. Nixon, *Voltaire and the Calas Case* (London 1961).

p. 185 Condorcet's omelette

Condorcet's *Esquisse* is best consulted in the edition established by Y. Belaval (Paris 1970). For an anthropologist's sympathetic exposition of Condorcet's project, see J.G. Frazer, 'Condorcet on Human Progress', in *The Gorgon's Head and Other Literary Pieces* (London 1927), 369-83; also Frazer's published lecture *Condorcet on the Progress of the Human Mind* (Oxford 1933).

The literature on artists and the French Revolution is large. I have mostly relied upon Thomas Crow's *Emulation: Making Artists for Revolutionary France* (Yale 1995). The Revolution's iconoclastic legacy is traced in D. Gamboni, *The Destruction of Art* (London 1997). The figurative 'echoes' of David's *Marat* are sounded in several essays from colloquium proceedings edited by R. Michel, *David contre David* (Paris 1993), 381-455; the painting itself is further expounded in W. Vaughan and H. Weston eds., *Jacques-Louis David's Marat* (Cambridge 1999). That it marks 'the beginning of

Modernism' is proposed by T.J. Clark in his *Farewell to an Idea* (Yale 1999), 15-53.

It may be worth noting here that for Robespierre and his contemporaries the guillotine was in some sense 'humane' in its operation: overt, swift and 'sweet' (*douce*). See J. McManners, *Death and the Enlightenment* (Oxford 1981), 368-408. The phrase 'one more little purge ...' comes from Richard Cobb, *Tour de France* (London 1976), 46.

p. 192 *'No se puede mirar'*

See the exhibition catalogue produced by A.E. Pérez Sánchez et al., *Goya and the Spirit of Enlightenment* (Madrid, New York and Boston 1989).

p. 197 Lord of the flies

More or less the full story of Géricault and the *Medusa* is given in L. Eitner, *Géricault's Raft of the Medusa* (London 1972); it is also told, with a novelist's *élan*, by Julian Barnes, in Ch. 5 of his *A History of the World in 10 1/2 Chapters* (London 1989).

For further discussion of the artist's preparatory studies – which in the end were not directly used much for the picture itself – see N. Athanassoglou-Kallmyer, 'Géricault's Severed Heads and Limbs: The Politics and Aesthetics of the Scaffold', in the *Art Bulletin* 74.4 (1992), 599-618.

p. 203 'The inventory started in 1839'

The title is derived from the opening salvo of Susan Sontag's various but invariably aphoristic essays *On Photography* (New York 1977).

Generally: J. Lewinski, *The Camera at War* (London 1978); and S.D. Moeller, *Shooting War: Photography and the American Experience of Combat* (New York 1989).

On Roger Fenton: H. and A. Gernsheim, *Roger Fenton: Photographer of the Crimean War* (London 1954); and V. Lloyd, *Roger Fenton, Photographer of the 1850s* (Yale 1988). For painters imagining the action that Fenton never showed, see M.P. Lalumia, *Realism and Politics in Victorian Art of the Crimean War* (Michigan 1984).

On Mathew Brady: D.M. and P.B. Kunhardt, *Mathew Brady and His World* (Alexandria 1977); M. Panzer, *Mathew Brady and the Image of History* (Washington 1997). For documentation of the 'rearrangement' of battlefield-corpses see W. Frassanito, *Gettysburg: A Journey in Time* (New York 1975). For more detail about Winslow Homer's artistic apprenticeship in the

Civil War, see N. Cikovsky, Jr., and F. Kelly et al., *Winslow Homer* (Yale 1995), 17-59. (The 'threat' of photography to freehand illustrators at *Harper's Weekly* may be indicated by the editorial subtitle added to the images of war produced by Homer and others: 'Drawn from life by our special artist'.)

Lincoln's rhetoric at Gettysburg as disinfectant: I quote from Garry Wills, *Lincoln at Gettysburg: The Words That Remade America* (New York 1992), 37.

Photography and the Paris Commune: J.A. Leith ed., *Images of the Commune – Images de la Commune* (Montreal 1978); D.E. English, *Political Use of Photography in the Third French Republic, 1871–1914* (Michigan 1984); and Q. Bajac, *La Commune photographiée* (Paris 2000).

p. 206 Saint Vincent's dream

On Courbet's political commitment, as *l'artiste citoyen*: J.H. Rubin, *Realism and Social Vision in Proudhon and Courbet* (Princeton 1980); and T.J. Clark, *The Absolute Bourgeois: Artists and Politics in France, 1848–1851* (London and New York 1973); also T.J. Clark, *Image of the People: Gustave Courbet and the 1848 Revolution* (London 1973).

Van Gogh as a 'disciple' of J.-F. Millet: see the exhibition catalogue edited by L. van Tilborgh and M.-P. Salé, *Millet/Van Gogh* (Paris 1998).

Van Gogh's virtual canonization as a modern (and not so secular) saint began almost as soon as he died, thanks to the efforts of Emile Bernard and others; the popular diffusion of this status was sealed by Julius Meier-Graefe's 1921 biography, subtitled *Roman eines Gottsuchers* ('Story of a God-seeker'). Fritz Novotny argued that the popular appeal of Van Gogh was not grounded in the melodrama of the painter's life, rather in his use of colour and form, leading all viewers to 'a deeper experiencing of nature' ('Die Popularität Van Goghs', in *Alte und Neue Kunst* 2.2, 1953); but this is a view rarely shared. Statistical proof of Van Gogh's popularity among the 'museum-going public' of Europe was offered by Pierre Bourdieu and Alain Darbel in their *L'amour de l'art* (Paris 1966). On the entire phenomenon, see N. Heinich, *The Glory of Van Gogh* (Princeton 1996), which offers 'an anthropology of admiration'. The creation of a posthumous 'life' of Van Gogh has been subject to several good critical studies, notably G. Pollock, 'Artists, Media, Mythologies:

Genius, Madness, and Art History', in *Screen* 21 (1980), 57-96; and C. Zemel, *The Formation of a Legend: Van Gogh Criticism, 1890–1920* (Michigan 1980). Fred Orton and Griselda Pollock once produced a book for the Phaidon Press which had all the appearance of yet another coffee-table volume but a staunchly 'realist' text (*Vincent Van Gogh: Artist of His Time*, Oxford 1978): this is deservedly reiterated – and wryly introduced – as 'Rooted in the Earth: A Van Gogh Primer', in F. Orton and G. Pollock, *Avant-Gardes and Partisans Reviewed* (Manchester 1996), i-iv; 1-50.

Karl Jaspers treated Van Gogh as a psychotic case in 1922 – though matching the vicissitudes of the artist's life to his works was not seriously feasible prior to the *catalogue raisonné* of Van Gogh's works established by J.B. de la Faille in 1928. See K. Jaspers (as translated by O. Grunow and D. Woloshin), *Strindberg and Van Gogh: An Attempt at a Pathographic Analysis with Reference to Parallel Cases of Swedenborg and Hölderlin* (Arizona 1977).

Heidegger's essay on 'The Origin of the Work of Art' began as a public lecture in Freiburg in 1935. The developed text, edited by H.-G. Gadamer, is *Der Ursprung des Kunstwerkes* (Stuttgart 1960); translated in M. Heidegger, *Poetry, Language, Thought* (New York 1971), 17-87; and translated and abridged in D.F. Krell ed., *Martin Heidegger: Basic Writings* (London 1978), 149-87.

Regarding *Starry Night* as a sublimated image of the Agony in the Garden: L. Soth, 'Van Gogh's Agony', in the *Art Bulletin* 68 (June 1986), 310-13; though note also the passages cited in Orton and Pollock *op. cit.*, 41.

On Van Gogh's Utopianism at Auvers, see C. Zemel, *Van Gogh's Progress: Utopia, Modernity and Late-Nineteenth-Century Art* (California 1997), 171-245.

p. 212 'We are making a new world'
The line by Oscar Wilde comes from his essay 'The Soul of Man under Socialism', as collected in *De Profundis and Other Writings* (Harmondsworth 1973), 34.

On Rodin's *Gates of Hell*: A.E. Elsen, *Rodin's Gates of Hell* (Minnesota 1960), in which the compositional flaws of the project are accepted, but its overall significance emphasized, perhaps to a fault (p. 141: 'Rodin's Gates are historically valuable as an expression of the *Weltangst* of the late nineteenth century that is also found in the art of Munch,

Ensor, and Van Gogh, and that led to the art of the German Expressionists').

Victor Hugo's allusion to Dante's *Inferno* is noted in the *Journal* of the Goncourt Brothers: see the entry for 11 July 1861.

Daniel Walker's study, *The Decline of Hell* (London 1964), would date the waning of belief in eternal torment to the seventeenth century. Hell's peculiar survival as a vacuous reserve was theologically argued by Hans Urs von Balthasar: his case may be found in *L'enfer: une question* (Paris 1988).

Marinetti's enthusiasm for (and experience of) violence is evident enough from biographies, such as G. Agnese, *Marinetti: una vita esplosiva* (Milan 1990); see also J. Howlett and R. Mengham eds., *The Violent Muse: Violence and the Artistic Imagination in Europe, 1910–1939* (Manchester 1994).

On artists' experience of the First World War, the fullest account is Richard Cork's *A Bitter Truth: Avant-Garde Art and the Great War* (Yale 1994). (For those 'conventional' artists who assisted in designing camouflage and so on, see E. Kahn, *The Neglected Majority: 'Les Camoufleurs', Art History and World War I* [Lanham 1984].) I have rather polarized the 'conversion' of C.R.W. Nevinson: an individual whose contrariness and complexities are more fairly explored in R. Ingleby et al., *C.R.W. Nevinson: The Twentieth Century* (London 1999).

Art within the context of general commemoration of the Great War is documented in J. Winter, *Sites of Memory, Sites of Mourning: The Great War in European Cultural History* (Cambridge 1995), on which I have also drawn, in the following chapter, for its account of 'Spiritualism' in post-war Britain.

D.H. Lawrence and Herakleitos: from a letter to Bertrand Russell in July 1915. See G.J. Zytaruk and J.T. Boulton eds., *The Letters of D.H. Lawrence: Volume II 1913–16* (Cambridge 1981), 364-65.

References to Edmund Blunden are drawn from an essay published in *The Listener*, 10 July 1929 (and republished in the same magazine for 19 January 1989, 20-1), complementing a memoir which appeared as *Undertones of War* (London 1928). The 'wet fingers screeching' noise: see L. Macdonald, *Somme* (London 1983), 65. 'All a poet can do today is warn': from the Preface drafted by Wilfred Owen for an eventual collection of his work (published posthumously in 1920), in D. Hibberd ed., *Wilfred Owen: War Poems and Others* (London 1973), 137.

11 THE COMFORTS OF UNHOMELINESS

Paradox is attached to the title of this chapter, as it must be: see the introductory parts of N. Carroll, *The Philosophy of Horror, or Paradoxes of the Heart* (New York and London 1990). If I have not actually used Noël Carroll's phraseology of 'art-horror' to denote the particular paradox of being scared by a fiction or a fabricated image, it is not from disagreement with Carroll's message – which is that we do not frighten ourselves in order to relieve 'the emotional blandness ... of modern life', but rather to appease our generic curiosity to know what is fundamentally unknowable.

There is further, and rather jaunty, analysis of horror's appeal in J.B. Twitchell, *Dreadful Pleasures* (Oxford 1985). Anyone prone to be 'shocked' by modern art in its various media – including rock lyrics and film – would also do well to read the historical survey by Richard Davenport-Hines, *Gothic: 400 Years of Excess, Horror, Evil and Ruin* (London 1998).

p. 221 'Horrific' fairy tales
I have alluded to Bruno Bettelheim's 'classic', *The Uses of Enchantment* (London 1976); sceptics of Freud will prefer the reasoning of Marina Warner, in her *No Go the Bogeyman* (London 1998).

p. 222 Freud and '*Das Unheimliche*'
Relevant texts in English as they appear in The Penguin Freud Library are 'The "Uncanny"', in Vol. 14, *Art and Literature* (Harmondsworth 1990), 339-76; and the second section of 'Thoughts for the Times on War and Death', in Vol. 12, *Civilization, Society and Religion* (Harmondsworth 1991), 77-89, which ends with the warning that we are 'living psychologically beyond our means', and the maxim: 'If you want to endure life, prepare yourself for death'. Further meditations by Freud on this theme and his related theory of a 'death instinct' appear in his study of 1920, *Beyond the Pleasure Principle*.

p. 223 Otto Dix
There is a compact introduction to Dix's engravings of war by John Willett in A. Griffiths et al., *Disasters of War: Callot, Goya, Dix* (London 1998); more generally, see F. Löffler, *Otto Dix: Leben und Werk* (Dresden 1977).

Maurice Bowra's remark about wartime witness is noted in the 1971 memoir collected in Cyril Connolly's *The Evening Colonnade* (London 1973), 39.

p. 225 Freud, Bataille and the Surrealists

Ernest Jones' 1912 study of *Der Alptraum*, translated as *On the Nightmare* (London and New York 1931), did much to spread Freudian dogma about the connection between infantile sexuality and psychological 'traumas'. Georges Bataille's exposition of Dalí's *Jeu lugubre* may be found in Vol. I of his *Oeuvres complètes* (Paris 1970), 210-16: for further essays and recorded opinions about Surrealism, see G. Bataille, *The Absence of Myth: Writings on Surrealism*, ed. M. Richardson (London 1994).

p. 228 Longinus 'On the Sublime'

Up until the early nineteenth century, the source of *Peri Hypsous* was accepted as the third-century philosopher and rhetorician Cassius Longinus; editions of the essay ever since have been more cautious (e.g. D.A. Russell, '*Longinus' On the Sublime*, Oxford 1964, where the author is reduced to simply 'L'). For a return to Longinus and a Neoplatonist, third-century context for *On the Sublime*, see M. Heath, 'Longinus, On Sublimity', in *Proceedings of the Cambridge Philological Society* 45 (1999), 43-74.

p. 228 Romanticism and 'the Sublime'

For a sample of the primary sources in English, and guidance around the extensive secondary literature, readers should consult A. Ashfield and P. de Bolla eds., *The Sublime: A Reader in British Eighteenth-Century Aesthetic Theory* (Cambridge 1996). It may be worth stressing here that it was under the guise of 'the Sublime' that 'the not-beautiful, the dreadful, the ugly and the terrible enter the theory of the arts in the eighteenth century' (see C. Zelle, 'Beauty and Horror: On the Dichotomy of Beauty and the Sublime in Eighteenth-Century Aesthetics', in *Studies on Voltaire and the Eighteenth Century* 305 [1992], 1542-45).

The citations from Kant come from his 1790 *Critique of Judgement*, as translated by W.S. Pluhar (Indiana 1987), 120.

For Burke's image of the theatre emptied by an adjacent execution, see Section I. 15 of his *Essay on the Sublime* in J.T. Boulton's edition (London 1958), 47-8. I owe the line about hijacked jet appeal to an

essay by S. Cresap, 'Sublime Politics: On the Uses of an Aesthetics of Terror', in *Clio* 19.2 (1990), 111-25.

I have left the link between Romanticism and Freud more implicit than stated: it is a connection nicely explored in N. Hertz, *The End of the Line: Essays on Psychoanalysis and the Sublime* (New York 1985).

For the occasion of S.T. Coleridge's definition of sublimity, see R. Holmes, *Coleridge: Early Visions* (London 1989), 230. Harold Bloom has used Coleridge to demonstrate Romanticism as more of a malaise than a 'movement': in *The Anxiety of Influence: A Reading of Poetry* (New York 1973). On the Romantic penchant for ailing, see section 4 of Susan Sontag's essay, *Illness as Metaphor* (New York 1978).

p. 230 Mountains and 'agreeable horror'

There is a full study of the Romantic response to mountains in M.H. Nicolson, *Mountain Gloom, Mountain Glory* (Ithaca 1959), put in broader context by Simon Schama, *Landscape and Memory* (London 1995), 447-62. For the Ruskinian graphic context of 'Mountain Gloom' and 'Mountain Glory' (both chapter titles within Vol. IV of *Modern Painters*), see P.H. Walton, *The Drawings of John Ruskin* (Oxford 1972), 72-97. For Ruskin's thoughts about the aesthetics of 'the Sublime', see Vol. I of *Modern Painters* (2nd edition, New York 1880), 40-1. The citation of Wordsworth at the Simplon Pass is from Book VI of the 1805 edition of *The Prelude*, lines 538-39: for further discussion of the young poet's predicament, see M. Wildi, 'Wordsworth and the Simplon Pass', in *English Studies* 40 (1959), 224-32.

p. 234 'The Romantic Agony'

This is the English title given to *La carne, la morte e il diavolo nella letteratura romantica* by Mario Praz (Florence 1930). It is an expansive study, perhaps now most valuable as an anthology of passages from 'good bad books' themselves long out of print. One such passage, from the Gothic novel *Melmoth the Wanderer* (1820) by C.R. Maturin, is worth repeating here, as an epitome of Romanticism's penchant for the terrible. In the words of one character in that story: 'It is actually possible to become *amateurs in suffering*. I have heard of men who have travelled

into countries where horrible executions were to be daily witnessed, for the sake of that excitement which the sight of suffering never fails to give, from the spectacle of a tragedy, or an *auto-da-fé*, down to the writhings of the meanest reptile on whom you can inflict torture, and feel that torture is the result of your own power. It is a species of feeling of which we can never divest ourselves, – a triumph over those whose sufferings have placed them below us . . .' After M. Praz, *The Romantic Agony* (2nd ed., Oxford 1970), 119.

p. 234 Sadism/Masochism

Sade's supporters claim the Marquis as a misunderstood man – see, for example, the overture of M. Hénaff, *Sade: L'invention du corps libertin* (Vendôme 1978) – but no one, so far as I know, has ever claimed any *literary* merit for his writings. The description of Sade's world as 'a sexual concentration camp' comes from E. Kennedy, *A Cultural History of the French Revolution* (Yale 1989), 106.

On 'the violence of an embrace', see G. Bataille, *Les larmes d'Eros* (Paris 1961), translated as *The Tears of Eros* (San Francisco 1989). This is an accessible picture-book summary of Bataille's understanding of Sadism as a primal human 'tendency'.

Sacher-Masoch's novel *Venus in Furs* is given in translation, with other writings, and an introductory essay, in a volume attributed to Gilles Deleuze, *Masochism* (New York 1989).

p. 238 Kierkegaard's anxiety

Kierkegaard's *The Concept of Anxiety* (or 'Dread') was first published in 1844: it is Vol. 8 of the Princeton edition of *Kierkegaard's Writings* (1980). A neat introduction is given by G.D. Marino, 'Anxiety in *The Concept of Anxiety*', in A. Hannay and G.D. Marino eds., *The Cambridge Companion to Kierkegaard* (Cambridge 1998), 308-28.

p. 239 After the 'abridgement of hope'

The phraseology of hope's 'abridgement' is used in Paul Fussell's study, *The Great War and Modern Memory* (Oxford 1975). Ezra Pound's description of a 'botched civilization' ('an old bitch gone in the teeth') is embedded in his sequence of 1920, 'Hugh Selwyn Mauberley'; on Pound's anti-Semitism at that time, see H. Carpenter, *A Serious Character: The Life of Ezra Pound* (London 1988), 359-62.

Virginia Woolf's remarks about the inadequacies of the English language for expressing pain come in the course of an essay entitled 'On Being Ill', first published in T.S. Eliot's journal, *New Criterion*. See A. McNeillie ed., *The Essays of Virginia Woolf* Vol. 4 (London 1994), 317-29 and 581-89. An important gloss on that sentiment is made by Elaine Scarry in her study *The Body in Pain* (New York and Oxford 1985), 5: '[Pain's] resistance to language is not simply one of its incidental or accidental attributes but is essential to what it is.'

I have echoed a passage from Woolf's essay which in its way emphasizes Milan Kundera's recognition of sympathy as the supreme – or most 'difficult' – virtue. That passage ought to be fully given here: 'But sympathy we cannot have. Wisest Fate says no. If her children, weighted as they already are with sorrow, were to take on them that burden too, adding in imagination other pains to their own, buildings would cease to rise, roads would peter out into grassy tracks; there would be an end to music and painting; one great sigh alone would rise to heaven, and the only attitudes for men and women would be those of horror and despair. As it is, there is always some little distraction – an organ grinder at the corner of the hospital, a shop with book or trinket to decoy one past the prison or the workhouse, some absurdity of cat or dog to prevent one from turning the old beggar's hieroglyphic of misery into volumes of sordid suffering . . .' (*op. cit.*, 319-20).

The brief reading here of the work of Giorgio de Chirico is more elegantly argued in the essays of Jean Clair's *Malinconia: motifs saturniens dans l'art de l'entre-deux-guerres* (Paris 1996). The citation from Käthe Kollwitz is drawn from E. Prelinger *et al.*, *Käthe Kollwitz* (Yale 1992), 76.

A good deal has been written about suggestive effects and understatement in the work of Edward Hopper: I have quoted from one essay by J.A. Ward, *American Silences* (Louisiana 1985), 168-202.

Francis Bacon's characterization of himself as working in a state of 'exhilarated despair' is recorded in David Sylvester's sequence of encounters with the painter, *The Brutality of Fact: Interviews with Francis Bacon* (3rd ed., London 1987), 83.

p. 242 Children's art at Terezin
For more on this, and the role of Friedl Dicker-Brandeis, see the exhibition catalogue edited by G. Heuberger, *Vom Bauhaus nach Terezín* (Frankfurt 1991); also *I Never Saw Another Butterfly. . .* ed. H. Volakova (New York 1993), which takes its title from a poem written in the camp by Pavel Friedman, containing the line, '*doch einem Schmetterling hab ich hier nicht versehen*'. Some 4,000 of the children's drawings are preserved in the State Jewish Museum in Prague. The mechanisms of the camp generally are documented in H.G. Adler's memoir, *Theresienstadt 1941–1945* (Tübingen 1955).

My mention of 'Holocaust art' will appear peremptory, even dismissive: I regret that, though it is not for want of searching out such memoranda, the extent of which may be measured by a number of survey-studies now published, including Z. Amishai-Maisels, *Depiction and Interpretation: The Influence of the Holocaust on the Visual Arts* (Oxford 1993), and M. Bohm-Duchen, *After Auschwitz: Responses to the Holocaust in Contemporary Art* (London 1995). It may be significant that in Laurence L. Langer's anthology, *Art From the Ashes* (Oxford 1995), Holocaust-generated 'art' is predominantly within the literary record.

The particular engagement of Anselm Kiefer with the challenge of Holocaust-memoranda is studied in L. Saltzman, *Anselm Kiefer and Art After Auschwitz* (Cambridge 1999).

12 FINALE: UNENDING

p. 245 The Buddha's repudiation of austerities
For textual confirmation in Buddhist lore that punishing the flesh gains no truly noble knowledge and insight, see D.L. Snellgrove ed., *The Image of the Buddha* (Paris and Tokyo 1978), 106. For further images of Buddha (or Sakyamuni, as Prince Siddhartha) fasting, see I. Kurita, *Gandharan Art, I: The Buddha's Life Story* (Tokyo 1988), 97-105.

The image of diminishing grief at the Buddha's death is also discussed in S. Moran, 'The Death of the Buddha: A Painting at Koyosan', in *Artibus Asiae* 36 (1974), 97-146.

p. 246 Matisse and soothing art
See the *Notes d'un peintre* of 1908, as collected in D. Fourcade ed., *Henri Matisse: Écrits et propos sur l'art* (Paris 1972), 50; and for the biographical context, Hilary Spurling's *The Unknown Matisse, 1869–1908* (London 1998), 423.

p. 246 Abstract 'Expressionism'?
Remarks here partly derive from Wilhelm Worringer's 1908 monograph, *Abstraktion und Einfühlung*, translated as *Abstraction and Empathy: A Contribution to the Psychology of Style* (London 1953); and Wassily Kandinsky's essay of 1911, *Concerning the Spiritual in Art* (translated in 1914 as *The Art of Spiritual Harmony*, but available under the first title as a Dover edition [New York 1977]).

p. 247 *Guernica*
That Picasso's *Guernica* is 'the most powerful invective against violence in modern art' is asserted by Robert Hughes, in his *The Shock of the New* (rev. ed., London 1991), 110, where it is also hailed as 'the last great history-painting'. The literature on *Guernica* is depressingly enormous: my digest makes use mostly of H.B. Chipp, *Picasso's Guernica: History, Transformations, Meaning* (Berkeley 1988), slightly supplemented by L. Ullmann, *Picasso und der Krieg* (Bielefeld 1993). For a tireless effort to trace 'echoes' of previous images in the painting, see F.D. Russell, *Picasso's Guernica: The Labyrinth of Narrative and Vision* (London 1980).

p. 249 Coda
My phrase 'the remorseless iconoclasm of reality' adapts a sentiment expressed by C.S. Lewis, writing as 'N.W. Clerk', in *A Grief Observed* (London 1961), 52 ('All reality is iconoclastic'). That it is a fault of art to create 'psychical distance' between its viewers and 'certain realities' is argued in the course of Arthur Danto's *The Transfiguration of the Commonplace* (Cambridge, Mass. 1981), 22.

ACKNOWLEDGMENTS

Vulnerable to the charge of dilettantism – and aware of approaching certain topics with all a newcomer's tinkling innocence – I have sought guidance from wiser minds, and snapped up many suggestions casually offered by colleagues. Certain specific debts are inscribed within the previous notes; others will have been lost; but generally I should like to thank – for their expertise and generosity with it – Paul Binski, Peter Burke, Don Cupitt, David Ekserdjian, Martin Gayford, Sir Ernst Gombrich, Catherine Pickstock, Peter Rickard, David Sedley and my father, the Reverend Alan Spivey.

Rachel Polonsky improved the text in very many places. She illuminated its writing throughout; and beyond.

I am deeply grateful, too, for the editorial scruples and attention of Jessica Spencer.

I have been a dull dog for company while this book was done – the damnable in-house absenteeism that settles upon an author absorbed and disturbed by the task in hand. I apologize to my wife and daughters; though it will, we suppose, happen again.

Göttingen 1997 – Cambridge 2000

LIST OF ILLUSTRATIONS

INDEX